Lincoln Township Public Library
2099 W. John Beers Rd.
Stevensville, MI 49127
(269) 429-9575

D0026208

Artists
of
Colonial
America

**Recent Titles in
Artists of an Era**

Artists of the Middle Ages
Leslie Ross

Artists
of
Colonial America

✌

ELISABETH L. ROARK

Artists of an Era

GREENWOOD PRESS
Westport, Connecticut • London

Library of Congress Cataloging-in-Publication Data

Roark, Elisabeth Louise.
 Artists of colonial America / by Elisabeth L. Roark.
 p. cm. — (Artists of an era, ISSN 1541–955X)
 Includes bibliographical references and index.
 ISBN 0–313–32023–3 (alk. paper)
 1. Artists—United States—Biography. 2. Art, Colonial—United States. 3. Art,
American. I. Title. II. Series.
N6507.R63 2003
709′.2′273—dc22
[B] 2003047240

British Library Cataloguing in Publication Data is available.

Copyright © 2003 by Elisabeth L. Roark

Library of Congress Catalog Card Number: 2003047240
ISBN: 0–313–32023–3
ISSN: 1541–955X

First published in 2003

Greenwood Press, 88 Post Road West, Westport, CT 06881
An imprint of Greenwood Publishing Group, Inc.
www.greenwood.com

Printed in the United States of America

∞™

The paper used in this book complies with the
Permanent Paper Standard issued by the National
Information Standards Organization (Z39.48–1984).

10 9 8 7 6 5 4 3 2 1

Contents

Color plates follow chapter 5.

Acknowledgments

A number of institutions and individuals aided in the research and writing of this study. I am grateful for the knowledgeable staffs and outstanding resources of the following libraries: Frick Fine Arts Library and Hillman Library of the University of Pittsburgh; Carnegie Public Library, Oakland Branch, Pittsburgh; and the libraries of St. Michael's College, Colchester, Vermont and the University of Vermont, Burlington. Thanks are due as well to the interlibrary loan staff of the Jennie King Mellon Library of Chatham College, Pittsburgh. Colleagues who have answered questions or provided an opportunity to discuss the ideas presented here include Joan Gundersen, Joy Sperling, Alan Wallach, Laurel Gabel, Gary Collison, Nancy Davis, and Susan Rather. At Chatham, I am grateful for the day-to-day encouragement of Michael Pestel and Steffi Domike. I am lucky to be a member of a consistently supportive faculty, especially during a difficult tenure year, 2002–03. No one could have more creative and caring students. Special thanks are due to the members of the Spring 2002 Colonial American Art seminar: Emily Becker, Joanne Braga, Katie Corcoran, Krisann Freilino, Katie Hoover, Eileen Kinch, Mechelle Lois, Michelle Nath, Melissa Newcomb, Erin Quiggle, Caitlin Ramsey, and Alisha Snyder; and "the team": Pam Cashdollar, Elizabeth Scott, and Mary Beth Kelly. I cannot express enough appreciation for the help and guidance of the staff at Greenwood Publishing Group. Many thanks to series editor Rob Kirkpatrick, who responded cheerfully to each anxious email. Illustrations editor Elizabeth Kincaid was a godsend. And finally, the family—the support of the Blumenthals, Keitels, Cooper-Keitels, Steinbergs, and Nahmans is much appreciated—thanks to all of you. This book is dedicated to my mother, Carol Roark, for special assistance; my brother,

Christopher Roark; my sister, Jennifer Nahman, who provided endless encouragement; and especially to my three guys—my husband, Richard Keitel, for love, strength, and humor, and my two redheads, Jordan and Daniel. I am here because of you.

Timeline

c. 30,000–13,000 B.C.E.	Peoples of Asia cross the Bering Strait to North America
1000 C.E.	Leif Eriksson explores Newfoundland
1492	Christopher Columbus explores Caribbean Islands
1497	John Cabot explores Atlantic coast of Canada
1499	Amerigo Vespucci explores South American coast
1507	German mapmaker erroneously credits discovery to Vespucci, labels continent "America"
1558	First permanent European colony in North America established by Spanish at St. Augustine, Florida
1585	John White, artist, accompanies Roanoke, North Carolina, expedition
1590	Theodore de Bry publishes *A briefe and true report of the new found land of Virginia,* with engravings based on White's watercolors
1607	Jamestown, Virginia, colony founded
1616	Smallpox epidemic decimates Native American population in New England
1619	First slave ship arrives at Jamestown
1620	Plymouth, Massachusetts, colony founded by Pilgrims
1621	First blast furnace built, Falling Creek, Virginia
1625	Dutch colonists settle New Amsterdam (later New York City)
1630	Massachusetts Bay Colony established at Boston; the "Great Migration" begins, 1630–42
1634	Cecilius Calvert, Lord Baltimore, establishes Maryland
1636	Colleges in Cambridge (later Harvard University) founded

1638	New Sweden, Delaware, founded
1639	*Bay Psalm Book,* Psalms set to music, translated
1648	Birth of John Foster, America's first printmaker
1649	Anne Bradstreet's *The Tenth Muse (Lately Sprung Up in America)* published
1652	Rhode Island enacts first law making slavery illegal
1659	Joseph Lamson, stonecutter, born
1663–65	Carolina established by eight Lords Proprietor
1664	Maryland passes law that mandates life-long servitude for blacks
c. 1670	John Foster creates *Richard Mather,* America's first print
c. 1671–74	*Mrs. Elizabeth Freake and Baby Mary* painted
1675–76	King Philip's War, Massachusetts
1681	William Penn establishes Pennsylvania
1682	Mary Rowlandson's *Narrative of the Captivity and Restoration of Mrs. Mary Rowlandson* published
1688–89	Maryland (or Protestant) Revolution eliminates Catholic rule in Maryland
1692	Salem Witch Trials
1693	College of William and Mary founded, Williamsburg, Virginia
1700	Colonial population is 275,000; Boston is largest city with 7,000
1704	First successful American newspaper, *Boston News-Letter,* published
1708	Henrietta Johnston arrives in Charleston
c. 1709	Lamson carves Jonathan Pierpont headstone
c. 1710	Justus Engelhardt Kühn paints earliest known depiction of an African American in American painting
1712	Gustavus Hesselius arrives in Delaware; tea introduced to America
1716	Theater built in Williamsburg, Virginia
1720s–40s	Great Awakening, evangelical Protestant movement
1725	Henrietta Johnston visits New York City
1728	John Bartram plants first botanical garden
1732	Benjamin Franklin publishes first edition of *Poor Richard's Almanac*
1735	Hesselius paints Lenni Lenape sachem Tishcohan and Lapowinsa
1737	Walking Purchase negotiations finalized by John and Thomas Penn
1738	Benjamin West and John Singleton Copley born
1743	American Philosophical Society founded
1751	Pennsylvania Hospital chartered
1754	French and Indian War begins
1756	Paul Revere works as master silversmith in Boston
1758	West leaves for Italy
1763	Treaty of Paris ends French and Indian War
1765	Stamp Act Crisis

1767	Townshend Acts
c. 1768	Copley's portrait of Paul Revere painted
1770	Boston Massacre; population of American colonies is 2,205,000
1772	West paints *William Penn's Treaty with the Indians*
1773	Boston Tea Party
1774	Copley leaves for Europe
1775	Paul Revere's midnight ride; Battles of Lexington and Concord; American Revolution begins.
1776	Declaration of Independence

Introduction: From White (1585) to West (1776)

In 1585, John White, the first English artist to visit America, landed at Roanoke Island and remained about a year, producing exquisite watercolors of local animals, plants, and the southeastern Algonquian Native Americans. We know little about White. We do not know exactly when he was born or when he died, whom he married or how many children he had. We know nothing of his training as an artist beyond what his watercolors reveal. We do know, however, that he was an integral part of an ambitious British plan to colonize North America's east coast and thereby transform the balance of political, religious, and economic power in Europe. And we know that White's watercolors played a fundamental role in that plan.

Almost two hundred years later, in 1776, not only had England transformed Europe's balance of power, but it had also altered every aspect of life on the Atlantic seaboard. England controlled virtually the entire coast, north from Georgia to current-day Maine, and inland to the Mississippi River. The British established such thriving urban centers as Boston, Philadelphia, and Charleston, displacing native cultures like the Algonquian. They developed lucrative trade routes and a mercantile economy that lined British pockets—both in England and America—with gold. Protestantism was the dominant religious force and monarchy the political mode under King George III. Yet England was confronting a colonial population unhappy with the mother county's increasingly oppressive economic policies and rigid political control. Americans were empowered by recent military success against France in the French and Indian War and demanding change. The stage was set for revolution.

The circumstances for artists were also radically different by 1776. After White's visit, most early colonial artists struggled to make a living among settlers more concerned with subsistence than cultivating the finer things in life.

But by 1776, two native-born artists, John Singleton Copley of Boston and Benjamin West of the Philadelphia area, had enough confidence to travel across the Atlantic and establish themselves as professionals in London's competitive art community. This was an amazing accomplishment for young men raised without the advantage of art schools or museums. West, in fact, attained the highest level of success in the English-speaking art world, an appointment in 1772 as a court painter to George III.

As West's court appointment suggests, one commonality between West and White is that both created works with profound political implications. Yet West's relationship with the king also distinguishes him from White, highlighting one difference of many between the two artists. Not only do we know West's birth and death dates and the details of his marriage and family life, a two-volume biography published during West's lifetime provides exhaustive accounts of his upbringing in America, his training, and his experiences abroad. Recent scholarship has filled many remaining gaps. While only seventy-three watercolors by White remain, West left hundreds of paintings and sketches for art historians to puzzle over. One of this study's concerns is how American colonial art evolved from White to West, from a little-known artist to one with dozens of studies dedicated to key aspects of his career, and the circumstances surrounding this transformation.

The history of colonial American art is a story of individuals and objects—but not average individuals and commonplace objects. It is the story of extraordinarily tenacious, often isolated individuals and visually compelling objects. The colonial period in America is ideal for the organization of the *Artists of an Era* series into separate artist biographies, for colonial American artists were, by circumstance if not choice, remarkably independent. There were no art movements, no academies or art schools, no joint artist treatises or manifestos. Instead, colonial artists worked alone; their experiences were idiosyncratic and strongly shaped by their distinctive locations. Thus the situation of Henrietta Johnston, who lived in early-eighteenth-century Charleston and created pastel portrait drawings to support her family, differed considerably from that of gravestone carver Joseph Lamson, who supervised a large shop in the Boston area at the same time. The unique experiences of colonial artists satisfy an additional objective of the *Artists of an Era* series: to explore the varied economic, political, religious, cultural, and social contexts of the period.

It is the objects the artists created that allow access to these contexts. Exploring a work of art's historical context can also take us far beyond the artist's individual situation. We will find, for example, that understanding Calvinist theology is necessary to assess portraits created in seventeenth-century Boston, and that political circumstances in London in 1770 influenced a painting depicting an event in Pennsylvania a century before. While commonplace objects may offer equal access to the past, those identified as the "fine arts" (a term used less often today because of its qualitative implications) prompt other important avenues of investigation. When studying colonial painting or silver, for instance, we are encouraged to explore the transmission of period styles like the Baroque

and the Rococo from Europe to America. Similarly, analysis of a work's formal, or visual, qualities allows us to answer questions such as, why is the painting of Mrs. Elizabeth Freake regarded as the finest American portrait created during the seventeenth century? Or, why is the work of John Singleton Copley considered the culmination of the colonial portrait tradition?

This dual interest—intriguing individuals and visually compelling works of art, both embedded in significant contexts—determined the selection of the 10 artists featured here. Therefore, John White, noteworthy for his watercolors' quality and his place as the first English artist in America, is also important for the 1585 voyage and his role as governor of the 1587 Roanoke colony, the doomed Lost Colony of which White was the only known survivor. Similarly, Paul Revere is regarded as late colonial Boston's finest silversmith; he also created engravings depicting events related to rising revolutionary agitation, such as the Boston Massacre of 1770. His prints and his standing in the Sons of Liberty and the Committee of Correspondence, which led to the famous midnight ride, encourage consideration of the American Revolution. This study does not pretend to be a comprehensive history of colonial America, but one that emerges from the artists and works of art selected. It is also important for readers to understand that the works of art discussed here do not illustrate American history. As we will see, even Revere's *Bloody Massacre* is far from historical fact. Instead, works of art are mediations or constructions, not documentation, of people, places, and events. The subject is always filtered through the artist's experiences and influenced by the artist's intent, that of his or her patron, and a shared collage of ideas and images with distinct cultural meanings.

An initial challenge governing the selection of artists was determining how to define colonial America. The Americas include all land from current-day Canada to Argentina, and their colonization involved a range of nations—Spain, Portugal, the Netherlands, France, Russia, and England. Many countries sent artists to the Americas, initially to document their acquisitions. As colonization proceeded and settlements grew, artists immigrated to meet settlers' needs. Spanish artists are recorded in Mexico and the North American southwest in the sixteenth century. Dutch artists traveled to New Netherland (later New York). There were, of course, indigenous artists in the Americas throughout the colonial period. For several reasons, I decided to focus on artists of European ancestry and maintain the traditional view of the American colonies as the east coast, or British, colonies alone. One reason was to limit the study's scope and make it more manageable. Another reason was that until recently scholarship in colonial American art history overwhelmingly favored the artists who worked in British America and whose names are known (an imperative for a biocritical study such as this). While what defines the American colonies has expanded since the 1960s, as historians explore New France and New Spain in greater detail, groundbreaking studies on the colonial art of regions such as the American southwest are relatively new. Few named artists who created works before 1776 are well documented (nor is 1776 even relevant, for colonization persisted outside of the thirteen colonies after that date). This is understandable. Historian Alan Taylor describes British America as

"the most populous, prosperous and powerful colonial presence on the continent," which influenced the way subsequent histories were written.[1] In addition, despite changes in recent scholarship, the thirteen colonies are what most people think of when they hear the phrase *colonial America*. My choice is consistent, then, with the expectations created by the book's title.

By focusing on the British colonies, I am able to provide a more comprehensive view of several areas rather than a superficial treatment of many. For example, in Boston, the most culturally developed city in late-seventeenth-century America, I explore several media—printmaking, oil painting, and sculpture—created within a single, dominantly Puritan milieu. Addressing a limited geographical area allows parallels between chapters to emerge. There are many similarities between mercantile Boston of the 1670s, embodied in the portraits of the Freakes examined in Chapter 3, and the pre-revolutionary city evident in the materialistic portraits of wealthy Bostonians by Copley addressed in Chapter 9. Thomas Penn, instrumental in the creation of Gustavus Hesselius's portraits of the Lenni Lenape chiefs Lapowinsa and Tishcohan in 1735 (the subject of Chapter 7), commissioned Benjamin West to paint *William Penn's Treaty with the Indians* in 1771 (examined in Chapter 10). Both works are linked to Pennsylvania politics and Indian affairs.

In addition, a common British framework allows one to underscore regional differences more effectively. The southern and northern colonies were as distinct as separate countries, and Pennsylvania was a world unto itself. Within the British colonies there was also great diversity in nationality. Of the artists addressed here, only two were born in England. One was Swedish, one German, one French Huguenot, and five American-born. I must also clarify the use of the terms *America* and *American,* which can be used to describe all of the Americas, north and south, and their inhabitants. For brevity's sake, here the term *America* is used synonymously with *North America* and particularly *British America,* and an *American* is a resident of this region. Chronologically, the book begins with John White's arrival in 1585 and concludes with the careers of Revere, Copley, and West, who were established professional artists prior to the Revolution and continued to work into the early nineteenth century. This study emphasizes their careers before 1776, the year the thirteen colonies declared their independence and the colonial era ended.

Focusing on a limited number of colonies with related cultural and contextual considerations also enabled me to develop several overarching narratives. In each chapter, I explore the challenges faced by professional artists in establishing a viable visual culture in a provincial environment. Questions that intrigue me include, if the artist was European, why did he or she come to America? What compelled artists to travel thousands of miles to a land that was, at best, culturally indifferent? Similarly, if the artist was native-born, what encouraged him to pursue a career in the arts, an unusual choice considering the circumstances? Related to this, each chapter addresses the artist's role in society, which changed radically in the 200 years between White and West. Sixteenth-century English men and women viewed artists as the social equals of others

who worked with their hands, such as tailors and bricklayers. By the early 1770s, Copley owned a grand home next to John Hancock, one of Boston's wealthiest men, and West was a confidant of the King of England. What conditions fostered such a dramatic shift in status?

Another consistency is the prominent place of religion in colonial life. While this is often hard to fathom in our secular age, for Christians of the sixteenth, seventeenth, and eighteenth centuries, religion was more often than not the organizing principle of life. It therefore had a profound impact on the arts of the colonial period. Many works of art functioned as visual expressions of religious faith, even those that appear to have little to do with spiritual concerns, such as portraits. This is understandable when one remembers that the search for religious freedom drove thousands to relinquish everything and risk an arduous and often dangerous journey across the Atlantic Ocean. One surprising commonality is how often apocalyptic ideas emerge as a motivation for colonization, and impact a range of works, from early-eighteenth-century gravestones to late-eighteenth-century painting.

A third narrative thread is how colonial artists depicted contact and conflict between races. One risk of focusing on British America is perpetuating the traditional view of colonial history as a triumphant tale of white men settling an empty land, improving it, and then growing strong enough to force out the English and establish the first modern democracy. Most people realize today that this is a gross oversimplification and ignores the roles played by women and other races. Instead American colonization involved an unprecedented mixing of Africans, Europeans, and Native Americans. It was a stressful situation for all involved, as they struggled to make sense of one another, and understandably, artists responded. I selected several painters who depicted Indians or African Americans—John White, Justus Engelhardt Kühn, Gustavus Hesselius, and Benjamin West—to explore this issue. Although all are white men (the alternative—African or Indian images of the colonizers—are rare and usually credited to unknown artists), the images they created provide glimpses of colonial attitudes about race that have provoked some of the most interesting scholarship in recent years.

Related to this, a final issue addressed repeatedly in the chapters that follow is the definition or construction of identity. Portraiture, as a theme, dominated the art of the British colonies, as it did that of England. Of the 42 works of art illustrated here, more than half are portraits. Beginning with John White's portrait of an Algonquian warrior, we see the artist utilizing European conventions of pose to construct an identity for the Indian that would be understandable to a European audience. Two hundred years later, Copley borrowed poses, backgrounds, even clothing from British portrait prints to convey the aristocratic associations his patrons desired. Portraits often involve a collaborative effort in which the sitter and artist work together to assert the sitter's conception of himself or herself. Therefore, portraits can reveal the colonists' accomplishments, aspirations, and affiliations.

These are but a few of the issues addressed in *Artists of Colonial America*. To ask and answer the right questions, raise the appropriate issues, and explore the

patterns that emerge, I have depended heavily on the insights of many other historians of American art. To build suitable contexts for the artists and their works I have also utilized resources in a range of disciplines—American history (particularly social history), anthropology, sociology, religious history and theology, and ethnography. I have acknowledged these works in the bibliographies that conclude each chapter. In gathering resources and considering the methodologies other historians have applied to the material presented here, it is apparent that far more scholarship is available on the artists of the later colonial period—Revere, Copley, and West—than on artists who worked prior to about 1740. With the exception of the Freake Painter, some of the newer methodologies in art history have not been applied to the artists addressed in the earlier chapters of this book. Some have not even been thoroughly investigated from a contextual perspective, which has resulted in new interpretive readings. For example, I suggest that Justus Engelhardt Kühn's well-known portraits of the Darnall children must be analyzed in the context of anti-Catholic prejudice in early-eighteenth-century Maryland to understand their intent.

As noted, the primary objective of *Artists of Colonial America* is to examine the lives and works of ten artists and provide them with a denser historical context by exploring their political, economic, religious, social, and cultural milieus. This augments our understanding of the artists and their works, just as exploring the works of art provides greater insight into the times in which they were created. I hope that the questions outlined above, the choices made, and the concerns set forth encourage the reader to continue and thereby encounter an era that is in many ways remote, and yet in its crucial features familiar, for it formed the foundation of our nation.

Note

1. Alan Taylor, *American Colonies: The Settling of North America* (New York: Viking Press, 2001), xv. For scholarship on colonial art of the southwest, see Diane Fane, ed. *Converging Cultures: Art and Identity in Spanish America.* Exhibition catalogue (New York: Brooklyn Museum in association with Harry N. Abrams, Inc., 1996); and Donna Pierce and Marta Weigle, eds., *Spanish New Mexico: The Spanish Colonial Arts Society Collection,* vol. 1 (Santa Fe: Museum of New Mexico Press, 1996).

CHAPTER 1

John White (c. 1545–1606?), Artist-Explorer

In 1585 the artist John White accompanied the first expedition of English settlers to Virginia, as the eastern coast of North America was then known. Sponsored by Queen Elizabeth I and coordinated by Sir Walter Raleigh, White and 107 other Englishmen lived for almost a year on Roanoke Island, off the coast of current-day North Carolina. According to historian Paul Hulton, the drawings and watercolors White created to document the plants, animals, and people he encountered are the "first convincing record to have survived of the people and the natural life" of the New World and a visualization of a Native American population unmatched until the mid-nineteenth century.[1] Two years later, in 1587, Raleigh appointed White governor of a second English colony and he returned with 118 men, women, and children to establish a permanent settlement at Roanoke. Here the first English child was born in America—White's granddaughter, Virginia Dare. And it was from Roanoke that the colonists mysteriously disappeared after White returned to England for supplies. The tragedy of White's doomed colony continues to haunt the popular imagination to this day.

White's participation in the 1585 voyage was not unprecedented. Artists hired to document new discoveries accompanied earlier French and Spanish expeditions to America; naturally, the English followed suit. Of course, the expeditions' supporters demanded evidence that their investment was worthwhile, but more compelling was the widespread fascination with this unexplored realm. Imagine the excitement generated in Europe by the discovery of a completely unknown land. Imagine as well the challenge for European artists to create images of people, places, plants, and animals the likes of which they had never seen before. White's paintings and drawings—of which 73 remain—are exquisitely executed works of art. But more importantly, they are among the earliest existing visual evidence of a European's perception of the New World and its resi-

1

dents. This dual function—as fine works of art and unprecedented ethnographic documentation—places White's works among the most significant artistic productions of colonial America.

Strangely, for an active politician and artist, little is known of John White's background. His name was so common that it is difficult to determine which John White, of the many listed in late-sixteenth-century English records, he was. Historians believe that he was born between 1540 and 1550, but this assumption is based only on how old he must have been to have a granddaughter in 1587. White's upbringing was most likely quite modest. Artists in England at this time were low on the social scale, considered the equal of other craftspeople who worked with their hands. White's status is confirmed by his daughter Elynor's marriage to Ananias Dare, a bricklayer and tiler; typically daughters married men of social positions similar to their fathers'.

Nor is there any definitive documentation of White's training or early career. Based on his existing watercolors and drawings, it is clear that he was apprenticed to a limner, an artist who specialized in miniature watercolor portraits. The word *limner* is based on the term "illuminator," the artist who decorated medieval manuscripts. A limner's work is characterized by attention to detail, an appropriate skill for one hired to record the particulars of heretofore-unknown American inhabitants. White's drawings of botanical and zoological specimens attest to his awareness of the growing field of scientific illustration. And the quality of his maps suggests that he had cartography training as well.

Yet it is unlikely that Raleigh invited White to accompany the 1585 expedition based on his artistic skill alone. Hulton suggests that White participated in a brief reconnaissance mission to the Roanoke area sponsored by Raleigh in 1584.[2] There is also evidence that White was part of a 1577 expedition, led by Sir Martin Frobisher, to Baffin Island in the southern part of Hudson Bay. Portraits by White of the Inuit (more commonly known as Eskimos) and a watercolor of Inuit fighting Englishmen have the verisimilitude of eyewitness accounts. In addition, White made copies of drawings of Native Americans by the artist Jacques Le Moyne de Morgues, who traveled to Florida with an expedition of French Huguenots in 1564. Le Moyne's work was certainly a model for White's American paintings, and his familiarity with it may have recommended him for the job.

While Raleigh's specific instructions to White no longer exist, they must have been similar to those given another sixteenth-century English artist-explorer to "drawe to lief each kind of thing that is strange to us in England . . . all strange birdes beastes fishes plantes hearbes Trees and fruictes . . . also the figures & shapes of men and woeman in their apparell as also their manner of wepons in every place you shall find them differing."[3] White's interpretation of his task was influenced by the expectations of his potential audience. His patron was Raleigh, a man of great intellectual curiosity, but also an investor who had a specific agenda in sponsoring colonization. Raleigh's primary motivation was financial gain, which required that Virginia's colonization proceed apace. Raleigh would have encouraged White to carefully record each unusual plant and animal to as-

sess its economic value, and representative Native Americans to gauge their nature; perhaps he even instructed White to accentuate the positive, for few of the challenges the colonists faced appear in White's watercolors. White knew that his work would be studied carefully by a European audience hungry for information, and that it was his job to reassure European investors that Virginia's natural resources were abundant and its natives were friendly, their weapons primitive and their villages undefended.

English Exploration and Colonization

Compared to Spain, Portugal, and France, England was slow to participate in the rush to colonize the Americas. The country was unsettled after the War of the Roses (1455–85) and at odds with Spain and the Roman Catholic Church after Henry VIII established the Anglican Church in the 1530s. This put demands on England's economic and military resources. Yet under Henry VIII's daughter Elizabeth I (ruled 1558–1603), who sponsored Walter Raleigh, several factors motivated exploration west. First and foremost were the economic incentives. England by the late sixteenth century was suffering a land shortage, as tenant farmers were put off land consolidated by wealthy landowners, and roving bands of the landless poor emerged. Among the upper classes, the law of primogeniture (which required that all of a father's goods passed to his firstborn son only) resulted in frustrated, restless younger sons who had no prospects in the mother country. All concerned viewed America as having great potential in terms of land development, new markets, and new products. Another economic motivation was the rise of mercantilism. Under mercantilism a country's wealth was based on the gold and silver it controlled, acquired primarily through trade. England had little surplus gold and silver and recognized the need to build a colonial empire with copious raw materials that would pass through the mother country, thereby increasing stores of currency and challenging the power of gold-rich Spain. The growth of a mercantilist economy also reflected the confidence of British seamen and the technical superiority of British ships.

Raleigh was motivated not only by money but also by his desire to promote the glory of England. Rising nationalism and religion combined to form a powerful impetus for permanent settlement in North America. Many British saw colonization as a religious crusade. Increasingly uncomfortable with the growth of Spanish and French Catholic settlements in the Americas, Queen Elizabeth I believed that Protestant settlements would redress the religious imbalance of the New World. The desire to convert the "heathen" to the "true" religion (i.e., Protestantism) was a key incentive for colonization.

Raleigh received a patent from the Queen in 1584 to explore the coastal region from the French-claimed St. Lawrence River to Spanish-held Florida. He called this land Virginia in honor of the virgin queen. Raleigh quickly collected 600 men, yet did not plan to travel himself. Instead he hired the explorer Sir Richard Grenville to command the ships, and Ralph Lane, an experienced sol-

dier, to govern the colony. The primary objectives of the 1585 expedition were to collect information about the area and to start a settlement. The participants included soldiers, gentlemen interested in free land, merchants, and several specialists: White, the metallurgist Joachim Ganz (Raleigh anticipated the discovery of gold in Virginia), and the scientist Thomas Harriot (1530–1621), who worked closely with White to map the area and compose the written narrative to accompany White's drawings and watercolors.

The expedition, housed in five ships, left England on April 9, 1585. The ships separated shortly after embarking. White's ship, the *Tyger,* landed at a Spanish fortification on Puerto Rico in May and spent several weeks taking on supplies and waiting for the other ships. White and Harriot collected specimens for White to draw and Harriot to record; White produced his first depictions of creatures unknown in England, such as an iguana and a crocodile. White created a birds-eye view of the Spanish encampment that offers a fascinating glimpse of an early colonial settlement fortified with entrenchments, ditches, and bastions and surrounded by a heavily wooded area. This is one of only two surviving works by White that depict the colonists; it shows armed guards, a portrait of Grenville on horseback, and men hauling timber and water to the *Tyger* offshore. The edges of the watercolor are "garnished" with tiny fish and fowl.

The *Tyger* headed north in June 1585 and eventually reached the barrier islands on the coast of what is today North Carolina. As the earlier reconnaissance mission reported, Roanoke Island, situated in the bay between the barrier islands and the mainland, seemed well protected, with abundant natural resources and friendly native inhabitants. Lane and 107 men disembarked and quickly built houses and a fort, marking the settlement as a military encampment.

Native Americans of the Southeastern Woodlands at Contact

European explorers of the sixteenth century believed that they were entering a land sparsely populated and ripe for development. In fact, estimates of the native population of the Americas at contact range from ten million to one hundred million. This population included cultures of great wealth and sophistication. Native Americans settled the Atlantic coast around 6000 B.C.E., and numbered approximately 700,000 in 1585. When White and his compatriots landed at Roanoke they found several well-established cultures on the coast between Albemarle Sound and the Pamlico River, including three allied nations, the Chowanoc, Weapemeoc, and Secoton. Each was part of the Southeastern Woodlands Algonquian language group and lived in Stone Age conditions, with tools made of stone, bone, and wood, but no metal technology. They fed and clothed themselves through agriculture, hunting, and fishing, as well as foraging for berries and other naturally occurring foodstuffs. There is evidence that they traded with other Native American cultures and were proficient weavers and ceramicists.

So much distinguished the Algonquian from their English visitors. Algonquian society was egalitarian and had little understanding of personal ambition, one of the primary English motivations for exploration and settlement. No elaborate laws existed because all members knew what was expected of them. Land was worked communally and the concept of land ownership—the basis of economic and political power in Europe—was foreign to the Algonquian. In fact, the Algonquian were animists and emphasized the connection between the secular and the sacred; all living forms were infused with spirits, and one did not abuse nature or it might strike back.

Two of White's watercolors provide extensive information about Algonquian lifestyles and settlements.[4] White and Harriot encountered the village of Secoton on July 12, 1585, and the village of Pomeiooc on July 17. The depiction of Secoton is based on several drawings that White combined to create a birds-eye view of an organized, abundant settlement. Sophisticated agricultural development is evident in fields with corn at three stages of growth: new shoots, green corn, and ripe corn in full tassel. Approximately a hundred people lived at Secoton. White showed their orderly dwellings, built of bent and tied poles covered with bark and thatch, and their activities, including a ceremonial dance, a lookout on a platform in the cornfield, and a communal meal. Historian David B. Quinn notes the significance of this image: "In this single picture White shows us more about the character of Woodland Indian life than could many thousands of words."[5]

While White portrayed Secoton as an open and unfortified village, suggesting that the residents were a peaceful people, his image of Pomeiooc shows a village surrounded by a stockade of thin wood poles that provide scant protection for 18 timber and thatch houses. Like Secoton, Pomeiooc has a ceremonial center where a ritual takes place. Residents are shown in family groups; one group includes a domesticated dog. White's views of Secoton and Pomeiooc conveyed a comforting message to White's European audience: the native people of Virginia were town dwellers, not nomadic barbarians, and the villages were either undefended or only nominally protected. Secoton, about eighty miles from Roanoke, was the farthest south that White and Harriot traveled. The farthest north they penetrated was the southern part of the Chesapeake Bay, about one hundred thirty miles from Roanoke, where they lived briefly among the Chesapeake Indians.

The ritual White depicted at Secoton is based on a larger watercolor of the dance alone. White painted 10 women and 7 men dancing around a series of poles placed in a circle. The poles are carved with heads that, according to Harriot, resemble "the faces of Nonnes [nuns] covered with their vayles [veils]." The dancers' movements appear jerky, almost robotic, and, certainly to White's eye, very unlike European dance. Harriot described the 3 women standing together at the center of the circle as the "fayrest Virgins" in the village.[6] Participants hold twigs and gourd rattles, suggesting that the ritual was related to the seasonal cycle and was intended to appease the spirits the Algonquian believed resided in all living things.

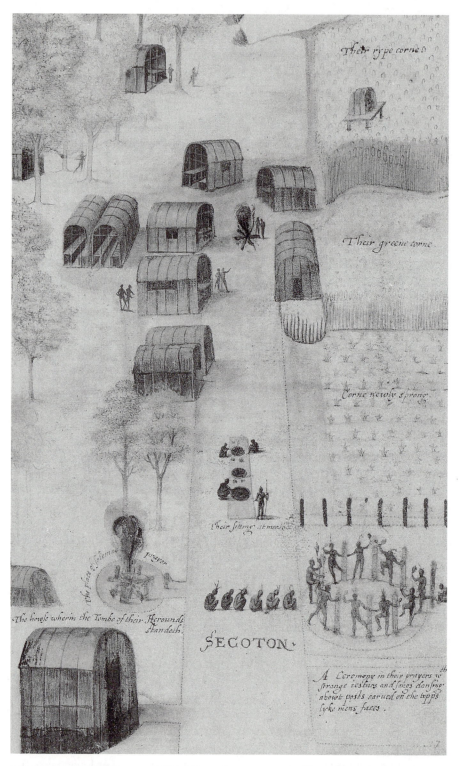

John White, *Village of Secoton*, 1585. Watercolor on paper (12¾ × 7¾ inches). © The Art Archive/British Museum/Eileen Tweedy.

Other images by White reveal Algonquian pastimes, including fishing. The coastal waters were warm and teaming with game, which White communicated in a watercolor that shows the sea in cross-section, filled with an unlikely combination of both shallow and deepwater fish (including a hammerhead shark); again, his goal was to provide as much information as possible. Clearly a composite like the view of Secotan, White depicted men using methods for both daytime fishing with dip nets and spears and nighttime fishing illuminated by a fire in a canoe. Weirs, enclosures made of reeds for trapping fish, appear at the left. The dugout canoe was of great interest to White's European audience. Constructed without metal tools, the thin, light canoe was one of the Algonquian's more sophisticated creations. This image conveyed essential information for those considering a move abroad: the raw material for settlement was abundant and available, and the Native Americans well able to manage it.

Accounts suggest that the natives were initially receptive to the English. Arthur Barlowe, a leader of the 1584 reconnaissance mission, wrote, "We were entertained with all love, and kindness. . . . We found the people most gentle, loving and faithful, void of all guile, and treason and such as lived after the manner of the Golden Age."[7] Apparently such goodwill did not persist, for Governor Lane's report, written upon his return to England, enumerates the many fierce and often violent confrontations between the settlers of 1585 and the Native Americans. Regardless, White captured the Algonquian at a crucial moment, essentially uninfluenced by European colonization. Within two generations they would undergo radical change.

John White's Portraits of the Algonquian

Perhaps the most compelling images White created are the full-length portraits of individual Native Americans. It is here that his skills as an artist are most evident. White focused primarily on the chiefs, their wives, and other important individuals, such as warriors and spiritual leaders. This was a significant choice, for England was rigidly hierarchical in the sixteenth century. Social status was determined by birth and land ownership, and this system was unlikely to change despite recent social upheaval. Respect for rank was endemic. The English were curious to see if similar conditions existed among Native Americans, and White accommodated their interests by choosing to paint individuals of status.

White's fascination with the details of Algonquian dress and accoutrements provides a wealth of material for modern scholars. There is, for example, no other existing record of such cultural practices as body painting and tattooing among the Algonquian. *Indian in Body Paint* depicts a tall, well-built man, perhaps the Roanoke chief Wingina, decorated for war or a ceremony. He wears a deerskin breechcloth with an animal tail attached at the back to support a quiver of arrows and holds a bow about six feet long (Native American weaponry fascinated Europeans). His calves, chest, arms, and face are decorated with geo-

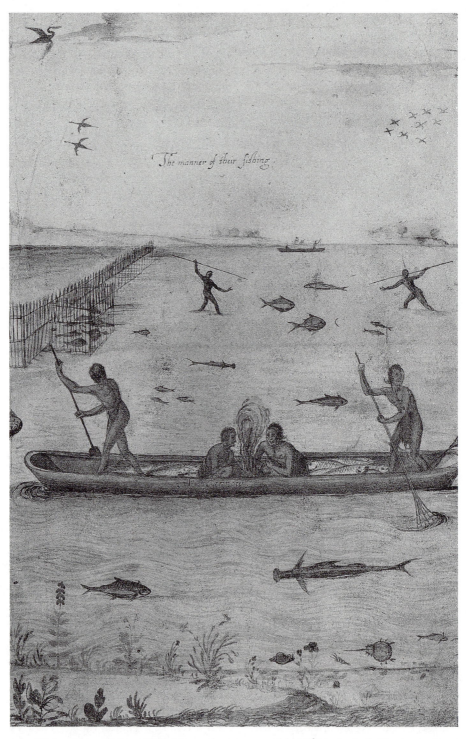

The manner of their fishing.

John White, *Indians Fishing*, 1585. Watercolor on paper (14 × 9¼ inches). © The Art Archive/ British Museum/Harper Collins Publishers.

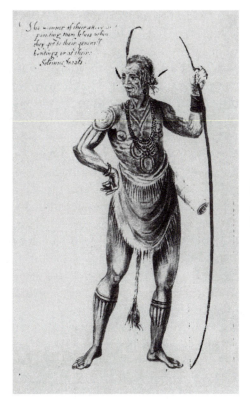

John White, *Indian in Body Paint*, 1585. Watercolor on paper ($10\frac{3}{8} \times 5\frac{7}{8}$ inches). © The British Museum/Topham-HIP/The Image Works.

metric designs and he wears turkey feathers in his hair, elaborate earrings, and bracelets or wrist guards unique to the southeastern Algonquian.

Harriot's text frequently comments on the nakedness of the Algonquian people. To most Europeans, anyone who wore fewer clothes than they did was considered naked. Emphasizing the Indians' nudity was one way Europeans defined the differences between themselves and the Native Americans. Clothing was linked to morality—the more clothes one wore, the better his or her character. Nakedness was associated with licentiousness and depravity. Despite this (or more likely because of it), Harriot took pains to emphasize the comparable modesty of Algonquian garments, describing the men as covered "from the navel unto the midds of their thighes . . . before and behynde, as the woeme doe with deers skynne handsomely dressed, and fringed." Harriot hoped this would be enough to assuage the concerns of reserved Westerners.[8] Underscoring the Native Americans' nudity had other implications as well: it indicated that the Indians were defenseless and therefore vulnerable to attack, and it suggested their potential openness to trade to acquire the clothing they so clearly lacked.

White painted a portrait of the wife of a chief of Pomeiooc in "deers skynne handsomely dressed," accompanied by her daughter who, according to an inscription on the drawing, was "of the age of eight or ten years." Their high cheekbones, narrow foreheads, flat noses, broad mouths, and flat faces with eyes

slightly tilted at the outer edge indicate the Asiatic origin of the Native Americans. The chief's wife supports her right arm in a sling of beads (probably the black pearls valued by the Pomeiooc). Multiple strands of beads were a sign of status. Her body is elaborately painted or tattooed, and she carries a large gourd used for collecting water. The child imitates her mother, her right hand entwined in the beads around her neck. In her left hand she holds a gift from the settlers, a doll covered from head to toe in Elizabethan dress, a pointed contrast with the scant clothing the girls of Pomeiooc wore before puberty.

In White's portraits of the Algonquian, their skin appears tawny or tanned, but not dark brown or black. This was an important distinction, for the English considered black the color of evil and black skin the mark of a sinful people. They also feared that living in a southern climate would darken their pale skin. In the late sixteenth century, the English believed the Native Americans to be of similar racial stock and therefore light-skinned at birth. The use of the term "red skin" to describe Indian complexions was not widespread until the end of the seventeenth century. The Indian's darker skin tone, the English speculated, was artificially produced by exposure to the sun or by dipping infants in a bath of walnut leaves to permanently stain the skin, and therefore could be avoided.[9]

White's portraits reveal his training as a limner and his familiarity with Mannerist conventions for representing the figure. Limners primarily painted watercolor portrait miniatures, tiny images of their sitters' faces, necks, and shoulders that were usually worn as jewelry or kept in a small case. Miniatures were items of status, and limners took pains to render the intricacy of sixteenth-century dress, jewelry, and lavish hairstyles. Miniature painting was an art of surfaces, and required both keen attention to detail and a steady hand to create individual strands of hair and tiny pearls and precious stones. The delicacy of White's images and the light touch of his brush parallel Elizabethan portrait miniatures by artists such as Nicholas Hilliard (1547–1619).

In the field, it is likely that White drew his subjects with black lead and color notes or washes and later produced the more polished watercolors for presentation. Watercolors, in which ground pigments are dissolved in water, are a translucent medium. White also used thicker body colors, or opaque paints, including metallic pigments and opaque white, to create detail and texture. He applied the paint in a linear manner, placing tiny, precise strokes side by side to build form, with broader washes of translucent color to define expanses like the water in the image of Indians fishing. White defined bodies with a thin dark outline and sensitively modeled them with light and dark tones to give the impression of three dimensions.

Limners had little interest in perspective or the depiction of vast spaces, hence the spatial inconsistencies and White's reliance on the birds-eye perspective in the views of Secoton and Pomeiooc. Nor did limners receive the training in anatomy necessary for realistically rendering the body; full-length portrait miniatures are rare. Yet White's need to provide as much information as possible about the Algonquian required him to depict the whole figure. White adopted their poses from

the Mannerist style then in vogue in continental Europe. Mannerism emerged in Italy in the 1520s, and is viewed by scholars as a reaction against the classical purity, order, and balance of Renaissance art and particularly its idealized approach to human form. Mannerist artists instead focused on the body's expressiveness, often ignoring classical idealism to create figures with oddly attenuated limbs in distorted yet elegant poses. While White's Indian portraits do not have the exaggerated proportions that characterize Mannerist body forms, the ballet-like poses he favored, with the legs crossed and arms akimbo, emerged directly from Mannerism. When White was confronted with the unfamiliar, it was inevitable that his portraits would in some ways conform to pre-existing visual patterns.

White's skill at depicting movement is apparent in a portrait he labeled "The flyer," most likely a shaman or spiritual leader. The flyer leaps through the air, his right leg below him and his left leg extended behind him, his arms stretched at his sides and bent at the elbows. Attached to the side of his head is a small bird, wings spread, which Harriot identified as a badge of office. White's image and Harriot's text are intriguing, for they reveal the European preoccupation with native religions, which they uniformly dismissed as idolatry. Of this image Harriot wrote, "They have commonlye sorcerers or jugglers which use strange gestures, and often contrarie to nature in their enchantments. For they are familiar with devils, of whom they enquirer what their enemys doe." Harriot enumerated their many gods "of different sorts and degrees," human in shape, and their belief in the immortality of the soul, concluding,

> Thes poore soules have none other knowledge of god although I thinke them verye Desirous to know the truthe. For when as wee kneeled downe on our knees to make our prayers unto god, they went abowt to imitate us, and when they saw we moved our lipps, they also dyd the like. Wherfore that is verye like that they might easelye be brought to the knowledge of the gospel. God of his mercie grant them this grace."[10]

Clearly, White's image and Harriot's text were intended to inspire missionary zeal. Harriot's words also reflect the pervasive belief that assimilating English practices was the Indians' best course.

White's portraits of the Algonquian suggest that they were an attractive and friendly people, again an important message to convey to his European audience. His perceptions reflected one of two persistent European views of Native Americans. On the one hand, many regarded them as a gentle, graceful people, backward and childlike but receptive to European civilization and religion. This perception was initiated by Christopher Columbus, who described the Arawak Indians he encountered on San Salvador in 1492 as "a loving people without covetousness" who "were so greatly pleased and became so entirely our friends that it was a wonder to see."[11] Such patronizing attitudes evolved further with the early promotion of America as a "new Eden," a golden land populated by innocent and uncorrupted beings, and were encouraged by the realization that the colonizers needed the Native Americans to survive and to build new trade

markets. A second, far more negative perception existed simultaneously. In this view, the natives were savage, beast-like cannibals, ideas based primarily on the biased accounts of early Spanish and French settlers in need of justifying their own horrific actions in subduing them. This duality persisted for centuries. Which perception writers and artists promoted depended upon their agenda and their context. Inspired by Raleigh, White was concerned with providing a favorable picture of Native American life. White and Harriot's dealings with the Algonquian appear to have been friendly, with no hint of the conflicts between the colonists and the Indians reported by Lane. Their presentation of the Algonquian is also consistent with what historian Alden T. Vaughan identifies as a shift in English thinking about Native Americans that occurred around 1583, resulting from a growing hatred of Spain in the years before the War of the Spanish Armada. "English accounts," Vaughan writes, "now accused the Spanish of being greedy and bloodthirsty at the expense of the Indians, who were represented as innocent and gentle."[12] Yet regardless of which perception held sway (and despite White's evident goodwill), the majority of Europeans still considered the Native Americans a lesser race, inferior and spiritually confused. This inferiority, Europeans believed, gave them a right to Native American land.

John White, Governor

The 1585 settlement at Roanoke failed, due primarily to a lack of supplies and the increasing hostility of the natives, who resented the settlers' continual demands for food. Tensions peaked after the murder of the Roanoke chief Wingina and an attack on a nearby Indian village on May 31, 1586, apparently a preemptive strike to thwart a rumored Indian conspiracy to burn the settlers' fort and kill Governor Lane. In response, the Algonquian blockaded the island, further reducing food sources. After a period of near starvation, a ship captained by Francis Drake arrived at Roanoke on June 9, 1586. Drake offered men and supplies to the tiny colony, but little food. A hurricane hit the island on June 13, further sapping the settlers' will. They decided to join Drake for the journey home, arriving at Portsmouth on July 28. The crossing was difficult, and many "Cardes [maps], Bookes and writings" were tossed overboard, including some of White's work, perhaps his depictions of plants, few of which exist, and mammals, none of which exist, although they were presumably created to complement his surviving depictions of fish and fowl.[13]

Raleigh was undeterred and immediately began to plan a third voyage to Virginia, this time focusing on an area closer to Chesapeake Bay. He appointed White governor of the new colony. It was unusual for a man of White's low social position to receive an appointment typically reserved for gentlemen or military officers. Shortly after he accepted the assignment, however, he was granted a coat of arms and listed in documents as "John White, gentleman," and gover-

nor of "the Cittie of Raleigh in Virginia."[14] Evidently his new post automatically included the necessary rise in status. White and Raleigh organized three ships and this time opened the journey to women and children as well as men, believing that families would provide the stability a permanent colony required. One woman who joined the expedition was White's pregnant daughter Elynor Dare, accompanied by her husband Ananias.

White's ships, captained by Simon Fernandes, left England on April 26, 1587. Again, the crossing was difficult and the travelers grew restless. When they landed on the barrier islands in July, with the expectation that they would remain there briefly to prepare for the move up the coast to the area Raleigh had targeted for the colony, Fernandes led a mutiny, insisting that they stay at Roanoke. The settlers rebuilt the fortified encampment established in 1584. Almost immediately, they faced difficulty maintaining food supplies and reestablishing friendly relations with the Indians. The colonists encouraged White to return to England for supplies and although he repeatedly refused, they convinced him that only his presence would expedite a shipment. He left on August 28, just 10 days after the birth of his granddaughter, Virginia Dare. Tragically, his return to the colony was postponed by the outbreak of the War of the Spanish Armada, which demanded all of England's maritime resources. For reasons that are not completely clear, White did not return to Roanoke until August of 1590, three years after he left. He found the settlement ravaged and the colonists gone. Several trunks containing his armor, books, and framed pictures and maps that White had buried before departing were unearthed and destroyed. Only two clues remained as to the colonists fate: a post carved with the word CROATOAN and a tree with the letters CRO, pre-arranged signals suggesting that the colonists had moved south to live with the friendly Croatoan Indians. White was forced to return to England immediately due to poor weather and the loss of all but one of the ships' anchors. Although he continued to agitate for additional search teams, he was never able to return to America. Some speculate that Raleigh may have postponed further searches because as long as the settlement was believed to exist he retained his patent and his control of all colonization efforts on the East Coast. White remained the only known survivor of what is today called the Lost Colony of Roanoke. No one in the colony was ever seen again by English eyes, though rumors persisted in the later colony at Jamestown, Virginia, that fair-skinned people in Western dress lived among the Native Americans.

White wrote an account of his last voyage in February 1593, describing the 1590 rescue mission as his fifth visit to America, further evidence that he participated in the Frobisher expedition of 1577 and the reconnaissance mission of 1584. Nothing is known of his life after 1593, although it is believed that he retired to one of Raleigh's estates in Ireland. In 1606 a Brigit White administered the will and estate of John White, "late of parts beyond the seas," perhaps evidence, although quite tentative considering his commonplace name, of the date of his death.

A Briefe and True Report of the New Found Land of Virginia

During White's return visit to England in late 1587, plans were under way to publish his drawings and watercolors accompanied by Harriot's chronicle. Theodore de Bry, an engraver and printer from Flanders (today Belgium), was living as a Protestant refugee in Germany. Sympathetic to Protestant inroads in the New World, he decided to publish a volume on Virginia as the first of a five-volume series titled *America*. A later volume on Florida included Jacques Le Moyne de Morgues's images. De Bry traveled to London in 1588 to collect White's and Le Moyne's drawings and watercolors. He published the volume on Virginia in 1590, when most believed Raleigh's colonists were still alive, and titled it *A briefe and true report of the new found land of Virginia*. Although published nearly one hundred years after Columbus's discovery, it was the first large-scale pictorial presentation of America in Europe. The title page informed the reader that the illustrations were "Diligentlye collected and draowne by Ihon [another spelling of John] White who was sent thiter speciallye and for the same purpose by the said Sir Walter Raleigh the year abovesaid 1585."[15]

De Bry and his assistants created engravings after 23 of White's watercolors, primarily the images of Native Americans and their settlements and pastimes. To produce the engravings, De Bry may have worked from the watercolors and drawings now owned by the British Museum or from another set created by White. An engraving is made by carving an image on a metal plate with a thin metal tool. The plate is rubbed with ink, which fills the carved lines. Excess ink is wiped away and the plate is covered with damp paper. It is then run through a printing press and the ink is transferred to the paper. Engraving, though laborious, replaced woodcut as the primary printmaking medium in sixteenth-century Europe because metal plates were long lasting and could produce multiple clear copies of the originals.

De Bry was not entirely true to White's originals. He modified the images, sometimes considerably, to make them more palatable to his European readers. De Bry rendered the faces of the Algonquian far more European in appearance than the Asian features White depicted, with higher foreheads, wider eyes, and puckered mouths. Hands and feet became plump and short. The women's hair, very straight due to their Asian heritage, De Bry styled and curled, particularly that of the three "fayrest Virgins" in the image of the ritual dance. In the engraving of the chief's wife and her child, De Bry removed the woman's headband, curled her hair, eliminated the markings on her chin, and added markings to her calves. Her daughter is much larger and holds a rattle in addition to the Elizabethan doll. The poses in De Bry's engravings are also more overtly Mannerist, with individuals such as the Indian in body paint rendered with exaggerated contrapposto (weight shift). De Bry also added landscape backgrounds and back views of the figures to show details not evident in White's originals. To the view of the village of Secoton he added more crops,

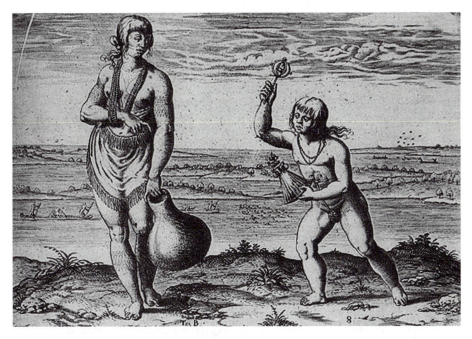

Theodore De Bry after John White, *A Chief Lady of Pomeiooc*. Engraving, from *A briefe and true report of the new found land of Virginia*, 1590. © Library of Congress.

including tobacco plants, pumpkins, and huge sunflowers—a plant that fascinated Europeans.

In De Bry's reinterpretations such details are accentuated, while the faces of the Algonquian lose their identity and become generic, suggesting little concern with them as individuals. This is consistent with the view that Native Americans were lesser beings, but Karen Ordahl Kupperman suggests that it may also relate to how sixteenth-century Europeans assessed status and identity. It was hair, dress, jewelry, and posture—the aspects of appearance most under one's control—rather than the appearance of one's face that created an identity and communicated social status. De Bry's European viewers certainly scrutinized the images of the Algonquian for what they revealed about the subjects' wealth, age, social position, and marital status, much as they would portraits of their peers. As Kupperman concludes, "It was determiners and maintainers of status, not intrinsic character judgments, which interested early colonists and travelers."[16] The Indians' facial features were less informative to European viewers, and were therefore generalized. This is consistent with White's concentration on individuals of status and Harriot's text's emphasis on the Algonquian's dress, posture, and accoutrements rather than their facial features

De Bry's volume concludes with several strange images of the Picts, an ancient tribe that was believed to have been among the first to settle the British Isles. These engravings, also based on watercolors by White, are complete fabrications. They show men and women with Caucasian features and long dark

hair, their bodies covered from head to toe with elaborate tattoos based on Re-
naissance decorative motifs. One Pictish man holds a severed head. Including
depictions of the Picts along with the images of Native Americans reflects the
sixteenth-century fascination with comparative ethnography. It implies that the
ancestors of the British were once savage and tattooed like the Native Ameri-
cans, hence the Native Americans could also become civilized.

A briefe and true report of the new found land of Virginia had two specific func-
tions. It was intended, of course, to inform European readers about the native
population of Virginia. Yet more importantly, it was a promotional piece dedi-
cated to encouraging others to settle abroad. De Bry's introduction notes that
the book is "directed to the Investors, Farmers, and Well-wishers of the project
of Colonizing and Planting there." In keeping with Raleigh's objectives, there is
nothing negative here, nothing to scare or worry prospective colonizers. In fact,
the first image after the title page depicts Adam and Eve, encouraging the per-
ception of America as a new Eden. The book, published simultaneously in Latin,
German, English, and French, was a great success. Between 1590 and 1620 it
underwent at least seventeen printings. Harriot's text and White's images would
act as an inspiration for the 1607 settlement at Jamestown.

De Bry's volume made White's work widely known and influenced the way
artists depicted Indians throughout the seventeenth century. For generations the
book was believed to be the only surviving record of White's original watercol-
ors. Then, in 1788, the watercolors, bound in a notebook, appeared in a Lon-
don sale catalogue. James Caulfield, Earl of Charlemont in Ireland, purchased
the notebook for 14 pounds. The watercolors remained in the Charlemont col-
lection until 1865 when the notebook came up at auction at Sotheby's in Lon-
don. Henry Stevens, a Vermont native and collector of early American artifacts,
was the first to recognize the works' historic value because of his familiarity with
De Bry's volume. He purchased the notebook for 36.25 pounds, then sold it to
the British Museum for 125 pounds. Although the watercolors appeared spo-
radically in periodicals and museum publications between the 1880s and the
1930s, they were first published in their entirety and in color in Stefan Lorant's
1946 book, The New World: The First Pictures of America, 361 years after White
created them. It was then that scholars realized the extent of De Bry's alterations
and the freshness and originality of White's vision. Through the efforts of the
British Museum and such scholars as Paul Hulton and David Beers Quinn,
White's originals have been widely published and exhibited since the 1960s, and
much more is understood about their creation and significance. Today, White's
watercolors are revered as among the most valuable documents and works of
art related to early settlement. They provide a wealth of information for histo-
rians, of course, but also for anthropologists, sociologists, zoologists, and ethno-
graphers. Art historians have placed White's work at the beginning of the vibrant
tradition of English watercolor painting. And for our purposes, that an artist
should play such a crucial role in the English colonization of America sets the
stage for further considerations of American colonial art in context.

Notes

1. Hulton, 3, 19.
2. Ibid., 8.
3. Ibid., 9.
4. All of White's images of the Algonquian are available for viewing at *Virtual Jamestown,* "Index of White Watercolors and De Bry Engravings," http://jefferson.village.virginia.edu/vcdh/jamestown/images/white_debry_html/jamestown.html.
5. Quinn, *Set Fair for Roanoke,* 188.
6. Harriot, plate XVIII.
7. Quoted in Nash, 212.
8. Harriot, plate VII.
9. Kupperman, 36–37.
10. Harriot, 25–26, plate XI.
11. Quoted in Nash, 49.
12. Vaughan, 17.
13. Quoted in Quinn, *Roanoke Voyages,* 293.
14. Hulton, 13.
15. Harriot, n.p.
16. Kupperman, 35, 44.

Bibliography

Bucher, Bernadette. *Icon and Conquest: A Structural Analysis of the Illustrations of De Bry's Great Voyages.* Translated by Basia Miller Gulati. Chicago: University of Chicago Press, 1981.

Doggett, Rachel, ed. *New World of Wonders: European Images of the Americas, 1492–1700.* Washington, D.C.: Folger Shakespeare Library, 1992.

Gaudio, Michael. "America in the Making: John White and the Ethnographic Image, 1585–1890." Ph.D. diss., Stanford University, 2001.

Harriot, Thomas. *A Briefe and True Report of the New Found Land of Virginia,* with engravings after John White. Frankfurt-am-Main: Johann Wechel for Theodore de Bry, 1590. Facsimile edition, Theodore de Bry, *Thomas Hariot's* [sic] *Virginia.* Ann Arbor: University Microfilms, Inc., 1966. Also available at www.lib.umi.com/eebo/html/pdf/6773.

Honour, Hugh. *The New Golden Land: European Images of America from the Discovery to the Present Time.* New York: Pantheon Books, 1975.

Hulton, Paul. *America 1585: The Complete Drawings of John White.* Chapel Hill, NC: University of North Carolina Press; London: British Museum Publications, 1984.

Hulton, Paul, and David Beers Quinn, eds. *The American Drawings of John White, 1577–1590.* 2 vols. Chapel Hill, NC: University of North Carolina Press, 1964.

King, J. C. H. *First Peoples First Contacts: Native Peoples of North America.* Cambridge, MA: Harvard University Press, 1999.

Kupperman, Karen Ordahl. *Settling with the Indians: The Meeting of English and Indian Cultures in America, 1580–1640.* Totawa, NJ: Rowman and Littlefield, 1980.

Nash, Gary B. *Red, White and Black: The Peoples of Early North America.* 4th ed. Upper Saddle River, NJ: Prentice Hall, 2000.

Quinn, David Beers. *The Roanoke Voyages, 1584–1590*. London: Hakluyt Society, 1955.
———. *Set Fair for Roanoke: Voyages and Colonies, 1584–1606*. Chapel Hill, NC: University of North Carolina Press, 1985.
Reich, Jerome. *Colonial America*. 5th ed. Upper Saddle River, NJ: Prentice Hall, 2001.
Trenton, Patricia, and Patrick T. Houlihan. *Native Americans: Five Centuries of Changing Images*. New York: Harry N. Abrams, 1989.
Vaughan, Alden T. "People of Wonder: England Encounters the New World's Natives." In *New World of Wonders: European Images of the Americas, 1492–1700*, edited by Rachel Doggett. Exhibition Catalogue. Washington, D.C.: Folger Shakespeare Library, 1992.
Virtual Jamestown. "Index of White Watercolors and DeBry Engravings." http://jefferson.village.virginia.edu/vcdh/jamestown/images/white_debry_html/jamestown.html.

CHAPTER 2

John Foster (1648–1681), America's First Printmaker

> After a while I came to look on Foster as one of the great men of that great age,—a scholar, a thinker, a printer, engraver, chemist,—a man worthy of the love, friendship, and admiration of the Mathers. Had Foster lived to the age that Franklin reached, Franklin might have been called a "second Foster."[1]

So wrote historian John Allen Lewis in 1879. The Mathers—Richard, the patriarch; Increase, his son; and Cotton, his grandson—were the leading family of Puritan ministers in colonial Massachusetts. The Franklin to whom Lewis referred was of course Benjamin Franklin, one of the most esteemed figures of the colonial period, and, like John Foster, an unconventional combination of scientist, printer, and intellectual. Foster, who died at the young age of thirty-two, was an early colonial Renaissance man who worked as a teacher, a mathematician, a specialist in medicine, and an astronomer. But more significantly for our interests, Foster was a printmaker, the creator of the first print—a portrait of Richard Mather, c. 1670—and the first map published in North America. Like Lewis, Foster's biographer Samuel Abbott Green described him as a man who had "several strings to his bow" (an appropriate metaphor for Foster, who also played the fiddle), and who was therefore typical of the adaptability required of early colonial artists.[2]

Only a few prints created by Foster survive, and they are admittedly unsophisticated when compared with seventeenth-century European printmaking. But Foster's active life and artistic work can act as touchstones for an investigation of many crucial features of early English settlement in New England. Foster's close connection to the Mathers and his portrait of Richard Mather encourage consideration of what distinguished Puritanism as a belief system and the role of ministers in establishing and maintaining Massachusetts as the first

religious oligarchy in British America. His work as a printer and printmaker—creating books, pamphlets, broadsides, and pictorial woodcuts—indicates that the Puritans were a literate people, and that their interests were primarily religious. Yet Foster also published a yearly almanac, a fascinating combination of science and superstition that underscores Puritan reliance on forces beyond religion to help them better control the mysterious realm they had settled. Foster's artistic work, though unrefined, is an unprecedented accomplishment in the New World, especially for a self-trained individual, and provides insight into print technology in colonial America. Before we turn to Foster, however, it is necessary to create a context for the artist and his work by providing a brief overview of the early years of Puritan settlement in Massachusetts.

Puritanism and Colonization

The term *Puritan* is used for English Protestants who wished to purify what they considered an increasingly Catholic-oriented, ritual-bound, and hierarchical Anglican Church. Beginning in the mid-sixteenth century, the Puritans struggled within the state-sponsored Church of England to reclaim what they regarded as the true Protestantism of Martin Luther (1483–1546) and John Calvin (1509–64): the authority of the Bible alone as God's law for human salvation; direct access to God via prayer; the elimination of church hierarchy and all sacraments except baptism and communion; the belief in predestination (the doctrine that although all people are born sinners, God in His wisdom elected some to be saved); and living a life of industry, truthfulness, strenuous self-discipline, and modesty to better deserve God's grace.

While Luther initiated the Protestant movement in Europe in 1517, Calvin was the most important theological influence on the English Puritans. Calvin encouraged the rejection of papal authority and the reliance on faith alone and the Bible for interpreting God's will (although ultimately unknowable to man). He emphasized the importance of ministers for clarifying the law of the Bible, and the role of the state in defending and supporting the church. Calvin's attitude toward art had a profound impact not only on Foster's work but also on the paintings and sculptures examined in Chapters 3 and 4. The Puritans were notorious iconoclasts (image destroyers) known for ravaging Catholic churches and demolishing all religious imagery. This proscription can be traced to Luther's difficulties with what he saw as Catholic idolatry—the worship of the image rather than the religious figure depicted. It ultimately derived from the Second Commandment, "Thou shall make no graven images," which Protestants took literally to mean that no visual images should be created of God or any other religious figure. Calvin followed the teachings of Luther, writing, "It is unlawful to attribute a visible form to God, and whoever sets up an idol revolts against the true God." Therefore, the Puritans' destructive actions have often been blamed on Calvin's influence. Yet Calvin did not ban all art forms. He had no difficulty with secular works of art, such as portraiture, as long as the image depicted something

in the visible world and was rendered realistically. He wrote, "And yet I am not gripped by the superstition of thinking absolutely no images permissible. But because sculpture and painting are gifts of God, I see a pure and legitimate use of each. . . . Only those things are sculptured and painted which the eyes are capable of seeing."[3] For the artist to idealize or change a form was an insult to God, insinuating that the artist could improve upon His creation.

King Henry VIII (ruled 1509–47) initiated English Protestantism in the 1530s when he rejected the pope for not allowing him to divorce and remarry. Henry established the Church of England, or the Anglican Church, with himself as head. The crown's commitment to Protestantism waxed and waned over the course of the sixteenth century. Henry's daughter, Mary, Queen of Scots, reinstated Catholicism during her reign of 1553 to 1558. Elizabeth I (ruled 1558–1603), a Protestant, reconstituted the Anglican Church but as a compromise maintained many of the trappings of Catholicism, much to the chagrin of the Puritans. By the early seventeenth century, Puritan separatists faced escalating persecution, culminating in King Charles I's 1628 appointment of William Laud as bishop of London and five years later Archbishop of Canterbury, the head of the Anglican Church. Laud insisted that elaborate Anglican rituals be maintained in all English churches and threatened to remove those ministers who persisted in preaching Puritan points of view.

It was shortly after Laud's appointment that Sir John Winthrop, a Puritan nobleman of considerable wealth, and a group of like-minded investors formed a joint-stock venture called the Massachusetts Bay Company, which received a royal charter on March 4, 1629. Unlike the Puritans who settled the famous Plymouth Colony in 1620, the colony established by the Massachusetts Bay Company was to be self-governing, with limited intervention or supervision from England. Increasingly concerned about Puritan disruptions of English religious life, Charles I was willing to grant the Massachusetts Bay Company unprecedented freedom, the better to rid the mother country of the Puritans.

The first ships carrying Winthrop and his followers landed on the Massachusetts coast in 1630. They settled on what was then known as the Shawmut Peninsula, now Boston, at the mouth of the Charles River. There they found a protected harbor and an area isolated enough to defend from Indian attack. The Puritans arrived in family groups led by university-trained ministers and minor nobility committed to building a commonwealth of true believers. The movement of Puritans from old England to New England from 1630 to 1642 is termed "The Great Migration" because more than 13,000 settlers ultimately followed Winthrop to Massachusetts.

It is crucial to understand Winthrop's vision for the colony, for it profoundly shaped the city within which Foster and other Boston artists worked. On his ship the *Arbella* Winthrop wrote of the new settlement as a "Cittie on a Hill," a beacon for all believers. Winthrop's words have a strongly millennialist cast. He viewed the Old World as corrupt and therefore soon to suffer the wrath of God. Consistent with age-old apocalyptic rhetoric, the Puritans believed that not only were the pope and the Roman Catholic Church the Antichrist (as Protestants had

maintained since the Reformation), but Charles I and the Anglican Church were as well, and only the Puritans were the true church of God's elect (termed *Puritan exceptionalism*). As historian Stephen Foster explains,

> In the beginning God created the heaven and the earth and in the end he created New England. This was the course of human history . . . as viewed from the quarterdeck of the *Arbella*. . . . Through their own estimation [the Puritans] were simply the most important body of people since the Apostles. The latter had brought true Christianity to the old Israel, the Puritans would recreate it in a new.[4]

Like the Israelites, the Puritans had entered a covenant with God, who instructed them to "fly into the wilderness" to escape Europe's swift demise.[5] Winthrop and others, including Richard Mather, wrote of New England as the New Jerusalem, borrowing a phrase from the Book of Revelation, "a refuge for manye, whom [God] meant to save out of the general destruction."[6]

Like many seventeenth-century Europeans, Winthrop carefully studied the symbols and metaphors in Revelation to better chart the chronology of the last days. The Puritans firmly believed that they lived in the end-times; Christ would soon return to earth, God's final judgment was imminent, and Satan would be, as Revelation prophesied, bound in the pit for 1,000 years. The Puritans felt they could hasten Satan's destruction by living as a pure Christian community where all would work together for the common good. In this way they would reform not only Christ's church, but also society as a whole, and ultimately join Christ in heaven for the millennial age. To do so, God's "elect" adhered to a strict set of rules that resulted in rigid homogeneity, tolerating no diversity of opinion regarding religious belief and encouraging unilateral respect for authority. Such unity of purpose also resulted in a clear political and social order that allowed the Massachusetts Bay Colony to grow peacefully and rapidly.

The experience of Reverend Richard Mather, whom Foster depicted in the first print created in America, is typical of Puritan divines. Mather was born near Liverpool, England, in 1596, the son of a small-businessman and artisan. A brilliant boy, he became a schoolmaster at age 15. At 18 he experienced a life-altering conversion to Puritanism. Shortly thereafter he entered Oxford University but remained only a year, returning to the Liverpool area to become pastor of a reformed church, for which he took holy orders in the Church of England (although as a Puritan, with some reservations). His refusal to wear Anglican vestments and conform to Anglican ritual resulted in his suspension from the pulpit in 1633. He crossed the ocean in 1635, feeling himself to be an exile, banished for his attempt to purify the Anglican Church.

In America, Mather accepted the pulpit of the Congregational Church in Dorchester (today South Boston). The Congregational form of church governance departed radically from the hierarchical nature of the Catholic and Anglican Churches. It was egalitarian and autonomous—each town had an independent, self-supporting congregation that selected its own minister. Congregationalism became the standard for New England Puritans, and Mather was regarded as an expert on Congregational policy. In 1648 he led the group of

John Foster, *Richard Mather*, 1670. Woodcut (7 8 1/8 × 5 3/8 inches). © Houghton Library, Harvard University.

ministers who drafted the Cambridge Platform, the definitive statement of the Congregational system. This document and others confirmed Mather's reputation as a relentless spokesman for New England's sacred mission. Mather also helped write the *Bay Psalm Book*, which translated the Psalms into meters suitable for singing in Congregational churches.

A talented and persuasive preacher, Mather's sermons and writings were best known for their directness, successfully applying the scriptures to his congregants' lives in logical and clear ways. According to his son Increase, although trained in Latin and Greek, Mather "studiously avoided obscure phrases, exotic words, or any unnecessary citations of Latin sentences," the better to reach a broad audience. Further, Increase wrote, "His way of preaching was plain, aiming to shoot his arrows not over his peoples' heads, but into their hearts and consciences."[7] Lengthy sermons were the cornerstone of Puritan worship, another contrast with the Anglican dependence on ritual. A man beloved by his congregation, Mather never missed a Sabbath service in 50 years of preaching.

John Foster, Printmaker, and *Richard Mather*, c. 1670

Richard Mather was the Foster family minister and baptized John on December 10, 1648. Foster's father, Hopestill, was well to do, a brewer by trade,

a member of the General Court (whose members the Colony's freemen and investors selected to meet four times a year to enact laws), and a captain in the militia. Foster's mother, Mary Bates Foster, also came from a prominent family. Her father, who sailed from England in 1635, was appointed selectman of Dorchester and a member of the General Court. John was their fourth child, one of nine siblings who survived to adulthood; some of whom, as was the fashion at the time, were named for Puritan virtues, including Thankfull, Patience, Standfast, and Comfort. Little is known of John Foster's early years, but one can assume that he sketched as a young boy and learned to carve wood. Most likely he attended grammar school and may have been tutored by Increase Mather, a close family friend, for he entered the Colleges in Cambridge (now Harvard University) in 1663.

In his first year at Harvard, Foster was ranked third in a class of seven. Ranking was determined not by grade point average but by social standing. The student with the wealthiest and most prominent parents was ranked first. For the most part, Harvard enrolled the sons of the affluent, although the tuition in the seventeenth century of four hogs a year or other barter worth around twenty pounds was reasonable and scholarships were available. Harvard's curriculum was based on that of the English universities. It was intended to train primarily ministers (the purpose for which Harvard was founded in 1636) and teachers. Foster's studies included Latin, Greek, and Hebrew; the "Trivium"—grammar, rhetoric, and logic; and the "Quadrivium"—arithmetic, geometry, music, and astronomy. He also studied metaphysics, ethics, natural sciences, ancient history, and medicine.

In 1669, two years after Foster graduated from Harvard, he took a position as a grammar school teacher in his hometown of Dorchester. He taught English, Latin, and writing, both at the schoolhouse and at his father's home; a government document of December 23, 1673, states that Foster was to be paid 10 pounds a year to "teach such lattin scholars as shall Come to his father's hous . . . and to instruct and give out Coppies to such as come to him to learne to writte."[8] Foster probably began experimenting with printmaking shortly after he graduated, to supplement his annual teacher's salary (outside tutoring) of 20 to 30 pounds a year. The first written evidence of Foster's work as a printmaker is a September 4, 1671, letter written to the Commissioners of the United Colonies by Reverend John Eliot: "Further I doe prsent you wth or Indians A. B.C. & or Indian Dialogs wth the request yt you would pay Printers work an ingenuous young scholar (Sr Foster) did cut, in wood, the Scheame."[9] The commissioners paid Foster 4 pounds for his work. No copies exist, but the "Indians A.B.C." was most likely a broadside of the alphabet, either with illustrations of Native Americans for children, or to teach Native Americans English letters. The latter is more likely, as Eliot was an Indian missionary who translated the Bible into the Algonquian language.

Foster probably created the wood engraving of Mather as a visual eulogy for the great minister, who died on April 22, 1669. Some scholars speculate that the print was intended to accompany a pamphlet written by Increase Mather,

titled *The Life and Death of that Reverend Man of God, Mr. Richard Mather,* published in Cambridge in 1670. The only version of the print that securely dates to c. 1670, the imprint owned by Harvard University illustrated here, appears on the left side of a larger sheet creased in the middle, as if intended to be bound in a book. The Harvard version was in fact bound with the pamphlet, yet it is possible that they were combined as late as 1701–02, when a group of loose pamphlets in the collection of Reverend Eliphalet Adams were fastened together. The Harvard imprint confirms Foster's authorship of the print. At the bottom is written in Latin "Johannes Foster sculpsit" (John Foster carved this). Above, in the same hand, is written "Richardus Mather." The writing has been identified as that of Reverend William Adams, Eliphalet's father and a Harvard classmate of Foster's.

Foster's portrait of Mather is very simple and somewhat primitive in its execution, yet also quite striking in the contrast of the detailed presentation of Mather's face and the bold, undifferentiated mass of the plain black academic robe that Puritan preachers wore in lieu of the elaborate vestments of Anglican ministers. For a reason that remains unclear, Foster carved the head and shoulders and the body on separate wooden blocks. The line between the blocks, just below Mather's shoulders, is obvious in the Harvard version of the print because Mather's right shoulder (to the left in the print) appears much lighter than the solid black of the robe below. In addition, the carving of the upper block is more sophisticated than that of the lower block. Foster carefully shaded the side of Mather's face and nose to suggest three dimensions and carved the individual strands in Mather's beard with curving lines of varied thickness. When these features are compared to Mather's hands below, it is clear that the lower block is treated more summarily.

Foster's use of two blocks has caused debate among historians. Some believe that he began with a single block but made a mistake. Instead of starting over, he cut the block at the shoulders and created a new head on a different block. Others suggest that Foster intended the Mather print as the first in a series of portrait prints of famous ministers and, ever practical, planned to reuse the body and simply create different heads. A third supposition is that the lower part was carved by an apprentice, hence the less adept workmanship, while Foster himself carved the head and shoulders, though this seems unlikely because Foster was only about twenty-two when he executed the print and had yet to establish himself as a professional printmaker who could take on apprentices.

A focal point of the print's lower half is two bright round dots; this is a tiny pair of spectacles that Mather holds in his right hand. In his left hand is a book, presumably the Bible, rendered somewhat awkwardly in reverse perspective with the far edge of the book shown larger than the near edge. Mather appears to be pausing from reading (for which, at his age, he probably needed the spectacles) to make a point to his congregants. Some see Foster's blunt presentation of the minister as a reflection of Mather's straightforward preaching style; it also exemplifies Calvin's insistence on realism in portraiture. Print historian Gillett Griffin eloquently described the print:

> The Mather woodcut portrait remains unique for its time and place. . . . Although crude, it has undeniable fascination, directness, and sincerity. The simple bold contrast of black and white, together with the expressive delineation of the head make a vivid American icon. . . . It is a sound cornerstone of American print-making.[10]

The Mather print, like all of Foster's images, is a woodcut. Although copper-plate engraving dominated seventeenth-century European printmaking, the metals and tools needed to create copperplates were prohibitively expensive for colonists, and the skills impossible for them to acquire. Wood, on the other hand, was plentiful and easy to carve. The quality of Foster's lines in the Mather print suggests that he began his career using a knife rather than a tool made specifically for wood engraving. It is likely that he carved the print on either boxwood, the wood of a fruit tree, or pine. Strangely, the wood grain on the upper block runs vertically, while the wood grain on the lower block runs horizontally, further distinguishing them.

Woodcut is a relief process of printmaking in which the forms that are to be printed are raised, and the white areas cut away (the opposite of the intaglio method of engraving described in Chapter 1, where the lines to be printed are carved into the metal plate). In other words, Foster meticulously carved close parallel lines and extracted the wood between them to create Mather's face. These lines and the bulk of Mather's gown remain raised. The block would be inked using a roller or an ink ball, have damp paper placed on it, and be run through a press, leaving the image of Mather in reverse on the paper. Multiple copies of the image could be made in this way, yet print historian Richard Holman suggests that only the Harvard imprint is original to c. 1670. The four other extant versions, owned by Princeton University, the Massachusetts Historical Society, the American Antiquarian Society of Worcester, Massachusetts, and the University of Virginia, Holman argues, were created by another printer from the same blocks in the 1730s for a later generation of Mather's descendents. As evidence he points to the fact that these versions are slightly larger than the Harvard imprint, and the meeting place of the two blocks is noticeably uneven in a way that could only have been caused by the blocks becoming wet and swelling, horizontally with the grain in the lower bock and vertically with the grain in the upper block.[11] In addition, the later prints, or re-strikes, differ from the Harvard version in that they have Mather's name typeset below and white lines on the gown to indicate a center opening and sleeves.

As noted, Foster most likely created the print to honor Reverend Mather or, at the behest of Mather's family, to distribute to his flock or to accompany the pamphlet written by his son Increase. It seems odd that America's first datable print did not appear until some forty years after the beginning of the Great Migration, but artistic production in the early colonies was at best piecemeal, as the settlers were far more concerned with surviving than producing works of art. It is also possible that printmaking evolved slowly in Boston because Puritan ministers maintained tight control of all printed matter and were not en-

thusiastic about visual imagery. Nevertheless, all extant seventeenth-century American prints were created in the Bay Colony, and certainly were an outgrowth of the demand for textual material such as books, broadsides, and currency. Almost everyone, including women and children, could read, a much higher percentage than in any other English colony or even in the mother country. Ownership of the Bible, other books, and religious tracts was more widespread in New England than anywhere else in the world. Yet while the first letterpress was established at Cambridge in 1640, it was another thirty years before Foster created the first printed image. The Mather portrait, printed around 1670, must have been run on Samuel Green's press in Cambridge, at that time the only one in the Boston area.

Portraiture was also the first subject to appear in painting. Several painted portraits exist from 1660s Boston. Generally, New England Puritans followed Calvin's dictates concerning secular art. Samuel Mather, son of Richard and brother of Increase, preached a sermon in 1660 that condemned religious imagery because of the Second Commandment, yet noted that this "is not meant of Images of Civil use, but for Worship. . . . For the Civil use of images is lawful for the representation and remembrance of a person absent, for honour and civil worship to any worthy person, and also for the ornament, but the scope of the Commandment is against Images in State and use religious."[12] Thus the Puritans viewed portraits as acceptable because they served a function in preserving the likenesses of beloved and significant individuals. Portraits of ministers were particularly valued, for ministers were exemplars of the faith and living embodiments of Christ. Of the few existing painted portraits created in 1660s Boston, most depict ministers. Foster's image of Mather would have served exceptionally well as an icon of Puritan moral exactitude, because multiple copies could be printed. Also, an image of an unquestionably devout first-generation American Puritan was a particularly timely reminder of the colony's purpose in 1670, when a third generation of American Puritans began to challenge the power of the religious oligarchy (discussed further in Chapter 3).

A Map of New-England, c. 1677

In addition to the portrait of Richard Mather, Foster produced several other existing works of true historic significance. The most ambitious is a map Foster created in 1677, the first map carved and printed in the American colonies. The 12-by-15-inch map depicts the coast of New England from Rhode Island to just south of the White Mountains in New Hampshire. The map's title block reads: "A Map of New-England, Being the first that was ever cut here, and done by the best Pattern that could be had, which being in some places defective, it made the other less exact: yet doth it sufficiently shew the Scituation of the Countrey, and conveniently well the distance of Places." Clearly Foster recognized the map's importance as the first printed in America, yet he also acknowledged its deficiencies. It was created to illustrate William Hubbard's

John Foster, *A Map of New-England* (The "White Hills" Map), c. 1677. Woodcut, from William Hubbard, *A Narrative of the Trouble with the Indians in New England* (12 1/8 × 15 15/16 inches). Courtesy of Massachussetts Historical Society.

account of King Philip's War of June 1675 through August 1676, titled *Narrative of the Trouble with the Indians in New England, from the first planting thereof in the year of 1607 to this present year 1677. But chiefly the late Troubles of the last Two years 1675 and 1676;* hence the map is also the first book illustration printed in America. The map's designer is unknown. It may have been Hubbard's work or based on a lost manuscript map.

King Philip's War was one of the longest and deadliest confrontations between the English colonists and the Native Americans. King Philip was the English name for the Wampanoag chief Metacom, who launched a full-scale war against the settlers after the execution of three Wampanoag for the murder of a Christianized Indian. Although this incident was the war's catalyst, it was only one of many precipitating factors. The Wampanoag had been at odds with the colonists for some time, due to the mysterious death of Metacom's brother while in custody at Plymouth, the decline of the fur trade as settlers occupied Indian hunting grounds, and the colonists' demand that Metacom turn over all Indian arms. During the 14-month conflict, the Wampanoag, joined by several other Native American tribes, destroyed 12 towns, killed several thousand settlers including one-tenth of all male colonists of fighting age, and wounded or captured thousands more. Although Native American troops came within 17 miles of Boston,

they were outnumbered by the colonists, had a less developed arsenal and suffered from food shortages. They therefore capitulated after Metacom's death in August 1676. The head of Metacom, whom Hubbard described as a "savage miscreant," a "bloody wretch" of "inveterate malice and wickedness," was put on a stake in Plymouth and displayed for the next 20 years as a warning to other impudent Indians.[13] While Foster's map provides no visual depictions of Indian-English conflict, sites are marked by the numbers 1 through 55, with the number 1 indicating Metacom's stronghold at Mount Hope, and the other numbers showing the locations of conflicts.

The orientation of the map is difficult for modern viewers to grasp, for Foster placed east at the bottom of the map, west at the top, north to the right, and south to the left. The document is crucial for understanding Puritan conceptions of the land they settled, not only for what it reveals about their sense of geography (Rhode Island, for example, is represented as a small island off of the coast of Massachusetts and Cape Cod as a decorative curl), but also for how Foster communicated this information. Towns are depicted as a series of small, attached squares with sharply pitched triangular roofs and occasionally a steeple. Foster indicated wooded areas by very distinctive trees created with two parallel lines for the trunk and a popcorn-like form to suggest leaves and branches. Other decorative details include five ships; several animals, including a bear, a fox, and a rabbit (or porcupine); and two hunters. The ocean is represented by a series of rhythmic, horizontal cuts to indicate waves. In fact, the majority of the map's lines are horizontal, in keeping with the direction of the wood grain. Vertical cuts against the grain are much harder to carve and prone to breakage. Like the Mather portrait, as Richard Holman writes, "the map has a distinctly medieval look and suggests primitive European woodcut maps of 150 years earlier," yet "to anyone with a taste for American beginnings it is a fascinating map of unsurpassed beauty."[14] It is also an astonishing accomplishment for a self-trained printmaker, particularly when we remember that Foster had to carve each letter in reverse so it would read correctly when printed.

Foster's map has fascinated historians since at least the middle of the nineteenth century, in part because two versions exist. One is called the White Hills map, and the other the Wine Hills map, for the same set of mountains in each bear these different titles. Which map came first and whether or not Foster carved both is a point of controversy. The White Hills map is the more accurate; the Wine Hills map has dozens of misspellings. Richard Holman believes that Foster created both maps, carving the block for the Wine Hills map first and shipping it to London before he could correct the mistakes because of Hubbard's wish to beat Increase Mather's forthcoming book on King Philip's War to publication in London. Thus Foster carved the White Hills map second for the version of Hubbard's text that he published in Boston, probably from a proof pulled from the Wine Hills block before it was sent abroad, and at a more leisurely pace, hence the corrected spelling.[15] Cartography specialist David Woodward argues, however, that the Wine Hills block was carved second, in England, by another engraver working from a proof of Foster's original. The mis-

spellings, then, were the result of this printmaker's inability to decipher some of the letters, as he would have glued Foster's original face down on the block to create the copy, and his unfamiliarity with the place names.[16]

Foster's Almanacs, 1675–81

Other significant Foster prints appear in a series of almanacs that he published annually between 1675 and 1681, titled *An Almanac of Coelestial Motions for the Year of the Christian Era 1675* (with slight variations in the title each year). The majority of Puritan settlers were farmers who depended on the almanac for information and advice on everything from the tides to the best date to plant corn. Foster's almanac differed from those published previously in Cambridge. He wished to attract a broader readership by including commercial astrology and illustrations. He was also unusual in that he controlled each aspect of production, writing the text, doing the astronomical calculations himself, carving the illustrations, and setting the type (as Benjamin Franklin would do almost a century later for *Poor Richard's Almanac*). Foster's almanacs included both astrology and astronomy, for Foster was fascinated by the mysteries of the stars. For the 1681 almanac he wrote a scholarly paper titled "Of Comets, their Motion, Distance & Magnitude," perhaps the first astronomical publication written in America, which reveals his familiarity with the most recent European studies of astronomy. The article includes the first illustration of the Copernican system in America, showing the planets rotating around the sun, to refute the earlier belief that the planets changed positions in the sky, moving in and out of the signs of the zodiac and thereby influencing all manner of things on Earth.

By the 1670s, scientific advances such as the Copernican system began to wean readers away from the longstanding belief in astrology. Comets, for example, were long believed to predict disaster; Foster wrote in his almanac of the "terrible Comet" seen at Boston in 1680 as "leaving the world in a fearful expectation of what may follow. . . . They are by most thought to be Fore-runners of evil coming upon the World, (though some think otherwise)."[17] Foster's parenthetical comment hints of the rational approaches to come. Nevertheless, most people still believed that the movement of the planets and the stars not only controlled the forces of nature, but also the human body. Foster illustrated this in the 1678 almanac with an image titled *The Dominion of the Moon in Man's Body (according to Astronomers)*, more commonly known as the Man of Signs. Pisces, for example, ruled the feet, so the almanac recommended particular care of the feet when the moon was in Pisces. Foster showed a figure of ambiguous gender (though called the Man of Signs, he appears to have breasts and curled hair) seated on a globe. Around him, Foster placed the symbols and names of the zodiac, with a line drawn from each sign to the body part it influenced. Below the image a poem reads in part:

John Foster, *The Dominion of the Moon in Man's Body* (Man of Signs),
1678. Woodcut, from *An Almanac of Coelestial Motions for the Year of
the Christian Epoch 1678.* © Library of Congress.

The *Neck* and *Throat,* the Bull will have,
The loving *Twins,* do rule the *Hands,*
The *Brest* and *Sides* in *Cancer* bands,
The *Heart* and *Back* the *Lyon* claims . . . [18]

Images of the Man of Signs first appeared in medieval manuscripts and despite the Enlightenment continued to be published in almanacs well into the nineteenth century. Foster's Man of Signs was the first published in America.

Reliance on astrology reveals the medieval and non-rational aspects of Puritan society. Struggling with a new land and the belief that their mission was ordained by God, they searched the sky for signs and portents of God's purpose or the devil's menace, attempting to decipher their role in the grand sweep of cosmic history. Astrology was one facet of a vast network of superstitions, including the analysis of other "prognostications," from dreams to the births of deformed animals. This was not thought to conflict with Puritan religious belief, but instead worked with it to clarify the will of God for man. Curiously, the later states of the Mather print (i.e., not the one at Harvard) have barely visible

impressions of the zodiac symbols for Aries, Gemini, and the moon's node or dragon's head in the lower part of Mather's gown. Holman speculates that wherever the blocks went after Foster's death, they were treated casually and possibly used to test new zodiac characters.[19]

John Foster, Printer

Richard Holman suggests that John Foster's frustration with the poor job of Cambridge printer Samuel Green on Foster's 1675 almanac encouraged him to try his hand as a printer, for "perhaps Foster looked at the title page and decided that a bright Harvard man could certainly do better."[20] Another Cambridge printer, Marmaduke Johnson, had planned to move his press to Boston in 1674 and open the first print shop in the city. When Johnson died suddenly, Foster purchased his equipment and shortly thereafter opened a shop in Boston, becoming the city's first letterpress printer and abandoning teaching for good. Foster's decision to leave his academic job for a manual trade is an interesting choice. At this time in English society there was a clear social distinction between the professions—intellectual occupations such as minister, doctor, lawyer, or teacher—for which one needed a college education, and the trades, which included all positions in which one worked primarily with the hands. In Europe one was a professional or a tradesman, and rarely if ever switched from one to the other. Foster's decision to work as a mechanic, as manual workers were then called, is unusual for an individual who, as a Harvard graduate and friend of the Mathers', was clearly part of the intelligentsia. This suggests the American colonies' greater occupational fluidity and Foster's adaptability.

The only existing imprints from Foster's first year as a printer are two sermons by Increase Mather, Foster's close friend. One is titled *The Wicked mans Portion,* a reaction to the execution of two murderers. The other is *The Times of men are in the hand of God,* a response to the explosion of a boat in Boston Harbor that killed three men (including John Freake, a focus of Chapter 3). It is likely that Foster was also self-trained as a printer, for Cambridge printer Samuel Green described him in a July 6, 1675, letter to John Winthrop, Jr., as "a young man that has no skill of printing but what he had taken notice by the by," though this comment may have been inspired by professional jealousy, as Foster was now Green's competition.[21]

Foster's publications reflect the predominantly religious orientation of seventeenth-century Boston. To succeed, Foster needed to respond to the public's (and their leaders, the ministers') demand for printed matter that complemented and encouraged their devout lifestyle. The majority are sermons, primarily by Increase Mather, on a range of subjects from how often to pray to child rearing (before newspapers, sermons functioned not only as pious exhortations but also as the principle communicator of news, as editorials, and even as advice columns). Foster also printed a broadside titled *Divine Examples of God's Severe Judgments upon Sabbath Breakers.* The broadside includes four small woodcuts

by Foster depicting the damned who chose to play football, gather wood, spin, or mill on the Sabbath. This was published in response to laws passed in 1677 and 1679 to prevent profanation of the Sabbath. Foster also printed non-religious books and pamphlets, including publications on the Indian wars, Roger Williams's 300-page attack on the Quaker "heretic" George Fox and other Quaker "atrocities" (though seeking religious freedom for themselves, the Puritans had no tolerance for other Protestant sects), and most importantly, the second edition of the poems of Anne Bradstreet. Before his death, Foster printed more important prose and poetry by native New Englanders than any other printer of the century.

Foster's Legacy

The Annals of the Town of Dorchester, published in Boston in 1846 (although written a century earlier), reported for the year 1681: "Died Mr. John Foster, son of Capt. Hopestill Foster; School-master of Dorchester, and he that made the then Seal or Arms of ye colony, namely an Indian with a Bow & Arrow &c."[22] This refers to a small circular wood engraving by Foster of an Indian holding a large bow, with a ribbon of Latin words extending from his mouth reading "Come Over and Help Us," that acted as the official seal of the Massachusetts Bay Company on documents printed by colonial authorities. John Foster died on September 9 after suffering for seven months from tuberculosis (then known as consumption). His will, composed, he wrote, with "my body languishing, but my understanding not distempered or impaired," and the inventory of his estate provide fascinating glimpses of his life beyond his work. In the will, he mentions his medical books, which he bequeathed to his sister Thankfull. Historians believe that Foster also worked as a doctor; this was not uncommon for a Harvard-educated man at a time when there were few professional physicians in the colonies. Foster also wrote a pamphlet titled *A Brief Rule To guide the Common-People of New-England How to order themselves and theirs in the Small Pocks, or Measels,* thought to be the earliest treatise on a medical subject published in America.

In his will, Foster left the bulk of his estate to his mother and his siblings, but reserved 20 shillings each for his good friends, the ministers John Eliot and Increase and Cotton Mather. The inventory also lists a "Gittarue Viall," in all likelihood a fiddle. His printing and printmaking equipment and his artistic work are listed as "his turning tools Carueing [carving] tools" and "his Cuts [engravings] and Coollors [colors]." The reference to "Coollors" has led some scholars to suggest that Foster was also a painter, though there is little evidence to support this. The American Antiquarian Society in Worcester, Massachusetts, owns a painted portrait of Richard Mather that may be the basis for Foster's print. It shows Mather in the same pose, holding a book but no spectacles, yet it is in such ruined condition that it is impossible evaluate who painted it, and no other paintings can be firmly linked to Foster's hand.[23] Until more evidence surfaces this must remain merely an intriguing speculation.

Another expense Foster's will lists is 20 to 30 shillings "to pay for a pair of handsome Gravestones." Amazingly these stones—a headstone and a footstone—still exist; they were removed from their original location in a Dorchester graveyard and placed in the Museum of Fine Arts, Boston, for protection. Besides Foster's engravings and other printed matter, the headstone is one of his most enduring legacies, for it is among the colonial period's most elaborate and finely carved stones. It also provides insight into how Foster's peers regarded him. The inscription on the headstone reads:

<div align="center">

The
INGENIOUS
Mathematician & printer
M[r]. JOHN FOSTER
AGED 33 YEARS DYED SEPT[R] 9TH
1681

</div>

The inscription emphasizes Foster's brilliance and his dual abilities as an intellectual and a manual worker. Foster's age at his death is incorrect; he was most likely born shortly before his baptism on December 10, 1648, and so was 32 when he died.

Below this inscription a phrase in Latin next to the letters "IM" reads: "Living thou studiest the stars; dying mayst though, Foster / I pray, mount above the skies, and learn to measure the highest heaven." This is a quote from a letter Increase Mather wrote to Foster upon word of his rapid decline in health. It alludes, of course, to Foster's work as an astronomer. Next, adjacent to the letters "JF," is Foster's reply: "I measure it, and it is mine; the Lord Jesus has bought it for me / Nor am I held to pay aught for it but thanks."

As intriguing as the text is the image carved at the top of the headstone. Father Time, the bearded figure on the right holding the scythe and hourglass, attempts to stay the hand of Death, represented as a skeleton who reaches to snuff the flame of a candle placed on top of a globe. The flame, of course, symbolizes life, and the message is that Foster's "light" was extinguished far too soon. Above the globe is the sun, perhaps another allusion to Foster's work as an astronomer or to an anagram of Foster's name devised by a friend after his death: I SHONE FORTH (the letter "I" was used interchangeably with the letter "J" at this time).[24] Such complex iconography is typical of Puritan gravestone carving and will be addressed in more detail in Chapter 4.

Foster's footstone is much simpler. Again, his name appears at the top, but below is an intriguing phrase from Ovid's *Metamorphoses* in Latin and its translation in English:

ARS ILLI SUE CENSUS ERAT—
SKILL WAS HIS CASH

This rather blunt and materialistic phrase alludes, of course, to Foster's skill as a printer. An entry on the stones in the catalogue for the 1982 exhibition *New England Begins: The Seventeenth Century,* offers this interpretation of the phrase:

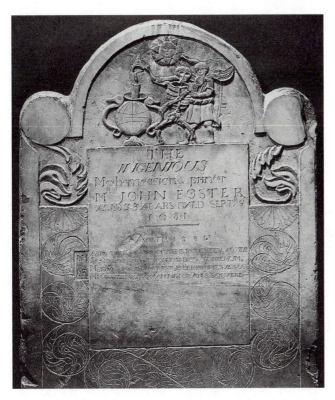

Attributed to the Old Stonecarver, John Foster's headstone, c. 1681. Slate (25⅝ × 23⅜ inches). Photograph © 2003 Museum of Fine Arts, Boston.

Far from making metaphorical references to the next world [like the headstone], the footstone seems concerned with just the opposite—the material lure of earthly pursuits. Taken together, the two Foster markers illustrate the essential polarity of the Puritan . . . pulled in opposite directions by many opposing forces, heaven and earth, spiritual essence and material substance. . . . The Foster stones are more than markers of the transience of mortal flesh, they are monuments to the duality of Puritanism, the contrast between earthly bondage and potential eternal joy.[25]

This was not the dichotomy it seems, for as we shall see in Chapter 3, the Puritans viewed the material and spiritual as interdependent. The headstone and footstone do not embody an "essential polarity," for Calvin and his followers believed that material reward was God's blessing for dedication to one's calling. Therefore, the stones work together to communicate not Puritan duality but Foster's fundamental well-roundedness.

In addition to Foster's gravestones, two elegies written at the time of his death survive. An elegy is verse composed in memory of the dead. In colonial America, elegies were printed as broadsides to be circulated among family and friends and pinned on or placed inside the coffin. Thomas Tileston and Joseph Capen, both friends from Dorchester, composed elegies that stressed Foster's intellectual gifts, particularly his work as a mathematician and an astronomer (both compare him to Archimedes, the ancient Greek mathematician) and his work as a printer and printmaker. Capen noted Foster's "peerless Skill in the practick [practical] Arts," effusing,

Oh how didst though in Curious works excell!
Thine Art & Skill deserve to See the Press,
And be Composed in a Printers dress.
Thy Name is worthy for to be enroll'd
In Printed Letters of the choicest Gold.

Capen concluded his poem by drawing parallels between Foster's work as a printer and his eventual resurrection:

Thy Body which no activeness did lack
Now's laid aside like an old Almanack
But for the present only's out of date;
Twil have at length a far more active State.
 Yea, though with dust thy body Soiled be,
Yet at the Resurrection we Shall See
A fair EDITION & of matchless worth,
Free from ERRATA, new in Heav'n Set forth:
Tis but a word from God the great Creatour,
It Shall be Done when he Saith IMPRIMATUR.[26]

Errata are mistakes made in publication, and imprimatur is a license to print or publish.

Benjamin Franklin reworked Capen's elegy for Foster in his own "Premature Epitaph" composed in 1728, in which he compared his body to an old book soon to be "a new and more beautiful Edition, Corrected and amended by the Author" (i.e., God).[27] Certainly, Franklin was aware not only of Foster's elegy but also of his pioneering efforts in printing and printmaking, and very likely admired his professional range in creating prints that served the purposes of piety, such as the portrait of Mather, and utility, such as the map and the almanacs. And Franklin clearly emulated Foster's cultivation of the sciences. If Foster had lived longer, would Franklin be recognized as a "second Foster," as Lewis suggested? We can only guess. Nevertheless, Foster was a uniquely gifted individual who not only advanced American printmaking and printing, but also set a precedent for the critical importance of combining text and image to reach a broad, we might say *democratic,* audience.

Notes

1. Quoted in Sibley, 222.
2. Green, 26.
3. Quoted in Craven, 18.
4. Foster, 1.
5. Quoted in Reich, 78.
6. Taylor, 167.
7. Quoted in Hall, "Plain Style," 110–11.
8. Quoted in Green, 5–6.

9. Quoted in Green, 6.
10. Griffin, 7.
11. Holman, "Mr. Richard Mather," 57–63.
12. Quoted in Craven, 21.
13. Quoted in Morrison, 186.
14. Holman, "Foster's Woodcut Map," 54.
15. Ibid., 53–96.
16. Woodward, 52–61.
17. Quoted in Green, 46.
18. Stowell, 85.
19. Holman, "Mr. Richard Mather," 60.
20. Holman, "Seventeenth-Century Prints," 33.
21. Quoted in Green, 24.
22. Quoted in Green, 11.
23. A reproduction of the painting appears in Gold, 67.
24. From Thomas Tileston's elegy for Foster, discussed below. Quoted in Green, 40.
25. Fairbanks and Trent, 320.
26. Quoted in Green, 37.
27. Stowell, 85.

Bibliography

Craven, Wayne. *Colonial American Portraiture: The Economic, Religious, Social, Cultural, Philosophical, Scientific, and Aesthetic Foundations.* Cambridge: Cambridge University Press, 1986.

Delbanco, Andrew. *The Puritan Ordeal.* Cambridge, MA: Harvard University Press, 1989.

Fairbanks, Jonathan L., and Robert F. Trent, eds. *New England Begins: The Seventeenth Century.* 3 vols. Exhibition Catalogue. Boston: Museum of Fine Arts, 1982.

Foster, Stephen. *Their Solitary Way: The Puritan Social Ethic in the First Century of Settlement in New England.* New Haven: Yale University Press, 1971.

Gold, Sidney M. "A Study in Early Boston Portrait Attributions: Augustine Clement, Painter-Stainer of Reading, Berkshire, and Massachusetts Bay." *Old-Time New England* 58, no. 3 (January-March 1968): 61–78.

Green, Samuel Abbott. *John Foster, The Earliest American Engraver and the First Boston Printer.* Boston: Massachusetts Historical Society, 1909.

Griffin, Gillett. "John Foster's Woodcut of Richard Mather." *Printing and Graphic Arts* 7 (1959): 1–19.

Hall, David. "Literacy, Religion and the Plain Style." In vol. 2 of *New England Begins: The Seventeenth Century,* edited by Jonathan L. Fairbanks and Robert F. Trent. Exhibition Catalogue. Boston: Museum of Fine Arts, 1982.

———. "Narrating Puritanism." In *New Directions in American Religious History,* edited by Harry S. Stout and D. G. Hart. New York: Oxford University Press, 1997.

———. *Worlds of Wonder; Days of Judgment: Popular Religious Belief in Early New England.* Cambridge, MA: Harvard University Press, 1989.

Holman, Richard. "Some Remarks on 'Mr. Richard Mather.' " *Printing and Graphic Arts* 7(1959): 57–62.

Holman, Richard B. "John Foster's Woodcut Map of New England." *Printing and Graphic Arts* 8 (1960): 53–96.

————. "Seventeenth-Century Prints." *Prints in and of America to 1850, Winterthur Conference Report.* Charlottesville: University Press of Virginia, 1970.

McGrath, Alister E. *A Life of John Calvin: A Study in the Shaping of Western Culture.* Oxford: Basil Blackwell, 1990.

Middlekauf, Robert. *The Mathers: Three Generations of Puritan Intellectuals, 1596–1728.* New York: Oxford University Press, 1971.

Morrison, Samuel Eliot. *The Intellectual Life of Colonial New England.* 8th ed. Ithaca: Cornell University Press, 1980.

Nash, Gary B. *Red, White and Black: The Peoples of Early North America.* 4th ed. Upper Saddle River, NJ: Prentice Hall, 2000.

Reich, Jerome. *Colonial America.* 5th ed. Upper Saddle River, NJ: Prentice Hall, 2001.

Sibley, John Langdon. *Biographical Sketches of Graduates of Harvard University in Cambridge, Massachusetts.* Vol. 2. Cambridge, MA: Charles William Sever, 1881.

Stowell, Marion Barber. *Early American Almanacs: The Colonial Weekday Bible.* New York: Burt Franklin, 1977.

Taylor, Alan. *American Colonies: The Settling of North America.* New York: Viking Press, 2001.

Woodward, David. "The Foster Woodcut Map Controversy: A Further Examination of the Evidence." *Imago Mundi* 16 (1967): 52–61.

CHAPTER 3

The Freake Painter (active 1670–c. 1680), an Anonymous Master

Today the artist who painted what many consider the most outstanding seventeenth-century American portrait is known only as the Freake Painter, an unfortunate appellation considering the modern connotations of the word *freak*. Typically, when an artist's name is lost to history, art historians assign the artist a title based on his or her best-known or most characteristic work. This is the case with the Freake Painter, whose masterpiece is the portrait *Mrs. Elizabeth Freake and Baby Mary,* painted c. 1671–74, one of a pair of portraits; the pendant depicts her husband John.[1] Although we know nothing about the artist beyond what his portraits convey, the Freake Painter is worthy of investigation because his work marks an important step in the evolution of the fine arts in America. First, the portraits are oil on canvas, which reveals that the colonists were interested in and able to afford such luxury items at that time. This, in turn, is evidence of the cultural maturation of the Boston area, where the Freake Painter worked. Second, the portraits' style discloses the colonies' cultural reliance on England, yet also reveals the distinctive aesthetic preferences of individuals living in a very different context. Third, the portraits provide clues about the social status and self-construction of the Freakes, who typified the wealthy merchant middle class of early colonial Boston. And fourth, as depictions of third-generation American Calvinists, the Freake portraits document the evolution of religious belief in Massachusetts from the strict Puritanism of the early settlers to a more relaxed approach. Portraiture is often considered the simplest and most straightforward of themes, without complex narratives or iconography (symbolism). In fact, as an exploration of the Freake Painter and his work will verify, portraits can be rich and revealing cultural documents that provide unparalleled insight into the subjects and their times.

American artists first created oil paintings in the Boston area in the 1660s.

Why do we see oil painting emerge as a medium in Boston at this time? The Boston area was the most settled, the most developed, and the most culturally advanced in the colonies. As established in Chapter 2, the initial motivation for settlement in Massachusetts was to escape religious persecution; colonization began with the Pilgrims at Plymouth in 1620 and swelled with the Great Migration of 1630, when John Winthrop lead over 2,000 Puritans to the Boston area to form the self-governed Massachusetts Bay Colony. By 1642, when the Civil War in England disrupted transatlantic migration, between 13,000 and 25,000 had migrated to New England. In the early years, subsistence, rather than art, was the main priority. But by the 1660s Boston experienced burgeoning commercial development as the demands of local consumers increased and international maritime commerce developed, making the city a profitable place to live. This attracted immigrants more concerned with economic opportunity than with religious freedom or Winthrop's promise of a Protestant utopia, especially as a series of economic depressions beset England. Many came from the most commercialized sections of England—London, Sussex, and East Anglia—and brought with them a capitalist and entrepreneurial mentality.

This is not to suggest that there was a sudden flowering of the arts in Boston in the 1660s and 1670s. To the contrary, there were few individuals wealthy or interested enough to commission portraits. Instead there was a gradual evolution of interest in oil painting that complimented the growing attraction to other luxury goods, such as fine furniture and silver. Of the approximately 50 surviving oil paintings created in the colonies during the seventeenth century, 40 were painted in the Boston area.

The Freake Painter and the Elizabethan-Jacobean Style

What can we conclude about the Freake Painter based on the scant evidence available? Certainly what attracted him (and he was undoubtedly male—women rarely worked professionally outside the home at this time) to Boston were the circumstances noted above. It was the only town in the English colonies where one could make a living as an artist in the 1670s. He probably worked primarily as a decorative painter, adding floral and geometric designs to walls and furniture, and/or as a sign painter, although no such work from his hand has been identified. Artists of English origin rarely signed their work in the seventeenth century, a frustration for scholars but understandable for the time. With few exceptions, the Italian Renaissance conception of the artist as an individual of genius and therefore worth recognizing had not yet arrived in England, where artists were considered the equal of other craftspeople, such as shoemakers or tailors. In addition, Boston in 1670 was a small town of less than 1,500 families. It was unnecessary for the Freake Painter to sign his work, because most likely everyone in the tiny circle of wealthy patrons knew who he was.

The Freake Painter was probably an English immigrant, for he worked confidently in a style that he must have studied abroad. As colonial portrait specialist Wayne Craven asserts, the Freake Painter was not a hack—an amateur with enough natural talent to fake artistic skill—but an artist of rare ability who understood proportion, perspective, and how to mix and manipulate oil pigments. These skills are consistent with artists who trained in England.[2]

Art historians identify the style of the Freake portraits as the Elizabethan-Jacobean style. It is called the Elizabethan-Jacobean style because it was the dominant style during the reign of Queen Elizabeth I (ruled 1558–1603), and artists continued to work in this way under King James I (ruled 1603–25). (James is the English translation of the Latin name Jacobus, hence James's reign is termed the Jacobean period.) The Elizabethan-Jacobean style actually originated under Henry VIII (ruled 1509–47). The German painter Hans Holbein the Younger (c. 1497–1543) fled to England in 1532 as a religious refugee. Holbein became the court painter to Henry VIII; the best-known portraits of Henry, a grandiose, iconic presence in bulky bejeweled dress, are from Holbein's hand. Partly influenced by English medieval portraiture, Holbein stressed the sitters' wealth through detailed presentations of richly embroidered clothing and expensive jewelry. The sitters' faces and hands, although realistic, were rendered with little shading, or modeling, to suggest depth and can appear quite flat. Elizabeth I actually commanded artists to paint her without shadows to emphasize her separateness, as queen, from the ordinary world. Light shadows were also considered to be more consistent with the clarity and beauty of the English complexion than the strong light-dark contrasts in Italian painting of the same period. Limited modeling and the detailed patterning of the clothing and jewelry, which also flattens form, results in sitters who appear two-dimensional, almost bodiless. The Elizabethan-Jacobean style is also characterized by negligible interest in defining deep space. The sitters' bodies tend to fill the picture plane, leaving little room for background detail. This compression of both form and space and the emphasis on surface design is accentuated by the rich colors Elizabethan-Jacobean artists favored. Deep reds, rich oranges, crisp blues, and bright yellows occur frequently in Elizabethan-Jacobean portraiture.

While the Elizabethan-Jacobean style died out in England in the 1630s due to the preferences of King Charles I (ruled 1625–49) and his French-born queen Henrietta for the Baroque style of continental Europe, it survived in the colonies, appearing some sixty years after its heyday in England in the work of the Freake Painter. It may seem strange that the Freake Painter would choose to work in a style then obsolete in England except in a few provincial and conservative pockets (including East Anglia, the home of many Puritan immigrants). In fact, this was a deliberate choice, for the Elizabethan-Jacobean style had strong links to Protestantism and the middle class. As discussed in Chapter 2, those who followed the teachings of John Calvin insisted on portraits that were realistic, plain, and unglamorous, forms "which the eyes are capable of seeing."[3] The Puritans, who looked with disapproval on the licentiousness of court life, rejected the courtly style that evolved under Charles I, which idealized and glamorized sub-

jects with flashy brushstrokes; sensuous full-bodied figures, often in dramatic poses; and aggrandizing elements such as great swags of drapery or lush landscape backgrounds. The English courtly style was defined by the Baroque painter Anthony Van Dyck, a native of Flanders (now Belgium) who became the court painter to Charles I in 1632. The Puritans viewed Van Dyck's preeminence at court and the style he developed as a betrayal of indigenous English tradition. Instead they favored the "true" English style established in the Elizabethan period. In addition, Puritanism was primarily a middle-class movement that renounced all things aristocratic. Despite the fact that the Elizabethan-Jacobean style was based on the artistic preferences of monarchs, it evolved into a style associated with conservative middle-class Puritans, who favored its straightforward naturalism to Baroque idealization that "deformed" God's creation.

With this understanding of the formal qualities and the class and religious implications of the Elizabethan-Jacobean style, it is now possible to examine the portraits of the Freakes with a better sense of why they look the way they do and what functions they fulfilled. The Freake Painter depicted Elizabeth Freake in an almost frontal position, typical of Elizabethan-Jacobean portraiture, with only a slight turn of the head and body toward her husband's portrait, holding her curiously rigid daughter Mary. Her features are precisely rendered, with almond-shaped eyes (a trademark of the Freake Painter). Her face is plain and pleasant, there is a slight smile on her lips, and her head is covered modestly with a white lace hood. The attention to detail and pattern that characterizes the Elizabethan-Jacobean style is most evident in Mrs. Freake's elaborate lace collar, the gold and silver embroidery of her red underskirt, her garnet bracelet and her pearls. Body forms, most particularly arms and hands, reveal little if any modeling and therefore appear as flat cut-outs rather than rounded limbs, although they project forward somewhat in the placement of their light forms against dark. Similarly, neither Mrs. Freake nor Mary appear to have laps despite the fact that both are seated; the Elizabethan-Jacobean style's emphasis on surface effects generally meant little concern with rendering anatomy accurately.

Yet the lack of modeling and realistic anatomy in *Mrs. Elizabeth Freake and Baby Mary* does not suggest a naive hand. Instead, it reveals how well the Freake Painter understood the Elizabethan-Jacobean style. This is reinforced by the artist's sense of color and design. In the portrait of Mrs. Freake he juxtaposed the red of the underskirt with the green of her dress. Red and green are complements, or colors placed directly across from each other on the color wheel. Juxtaposing complements heightens each color. The Freake Painter also created compositional coherence coloristically by repeating related red tones in the underskirt, the ribbons on her sleeve and her bodice laces, the highlights on the chair, the lips and cheeks of Mrs. Freake and her daughter, and the curtain behind them. Hence the painting's striking appearance is not the result of an illusionistic three-dimensional figure in a realistically defined space, but strong colors integrated into a unified design.

It is also clear when one examines the portrait that the Freake Painter was

well versed in the complex interaction of pigments, solvents, resin, and varnish needed to create an oil painting. The pigments he used, which were thoroughly analyzed by curator Jonathan Fairbanks of the Museum of Fine Arts, Boston, are consistent with the color and composition of paints mixed in England.[4] In some areas he handled the brush like a miniaturist, creating detail with small strokes placed side by side. In other areas he used broad layers of both semi-opaque and semi-translucent paint to create form and light. The lightest and most prominent features, such as parts of Mrs. Freake's face, are rendered in impasto (thick paint that projects from the surface of the canvas).

Mrs. Freake sits on an expensive "turkeywork" chair (so called because of its upholstery's resemblance to Turkish carpets) before a small table and swag of drapery. The dark background reveals the influence of Dutch painting, which, as the product of a Calvinist culture, complemented the aesthetic interests of the Puritans in its realistic approach to portraiture. In the portrait of John Freake the dark background almost absorbs his dark brown coat and hair, accentuating the elaborate patterning of his Venetian lace collar, the silver brooch or tassel he holds, and his elegant tufted sleeves with ruffled cuffs. Like his wife, he wears a gold ring and is depicted slightly smaller then life-size.

The Freakes

The intricate lace collars, the turkeywork chair, the expensive jewelry—what do these clues reveal about the Freakes? Clearly, they were a wealthy family. At the time the Freake Painter created the portraits, John Freake, who was born in England in 1635 (the third child of Thomas Freake, the son of a knight) and came to the colonies before 1658, was thirty-six years old and a prosperous merchant living in Boston's North End. He owned two houses, a mill, a brew house, land (including waterfront property and a wharf on Boston Harbor), and part interest in six ships. He was also an attorney, and his prominent and respected place in the community is indicated by his appointment as a juryman and as constable, and his service as a trustee of the Second Church of Boston (a Puritan church). In the portrait he is handsome, with a thin mustache and shoulder-length wavy hair—a self-confident and somewhat self-conscious individual. His hairstyle is revealing, for it is not the closely cropped hair of the strict Puritan Roundheads, nor the long curly wig of an aristocrat. He charted a middle course by growing his own hair to his shoulders.[5]

John Freake's dress was luxurious for 1670s Boston, but not overly ostentatious. Instead of the plain black coat and square white collar the early Puritans favored, he wears a dark brown velvet coat with silver buttons and a rounded Venetian lace collar, most likely imported. Beneath his coat is a fine white muslin shirt with fashionably tufted sleeves. In his right hand he holds a pair of gloves, the traditional symbol of a gentleman. The curved fingers of his left hand direct the viewer's eye to either a silver brooch or the collar's elaborate tassel he holds between his thumb and forefinger. We must remember that fine dress was not

only a sign of status but also a significant investment in the seventeenth century. The inventory of John Freake's estate at his death listed his clothing in detail, including "His owne wearing apparrell silk linnen and woollen . . . His owne signet and sett of gould buttons . . . a Remnant searge and black coate" and "10 paire of Gloves."[6]

The portrait of Mrs. Freake also appears to be as much an inventory of the family's wealth as a likeness of the sitter. In addition to the lace collar, triple strand of pearls, and garnet bracelet noted previously, Mrs. Freake wears a green dress probably made of moiré silk or taffeta, which she has pulled up to reveal her beautifully embroidered red underskirt. The high neckline of her dress and her covered hair suggests that she is decorous, as a married woman of her class should be, yet not so modest as to shy away from exhibiting her good fortune. The sleeves of her dress are also raised and tied with black and red ribbons to show the puffed sleeves of her white shirt. The Freake Painter's ability to convincingly render such a range of fabrics is another testament to his skill.

Elizabeth Freake was the daughter of Thomas Clarke, a wealthy merchant. She was born in 1642 and so is 29 years old in the portrait. She married John Freake in 1661. She is shown in her primary roles in life—as a wife (her portrait was displayed as a pendant beside that of her husband) and as a mother. Mary was the Freakes' eighth child, born in 1674. Radiography has revealed that Mary was not part of the original composition. The Freake Painter initially painted Mrs. Freake around 1671 with her hands folded in her lap, holding a fan, a sign of her status and gender much like the gloves her husband holds. After Mary was born the Freake Painter evidently returned to the Freake home to add her to the composition, which might explain why she appears so stiff and sits so unnaturally. To the lower left in the portrait, an inscription reads "Aetatis Suae 6 mo[th]" (age six months). Mary is dressed much like her mother, with a white head cover, a light gold-colored dress with its sleeves rolled up to reveal a white shirt with puffed sleeves, a white lace collar, and a long white apron. At the time he added Mary, the Freake Painter changed Mrs. Freake's collar from a long pointed style to a more fashionable rounded style, decreased the puffiness of her sleeves, and replaced the sleeves' original horizontal ribbons with vertical ones. He also altered the portrait of Mr. Freake, lowering his eyes three-quarters of an inch, restyling his hair, and replacing a glove held in his left hand with the silver brooch or tassel. Art historian John Michael Vlach suggests that one reason the Freake Painter made these changes was to place an even greater emphasis on the Freakes' wealth. Decreasing the width of Mrs. Freake's sleeves allowed more of the turkeywork chair to show, and placing his fingers around the silver brooch or tassel communicated Mr. Freake's ability to afford imported goods. Vlach also points out that the changes are so well integrated that without x-ray technology one would be unaware of them, further evidence of the Freake Painter's professionalism.[7]

The addition of Mary is important, for it reveals the significance of family to the Puritans and a shift in attitudes toward children at this time. The family was a crucial unit in Puritan society. In New England there was a balance of genders,

thus more families and greater stability. Nevertheless, earlier Puritans treated children quite harshly, even sending them away from home to be raised by others so as not to become too attached and to avoid spoiling them. Strict Puritans believed children were born damned, carrying the burden of original sin, and therefore, to prepare for salvation, they must be literally whipped into shape with corporal punishment and constant reminders of damnation. As Philippe Ariès writes, ministers were "unwilling to regard children as charming toys, for they saw them as fragile creatures of God who needed to be both safeguarded and reformed."[8] Although there was no clear conception of the special nature of children or of childhood as a distinct stage of life until the early Enlightenment, there was an evolution of these ideas over the course of the seventeenth century, evident here in the protective love Mrs. Freake demonstrates for Mary, leading some to call her the "Puritan Madonna." Although the literature of the time discouraged women from excessive emotional attachment to their children, Mrs. Freake holds Mary with great tenderness and a sense of pride, suggesting that later Puritans like the Freakes did not consider their children depraved.

As the inclusion of Mary suggests, one of the portrait's functions was to celebrate the sacredness of family and the Puritans' interest in lineage. Similarly, as pendants, they acknowledged the Freakes' domestic union and role as parents. As their fine dress indicates, the portraits also functioned as status symbols, and most likely hung in the entry hall of the Freake home to impress visitors. A fourth function was to preserve the appearance of the Freakes for posterity, a role that John Freake's portrait would perform sooner than expected when he died in an explosion on one of his ships in 1675. (Mrs. Freake would remarry and have five more children. She died in 1713, at the age of 71. Mary lived until 1752.) Puritan teachings emphasized the transience of human life, and portraits were believed to act as effigies of the spirit. And finally, the portraits mark the Freakes as members of a particular social class, a class of increasing significance at this time in Boston's history.

Mercantile Boston in 1670

While the portraits of the Freakes obviously express their personal circumstances, they also embody a merchant population that was growing in influence in 1670s Boston. Wealthy merchants like John Freake began to replace ministers as community leaders, dominating town life economically, socially, and politically. Today scholars debate the balance of control between the religious oligarchy and the increasingly outward-looking, urbanized, and secularized merchant class. Some believe that religious control declined as commercialization triumphed (termed the declension theory). Others see not an abandonment but an evolution of the moral, Christian, homogeneous society envisioned by Winthrop. Regardless, the Freake portraits exemplify a time of significant economic, social, and religious transformation.

Beginning in the fifteenth century, capitalism replaced medieval feudalism as

the dominant economic system in Europe. Capitalism is characterized by private or corporate ownership of capital goods and by prices, production, and distribution of goods that are determined mainly by a free market. Boston, at the mouth of the Charles River, was well situated for the development of a free-market economy. The rapidly growing population demanded goods, which benefited local manufacturers, and a fine harbor encouraged lucrative trade with foreign markets. The result was an ideal environment for entrepreneurial growth. By 1670 Boston was the most commercialized town in New England, and residents actively imported the fine laces, embroideries, and jewelry depicted in the Freake portraits. The Freake Painter's adept handling of such material goods, the result of his training in the Elizabethan-Jacobean style, evidently appealed to patrons as a testament not only to their individual wealth but also to the growing economic sophistication of the colonies.

John Freake personified the successful seventeenth-century American merchant. He had a hand in most major commercial enterprises in 1670s Boston. He was a landholder with two homes, which automatically marked him as a man of status. He owned a mill, most likely for processing wheat, a staple commodity, and a brew house to supply the many taverns of colonial Boston. With a part interest in six ships, he was also involved in shipbuilding and international trade. Shipbuilding was a powerful impetus for economic development. Lumber was plentiful and inexpensive, enabling New England to produce ships at half the cost of London shipyards. Trade routes developed between New England, the English colonies in the West Indies, and the mother country, resulting in an increasingly diversified commercial economy. By 1700, Boston was the third most profitable city in the British Empire in shipping, behind only London and Bristol.

That Elizabeth Freake was native-born typifies the changing demography of colonial Boston in the last half of the seventeenth century. Immigration slowed after the 1642 outbreak of the Civil War in England, but population growth climbed as the colonists produced large families. Historian Anthony McFarlane explains:

> A striking feature of New England's development was its rapid transition from an immigrant to a settled society. . . . Abundant supplies of land and food, a balanced ratio of men to women, and a low incidence of epidemic disease made for higher birth rates and low mortality, and the region consequently enjoyed a rate of population growth that was without parallel either in the Old World or in most parts of the New.[9]

According to statistics, Colonial American women gave birth to an average of eight children between ages twenty and forty. With thirteen children, eight of whom survived past infancy, Mrs. Freake certainly contributed to the mid-century population boom.

As the Freake portraits suggest, the American colonies were an upwardly mobile society. Unlike the strict social hierarchy of England, there was fluidity between classes, for social stratification was mitigated by the lack of both a fixed

aristocracy and masses of indigent rural poor. Instead, Colonial American society divided itself more loosely into the following groups: the "better sort," or rich; the "middle sort," typically farmers; small business owners and skilled artisans; and the "meaner" or "lower sort," or poor. The original Puritan settlers were primarily of the middle sort. By 1671, the Freakes were clearly of the better sort; nevertheless, they were still middle-class because of the nature of Mr. Freake's work and Puritanism's explicit repudiation of claims of economic privilege or nobility.

It is important to bear in mind that capitalism emerged at the same time as Protestantism, and both were middle-class phenomena. Capitalism, in its striving for material gain, complemented the practical orientation of much Protestant belief and was consistent with the teachings of John Calvin. The commercialism of this period was not antithetical to Puritan values—it actually derived from them. As historian Alan Taylor writes, in seventeenth-century Boston "the religious and economic were interdependent in the lives of people who saw piety and prosperity as mutually reinforcing."[10]

Puritan Boston in 1670

It may seem surprising that the Freake portraits also articulate religious belief, until we remember that in Puritan Boston religion infused all aspects of life. While the Freakes' obvious display of wealth may appear resolutely anti-Puritan, in fact it was consistent with their adherence to Calvinist theology. Crucial for understanding the work of the Freake Painter is Puritanism's foundation in the virtues of diligence and industry. John Calvin defined one's occupation as a secular "calling" and part of God's plan for each individual; hard work, therefore, regardless of station, resulted not only in material gain but contributed to one's salvation and honored God. Industriousness and self-discipline were considered integral to faith. Out of this emerged what is today known as the Protestant work ethic, a philosophy that profoundly influenced American society. Calvin also defined the doctrine of prosperity, which considered worldly success evidence of God's blessing, and the theory of diligence, based upon the belief that idleness was a sin.

Calvin's emphasis on the compatibility of the material and the spiritual lent credence to the aspirations of upwardly mobile Bostonians. It permitted modest enjoyment of worldly pleasures because they were an outward sign of God's blessing. As Craven indicates, Calvin recommended a middle course between the unnecessarily austere life of a hermit or monk and excessive indulgence, which could lead to the sins of lust, gluttony, and pride. God rewarded the diligent worker with prosperity, but, ministers warned, worldly goods should not distract from one's ultimate purpose: preparation for salvation in the next world. Moderation was key, yet Calvin placed no limits on prosperity, an appealing situation for middle-class Protestants intent on rising in society.[11]

Seventeenth-century Bostonians would have recognized the Freake portraits, then, as expressions of the Calvinist doctrine of prosperity and God's blessing on

the Freakes through material reward. Puritans could not include overt symbols of piety in portraits because of the ban on religious art, but they could visually express their devoutness through fine clothing and jewelry. Even the addition of Baby Mary can be viewed in religious terms, for Puritans believed that procreation was a product of divine will and "among the Choice Favours and Gifts of Providence."[12] Yet the Freakes, while clearly not the strict Puritans of the earlier generation, were not so extravagant as to be mistaken for aristocrats. According to seventeenth-century documents, Elizabeth Freake was a pious woman and John Freake was a church trustee who shunned noble pretensions.

At the same time as the Freake Painter was creating images consistent with Calvinist theology, he also captured a religion in transition. In renouncing the conservative appearance of earlier Puritans, the Freakes typified the third generation of American Calvinists who were no longer motivated strictly by religious concerns. As Craven suggests, the Protestant work ethic and the doctrine of prosperity "carried within them the seeds of erosion of spiritual concerns," as worldly success neutralized Puritan austerity.[13] Commitment to the work ethic and the theory of diligence resulted in material gain, which in turn led to greater ambition, which destroyed the earlier Puritan commitment to working for the greater good. By 1674 Puritan clergy recognized the deleterious effects of this change and feared it would devastate the harmonious, homogeneous (and closely regimented) society they were attempting to build. That year Reverend Samuel Torrey wrote, "Truly, the very heart of New England is changed, and exceedingly corrupted with the sins of the times. There is a spirit of profaneness, a spirit of pride, a spirit of worldliness, a spirit of sensuality . . . a spirit of libertinism, a spirit of carnality," especially, he asserted, among the younger generation.[14] It was difficult for the ministers to make much headway, however, for the theological foundation of Puritanism encouraged secular work and prosperity.

Other factors, such as an increase in population (including many non-Puritans), expansion into the countryside, and growing trade with the outside world encouraged the breakdown of the closed religious community established by John Winthrop. In 1666, when King Charles II sent commissioners to Boston to initiate greater control of the colony, John Freake sided with the commissioners over the religious oligarchy, as did many Boston merchants who favored greater religious toleration and closer contact with England. This was the first step in the transformation of the Massachusetts Bay Colony into a royal colony. In 1684–86, Charles revoked the colony's charter. Thus, the holy commonwealth of John Winthrop became not a self-governed millennial kingdom but a province of the British crown. With this change the power base of the Puritan old guard eroded rapidly.

Other Works by the Freake Painter

Scholars have identified about ten portraits that appear to be from the hand of the Freake Painter. Eight of the paintings, excepting the Freake portraits, bear

the date 1670 and share compositional conventions and a consistent style and color scheme. This is the largest existing group of portraits by a seventeenth-century American artist, further evidence of the Freake Painter's significance. After the portraits of the Freakes, his most appealing works are three portraits of the children of Robert Gibbs, Sr. Inscriptions on the portraits tell us that Margaret, the eldest, was seven years old when her portrait was painted. Robert Gibbs, Jr., was four and a half, and young Henry was one and a half. All three share the almond-shaped eyes characteristic of the Freake Painter.

Each child is presented full-length, standing on a black and white checkerboard floor. The floor reveals the Freake Painter's awareness of linear perspective, the mathematical definition of space defined by Italian Renaissance architect Leon Battista Alberti (1404–72). In one-point perspective the orthogonals, or lines that recede from the picture plane, converge at a point on the horizon. Here, the orthogonals meet at almost the exact horizontal center of each por-

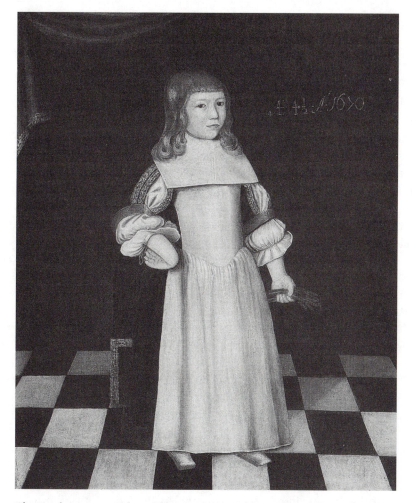

The Freake Painter, *Robert Gibbes Jr.*, 1670. Oil on canvas (40 × 33 inches). Photograph © 2003 Museum of Fine Arts, Boston.

trait, slightly above each child's head, underscoring their faces as the portraits' focal points. The Freake Painter's knowledge of perspective is further confirmation that he was a trained professional. Yet despite his attempt to render space realistically, each child, in keeping with the Elizabethan-Jacobean style, appears as flat as a paper doll.

Like the image of Baby Mary, the Gibbs portraits document a change in Puritan attitudes toward children. The choice to have the portraits painted at all suggests the children's significance and the importance of lineage. Robert Gibbs, Sr., was born in England and, as the fourth son of knight and gentleman Sir Henry Gibbs, received little of his father's wealth due to the laws of primogeniture. Like John Freake, he immigrated to America around 1658, married the daughter of a wealthy mill owner, and became a successful merchant. Shortly before he commissioned the Freake Painter to paint the portraits of his children, he built a large home referred to in a contemporaneous publication as a "stately Ediface."[15] Preserving the likenesses of the children also reflects the Puritan concern with life's transience, for the mortality rate among the very young was quite high at this time. In fact, Margaret Gibbs died shortly after her portrait was painted.

As in the Freake portraits, the children's apparel indicates the family's wealth and God's blessing upon them. Each child is dressed like a miniature adult, wearing finely embroidered outer robes with sleeves that have one slash (an ovoid hole in the outer layer of the sleeve through which the white undershirt is visible). Multiple slashes marked clothing as aristocratic; Puritan sumptuary laws permitted only a single slash. Typical for boys under age eight, Henry and Robert are dressed like girls (at eight boys wore doublets and knee breeches, like their fathers). What distinguishes Robert's gender, however, is his square collar, the absence of ribbons, and the gloves he holds to indicate his future status as a gentleman. His pose is also significant; the full-length portrait with the elbow cocked and one hand on the hip was borrowed directly from Elizabethan-Jacobean portraits of English aristocrats and was intended to suggest poise and authority, somewhat anomalously in a portrait of a four and a half year old. It also reveals the Freake Painter's lack of training in foreshortening and anatomy, for Robert's hand bends back at an unnatural angle and looks more like a flipper than a human appendage.

The portraits of the Gibbs children probably hung in the entry hall of the Gibbs home, where guests were received. Nevertheless, the Freake Painter's portraits were private images and not intended for display outside the home, therefore no evidence exists of contemporary reactions to his work. That changed dramatically after 1913, when the Freake portraits entered the collection of the Worcester Art Museum in Worcester, Massachusetts, presented by descendants of John and Elizabeth Freake. In the 1930s the portraits appeared in exhibitions and catalogues and immediately attracted public scrutiny as the finest examples of seventeenth-century American portraiture in existence.

The Freake portraits entered the public eye just when interest in American folk art exploded, due in part to the nationalist and isolationist emphasis of art collecting and art scholarship in America in the years between the two world

wars. Scholars and collectors noted the formal parallels between the work of self-trained folk artists of the nineteenth and twentieth centuries and the Freake Painter's portraits. For example, folk artists tend to emphasize pattern and have little conception of how to render space and anatomy realistically. Therefore, like the Freake portraits, folk portraits appear quite flat. Some scholars described the Freake portraits as the beginning of an American folk tradition, what Vlach describes as "an emerging mythology constituting American folk art as the wholesome expression of a national heritage," and placed the portrait of Mrs. Freake in a continuum that culminated in the work of Grandma Moses.[16] As we have seen, however, this is a gross misrepresentation. The Freake Painter was not self-trained, and therefore not a folk painter. Instead, he was a gifted and confident artist working in an old-fashioned tradition, one that prized the very pictorial conventions that later would characterize American folk art. The flatness of his forms was deliberate, not the result of a lack of training, and any visual parallels with folk art are merely incidental.

In recent years the portrait of Mrs. Freake alone or the pendant portraits of husband and wife have appeared in nearly every survey of American art history. Today the work of the Freake Painter is placed in its appropriate context as the production of a highly skilled artist and as crucial evidence of the socio-cultural and religious values of middle-class Protestant society in 1670s Boston. While art historians regard the Freake Painter's portraits as multi-layered historical documents, they also appreciate their beauty and compelling charm, and their uncanny ability to acquaint us with the individuals who established the nation.

Notes

1. In some literature the Freake Painter is referred to as the Freake Limner, a misnomer because the term limner applies only to miniature painters. See Fairbanks, 413–14. Fairbanks, 416, also discusses the speculation that the Freake Painter could have been Samuel Clement or his father Augustine Clement, both listed as "painter-stainers" in seventeenth-century documents, but concludes that this "requires further proof."

2. Craven, 38.

3. Quoted in Ibid., 18.

4. Fairbanks, 447–53.

5. Craven, 42–43.

6. Quoted in Fairbanks and Trent, 462, and *Worcester Art Museum,* "Unidentified Artist, *John Freake,*" in *Early American Paintings in the Worcester Art Museum,* http://www.worcesterart.org/Collection/Early_American/unidentified_17th/john_f/discussion.html.

7. Vlach, 98.

8. Ariès, 133.

9. McFarlane, 157.

10. Taylor, 166.

11. Craven, 7, 13.

12. Quoted in Scholten, 14.

13. Craven, 13.
14. Quoted in Ibid., 14
15. Quoted in Fairbanks and Trent, 458.
16. Vlach, xiii.

Bibliography

Ariès, Philippe. *Centuries of Childhood: A Social History of Family Life*. Translated by Robert Baldick. New York: Vintage Books, 1962.

Craven, Wayne. *Colonial American Portraiture: The Economic, Religious, Social, Cultural, Philosophical, Scientific, and Aesthetic Foundations*. Cambridge: Cambridge University Press, 1986.

Fairbanks, Jonathan L. "Portrait Painting in Seventeenth-Century Boston: Its History, Methods, and Materials." In vol. 3 of *New England Begins: The Seventeenth Century*, edited by Jonathan L. Fairbanks and Robert F. Trent. Exhibition Catalogue. Boston: Museum of Fine Arts, 1982.

Fairbanks, Jonathan L., and Robert F. Trent, eds. *New England Begins: The Seventeenth Century*. Vol. 3. Exhibition Catalogue. Boston: Museum of Fine Arts, 1982.

Fass, Paula S., and Mary Ann Mason, eds. *Childhood in America*. New York: New York University Press, 2000.

Green, Samuel M. "The English Origins of Seventeenth-Century Painting in New England." In *American Painting Before 1776: A Reappraisal*, edited by M. G. Quimby. Charlottesville: University Press of Virginia, 1971.

McFarlane, Anthony. *The British in the Americas, 1480–1815*. London and New York: Longman, 1992.

Miller, Lillian B. "The Puritan Portrait: Its Function in Old and New England." In *Seventeenth-Century New England*, edited by David D. Hall and David Grayson Allen. Boston: Colonial Society of Massachusetts, 1984.

Nash, Gary B. *Red, White and Black: The Peoples of Early North America*. 4th ed. Upper Saddle River, NJ: Prentice Hall, 2000.

Reich, Jerome. *Colonial America*. 5th ed. Upper Saddle River, NJ: Prentice Hall, 2001.

Scholten, Catherine M. *Childbearing in American Society: 1650–1850*. New York: New York University Press, 1985.

Strong, Roy. *The English Icon: Elizabethan and Jacobean Portraiture*. New Haven, CT: Yale University Press, 1969.

Taylor, Alan. *American Colonies: The Settling of North America*. New York: Viking Press, 2001.

Vlach, John Michael. *Plain Painters: Making Sense of American Folk Art*. Washington, D.C.: Smithsonian Institution Press, 1988.

Worcester Art Museum. "Unidentified Artist, *John Freake*." In *Early American Paintings in the Worcester Art Museum*. http://www.worcesterart.org/Collection/Early_American/Artists/unidentified_17th/john_f/discussion.html.

Worcester Art Museum. "Unidentified Artist, *Elizabeth Freake and Baby Mary*." In *Early American Paintings in the Worcester Art Museum*. http://www.worcesterart.org/Collection/Early_American/Artists/unidentified_17th/elizabeth_f/discussion.html.

CHAPTER 4

Joseph Lamson (1658–1722), Stonecutter

Sculpture lagged behind painting in colonial America. Picking up a chisel and hammer and attempting to carve stone is more challenging than picking up a quill to draw or a brush to paint. There were few examples to study because sculpture, unlike painting or printmaking, was difficult to transport from the Old World. In Puritan New England there was also the strict adherence to the Second Commandment, "Thou shall make no graven images," which was believed to apply more directly to sculpture than to two-dimensional art forms because it was graven, or carved. As noted in previous chapters, the Puritans, as Calvinists, looked at much visual art with suspicion because of its association with idolatry. Sculpture in particular, as it decorated the Catholic churches of Europe, was considered idolatrous.

The only sculptures that remain from colonial New England are thousands of carved gravestones. These stones are tangible remnants of the past and are accessible to all, as most reside in public burial grounds. Gravestones reveal important aspects of Puritan social, religious, and cultural history. Although often beautifully carved, it is their rich iconography, or symbolism, ranging from the grim (skulls and crossbones) to the appealing (plant motifs and cherubs), that most engages modern viewers. Each gravestone carries messages for the living that are a fascinating challenge to decipher. The stones speak to us, though in a language that is often unfamiliar, emerging from the ideologies of a time so distant from our own. In addition to their engrossing iconography, the large number of existing New England gravestones pose some intriguing questions: How did gravestones escape the Puritan proscription of graven images? Why did the Puritans, notorious for their rejection of any visual art form that was religious in nature, memorialize their dead in this way?

One challenge to understanding colonial gravestones is that so many grave-

stone carvers remain little known, despite the fact that about 300 New England carvers' names or initials have been identified. There was, however, one Boston-area sculptor who is distinguished by how much we know about him. Joseph Lamson is one of about 15 late-seventeenth-century American stonecutters whose whole name we know, and there is more documentation of his work than most, especially in colonial probate records (accounts of estates made after death). Lamson, who was born in 1658, had a career that spanned four decades. He inaugurated a stonecutting dynasty; more than three generations of Lamson sculptors succeeded him, producing grave markers well into the nineteenth century. Stones by Joseph Lamson are found primarily around Boston, but are also located as far north as North Andover, Massachusetts, and as far south as Connecticut. Lamson's hand is distinctive and easy to identify. Not only did he perfect many commonly used motifs, he also was among the most inventive of colonial sculptors, introducing new themes, carving his forms more volumetrically, and creating beautifully integrated designs. A prime example of Lamson's work is the headstone of Reverend Jonathan Pierpont, c. 1709. In the stone's tympanum (the rounded top portion) is the standard winged death's head, but on the sides are portraits of Pierpont, believed to be among the first sculpted portraits in British America, atop beautifully carved borders of abstract vegetal designs. Art historian Allan I. Ludwig, one of the foremost authorities on colonial grave markers, describes it as "one of the finest stones in New England."[1]

Joseph Lamson

Joseph Lamson was born in Ipswich, Massachusetts, in August 1658 to William and Sarah Ayres Lamson. His father, who was born in England and settled in Ipswich in 1637, was a farmer who also worked as a surveyor and held other civic posts. He died when Joseph, the second youngest of eight children, was under fifteen months old. Joseph's mother soon remarried, though there is evidence that her children were put out to live with other families. Joseph's earliest recorded job was as a mariner. He shipped out in 1675 with a Captain Turner as part of a Connecticut River expedition during King Philip's War of 1675–76 (see Chapter 2). In 1678 Lamson settled in Malden, Massachusetts, and shortly thereafter married Elizabeth Mitchell. Together they had eight children; six survived childhood. Scholars speculate that he may have studied stone carving with the Old Stonecarver, an anonymous sculptor also known as the Charlestown Carver or the Boston Stonecutter whose work dates from either 1672–83 or 1653–95 (depending on the historian you choose to believe). The Old Stonecarver's grave markers are distinguished by death's heads with large craniums and highly arched eyebrows that merge with the line of the nose and terminate in small upturned hooks; the same kind of skull is found on Lamson's early stones. Lamson also worked as a surveyor like his father and produced stonework such as slate tiles for roofs in his capacity as a stonecutter. The large number of gravestones attributed to Lamson suggests that this was his primary business. Lam-

son stones are found not only in Charlestown, Malden, and Boston, but also in many other towns along the Charles River, including Revere, Concord, Wakefield, Cambridge, Woburn, and Marblehead. Attributions are based primarily on probate records and characteristic motifs, lettering, types of stone, distribution, and manners of carving.

Lamson's career, then, was that of a typical colonial craftsman or artisan. He underwent an apprenticeship, probably with the Old Stonecarver, established his own shop, and took on apprentices (including his sons Nathaniel and Caleb, who took control of the shop in 1712). He trained his apprentices as he had been trained in how to select the stone, which was usually harvested from rock outcroppings, how to shape the stone and then prepare the face by smoothing it with a harder stone or sand and water, how to sketch the design on the stone using a compass and dividers, and then how to work chisels, gouges, gimlets and steel points to carve the stone. Gravestone carving was not considered a fine art, and Lamson did not describe himself as a sculptor. In contemporary records he is referred to simply as Joseph Lamson, stonecutter. As noted in earlier chapters, visual artists in early colonial society were accorded no more status than others who worked with their hands. Socially they were the equals of craftsmen such as masons and shoemakers. Joseph Lamson's brothers held social positions similar to his; one was a brick maker (Samuel, 1649–92), another a seaman (Nathaniel, 1656–1722).

That Lamson had an active and successful business is indicated by the number of times his name appears in probate records. These documents also reveal what little we know about ordering gravestones. Stones were very rarely in place at the funeral, which typically occurred three to eight days after a death. Most were erected a few months or even years later. Generally patrons selected a precut or "stock" stone awaiting only the inscription. It appears that only significant or wealthy individuals, such as John Foster and Jonathan Pierpont, had personalized imagery; the vast majority of Lamson stones have more generic forms that could be used for anyone. Understanding the forms Lamson used, however, and the significance and complexity of his work, demands an investigation of Puritan attitudes toward death, for as gravestone specialists Dickran and Ann Tashjian assert, we must scrutinize Lamson's work within "the intangible network of ideas, attitudes, and values that brought it into being."[2]

Puritan Attitudes toward Death

The Puritans have long been perceived as a gloomy people overly concerned with death. There are several reasons for this view. First, the Puritans carried with them from England a highly developed death culture that was in many ways quite medieval in perspective. For example, medieval tombs often stress the horrifying physical changes wrought by death with life-sized stone effigies of decayed and vermin-infested flesh. During the seventeenth century, London was beset by periods of starvation, the bubonic plague, and other epidemics.

Understandably, English death culture maintained the medieval obsession with death's more gruesome aspects and the skeleton remained a common motif on English tombs. Second, death was equally present in the Bay Colony. The struggle to cultivate the wilderness, to overcome food shortages and the contamination of food and water, the conflicts with Native Americans, and epidemics of diphtheria, small pox, influenza, and pneumonia ravaged the population, resulting in a high death rate (although much lower than earlier English settlements at Jamestown and Plymouth). As noted in Chapter 2, King Philip's War of 1675–76 decimated New England's colonists; of white settlers alone a greater proportion died than in any subsequent American war. The year after the war ended a smallpox epidemic in Boston killed one-fifth of the town's population. The frequent tolling of church bells for funerals became such a nuisance that laws were passed to regulate it.

A third reason for the Puritans' reputation as death-obsessed is extant sermons and other writings that appear to relish in the horrors of death. Of Cotton Mather's 200 published sermons, 45 address death and dying. Jonathan Edwards, an early-eighteenth-century minister, wrote,

> Death temporal is a shadow of eternal death. The agonies, the pains, the groans and gasps of death, the pale, horrid, ghastly appearance of the corps, its being laid in a dark and silent grave, there putrefying and rotting and becoming exceedingly loathsome and being eaten by worms is an image of hell. And the body's continuing in the grave, and never rising more in this world is to shadow forth the eternity of the misery of hell.[3]

Clearly, Edwards's view of death was something to be feared. But one must understand the context within which he spoke. His words were a warning for those who had not committed to seek salvation. Those who sought God's grace would avoid such a horrifying eternal death, but only if they were among the elect. The notion of the elect, based on the doctrine of predestination—God's selection of few individuals to be saved—meant that conceptualizing death was an activity fraught with tension because one did not know the fate of one's soul until death. Puritan theology denied any assurance of salvation. God decided one's fate at the time of creation and His will was inscrutable and uninfluenced by earthly behavior (although one must still seek salvation with good deeds and a disciplined life).

More than any other factor, the belief in predestination shaped the Puritan approach to death. Beginning in childhood, Puritans were inundated with fearsome sermons and writing—including schoolbooks—about their wickedness and depravity and the terrors of hell. The *New England Primer* taught the alphabet with rhymes such as "T–*Time* cuts down all / Both great and small," accompanied by an illustration of a skeleton holding an hourglass and scythe, and "Y–*Youth* forward slips / Death soonest nips." Jonathan Edwards, speaking to his congregation's young, stated, "I know you will die in a little time, some sooner than others. 'Tis not likely you will all live to grow up."[4] In adulthood, Puritans feared eternal damnation for each sin, endlessly sought signs of God's favor, and often suffered bitter torment in the face of death. Add to this the Puritan belief

in the imminence of the Apocalypse and the Last Judgment and it is no wonder that death became such a presence in Puritan life.

Yet as Christians, the Puritans also viewed death as a much-desired release from the trials of earthly life. Edwards's gruesome view of death was considered fit punishment for the wicked, but most writings concentrated equally on death's spiritual joys. The two perspectives were difficult to reconcile and confusion about death permeated Puritan society. As Puritan historian David E. Stannard aptly remarks, "The ambivalence inherent in such a dual concept, that death is in a sense both punishment and reward, is evident in virtually every Puritan funeral sermon or other discourse on the subject."[5]

These concerns were worked through visually in the tombstones. Ann and Dickran Tashjian describe the graveyard as a space for discourse between this world and the next rather than a final resting-place.[6] Gravestone imagery was the idiom of this discourse. The ambiguity of death as both a circumstance to be feared and also a necessary initiation into the rewards of heaven—and the complex theological questions this raised—perplexed many Puritans. As we shall see, Lamson's stones often combine images that reflect upon the grim reality of death *and* acknowledge the glories of heaven. This duality characterized gravestone iconography prior to about 1730.

A fourth reason for the persistent view of Puritans as preoccupied with death is more recent—the writings of American author Nathaniel Hawthorne, who published novels and short stories in the mid-nineteenth century that focused on Puritan New England. As a descendant of Puritan settlers, Hawthorne was fascinated with what he regarded as their gloomy mindset. In *The Scarlet Letter* (1850) and *The House of the Seven Gables* (1851), Hawthorne depicted the Puritans as a supremely dour, repressed, and guilt-ridden people. For many years, Hawthorne's view of the Puritans was considered historical fact rather than creative fiction, causing the well-known twentieth-century curmudgeon H. L. Mencken to describe Puritanism as "the haunting fear that someone, somewhere, may be happy."[7] Hawthorne chose not to emphasize the contentment of merchants like the Freakes, probably because a more melancholy perspective was consistent with how the nineteenth-century Romantics wished to view the Puritans.

As the impact of Hawthorne's writings on current perceptions of the Puritans suggests, we must also scrutinize our own society's view of death. In twenty-first-century Western culture, death is resolutely not a part of life; in fact, death is often hidden. We no longer die at home but in the hospital. Distinctive mourning dress and periods of public bereavement no longer exist. In the last century, more often than not, grave markers are simple, homogeneous, and nondescript compared to those of the Puritan era. Thus the Puritan focus on death seems aberrant to us. A statement made about the English Victorians of the nineteenth century, a culture also considered to be death-obsessed because of their elaborate mourning rituals and extravagant grave markers, could apply to the Puritans as well: they treated death the way we treat sex, and vice versa. While sex is so present in contemporary society, death is not. Conversely, in the Puritan era, discussion of sex was taboo, while pondering death was a community pas-

time. Stannard notes that the Puritans "faced death with an intensity virtually unknown in modern American life."[8]

As Stannard's statement indicates, Hawthorne's writings and the modern aversion to death have not completely skewed our perception of the Puritan engagement with death. The artifacts that remain do reveal a highly developed funereal culture. In addition to the grave markers, mourning rings passed out by wealthy families to commemorate the deceased still exist, carved with the same motifs that appear on the gravestones. So do mourning gloves, which were sent as invitations to funerals; Puritan minister Andrew Eliott collected over three thousand pairs during his lifetime. Broadsides, poster-like prints with an elegy for the deceased surrounded by pictures of skeletons, coffins, and crossbones, reveal the effort to commemorate the dead and the disruption to the community created by death.

The richly carved gravestones, the distinctive mourning dress, and the decorated broadsides must have had a profound impact on New England's Puritans, a community with a dearth of visual imagery. Gravestones were intended to memorialize the dead, but their imagery was primarily for the living and served a didactic function: to teach a lesson about death visually rather than textually or verbally. A shared system of signs recognizable to visitors who frequented the graveyard (as many did because of the high death rate) communicated messages of both hope and fear.

Zechariah Long Stone, c. 1688

Joseph Lamson's career as a stonecutter was well established by 1688, when he carved the Zechariah Long grave marker in the Phipps Street Burial Ground in Charlestown. It is a wonderful example of Lamson's capabilities at the time, and typical of the motifs he favored, including the ubiquitous winged skull and hourglass, the exuberant organic side panels and the curious winged imps—iconography that has puzzled and intrigued scholars. Although awkward in places (especially the spacing of the words, which may have been inscribed by an apprentice), the Long stone exemplifies Lamson's strengths as a designer and a carver. It is modest in size, about twenty-two inches high and eighteen inches wide, and rectangular in shape, resembling a doorway. The doorway reference is reinforced by the frame around the inscription, a Lamson trademark. The carving is quite linear; the forms are defined by lines rather than rounded out. The Long stone is low relief rather than high relief; the forms are flat and do not project strongly from the back slab. Low relief carving is typical on early Massachusetts gravestones, in part because they are made of slate, a hard, dark stone that is difficult to carve but long lasting and plentiful in New England (unlike marble and granite, the materials favored for later gravestones, which had yet to be quarried in any quantity in America).

The doorway reference is deliberate and reflects the Puritan view of death as a time of transition, a shift from the mundane and material concerns of life to a

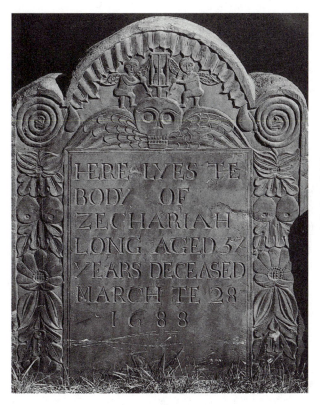

Joseph Lamson, Zechariah Long stone, c. 1688. Slate (21¾ × 18½ inches). Courtesy of Gary Collison, from the Daniel and Jessie Lie Farber Collection of Photographs.

loftier spiritual realm. Puritans believed that while their bodies remained in the grave until the Last Judgment, the souls of the elect underwent a transformation. They entered a blissful period of rest, where, as John Calvin wrote, "they await with joy the fruition of their promised glory; and thus all things remain in suspense until Jesus Christ appears as the Redeemer."[9] Then, after the Last Judgment, their souls are reunited with their bodies in heaven. Yet perceptions of the soul's state after death became increasingly ambiguous at this time as theologians debated whether the soul actually waited until Judgment or went to heaven immediately. Regardless, some sort of transition took place, hence the door shape. Like the Long stone, most Puritan gravestones are taller than they are wide and have a rounded top, called a tympanum after the carved stone half-circle over medieval church doors, and side panels that resemble supporting door posts. Some gravestones make even more direct references to doorways with architectural motifs such as columns, arches, and triangular pediments instead of rounded tympana. The implication is, of course, that one is moving from one place to the next; the doorway is a gateway to another world. Puritan minister William Perkins wrote that death was "a little wicket or doore whereby we pass out of this world and enter into heaven."[10] Often inscriptions on the gravestones use the words "translated" or "exchanged worlds" rather than "died" before the date of death. Lamson's stones explicitly state that it is the body that rests beneath the stone;

the inscriptions "Here lies the Body" or "Here Lyes Buried the Body" indicate that the deceased's immortal portion—the soul—has gone elsewhere.

A second theme that is found repeatedly on tombstones is references to the fleeting nature of time. Note that Lamson placed an hourglass, one of the earliest motifs to appear on colonial gravestones, in a place of priority at the top of the tympanum. This emphasis on the temporal reflected the Puritan view that earthly life is but a momentary state and death inevitable. The most common inscriptions on Puritan gravestones prior to about 1710 are the Latin "fugit hora" (time flies) and "memento mori," which translated means "remember death" but also refers to the popular epitaph, "As you are now, so once was I; as I am now you soon shall be. Remember death and follow me." Clearly, such a message was addressed to the living, warning of the certainty of death and encouraging them to keep it ever-present in their minds.

Throughout his career Lamson utilized the most common motif, the winged death's head, yet as Ludwig suggests, Lamson perfected it.[11] The skull, of course, was a traditional medieval emblem signifying death. It symbolized the mortal remains and also had a memento mori implication. Cotton Mather, in his book *Death Made Easie & Happy,* encouraged the reader to remind himself each day "that he is to die shortly. Let us look upon everything as a sort of Death's-Head set before us, with a *memento mortis* written upon it."[12] Yet attaching wings to the skull, as on the Long stone, emphasized the changes wrought through death. It suggested the soul's transformation when freed from the prison of the body, and may have symbolized the liminal state after death but before Judgment. The Tashjians describe the winged death's head as "a Christian symbol of physical death and spiritual resurrection that was equally affirmative and horrific"—signifying mortal and decaying remains, but ultimately symbolizing the rejoining of the mortal and the spiritual at Judgment Day.[13] Thus the winged death's head affirmed the dual nature of the Puritan view of death.

The winged death's head on the Long stone resembles those carved by the Old Stonecarver in the swooping, connected eyebrows and the square, uniform teeth. The wings' feathers seem to grow from the teeth, replicating their neatly regimented rows. The consistency of the stone's design is evident in the way the wings' sweeping rhythm is echoed in the organic design below. The side panels' imagery includes abstracted leaves and flowers and round shapes just above the midpoint of the stone that look surprisingly like women's breasts. A common motif on colonial gravestones, some scholars suggest that these are in fact breasts and therefore evidence of a surprising erotic element that perhaps referred to contemporaneous sermons that likened the scriptures, the church, and its ministers to divine milk sent to nourish the soul. More likely, considering the organic forms around them, they are gourds, which symbolized resurrection because God gave a gourd to Jonah, who Christians believe prefigured Christ's time in the tomb with his three days in the belly of the whale. Iconographically, plants also refer to the transience of life in that they last but a short time on earth. The Book of Job, 14:1–2 reads, "Man that is born of woman is of few days and full of trouble. He cometh forth like a flower and is cut down." Yet plants also de-

noted spiritual renewal because they are reborn again each spring. Like the winged death's head, then, Lamson's foliated jambs can be read two ways: as symbols of life's transience and as symbols of rebirth, again emphasizing the duality of Puritan attitudes toward death. The swirls at the top of the jambs, which were also part of the standard design repertory of colonial carvers, reinforce this, for they probably represent the constant change and motion of the cosmos and, placed on either side of the winged death's head, indicated the soul's nebulous state prior to the Last Judgment.

The most original motif on the Long stone consists of small naked men with wings that appear in the tympanum beneath a ruffled curtain-like form, another Lamson trademark. These have been called winged "imps of death"; despite the wings, they are not chubby and sweet looking and therefore do not resemble cherubs. Lamson used this theme repeatedly. Gravestone scholar Ralph Tucker, in his exhaustive study of the Lamson family, lists thirty imp stones carved by Joseph that cluster primarily in Charlestown and Cambridge.[14] On most Lamson stones the imps aid in the death process by carrying funeral palls, lowering the coffin into the grave, or holding an hourglass. The imps on the Long stone are more aggressive. They hold arrows and appear to stab at the top of the skull. Tucker describes them as "head punchers." Such "darts of death" or arrows appeared in contemporary religious literature, including a poem written by Puritan minister Edward Taylor:

Oh! Good, Good, Good, my Lord. What more I Love yet.
Thou Dy for mee! What, am I dead in thee?
What did Deaths arrows shot at me thee hit?
Didst slip between that flying shaft and mee?
Didst make thyselfe Deaths marke shot at for mee?
So that her Shaft shall flying no far than thee?[15]

Here, Christ accepts the blows of the arrows of death so that the believer will live eternally. Thus, while the Long stone's scowling skull and belligerent imps were a clear reminder of death's fearsome nature, the darts also referenced Christ's sacrifice that granted the elect eternal life.

Much of the iconography found on colonial gravestones was borrowed from print sources, such as broadsides and, more importantly, English emblem books. Emblem books are repositories of symbols that combine engraved images with descriptions of their meaning. Gravestone iconography based on emblem book imagery can be simple, like the hourglass, or quite complex. For John Foster's tombstone, illustrated in Chapter 2, a sculptor believed to have been the Old Stonecarver borrowed an image from a 1638 emblem book by Frances Quarles titled *Hieroglyphiques of the Life of Man*. Here, Father Time with his scythe and hourglass attempts to stop death, represented as a skeleton, from snuffing a lighted candle that symbolizes the life force. Below the image is a poem that describes time and death as partners. Together they reinforce the theme that earthly life is transient and death a certainty. Emblem books were a crucial resource for

American carvers and evidence of the direct transmission of sophisticated iconography from the mother country to the colonies. Gravestone historian Lauren Gabel has traced other motifs, including Lamson's imps, to needlework, indicating that carvers sought sources in popular art forms as well.[16]

As revealing as the motifs that appear with frequency on Puritan gravestones are the images that do not appear. There are no depictions of the cross, Christ, or Mary, and only a few motifs that might represent God, such as a hand reaching through clouds, due to Puritan intolerance of religious subject matter in art. Despite this, as we have seen, the stones repeatedly reference spiritual concerns. Why then were they exempt from iconoclasm? This thorny issue has been the subject of much debate among scholars. Allan Ludwig writes of the Puritans' burning need for imagery when faced with the frightening prospect of death. Confronting death in a new and unfamiliar place, they turned to the visual arts for comfort and emotional release, an urge so powerful that it negated their fear of idolatry, thereby distinguishing American Puritans from their English counterparts.[17] More convincing is the Tashjians' argument that the Puritans considered all death practices, including the creation of richly decorated tombstones, in the civil rather than the religious realm.[18] Funerals, for example, were not organized or presided over by ministers, for they were civic functions. If death imagery was not related to the ecclesiastical, it could not be tainted with idolatry. Unlike crosses and images of Christ, forms such as death's heads, hourglasses, and scythes were considered secular. They had replaced religious imagery on English grave markers in the 1560s, after a period of intense iconoclasm that included the destruction of many tomb sculptures considered too reminiscent of Catholic art. Naturally, the decoration of New England Puritan gravestones followed suit.

Scholar Lucien L. Agosta approaches this question from another perspective. Puritans were comfortable with sculpted gravestone imagery, Agosta argues, because of their familiarity with images in emblem books like Quarles's *Hieroglyphiques of the Life of Man*. They accepted this convention on their tombstones because, like emblems, the stones were teaching tools intended to help Puritans follow the right path.[19] Other scholars have also suggested that gravestones were exempt from iconoclasm because they commemorated the dead and were didactic. Like portraiture, then, gravestones are evidence of Puritan "functionalism" in the arts, the Calvinist view that art was acceptable as long as it worked in service to mankind, teaching truths essential to salvation—a task certainly fulfilled by Puritan gravestone iconography.

Jonathan Pierpont Stone, c. 1709

The Jonathan Pierpont stone is Lamson's masterpiece. Reverend Pierpont died in 1709, so Lamson carved this stone close to the end of his career, a few years before turning over his shop to his sons. At 30 inches by 27 inches, it is larger than the Long stone and far more elaborately carved. It stands today in its orig-

inal location in a Wakefield, Massachusetts, burial ground. Again, the unity of the composition is worth noting. The winged death's head fills the tympanum below an abstracted floral shape, but does not dominate as in the Long stone because of the richness and complexity of the total design. Beneath the death's head the inscriptions "MEMENTO MORI" and "FUGIT HORA" flank four wingless imps holding funeral palls arranged symmetrically around an hourglass. Portraits of Pierpont appear at the top of the side panels, surmounting elaborately carved floral motifs that echo the scalloped feathers of the wings and the frame around the inscription, drawing the composition together. Other unifying shapes include the repeated round forms of the skull's eyes and the rosettes at the sides and bottom.

The Pierpont stone's carving is deeper and more volumetric than that of the Long stone, creating light/dark contrasts that enliven the design. Pierpont's portraits reveal a new naturalism. The eyes are placed within sockets, the noses appear to project because of depressions carved beneath them, the cheeks swell slightly, and the lips are formed of two lines and seem positioned to speak. Here Lamson evolved from the two-dimensional conception of the face evident on his earlier stones to a more sculptural, three-dimensional conception. Ludwig writes that over the course of his career "Lamson had in effect relived part of the movement of Western art from abstraction to naturalism."[20]

Lamson first carved faces on the top of foliated side panels in the 1680s, al-

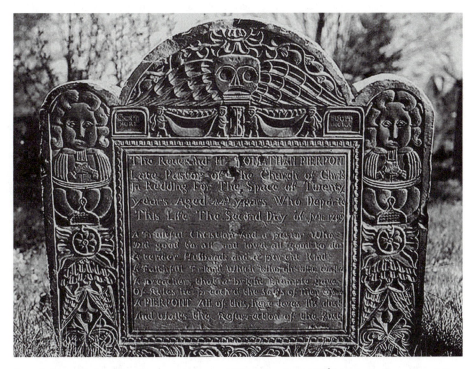

Joseph Lamson, Jonathan Pierpont stone, c. 1709. Slate (30 × 27$\frac{1}{4}$ inches). Courtesy of Gary Collison, from the Daniel and Jessie Lie Farber Collection of Photographs.

though these are believed to be anonymous "soul effigies," not images of the deceased (faces found on women's stones, for example, are male). Pierpont's images are not generic figures but portraits, including not only the face as in the earlier Lamson soul effigies but also the upper body in ecclesiastical dress, with hands clutching a small Bible, identifying the figure as a minister. Although not especially individualized, these are thought to be the first sculpted portraits created in British America. Ludwig aptly stresses Lamson's "inventive carver's mind" that, unlike earlier sculptors, "did not depend so blindly on printed sources for material." Lamson, therefore, was "the first [American] carver who actually created what may be called a 'localism' or true provincial variant of the English manner."[21] The conceptual significance of Lamson's move away from English prototypes cannot be overemphasized.

The portraits also reveal Lamson's iconographic sophistication. Pierpont was the minister of a Congregational church in Reading, Massachusetts. Cotton Mather described him somewhat curiously as "a painful, faithful useful and humble minister."[22] David H. Watters considers Lamson's presentation of Pierpont at the top of architecturally-influenced side panels a reference to the Puritan belief that ministers were "pillars" of the church, and ultimately, of the Temple that would arise in the New Jerusalem after the Last Judgment. Many expected the Temple of the New Jerusalem "literally to descend to earth to be peopled by resurrected 'pillars'" such as Pierpont.[23] The side panels' lush plants may refer to the Garden of Eden, thought to be a prototype for the New Jerusalem. Such associations, though lost to us today, would have been understood by viewers raised with Puritan convictions. The death of a Puritan minister was a severe disruption, often described as the loss of a pillar of the community. In a 1684 sermon, Reverend Samuel Willard spoke of the recent death of several ministers, "When the Pillars are gone, how shall the building stand?"[24] As the Puritan world shrank in the face of worldliness and liberalism, the death of pillars such as Pierpont increased the sense of threat from the outside world and devastated the homogeneous community that the Puritans had hoped to build.

The inscription on Pierpont's stone augments these themes and is evidence of the growing complexity of epitaphs in the eighteenth century. It reads:

> A Fruitful Christian, And a pastor Who
> Did good to all, and lov'd all good to do:
> A tender Husband; and a parent Kind:
> A Faithful Friend, Which Who oh! Who can find
> A preacher, that a bright Example gave
> Of Rules he preach'd, the Souls of Men to save
> A PIERPONT All of this, here leves his dust
> And Waits the Resurrection of the Just.[25]

Stannard writes that "the somber, mundane, but carefully wrought and tended gravestones and burial grounds were the product of a culture that was acutely conscious of the precariousness of its very existence and that was shaken to its

core with the death of each and every one of its supporting members."[26] The Pierpont stone asserted this minister's crucial position in the Puritan community and assured the faithful that he would rejoin his congregation after "the Resurrection of the Just." The placement of the portraits on the side panels suggests that in the millennial world that followed, he would play a similar role as a pillar of the Temple of the New Jerusalem. Therefore, the Pierpont stone, which was probably commissioned by Pierpont's congregation, acted as an icon of sorts, commemorating a beloved leader yet also inspiring future generations to halt the perceived spiritual decline.

John Fowle Stone, c. 1711

Another of Lamson's late works, the John Fowle stone of c. 1711, deserves mention for it is a very different visual conception with imagery that signals shifting perceptions of death in the early eighteenth century. Lamson moved the inscription to the lower quarter of the stone, replacing it with an elaborate coat of arms depicting a rampant lion between three roses. Coats of arms appear frequently on colonial stones to assert the deceased's status. Surrounding the lion is a vivid, fantastical border of stylized leaf forms that undulate like the flames of a fire. Similar shapes mark the frame around the coat of arms, and this exuberant rhythm is carried through in the foliated side panels and the tympanum surrounding a cherub. Such elaborate curving forms are reminiscent of the Baroque style then fashionable in Europe, unlike the more straightforward carving of most of Lamson's work. John Fowle was a militia captain who died at the age of 74, leaving his family wealthy enough to afford this lavish gravestone, which stands today in Phipps Street Burial Ground in Charlestown.

The cherub is an even better demonstration of Lamson's ability to carve a face in three dimensions. Here the eyes are more successfully set into the skull and the lower half of the face—the lips, cheeks, and chin—have a roundness that is most convincing. Much of the rest of the stone maintains Lamson's linear manner, particularly the undulating lines of the organic forms and the cherub's wings, although the coat of arms projects strongly from its rough, undressed background.

The appearance of a cherub in the place typically reserved for a winged death's head suggests changes in attitudes toward death. As the eighteenth century progressed, the death's head and other grim imagery such as crossbones, scythes, and imps of death, increasingly shared New England's burial yards with more optimistic imagery. Clearly, a cherub had different implications than a skull. While the skull was a reminder of the deceased's mortal remains and the winged skull the time of transition before the resurrection, the cherub may have represented the deceased's soul winging its way directly to heaven, as suggested by the contrast between the cherub's upturned wings and the death's head's downturned wings. A much later stone, that of Betsey Shaw, c. 1795, in Plymouth, Massachusetts, shows a brick tomb from which rises a cherub

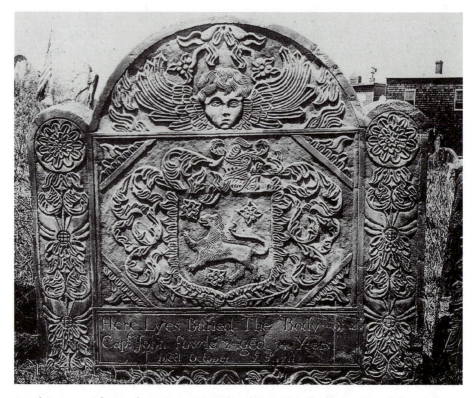

Joseph Lamson, John Fowle stone, c. 1711. Slate (29 × 29 inches). Courtesy of Gary Collison, from the Daniel and Jessie Lie Farber Collection of Photographs.

just unfolding its wings for the flight. Here, the earlier ambiguity about the state of the soul after death seems cheerfully resolved.

The cherub form has a complex history in Western iconography. In the Bible, cherubs guard Eden and the Ark of the Covenant. Visually, the form evolved from the cupids, or *putti,* of Ancient Greece and Rome and later became popular in the Renaissance because of its classical associations. According to an English dictionary of 1661, cherubs were "images of men with wings and comely faces."[27] Puritans believed that cherubs were the only type of angel visible to man and that they helped guide the soul to heaven, suggesting that the cherubs on eighteenth-century gravestones could represent either the deceased's soul or the cherub who guided it to heaven, further confusing matters. Several Lamson stones, probably carved by Joseph or Nathaniel around 1713, have small cherubs above winged death's heads, suggesting that they were considered distinct entities. Tucker notes that "the ambivalence in the religious thinking of the day is wonderfully apparent in such cases."[28]

Regardless, the growing use of cherubs on colonial gravestones implies less fear of death and a new belief in the assurance of salvation. Some scholars speculate that the cherubs were the result of a gradual "enfleshment" of the death's

head, evolving from the stark, bony skull of earlier stones to an increasingly plump skull that occasionally appears to be smiling to the fully fleshed, round-cheeked cherub. Such a progression is complicated, however, by cherubs like that on the Fowle stone that emerge quite early in the century, and death's heads that appear quite late (Lamson's grandsons continued to carve death's heads well past the 1780s). Further, it is difficult to confirm such an evolution chronologically because the dates on the stones are not always reliable indicators of when they were carved. Depending on the family's finances and other factors, a stone could be carved several weeks or several years after a death (hence the dating here of Lamson's stones as *circa* dates).

Scholars connect the appearance of cherubs on New England grave markers to religious changes that culminated in the Great Awakening of the 1720s through the 1740s. The Great Awakening was a Protestant movement, but one that departed in many ways from the strict Puritanism of earlier generations. A complex phenomenon, it has been termed an "evangelical Calvinism" that placed greater emphasis on emotion, dramatic "born again" conversions, and mass religious revival meetings lead by dynamic preachers. Some consider the Great Awakening a reaction against the formality of Puritanism and the intimidating doctrine of predestination. It is also regarded as the final stage of deterioration of Puritan culture. Adults rejected the concept of the elect for the more comforting belief that through one's deeds one could earn salvation. Children were encouraged to no longer fear death but instead view it as a longed-for reunion with God in heaven. Funeral sermons and other writings de-emphasized death's fearsome nature and embraced it as a joyful change. The earlier tension created by predestination dissipated, replaced by optimism about salvation and the soul's direct access to heaven. On gravestones and in writings, visions of immortality increasingly superceded visions of the body moldering in the grave for eternity. In addition to the change in imagery, the phrases "fugit hora" and "memento mori" gave way to hopeful epitaphs, such as:

> Here cease thy tears, suppress thy fruitless mourn
> His soul—the immortal part—has upward flown
> On wings he soars his rapid way
> To yon bright regions of eternal day.[29]

The Hannah Goodwin stone, of Plymouth, Massachusetts, c. 1777, which includes a cherub in the tympanum, is even more direct:

> The Soul prepar'd Needs no delays
> The Summons comes the Saint [the deceased] obeys
> Swift was Her flight & short the Road
> She closed Her Eyes & saw Her God.[30]

The cherub's early appearance on the Fowle stone suggests that Lamson was on the cutting edge of religious and cultural change. Although he stopped carving gravestones the decade before the Great Awakening began, new ideas were

in the air as early as 1711. His sons, grandsons, and great-grandsons would continue his work, responding with a wider range of uplifting motifs. Historian Peter Benes notes that between 1725 and 1766 cherubs appeared more frequently on Lamson stones for the wealthy, like John Fowle, as if money assured salvation.[31] Today Lamson family stones are found as far north as Nova Scotia and as far south as South Carolina and Barbados (it was common to ship stones, and there was a wharf near the Lamson shop). Joseph Lamson died on August 27, 1722, at the age of 64. His simple gravestone, carved by one of his sons with a winged death's head in the tympanum and stylized acanthus leaves in the jambs, stands today in a Charlestown burial yard.

Colonial Gravestones Today

Those who purchased gravestones from the Lamsons and even the Lamsons themselves did not consider them works of art as we understand the phrase today. Instead, as we have seen, they were commemorative and didactic tools. Historically, the stones were not treated like works of art either. In the eighteenth century, inscriptions were often smoothed over, and new inscriptions carved in their places, an example, Harriette Forbes notes, of the "economical habit" of colonial Americans.[32] Puritan stones were neglected as Puritanism waned and burial sites—especially those in the inner cities—became more and more crowded. New coffins were placed on top of the old, and sometimes coffins and the bones they contained were disinterred and discarded. Gravestones were moved, placed in tight, overlapping rows, or destroyed. This decline continued with the introduction of the Rural Cemetery Movement in the 1830s, in which large, park-like burial grounds were established at the edges of most large and mid-sized urban areas. The word *cemetery,* Greek for "sleeping place," was first widely used in the nineteenth century and typifies the beautification of death Romanticism encouraged.

In the late nineteenth century, with the colonial revival that followed the 1876 centennial celebration, American historians first realized the incredibly rich resource awaiting them in the hundreds of burial grounds of New England. Interest grew in the 1920s, due in part to the country's artistic isolation and nationalism in the period between the two world wars, which fueled interest in indigenous art forms. Harriette Forbes, beginning in the 1890s, was among the first to photograph the stones that remained and attempt to categorize the motifs and the artists, including Lawson, resulting in her groundbreaking 1927 study, *The Gravestones of Early New England and the Men Who Made Them.* After this, the practice of gravestone rubbing to preserve the designs became a popular amateur pastime, but the scholarly study of colonial gravestones did not advance, as many perceived the stones as a quaint, low art form with little meaning. Allan Ludwig roundly refuted this view in his sweeping 1966 study, *Graven Images: New England Stonecarving and Its Symbols, 1650–1815.* Ludwig placed the stones within a broad historical context, focusing particularly on their iconog-

raphy. Subsequent studies by Dickran and Ann Tashjian, *Memorials for Children of Change: The Art of New England Stonecarving,* 1974, and Peter Benes, *Masks of Orthodoxy: Folk Gravestone Carving in Plymouth County, Massachusetts, 1689–1805,* 1977, further defined the motifs, the makers, and the rationale behind the stones, and complemented new sociological studies on Puritan attitudes toward death by David E. Stannard and Gordon Geddes. Out of broad treatments like these emerged more recent studies focusing on specific carvers and imagery. In the 1970s gravestone scholars first joined together to present public symposia on gravestones. In 1980, the Association for Gravestone Studies began to publish *Markers,* an annual scholarly journal dedicated to funerary sculpture and cemeteries. Today, gravestones and cemeteries are the subject of intense investigation by scholars in a range of disciplines, including art history, history, sociology, ethnography, archaeology, and anthropology.

The continued decay of colonial gravestones is of concern to scholars who study them. Natural weathering is to be expected (although this has accelerated in recent decades due to pollution), but because most sit on public ground that is often difficult to protect, vandalism is frequent. Gravestone theft is commonplace, with stones disappearing from burial yards only to reappear in disreputable antique stores. Occasionally important stones at great risk are removed from the burial yards and placed in museums, such as the John Foster stone now on view at the Museum of Fine Arts, Boston. But it is rare for cities to take such action, despite the importance of preserving gravestones as part of our cultural heritage. Local historical societies and preservationists often provide effective grassroots protection and restoration projects, however.

Perhaps the struggle to preserve gravestones reflects the traditional secondary status of sculpture in America. While painting developed at a rapid pace in the eighteenth century, sculpture continued to lag behind. Not until after the Revolution did sculpture emerge as a fine art in America, and even then sculptors found it difficult to establish themselves as professionals in a country that showed little interest in the medium until well past the middle of the nineteenth century. Yet stonecutters like Lamson, while not considered fine artists by their contemporaries, did initiate an American sculpture tradition. Challenged to commemorate the dead, Lamson created works of art that helped the community process the ambiguity that surrounded death in Puritan culture. He also left a tremendous visual legacy for those of us fascinated by the workings of the Puritan mind.

Notes

1. Ludwig, 313.
2. Tashjian and Tashjian, *Memorials for Children of Change,* xiv.
3. Quoted in Ludwig, 77–82.
4. Quoted in Stannard, 65–66.
5. Ibid., 77.
6. Tashjian and Tashjian, *Memorials for Children of Change,* 14.
7. Hall, 102.

8. Stannard, ix.
9. Quoted in Ibid., 99.
10. Quoted in Ibid., 76.
11. Ludwig, 305.
12. Quoted in Ibid., 77–78.
13. Tashjian and Tashjian, *Memorials for Children of Change,* 62.
14. Tucker, 151, 165.
15. Quoted in Ludwig, 100–107.
16. Gabel, "A Common Thread."
17. Ludwig, passim.
18. Tashjian and Tashjian, *Memorials for Children of Change,* passim, and Tashjian, "Puritan Attitudes Toward Iconoclasm," 43–45.
19. Agosta, 47–70.
20. Ludwig, 309.
21. Ibid., 300, 305.
22. Forbes, 47.
23. Watters, 197.
24. Quoted in Stannard, 130.
25. Quoted in Tashjian, *Memorials for Children of Change,* 242–43.
26. Stannard, 146.
27. Quoted in Tashjian, *Memorials for Children of Change,* 83.
28. Tucker, 185.
29. Quoted in Deetz, 99.
30. Quoted in Agosta, 53.
31. Benes, 50.
32. Forbes, 13.

Bibliography

Agosta, Lucien L. "Speaking Stones: New England Grave Carvings and the Emblematic Tradition." *Markers III: The Journal of the Association for Gravestone Studies* (1985): 47–70.

Benes, Peter. *Masks of Orthodoxy: Folk Gravestone Carving in Plymouth County, Massachusetts, 1689–1805.* Amherst: University of Massachusetts Press, 1977.

Chase, Theodore, and Laurel K. Gabel. "Headstones, Hatchments, and Heraldry, 1650–1850." *Gravestone Chronicles II.* Boston: New England Historic Genealogical Society, 1997.

Deetz, James. *In Small Things Forgotten: An Archaeology of Early American Life.* Rev. ed. New York: Doubleday, 1996.

Deetz, James F., and Edwin S. Dethlefson. "Death's Head, Cherub, Urn and Willow." In *Historical Archaeology: A Guide to Substantive and Theoretical Contributions,* edited by Robert F. Schuyler. Farmingdale, NY: Baywood, 1978.

Forbes, Harriette Merrifield. *The Gravestones of Early New England and the Men Who Made Them.* 1927. Reprint, New York: Da Capo Press, 1957.

Gabel, Laurel K. "A Common Thread: Needlework Samplers and American Gravestones." *Markers XIX: The Journal of the Association for Gravestone Studies.* (2002): 19–49.

Geddes, Gordon. *Welcome Joy: Death in Puritan New England.* Ann Arbor: UMI Research Press, 1981.

Hall, David. "Literacy, Religion, and the Plain Style." In vol. 2 of *New England Begins: The Seventeenth Century,* edited by Jonathan L. Fairbanks and Robert F. Trent. Exhibition Catalogue. Boston: Museum of Fine Arts, 1982.

Ludwig, Allan I. *Graven Images: New England Stonecarving and Its Symbols, 1650–1815.* Middletown, CT: Wesleyan University Press, 1966.

Seventeenth, Eighteenth, and Nineteenth Century Cape Cod Gravestones. "Lamson Carvers." http://www.capecodgravestones.com/carvers/lamson.

Stannard, David E. *The Puritan Way of Death: A Study in Religion, Culture, and Social Change.* New York: Oxford University Press, 1977.

Tashjian, Dickran. "Puritan Attitudes Toward Iconoclasm." In *Puritan Gravestone Art II,* edited by Peter Benes. Boston: Boston University, 1978.

Tashjian, Dickran, and Ann Tashjian. *Memorials for Children of Change: The Art of Early New England Stonecarving.* Middletown, CT: Wesleyan University Press, 1974.

Tucker, Ralph L. "The Lamson Family Gravestone Carvers of Charlestown and Malden, Massachusetts." *Markers X: The Journal of the Association for Gravestone Studies* (1993): 150–217.

Watters, David H. "A Priest to the Temple." In *Puritan Gravestone Art II,* edited by Peter Benes. Boston: Boston University, 1978.

CHAPTER 5

Justus Engelhardt Kühn (?–1717), Portrait Painter to a Colonial Aristocracy

Around 1710, German immigrant Justus Engelhardt Kühn painted a portrait of a young Maryland boy, Henry Darnall III, standing before a marble balustrade above a vast cultivated landscape and manor house (plate IV). He is dressed in an expensive yellow brocade coat, shoes with jeweled buckles, and a sweeping green velvet cloak. Such grandiose accoutrements indicate Darnall's wealth and status. This is also true of the African American who gazes with adoration at his young master. We immediately recognize him as a slave, not only because he is dark-skinned and positioned beneath Henry Darnall, but also because of the metal collar he wears, a symbol of servitude reminiscent of the shackles that constrained slaves during their voyage from Africa. Like fine clothing and extensive lands, human property was evidence of high station in early-eighteenth-century Maryland. Kühn's portrait is disturbing to twenty-first-century viewers because of the assumptions it makes about race and class. It raises questions that call for answers. Who was Henry Darnall and why was he painted in this manner? Who was the slave, and what does his inclusion in the portrait reveal about southern colonial society? And what do we know of Kühn, who created a portrait unlike anything produced in the colonies up until that time?

Justus Engelhardt Kühn was the first recorded professional portrait painter in the southern colonies, and in this portrait he painted the earliest known depiction of an African American in American art. Only about a dozen portraits attributed to Kühn survive, and four of those are surprisingly elaborate full-length portraits of children—surprising for colonial works of art of the early 1700s because of their compositional and iconographic sophistication.[1] The others are bust-length portraits of adults.[2] All of Kühn's portraits depict members of three related Catholic families who were among Maryland's first

families. Thus Kühn's work encourages consideration of Maryland's founding
and settlement to gain insight into his portraits' subjects, who were closely in-
volved with the colony's early history. Maryland's colonial experience is an in-
triguing contrast with that of colonial Massachusetts—a contrast that typifies
the distinctions between northern and southern colonization. While the En-
glish settled both areas, Massachusetts' Puritans had a unique religious moti-
vation that combined with economic and political ambitions in their attempt
to create a pure Protestant utopia very different from the country they left be-
hind. Maryland's settlers also sought religious freedom, for as Catholics they
too suffered persecution in England. In fact, Kühn's portraits of the Darnall
children offer intriguing visual evidence of their commitment to their faith.
But unlike the Puritans, they had no desire to transform society. The portraits'
aristocratic trappings indicate the Darnalls' wish to replicate the lifestyle that
they had enjoyed in the mother country.

The differences between northern and southern colonization extended to the
arts. While there is slight evidence that itinerant portrait painters worked in the
south before Kühn arrived, their names are unknown. Kühn is the earliest doc-
umented portrait painter in the south, producing his first extant works around
1710. Therefore, the development of painting in Maryland took place about fifty
years after the first portraits were painted in Massachusetts. The south's pattern
of settlement—large isolated plantations instead of urban centers—was not
conducive to the cultivation of the arts. Unlike Boston, even cities such as Anna-
polis, where Kühn settled, did not have a critical mass of wealthy patrons in-
terested in supporting the arts until after about 1730. Also, closer ties between
the southern colonies and England meant more frequent travel there. Wealthy
southerners may have sailed abroad to have their portraits painted by such lead-
ing English artists as Peter Lely and Godfrey Kneller.

As the portrait of Henry Darnall III suggests, the institution of slavery also
distinguished the southern and northern colonies. During the colonial period
there were slaves in the north, but the percentage of the population they com-
prised was much lower than in the south, where the landed gentry depended
on free labor for economic viability. Kühn's depiction of a slave encourages ex-
amination of the brutal conditions that made it permissible to paint an image
of a person with a metal collar around his neck. In the past thirty years art his-
torians have focused increasingly on the implications of race, gender, and class
in portraiture, suggesting new meanings that greatly enrich our understanding
of the works of art and their times. Kühn's image of Henry Darnall III and his
slave provides crucial information about the perception of African Americans
in southern colonial society. The portrait is, however, a white man's interpre-
tation of an African American and one intended to please a specific audience
of white patrons. In analyzing Kühn's work, we must be conscious of the dis-
tortions this creates. But precluding the discovery of accounts by early-eigh-
teenth-century slaves themselves, the portrait remains rare evidence of their
difficult circumstances.

Kühn and the Provincial Baroque Style

The first evidence of Kühn's existence in Maryland is an application for naturalization submitted at the Annapolis courthouse in December 1708. This does not mean that he arrived in 1708; in fact, most settlers applied for naturalization after living in the colonies for several years. Receiving approval for naturalization allowed Kühn to enjoy all the rights of native-born citizens, including selling and owning property. We know nothing of Kühn's earlier life in Europe. His application described him as a painter, a German, and a Protestant. Portraits Kühn painted that include text have characters in old-style German script. An example of this is his portrait of Ignatius Digges, which reads in Latin, "Anno Aetatis Suae 2 1/2 1710. J. E. Kühn Fecit" ("Age 2 1/2 1710. J. E. Kühn made this"). Some speculate that like so many others, Kühn was a religious refugee. In the late seventeenth and early eighteenth centuries, religious wars raged in the Rhine Valley and many Protestants fled to America.

An awareness of the radical changes taking place in the American colonies may also have motivated Kühn to immigrate. After 1700 British America underwent a staggering economic and demographic expansion. The population in 1775 was nine times that of 1700, growing from about 250,000 to over two million. Family per capita income rose half a percent each year. As stability increased and the settlers moved beyond concern with survival, there was mass immigration of members of the artisan class—carpenters, masons, bricklayers, silversmiths, and visual artists—who saw economic advantages in catering to a growing population's needs. Artisans like Kühn traveled not only from England but also from other countries in Europe, particularly Germany, Switzerland, Scotland, and Ireland.

Although the historical record concerning Kühn is frustratingly blank, we can tell quite a bit about his training based on his surviving portraits. Kühn's work is evidence of his familiarity with the Baroque style. The Baroque style dominated European art of the seventeenth century and had a particularly strong effect on portraiture. Kühn's paintings utilize Baroque portrait devices developed by Peter Paul Rubens and Anthony Van Dyck of Flanders (now Belgium) in the early- to mid-seventeenth century. As a German artist, Kühn probably knew their work, and like many less well-known northern European painters adopted their style because it was fashionable and therefore desired by patrons.

The Baroque portraits of Rubens and Van Dyck are known for their animation; the sitters communicate with the viewer through direct eye contact and lively expressions. Baroque portraits accentuate the sitter's wealth with careful attention to the details of fine fabric and jewelry, apparent here in Henry Darnall's brocade coat, silver buttons, and jeweled shoe buckles. This is a trait that the Baroque style shares with the Elizabethan-Jacobean style discussed in Chapter 3, but Baroque painting is distinguished from the earlier style by the fluid handling of the paint. Unlike the Freake Painter's meticulous brushstrokes, Kühn's work shows the artist's hand in the looser application of paint evident in

Henry's lace jabot and the soft feathering of his hair. Rich color also character-izes the Baroque style, notable here is the juxtaposition of the golden yellow of Henry's jacket, the red-orange tones of the curtain and the slave's jacket, and the cloak's deep green. Also apparent in the image are typically Baroque aggrandiz-ing elements, such as a great swag of drapery and an impressive architectural setting. When a landscape background is included in a Baroque portrait, as in Kühn's portraits of children, the sitter is often juxtaposed with a vast space; defin-ing deep three-dimensional space on a two-dimensional surface fascinated Baroque artists.

While Kühn's interpretation of the portrait style of Van Dyck and Rubens in-cludes all the trappings of the Baroque style, it also suggests a fairly naïve hand. A priority of Baroque artists was creating fully rounded bodies that exist in re-alistic-looking spaces. Kühn succeeded in indicating the three-dimensionality of Henry's body by modeling his clothing in light and dark. Darnall's face was sensitively handled, with a subtly shaded nose, the mouth carefully set into the face, and striking dark eyes. Yet Kühn lacked the technical skill to truly suggest a living presence, a priority of Baroque portraiture. Darnall's body does not have the relaxed fluidity that characterizes the style. Instead he appears stiff and doll-like, with details, such as the position of his feet, that indicate Kühn's difficulty with rendering the body in space. Instead of representing Henry realistically *in* a three-dimensional space he appears to be pasted *on* the space, as if it were a flat backdrop like those used by portrait photographers today. The lack of con-sistent perspective in the column's base at the right and the awkward rendering of the slave's right arm and shoulder provide further evidence of deficiency in Kühn's training. Thus Kühn's work might be described as a provincial variation of the Baroque style.

Despite these flaws, Kühn's portrait of Darnall, with its elaborate background and exhaustive detailing, remains the most complex extant composition at-tempted in the colonies up to that time. Henry appears to glow from within, due to the darker tones of the marble, the clouds, and the curtains around him. Kühn's careful framing of his subject reveals a professional's awareness of how to prioritize the sitter. Kühn's interpretation of the European grand manner, as this type of portrait is termed, must have satisfied his wealthy patrons, who saw themselves as members of a transplanted European gentry. As noted in Chapter 3, since the court of Charles I in the 1620s, Baroque was the style of the Eng-lish aristocracy. Kühn's introduction of grand manner portraiture to the colonies is an important step in the evolution of American art.

Settling Maryland

Perhaps Kühn chose to live in Maryland because his portrait style compli-mented the aristocratic pretensions of the colony's wealthiest settlers. The found-ing of Maryland was the result of a proprietorship granted to Cecilius Calvert, the second Lord Baltimore, by King Charles I in 1632. George Calvert, the first

Lord Baltimore and former Secretary of State for King James I, had visited the area in 1629 and thereafter petitioned for the grant, which went to his son when he passed away. This was the first grant of colonial land received by an English Catholic; Calvert named his property Maryland in honor of Charles's wife, the Catholic queen Henrietta Marie. Although Charles treated Catholics more sympathetically than most English monarchs since Henry VIII broke with Rome in the 1530s, they continued to suffer financial penalties for practicing their faith and exclusion from most official positions; for Catholic priests, saying Mass on English soil was considered a treasonable act.

In 1634 two ships, the *Ark* and the *Dove,* carried sixteen Catholic gentlemen, three Jesuit clergy, and about a hundred and twenty Protestant servants to an island in the Potomac River. Cecilius Calvert did not travel himself but sent his brother Leonard to govern the colony. Both Calverts advocated an unprecedented degree of religious freedom, attracting Puritan and Quaker settlers as well as other Catholics encouraged by the missionary zeal of the Jesuits and entrepreneurial opportunities. Catholic immigration to Maryland swelled during the Civil War of the 1640s, when Charles I was beheaded and the Puritan Commonwealth under Oliver Cromwell re-instituted harsh anti-Catholic policies. For the Calverts, the war underscored the need to keep religion out of politics. They initiated "An Act Concerning Religion," more commonly known as the Religious Toleration Act, in 1649. Intended to safeguard the rights of all Christians and assuage longstanding Protestant-Catholic antipathy, it read, "noe persons . . . whatsoever in this Province . . . professing to believe in Jesus Christ, shall henceforth bee any waies troubled, Molested or discountenanced for or in respect of his or her religion or in the free exercise thereof."[3] A landmark statute in provincial governance, it established a precarious balance often challenged by the colony's Protestants.

The Calverts' control fluctuated during the seventeenth century depending on religious and political circumstances in England, but they maintained a high level of influence because of their wealth and extensive land holdings. The Calverts particularly recruited "second sons"—English aristocrats who, because of the law of primogeniture, did not receive land inheritances. Many came, drawn not only by the promise of religious tolerance but also by the Calverts' commitment to replicating England's hierarchical social system. The Calverts envisioned an aristocratic utopia with genteel families controlling productive plantations worked by indentured servants and slaves. They granted wealthy immigrants large parcels of land, initially two thousand acres to those who brought five adults with them. Thus land and wealth in Maryland was concentrated in a few rich families like the Darnalls. Three-quarters of Maryland's settlers were, however, very poor. The largest proportion were male indentured servants attracted by the opportunity to work for a set number of years and then buy land of their own.

Like the Massachusetts Puritans, those who settled in Maryland were also attracted by the colony's economic potential. Maryland was a coastal plain and had rich soil for planting and navigable waterways for easy trade and ready access

to the large plantations along the Chesapeake Bay. The cash crop was tobacco. Tobacco planters and tobacco merchants would dominate the political and social life of Maryland.

The three Catholic families Kühn painted—the Darnalls, the Diggeses, and the Carrolls—followed the Calverts to Maryland. Henry Darnall I, born in 1645, was the son of London lawyer Philip Darnall, who accompanied George Calvert, the first Lord Baltimore, on a diplomatic mission to France, where both converted to Catholicism. Probably encouraged by Charles Calvert, the third Lord Baltimore, to whom he was related, Henry Darnall I immigrated to Maryland in the 1660s or early 1670s, established a plantation, and became a member of the dominantly Catholic Governor's Council in 1679. He was appointed Proprietary Agent and a colonel in the militia, and served as Deputy Governor between 1682 and 1689. By then Catholic influence in Maryland had waned for several reasons, including a large influx of Protestants who outnumbered Catholics four to one. Political and religious shifts in England after the Restoration of the crown in 1660 and the Glorious Revolution of 1688–89, which reinstated a strong Protestant monarchy with William and Mary, also had an impact on the balance of power in Maryland. Living in London, the current Lord Baltimore upset Maryland's Protestant colonists with acts they considered disloyal to William and Mary and the favoritism he showed Catholic settlers like the Darnalls.

Tensions culminated in the Maryland (or Protestant) Revolution of 1689, when the Protestant Associates lead by Colonel John Coode attacked troops loyal to Calvert lead by Henry Darnall I. As Darnall wrote in his account of the Revolution, after Coode's 700-man siege on Mattapany House, the loyalist base, "Wee being in this condition and no hope left of quieting the People thus enraged, to prevent effusion of blood, capitulated and surrendered."[4] The religious toleration that distinguished Maryland from the other British colonies was gone for good. Maryland became a royal province, Catholics were barred from holding office, and Henry Darnall I lost his government appointments. In 1692 Anglicanism was established as the official religion of the colony. Despite these setbacks, as Harry Clyde Smith wrote in his history of the Darnall family,

> Henry Darnall was both affluent and influential. He owned much land and many slaves. At his death [in 1711], he bequeathed some thirty thousand acres of land. A devout Roman Catholic, he sent his sons to Jesuit schools in Europe—one of the inciting factors in the "Protestant Revolution," following which Henry maintained secret quarters in his home, with all equipment necessary for observing the rites of his religion.[5]

This was also necessary because of the 1704 passage of "An Act to prevent the Growth of Popery within this Province," which, among other anti-Catholic rules, barred Catholics from teaching school and priests from celebrating Mass in public. Kühn painted bust portraits of Henry Darnall I and his wife Eleanor around the same time that he painted their grandson, about a year before the patriarch's death.

Henry Darnall III, c. 1710

Henry Darnall II (1682–1737) inherited the plantation from his father. In 1701 he had married Anne Digges, the stepdaughter of Charles Calvert, the third Lord Baltimore. Kühn painted her portrait around 1710 as well. Henry Darnall III was born in 1702, one of four children including a sister Eleanor, born in 1703, whom Kühn also painted. Henry III lived until after 1788 and held office as Chief Naval Officer of Prince George's County (1755–61), Receiver of Rents for the Lord Proprietary (the Calverts regained control of Maryland in 1715 after they converted to Anglicanism), and Attorney General (1751–56). To hold these positions, Henry III also converted, although he was often under fire because his six children and his wife, Anne Talbot, the niece and ward of a prominent Jesuit priest, refused to convert.

In painting the Darnalls, Diggeses, and Carrolls, Kühn became in effect the court painter to Maryland's wealthy Catholic elite. As in any aristocratic society, lineage was crucial, hence the commissioning of portraits of the families' children. Henry Darnall III's portrait reflects his parents' aspirations for their eldest son—that he would become the master of a grand estate. Large portraits such as this and the sizable homes needed to hold them established credibility for those attempting to maintain (or, occasionally, construct) an aristocratic family pedigree. Therefore the Darnalls' motivation for commissioning Kühn to paint their children was similar to that behind the Gibbs children's portraits; both families aimed to emphasize lineage and family wealth. Yet Kühn's portraits were not, of course, intended to assert Calvinist values like those of the Freake Painter. Instead, the complexity of the Darnall portraits in comparison with the simpler Gibbs portraits suggests a completely different context, one that prized a patrician way of life. Intriguingly, however, there is evidence that the Darnall portraits also had a religious intent heretofore-unrecognized in Kühn scholarship.

Henry was about eight years old when Kühn painted his portrait, the age that the unisex robe worn by boys under eight was replaced with the coat and breeches of an adult male. Perhaps the portrait marks this important transition. As one would expect, Darnall's clothing in the portrait is expensive and stylish. His coat is a lush yellow-gold brocade with a red-orange lining evident at the collar and cuffs and over a dozen silver buttons. He wears a lace jabot, high-heeled black shoes with silver buckles inset with jewels, and breeches banded with what appears to be metallic embroidery. The Darnalls would have had to import such attire, which is further evidence of their wealth. The green velvet cloak is an affectation commonly used in Baroque portraits to accentuate the sitter's significance, and not an actual item of apparel. Henry holds hunting implements—a bow and arrow, and behind him, a quiver—and his slave proffers a dead partridge (a common game bird in Maryland at this time), apparently the result of a successful hunt. These are traditional symbols of masculinity that appear frequently in European aristocratic portraiture. Both the dead bird and the cultivated landscape behind Henry indicate the Darnalls'

desire to control Maryland's unruly wilderness.[6] The metal collar around the slave's throat indicates colonists' need to control their slaves, whom they also considered uncivilized.

All four of Kühn's portraits of children show them before astounding vistas that include cultivated gardens and huge manor houses—astounding because nothing approaching this grandeur existed anywhere in the colonies at this time. The portraits' backgrounds are complete fictions, as are the marble balustrades with sculpted pillars and vases, and their invention provides the best evidence of Maryland's first families' aristocratic pretensions. In reality, even the gentry's homes in early-eighteenth-century Maryland were quite modest, although in 1710 Henry Darnall I was building Woodyard, the family estate (the ruins stand today near Andrews Air Force base). The fantasy background asserts young Henry's position as the future lord of the manor; perhaps the painting was intended to hang in Woodyard's entrance hall. Thus, as art historian Wayne Craven concludes, the portrait's background is not merely a decorative space filler but an indication of the Darnalls' perception of their place in society.[7] It is often suggested that Kuhn based the background on an engraving of a European estate, although no specific source has been found. If so, its use confirms the desire of Kühn and his patrons to draw parallels between the landed aristocracy of Europe and that of the colonies. Art critic Robert Hughes remarks, "The image records the defiant, illusory desire of the colonial gentry to imagine themselves as an extension of European culture—which indeed they were, but not in the grand sense they envisioned for themselves."[8]

Colonial Slavery

The most remarkable aspect of Kühn's portrait of Henry Darnall III is not the subject of the painting, for there are many colonial American portraits of wealthy children, but his companion, one of only a handful of depictions of slaves. European portraits of aristocrats from the Renaissance and Baroque periods often include young blacks as servants. Van Dyck produced several, including *Marchese Elena Grimaldi*, 1623 (National Gallery of Art, Washington), which depicts a young African servant holding an umbrella above his mistress. Like the slave in the Darnall portrait, he gazes at his white owner with a reverential expression. Grimaldi lived in the Italian city of Genoa, which was active in the slave trade at this time. Intriguingly, around 1670 Dutch artist Gerard Soest painted a full-length portrait of Cecilius Calvert, second Lord Baltimore, handing a map of Maryland to his grandson, Cecilius Calvert II, while a young black servant looks on.[9] There is no evidence that Kühn knew this work, but the Darnalls might have.

In their attempt to duplicate the English aristocratic lifestyle, the Darnalls and their peers faced a fundamental problem: there was no built-in population to whom they could be superior, no peasants who would work their land cheaply. Initially they imported white indentured servants, who usually came voluntar-

ily but often escaped from servitude because land was so readily available and they could mix easily with the other colonists. Those who completed their four or five years of indenture and earned their freedom insisted on a political voice, to the gentry's chagrin. Therefore Maryland's plantation owners increasingly turned to the slave trade after about 1660. Slaves cost more than white indentured servants, about twenty-three pounds versus twelve pounds in 1674, but guaranteed lifetime service instead of term-limited work. Young males between the ages of ten and twenty-four were favored because of their ability to do field labor, though young women sold for higher prices because they could bear future slaves. In late-seventeenth-century Maryland, white indentured servants still outnumbered Africans by about four to one, but between 1695 and 1708, just before Kühn painted Henry Darnall and his slave, over four thousand slaves arrived in Maryland.

The impetus for the American slave trade is well known. The unprecedented size of the lands the colonial powers wished to cultivate needed extensive, inexpensive labor. A small-scale operation initially, African slaves were typically members of African cultures defeated during conflicts with other African cultures, taken captive, and then sold into slavery. As the demand increased, warfare was initiated specifically to acquire slaves. Shipped to America in horrendous conditions, many did not survive the brutal middle passage across the Atlantic Ocean. Those who lived were confined to a life of uncompensated service and harsh treatment at the hands of slave traders and owners.

During the eighteenth century the English wrested control of the slave trade from the Dutch, shipping about two million Africans to the British colonies. Eighty percent were sent to the West Indies, where the harsh climate and backbreaking work on lucrative sugar plantations limited a slave's life expectancy to only a few years. In 1675 there were 1,250 slaves in Maryland; between 1700 and 1750 the number grew to 75,000. As slaves composed an increasing percentage of the south's population, white colonists feared revolt and established slave codes, with the first instituted in Virginia in 1682. Slave codes are evidence of white apprehensiveness, as the gentry certainly recognized that their lifestyle depended on the brutal oppression of the growing slave population. The slave codes addressed white concerns such as miscegenation and what whites perceived as the violent and libidinous nature of blacks. In addition to legalizing perpetual slavery, the slave codes made slave status hereditary. To maintain control, physical punishment such as whipping, branding, and mutilation escalated. Historian Robert J. Brugger writes, "Thus slavery, providing a labor supply, had another function in placing controls on a disturbing social element. Negroes, English colonists decided, belonged in slavery; better for everyone that they remain under white control."[10] Organized slave revolts did take place in the eighteenth century, but they were not common.

The attitudes that encouraged slavery are unmistakable in the Kühn portrait. As discussed in Chapter 1, the English viewed those with darker skin as inferior, as "savage" and "barbarian." Such vicious stereotypes allowed them to rationalize slavery, making it easier to exploit those deemed less human. An

Englishman in eighteenth-century Jamaica wrote, "the planters do not want to be told that their Negroes are human creatures. If they believe them to be of human kind, they cannot regard them . . . as no better than dogs or horses."[11]

The African American's dress in Kühn's portrait indicates that he was a house servant. It was not uncommon for wealthy southern children to receive a young slave as a companion and a body servant whose responsibilities included dressing the young master. Here the slave is shown in livery, a servant's uniform of a rust-colored coat and white shirt. Domestic service was physically less grueling than working the fields, but house slaves were cut off from the slave quarters, the only area where it was possible to maintain a semblance of family life and African culture. Thus domestic slaves were forced to assimilate further than their peers, as the slave's clothing suggests. Despite their proximity, they were not considered part of the master's family; in the portrait the marble balustrade literally separates Henry and his slave, reflecting the social and economic barrier between them. Of course, the slave's name is unknown. His age suggests that he was probably American-born, as was increasingly the case in eighteenth-century Maryland. His features appear generalized (although Henry's do as well, perhaps due to Kühn's limited skills), leading some to speculate the slave may be as fictional as the portrait's background. This seems unlikely, however. While the Darnalls did not own a house like the one in the painting, they were slave owners for decades before Kühn painted the portrait. Henry Darnall I owned over one hundred slaves at his death in 1711.

The Emblematic Tradition in Kühn's Portraits of Children

Another fascinating aspect of Kühn's portraits of the Darnall children is their iconographic complexity. The portrait Kühn painted of Eleanor Darnall was intended to hang as a pendant beside her brother's portrait. It is the same size and the children turn slightly toward each other. The works share elaborate marble balustrades and lavish garden backgrounds, although not contiguous ones. Like her brother, Eleanor is well dressed, in clothes and a hairstyle that recall the fashions of Queen Anne's court in England. The portraits also share a European emblematic tradition that provided common objects with symbolic meanings. Emblem books, widely available in the colonies, combined engraved images with prose or poetry describing the meaning of the image. Chapter 4 explored gravestone carvers' use of emblems to communicate messages about death to the living. Similarly Kühn's portraits of children contain objects intended to convey levels of meaning not immediately apparent if one takes them at face value.

In 1988 art historian Roland E. Fleischer compared the portraits' motifs with symbols in emblem books such as *Emblems for the Improvement and Entertainment of Youth* and Cesare Ripa's *Iconologia,* both published in multiple editions throughout the seventeenth century. Fleischer describes the portraits as dis-

courses on the theme of love. In Henry's portrait the bow and arrow and the dead bird, Fleischer suggests, not only refer to the aristocratic pastime of bow hunting, but also appear in emblem books as symbols of love and friendship. The bow, arrow, and quiver are associated with Cupid, the son of Venus, goddess of love. The cherub carved on the plinth next to Henry reinforces this connection. The cultivated garden and fountain in the background, Fleischer argues, relate to emblem book images of the Garden of Love, the domain of Venus.[12]

Eleanor is also positioned before an enclosed garden with a fountain. Instead of a slave, her companion is a brown and white dog (the implied parallel between the slave and the dog is consistent with white perceptions of the inferiority of Africans). Dogs have several iconographic implications depending on the context. Fleischer identifies this dog as an attribute of love and friendship, based on how dogs typically function in the emblem books he studied. Eleanor is framed by a large vase of flowers and a column encircled by a vine. As noted in Chapter 4, plants and flowers also carry symbolic meaning. According to Fleischer, the vine is an emblem of love and the unsupported vine specifically symbolic of an unmarried woman. The large bouquet of flowers to the right vies with Eleanor for attention. Each flower is meticulously delineated, making it possible to identify them, although Fleischer interprets only the rose as a symbol of Venus. Less convincing is Fleischer's speculation that the carved heads on the vase and the plinth are lions' heads despite their clearly human features and resemblance to "grotesques," carved masks often found in Baroque gardens.

Fleischer's analysis suggests that Kühn selected emblems that work together to convey a particular concept. The theme of love is a common one in Baroque portraiture, although how it related to the Darnall children is unclear. Was it intended to express how much their parents loved them? Or that the children themselves had loving natures, "perceiving," as Fleischer writes, "young males with their bows and arrows as earthly Cupids and young girls with their fountains, shells, and roses as budding Venuses"?[13] Fleischer's inability to explain why Kühn would paint emblems of love in the Darnall children's portraits impels one to probe further, as emblems were usually selected to communicate something specific about the sitter. Additional investigation indicates that the symbols in the portraits can be connected more precisely to Catholic emblem books of the seventeenth century, rather then the secular ones Fleischer studied, and to established traditions in Christian iconography. The Jesuits, who accompanied the first Catholic settlers to Maryland and subsequently dominated Catholicism in the colony, published over 1,700 emblem books between 1600 and 1700, recognizing their potential to teach Catholic doctrine and values.

The key to understanding the portraits' religious implication is the prominence of the dog, toward which each child turns and Eleanor emphasizes by placing one hand on its head and pointing at it with the other. The dog's calm pose and watchfulness implies a long-standing interpretation of dogs as symbols of fidelity. The Latin root of *fidelity* is *fides*, the basis for the popular dog name, Fido. *Fides* is also the Latin word for faith. Kühn's emphasis on the dog suggests that the portraits may be discourses on faith rather than love. In Chris-

tian iconography dogs also symbolize the priests who protected and guided their human flock, as sheepdogs safeguard sheep.

Nearly all of the emblems Fleischer interprets as symbols of love appear in Catholic emblem books as symbols of Jesus or the Virgin Mary. The enclosed garden, its fence appearing so prominently behind Eleanor in the portrait, symbolized Mary's inviolate state, based on the Song of Solomon, "A garden enclosed is my sister, my spouse; a spring shut up, a fountain sealed." Termed the *hortus conclusus* in Marian iconography, such gardens often include fountains as indications of Mary's purity and another line in the Song of Solomon, "a fountain of living waters." Much like the background in Kühn's portrait of Eleanor, a walled garden with a fountain appears as the frontispiece in an emblem book by Jesuit Henry Hawkins, *Partheneia Sacre,* subtitled *The Mysterious and Delicious Garden of the Sacred Parthenes,* published in 1633. Unlike secular emblem books, *Partheneia Sacre* was not intended as entertainment or a didactic instrument but as an aid in meditating on the Virgin Mary. The Parthenes were a Sodality, a group of lay Catholics under Jesuit control who were dedicated to Mary, particularly the Virgin of the Immaculate Conception. Sodalities were considered heretical by English authorities. Hawkins described their establishment "throughout al *Europe* first & then through *America,* the new world . . . under the soveraign and most blessed name of MARIE." This could refer to Jesuit inroads in New France and New Spain, although the 1633 publication date of *Partheneia Sacre* corresponds to the founding of Maryland, named, it is said, in honor of the Virgin in addition to Henrietta Marie.

Partheneia Sacre, considered the most important Catholic emblem book in English literature, uses the enclosed garden as a framework for a whole scheme of devotion. The frontispiece shows a garden surrounded by walls, with walkways, and geometric beds organized around a circular fountain and a manorlike house. The garden plantings include roses and lilies, flowers sacred to Mary. As Fleischer notes, the rose is a symbol of Venus, but to Catholics it represents Mary, regarded as "a rose without thorns." Roses fill the vase next to Eleanor, and a large cut rose lies on the balustrade close to her. Perhaps the emphasis in Catholic prayer on saying the rosary (from the Latin *rosarium,* or *rose garden*) explains its prominent placement. The tulip, featured at the top of the vase of flowers, is described in *Partheneia Sacre* as "a singular ornament to [Mary's] garden; looke and observe it wel."[14] The vine, at the left in the portrait, is not an emblem specific to Mary in *Partheneia Sacre*, although a vine encircles another emblem, the pearl. The vine is a symbol of Jesus, who said "I am the true vine" (John 15:1). Similarly, the pearl's iconography extends metaphorically to Jesus, whom Hawkins describes as "the precious pearl, Christ Jesus in her womb." Eleanor wears a pearl necklace in the portrait.

The abundance of Catholic symbols in Eleanor's portrait may have a gender implication. In colonial America, "the survival of Catholicism," writes historian Jay P. Dolan, "depended upon the women, who maintained the rhythms of Catholic life in the home." Women directed religious instruction and "made sure that the children were raised Roman Catholic even when their husbands con-

formed to the Church of England"[15] (as Anne Talbot did when Henry Darnall III later converted). Maryland Catholics primarily worshiped at home, in imitation of their persecuted predecessors in England, but also because of the small number of Catholic priests, the lack of Catholic churches in the colony, and increasingly harsh laws against public Mass. While Henry's future as lord of the manor is implied by his portrait, Eleanor's portrait suggests her prospective role as caretaker of the faith, as she protectively rests her hand on the dog's head.

Yet the portrait's presentation of Henry's role may not be as clear-cut as earlier interpretations suggest. Fleischer's identification of Henry with Cupid is convincing because of the bow and arrows he holds, but in Catholic emblem books Cupid is a symbol of the infant Jesus and divine love. The arrow Henry holds so prominently before him is in Christian iconography considered a spiritual weapon signifying the dedication of one's life to the service of God. It is also an attribute of Saint Sebastian, a third-century Christian whom the Roman Emperor Diocletan ordered to renounce his faith or die. Sebastian chose the latter and was tied to a column and shot through with arrows, which miraculously did not kill him. The arrow Henry holds may therefore indicate the steadfastness of the Darnalls' faith in the face of persecution or imply Henry's future role as a defender of the faith like his grandfather. The other evidence of the hunt—the dead partridge held by the slave—is also identified by Fleischer as a token of love. But according to Christian iconography, partridges are symbols of the devil. Perhaps the implication of a dead partridge is the defeat of Satan (the persecutor of the faithful). Henry, like Eleanor, is backed by an enclosed formal garden with a fountain. The enclosed garden also symbolized immunity from the attacks of Satan and protection from original sin. Behind Henry the walkways form a prominent Latin cross, like those of the garden illustrated in *Partheneia Sacre*.

Several uncertainties remain, however. The slave's role is unclear in a religious reading of the painting—perhaps he is simply a Baroque affectation intended to imply the Darnalls' status, though this seems unlikely considering Kühn's deliberate references to the Darnalls' faith. The meaning of the two prominent grotesques in Eleanor's portrait is not discernable either, though perhaps further research will clarify their intent. Although no documents exist that confirm either Fleischer's interpretation of the paintings or my own, the family's commitment to their faith strengthens the latter explication. As noted, after the Revolution of 1689, Catholics were a persecuted religious sect. They had to worship underground, as did the Darnalls in their private chapel. Josephine Evetts Secker identifies devotional literature like *Partheneia Sacre* as a particular need of persecuted Catholics to sustain their faith, as they were largely deprived of most sacraments and public worship.[16] Some brave souls tried to worship publicly. Charles Carroll, one of the wealthiest men in Maryland and the husband of Henry Darnall II's sister Mary, did and was promptly arrested and forced to spend two nights in jail.

Jay Dolan describes Henry Darnall I as "the principal leader in the Catholic community until his death in 1711," and a book on Maryland's revolutions characterizes him as "the colony's foremost Catholic."[17] After the passage of "An Act

to prevent the Growth of Popery" in 1704, which attempted to banish the Je-
suits by imposing fines, imprisonment, or exile for saying Mass. Henry Darnall
I and other prominent Catholics petitioned to legalize Catholic worship in pri-
vate homes. An act to this effect was passed in 1707, reinforcing the domestic
character of Maryland Catholicism. But in 1717, the Maryland assembly voted
to disenfranchise Catholics completely, removing their right to vote, hold office,
practice law, and educate their children according to their faith. In response,
Catholics again petitioned for relief, noting "by these Laws we are almost re-
duced to a Levell with our Negros not having even the privilege of Voting."[18]

Considering the circumstances for Maryland Catholics in 1710, overt sym-
bols of their faith would be dangerous in portraits probably intended to hang
in Woodyard's public area. Referencing the Virgin Mary would be particularly
risky, for Protestants vociferously rejected the Catholic emphasis on Mary in rit-
ual, worship, and prayer. But a series of emblems that could be interpreted in
another way—as standard Baroque tokens of love rather than an assertion of a
persecuted faith—would allow the Darnalls to safely acknowledge what was
such an essential part of their identity. Does suggesting the portraits' religious
intent invalidate earlier interpretations of their role as status symbols? No; in-
stead, it indicates how multi-layered portraits can be. To most viewers, those of
the eighteenth century and those today, the portraits are clear statements of pres-
tige and the Darnalls' aristocratic pretensions, communicated by the use of the
Baroque style, the fine clothing, the elaborate settings, and the obsequious slave.
At a deeper level, viewers might then recognize the objects in the portraits as
symbols of love in the Baroque emblematic tradition. But family and friends of
the Darnalls, whom Dolan describes as an intensely tight-knit community, would
see the portraits in a completely different light.[19] To them, the dog's prominence
would indicate that the emblems related to faith rather than love and empha-
sized the Darnalls' maintenance of their religion in the face of persecution, pre-
senting Henry as a defender of the faith and Eleanor as its caretaker. There is
other evidence of the Darnalls' commitment to Catholicism. Both Henry and
Eleanor were sent abroad to study at Jesuit schools in France and Flanders (this
was particularly unusual for a young girl from the American colonies). Although
Henry would convert to Anglicanism to advance his career in Maryland poli-
tics, Eleanor married Daniel Carroll in 1727 and had two sons. One was John
Carroll, born 1736, who would become the first Roman Catholic bishop and
later archbishop of the United States and determine the direction American
Catholicism would take after the American Revolution.

Fragments of a Life and an Unanticipated Legacy

That Maryland's Catholic gentry would be able to interpret the iconography
of the Darnall children's portraits is certain, for they were highly educated. Mary-
land's Jesuits had a lending library of religious and devotional literature that cir-

culated among the community. Similarly, Kühn's use of the emblematic tradition suggests that he too was a man of learning. Although he placed the emblems quite blatantly—once conscious of their intent they appear arranged for the viewer with all the subtlety of a billboard advertisement—the fact that he used emblems at all is evidence of the increasing sophistication of artists in America. Recognizing Kühn as an intellectual rather than simply a manual worker signals changes in the artist's status in English society. Previous chapters have indicated that visual artists were considered equal in status to such other manual workers as bricklayers and shoemakers. J. Hall Pleasants, who wrote a brief biography of Kühn in 1939, suggests that he probably rented a house in the area where silversmiths and other craftsmen lived in Annapolis. Yet in eighteenth-century English society there was growing recognition of the artist's intellectual nature. To paint the complex portraits patrons demanded, artists had to be well read. Kühn certainly must have been to use emblems that, as he was a Protestant, were not part of his own tradition.

In addition to the dozen or so portraits that survive, there is evidence that Kühn also painted coats of arms (understandable, considering his patrons' emphasis on lineage and his interest in emblems). Like most colonial artists he would have had to branch out from easel painting to make a living. Although we know little of Kühn's lifestyle in America, documents indicate that he married a woman named Elizabeth and had a son in 1714. He was elected a warden at Saint Ann's Church (Anglican) in Annapolis, responsible for "too flaggons, One Chalice, One dish, two Salvers, one Holland Table cloth and three napkins" (five of the six pieces of silver entrusted to Kühn survive at the church today).[20] Unfortunately, six months after his appointment Kühn died, in November 1717. Charles Carroll, the wealthy Catholic who spent time in jail for worshipping in public, administered Kühn's estate, further evidence of the artist's close connection to Maryland's leading families. Apparently Kühn was not a financial success, for he died in debt, with an estate worth only 47 pounds. Whether this was due to lack of skill, the scarcity of patrons, or living beyond his means we will probably never know. However, probate records at the time of his death provide some intriguing clues. His estate included "sev'l parcells of paint & other things belonging to painting" valued at seven pounds, and fourteen "pictures & Landskips"—the latter are presumably landscape paintings, the first recorded evidence of paintings other than portraits created in the English colonies.[21] He also owned 39 books, a further indication that he was a learned man. The document suggests his love of music as well—he owned a flute valued at three shillings—and expensive clothes, worth nine pounds at his death, not an inconsiderable amount in 1717.

In recent years Kühn's portraits of the Darnall and Digges children have been included in survey texts on American art and exhibitions of eighteenth-century portraiture. Such studies emphasize Kühn's position as the first identifiable portrait painter in the south and the introduction of grand manner portraiture to the colonies. Understandably, the slave included in Henry's portrait is also a focus of attention. The portrait appeared in a groundbreaking exhibition and

catalogue of images of African Americans in American art, *Facing History: The Black Image in American Art, 1710–1940,* presented by the Corcoran Museum of Art in 1990. As the exhibition's title indicates, Kühn's portrait was featured as the earliest image of an African American in American art. In tracing this theme across time, *Facing History* allows us to see how American society perceived its black citizens and how art reinforced, in most cases, restrictive stereotypes that denied "the inherent humanity of black people." Of Kühn's portrait of Henry Darnall III, exhibition curator Guy C. McElroy writes that it

> established an artistic convention emulated by generations of eighteenth and nine-teenth century artists. The servant exists in Kühn's portrait not as a fully realized human but as the chattel of the son of a wealthy slave owner. . . . His supplicant position is typical of the image of African-Americans—forcibly uprooted and brought to America—that held sway over the well-to-do elite of landed colonial America.[22]

Although this was not Kühn's intent, the fact that the portrait of Henry Darnall has become an icon of race prejudice is confirmed by its use in an intriguing exhibition formulated by the artist Fred Wilson in 1992–93, titled *Mining the Museum.* The Maryland Historical Society, which owns the portrait, invited Wilson to use any items in their collection to create an installation reflecting his concerns as an African American. Wilson placed Kühn's portrait in a room with other early American portraits of white children and their slaves, focused spotlights on the slaves—who, like the slave in the Kühn portrait, are depicted in shadow—and recorded an audio tape to play near each portrait with questions such as "Who am I? Am I your brother? Am I your friend? Am I your pet?" The installation was intended to provide the slaves with voices and to provoke viewers to contemplate America's painful legacy of race prejudice.[23]

One cannot deny the significance of Kühn's representation of the slave. Yet as this chapter suggests, contemporary scholarship's emphasis on the slave may have blinded scholars to another important aspect of the portrait: unique visual evidence of anti-Catholic prejudice in Maryland in the early eighteenth century. When studying such iconographically complex works of art, we need to keep in mind their historical context and the values of the patrons who commissioned them. As Fleischer points out, "while an individual emblem may have several quite different meanings, its intended meaning in each case must be derived from its context."[24] In the case of Kühn's portraits of the Darnall children, the context was a decidedly Catholic one.

Notes

1. Two of Kühn's portraits of children are illustrated here. A third portrait, of two-and-a-half-year-old Ignatius Digges, is in a private collection, illustrated in Saunders and Miles, 89. A fourth, titled *Portrait of a Young Girl,* owned by the Nelson-Atkins Museum of Art, Kansas City, is illustrated in Craven, 243.

2. Black and white reproductions of Kühn's portraits of adults are published in Pleasants. A good color reproduction of Kühn's portrait *Daniel Dulany the Elder* is available at *Maryland State Archives,* "The Peabody Collection," http://www.mdarchives.state.md.us/msa/speccol/sc4680/html/kuhn.html.

3. Quoted in Dolan, 77.

4. *Combs-Coombs & c. Research Group,* "The Maryland Revolution of 1689: Col. Henry Darnell Surrenders and Flees," http://www.combs-families.org/combs/records/md/1689/darnell.htm.

5. Smith.[2]

6. Many thanks to Eileen Kinch for this observation.

7. Craven, 238.

8. Hughes, 50–51.

9. This portrait is illustrated in Bruger, 6.

10. Ibid., 45.

11. Nash, 155.

12. Fleischer, 9–18.

13. Ibid., 31.

14. Quoted in Freeman, 175.

15. Dolan, 83.

16. Secker, 237.

17. Dolan, 80, and Carr [3]and Jordan, 171.

18. Dolan, 85.

19. Ibid., 80.

20. Pleasants, 9.

21. Ibid.

22. McElroy, xi.

23. Corrin.

24. Fleischer, 3.

Bibliography

Apostolos-Cappadona, Diana. *Dictionary of Christian Art.* New York: Continuum, 1994.

Bath, Michael. *Speaking Pictures: English Emblem Books and Renaissance Culture.* London: Longman, 1994.

Berlin, Ira. *Many Thousands Gone: The First Two Centuries of Slavery in North America.* Cambridge, MA: Harvard University Press, Belknap Press, 1998.

Bossy, John. "Reluctant Colonists: The English Catholics Confront the Atlantic." In *Early Maryland in a Wider World,* edited by David B. Quinn. Detroit: Wayne State University Press, 1988.

Bruger, Robert J. *Maryland: A Middle Temperament, 1634–1980.* Baltimore: Johns Hopkins University Press, 1988.

Carr, Lois Green, [2]and David William Jordan. *Maryland's Revolution of Government, 1689–1692.* Ithaca: Cornell University Press, 1974.

Combs-Coombs & c. Research Group. "The Maryland Revolution of 1689: Col. Henry Darnell Surrenders and Flees." http://www.combs-families.org/combs/records/md/1689/darnell.htm.

Craven, Wayne. *Colonial American Portraiture: The Economic, Religious, Social, Cultural,*

Philosophical, Scientific, and Aesthetic Foundations. Cambridge: Cambridge University Press, 1986.

Corrin, Lisa G. *Mining the Museum: An Installation by Fred Wilson.* New York: New Press, 1994.

Degler, Carl N. "Slavery and the Genesis of Race Prejudice." In *Colonial Southern Slavery,* edited by Paul Finkelman. New York: Garland, 1989.

Dolan, Jay P. *The American Catholic Experience: A History from Colonial Times to the Present Day.* Garden City, NY: Doubleday, 1985.

Ferguson, George. *Signs and Symbols in Christian Art.* New York: Oxford University Press, 1959.

Fleischer, Roland E. "Emblems and Colonial American Painting." *American Art Journal* 20, no. 3 (1988): 2–35.

Freeman, Rosemary. *English Emblem Books.* London: Chatus and Windus, 1948.

Hughes, Robert. *American Visions: The Epic History of Art in America.* New York: Alfred A. Knopf, 1997.

Johnson, Whittington B. "The Origin and Nature of African Slavery in Seventeenth-Century Maryland." In *Colonial Southern Slavery,* edited by Paul Finkelman. New York: Garland, 1989.

Maryland State Archives. "The Peabody Collection." http://www.mdarchives.state.md.us/msa/speccol/sc4680/html/kuhn.html.

McElroy, Guy C. *Facing History: The Black Image in American Art, 1710–1940.* Exhibition Catalogue. Washington, D.C.: Corcoran Gallery of Art, 1990.

Nash, Gary B. *Red, White and Black: The Peoples of Early North America.* 4th ed. Upper Saddle River, NJ: Prentice Hall, 2000.

Pleasants, J. Hall. *Justus Engelhardt Kühn, An Early Eighteenth Century Maryland Portrait Painter.* Worcester, MA: American Antiquarian Society, 1939.

Reich, Jerome. *Colonial America.* 5th ed. Upper Saddle River, NJ: Prentice Hall, 2001.

Saunders, Richard, and Ellen Miles. *American Colonial Portraits, 1700–1776.* Exhibition Catalogue. Washington, D.C.: National Portrait Gallery, 1987.

Secker, Josephine Evetts. "Henry Hawkins, S.J., 1577–1646: A Recusant Writer and Translator of the Early Seventeenth Century." *Recusant History* 11, no. 5 (April 1972), 237–52.

Smith, Harry Clyde. *Darnell, Darnall Family.* Baltimore: 1979.

Wheelock, Arthur K., et. al. *Anthony Van Dyck.* Exhibition Catalogue. Washington, D.C.: National Gallery of Art, 1991.

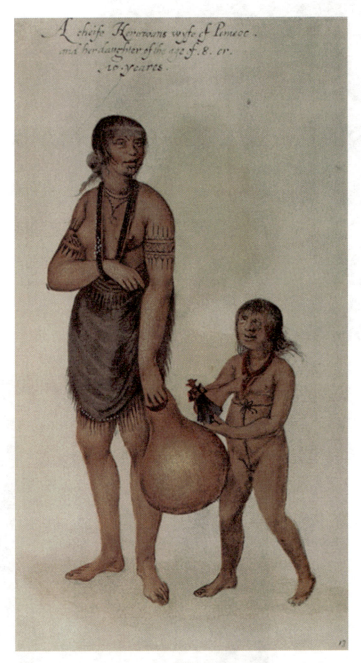

John White, *Woman of Pomeiooc and her Daughter*, 1585. Watercolor on paper (10 3/8 × 5 7/8 inches). © Library of Congress.

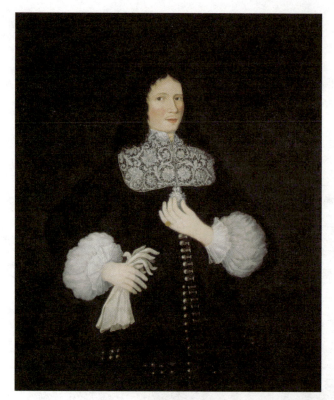

The Freake Painter, *Mr. John Freake,* c. 1671–74. Oil on canvas (42 1/2 × 36 3/4 inches). © Worcester Art Museum.

The Freake Painter, *Mrs. Elizabeth Freake and Baby Mary,* c. 1671–74. Oil on canvas (42 1/2 × 36 3/4 inches). © Worcester Art Museum.

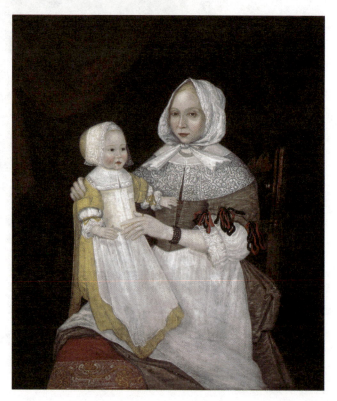

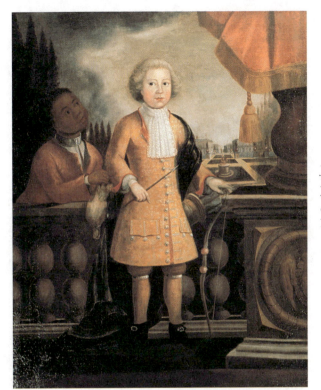

Justus Engelhardt Kühn, *Henry Darnall III*, c. 1710. Oil on canvas (54 3/34 × 44 11/64 inches). © Maryland Historical Society, Baltimore, Maryland.

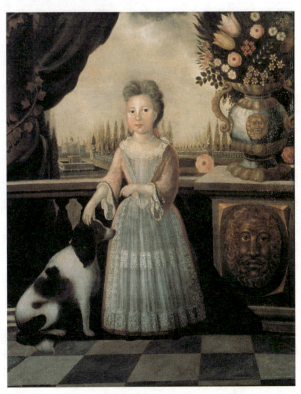

Justus Engelhardt Kühn, *Eleanor Darnall*, c. 1710. Oil on canvas (54 1/64 × 44 1/64 inches). © Maryland Historical Society, Baltimore, Maryland.

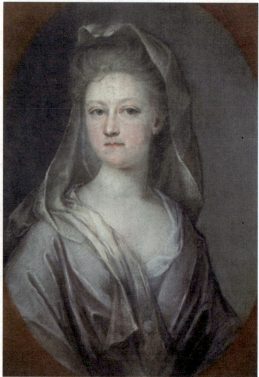

Henrietta Johnston, *Woman in Gray,* 1705. Pastel on paper (13¾ × 10 inches). © Private Collection.

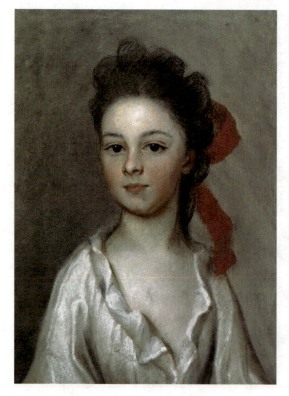

Henrietta Johnston, *Henriette Charlotte de Chastaigner,* 1711. Pastel on paper (11⅝ × 8⅞ inches). © Gibbes Museum of Art/Carolina Art Association.

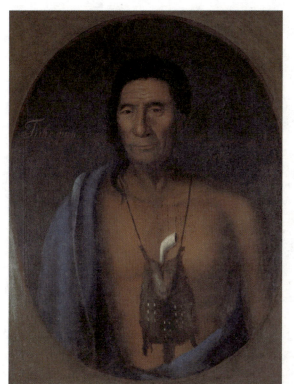

Gustavus Hesselius, *Tishcohan*, 1735. Oil on canvas (33 × 35 inches). Courtesy of The Historical Society of Pennsylvania Collection, Atwater Kent Museum of Philadelphia.

Gustavus Hesselius, *Lapowinsa*, 1735. Oil on canvas (33 × 25 inches). Courtesy of The Historical Society of Pennsylvania Collection, Atwater Kent Museum of Philadelphia.

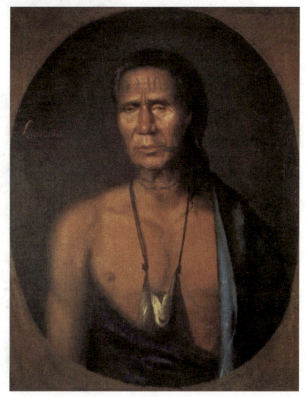

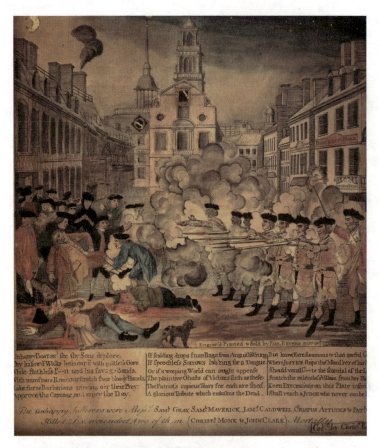

Paul Revere, *The Bloody Massacre*, 1770. Oil on canvas (9 3/4 × 8 3/4 inches). Photograph. © 2003 Museum of Fine Arts, Boston.

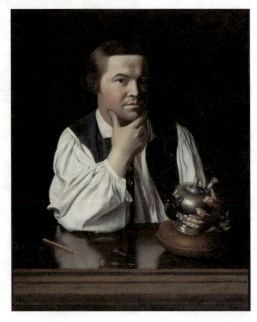

John Singleton Copley, *Paul Revere, Jr.*, c. 1768. Oil on canvas (35 × 28 1/2 inches). Photograph © 2003 Museum of Fine Arts, Boston.

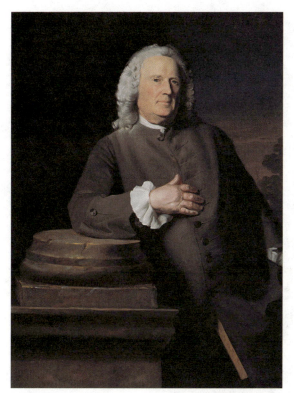

John Singleton Copley, *Epes Sargent,*
1760. Oil on canvas (49⅞ × 40
inches). © National Gallery of Art,
Washington.

John Singleton Copley, *Margaret
Kemble Gage,* 1771. Oil on canvas
(50 × 40 inches). © The Putnam
Foundation, Timken Museum of
Art, San Diego.

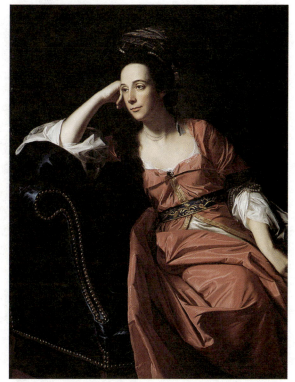

Benjamin West, *Venus Lamenting the Death of Adonis*, 1768. Oil on canvas (64 × 69 1/2 inches). © Carnegie Museum of Art, Pittsburgh; Purchase.

Benjamin West, *The Death of General Wolfe*, 1770. Oil on canvas (59 1/2 × 84 inches). © Library of Congress.

Henrietta Johnston (c. 1674–1729), America's First Professional Woman Artist

On November 11, 1709, Anglican minister Gideon Johnston wrote a letter to the bishop of Salisbury, England, from Charleston, South Carolina, where he served as rector of St. Philip's church. Bemoaning his difficult financial circumstances in the colonial backwater, Johnston pointed to his wife, Henrietta, as a primary means of support: "Were it not for the Assistance my wife gives me by drawing of Pictures (which can last but a little time in a place so ill peopled) I shou'd not have been able to live."1 Thus Gideon Johnston identified Henrietta Johnston as the first professional woman artist working in the English colonies. Other American women may have sketched and painted prior to 1709, but no record of them exists. What distinguishes Henrietta Johnston as a professional is that she was paid for her work. Johnston created charming portraits of friends and acquaintances, small, delicate images that in some instances were used to settle her husband's debts. While Chapter 5 described Justus Engelhardt Kühn, whose earliest works date to c. 1710, as the first documented professional portrait *painter* in the southern colonies, Henrietta Johnston was in fact the first portraitist in the south, although she worked in pastel rather than oil. This is an important distinction, for pastel was not widely used in the early eighteenth century and, as a drawing material, was traditionally accorded a lower standing in the hierarchy of art media than the oil paints Kühn used. Yet it would gain favor later in the century. Henrietta Johnston, also America's first pastelist, was a pioneer in the medium.

Charleston in 1709 was far from the sophisticated urban center that it would become by the American Revolution. Instead it was a small colonial outpost, a raw frontier founded about forty years before, primarily as a trading port and the seat of the Carolina government. What the Johnstons discovered when they arrived in 1708 was an environment for which they were woefully unprepared.

The heat and humidity, the mosquitoes, and the threat of Indian and pirate attacks, combined with persistent discord among their parishioners, resulted in a far from ideal situation for the rector and his wife. They also found that they had no home; a minister from Maryland had usurped St. Philip's parsonage. While they regained the parsonage six months later, they received little financial support from the Society for the Propagation of the Gospel in Foreign Parts, which had appointed Gideon Johnston commissary, the bishop of London's representative for Carolina and the Bahamas. And both Gideon and Henrietta suffered from grave illnesses, including malaria, gout, and yellow fever.

Despite the miserable circumstances, Johnston was able to produce skillful portraits of Charleston's elite, particularly the French Huguenots who had immigrated there seeking religious freedom. All early colonial artists faced challenges in their efforts to create works of art in America, but Henrietta Johnston carried more burdens than most because of her gender. As a woman, she was her family's primary caretaker, running a household that often swelled to ten or more as she took in homeless members of Gideon's congregation. Gender roles were quite rigid for urban women of Johnston's class in Europe and America in the early eighteenth century. Men functioned in the public sphere, conducting business outside the home. Women were restricted to the private sphere, managing domestic affairs. This was especially taxing in the colonies, where many household goods had to be made by hand. A woman's economic position depended entirely on that of her nearest male relative, usually her husband or father, and working in public was rarely the purview of a proper woman. Generally, only desperate circumstances, such as a husband's death, impelled colonial women of Henrietta Johnston's class to work outside the home. Her husband's poverty and his frequent inability to work because of illness or travel required that she work to provide income to supplement his meager clergyman's salary. That she did so by creating and selling works of art was unprecedented for a woman of this time and place. Johnston's existing portraits, her husband's letters and the few that survive from her own hand, and her twenty year career as an artist suggest she was a woman of intelligence, amazing perseverance, and no small artistic talent.

Johnston's Origins, Training, and First Marriage

What little we know of Henrietta Johnston's years in Europe before she settled in Charleston suggests that, initially at least, she had no plans to live and work in America. She was born Henrietta de Beaulieu around 1674, probably in northwestern France. Her parents were Huguenots, French Protestants who fled to England in 1687 to escape the campaign of terror, beatings, church burnings, and forced conversions to Catholicism that resulted from Louis XIV's 1685 revocation of the Edict of Nantes, which had guaranteed Huguenots the right to worship freely. The first documented evidence of Henrietta de Beaulieu's existence is a 1694 application for marriage which describes her as a resident of

the parish of St. Martins-in-the-Fields in London (suggesting she converted to Anglicanism), about twenty years old, and the daughter of a widow, Susanna de Beaulieu. Johnston's first husband, Robert Dering, born in 1669, was the son of Sir Edward Dering, a baron with extensive land holdings in England and Ireland. Robert and Henrietta Dering moved to Dublin, where Robert's brothers held prominent social and political positions. They had two daughters, one named Mary, the other's name unknown, sometime before 1698. The date of Robert Dering's death is also unknown. It is believed to have taken place between 1698 and 1702.

Henrietta Dering's first extant pastel portraits were created in 1704 in Dublin, and primarily depict members of her deceased husband's family and their friends, the Southwells and Percivals (including Sir John Percival, later a member of the Irish House of Commons and a trustee of the colony of Georgia). These carefully drawn images, about ten by fourteen inches, show the sitters half-length, their bodies turned to the left or right and their heads positioned in the opposite direction to give the poses a sense of dynamism. Two of the finest works from Johnston's Irish period are the portrait of an unknown woman dressed in gray, c. 1705, and the portrait of a male member of the Titcombe family, 1704–05. Evident here is her command of her medium, defining her subjects' clothing with parallel diagonal strokes of pastel and blending the forms of the face to create smooth, solidly modeled likenesses. Also apparent is Johnston's attention to detail; the sitters' lower eyelashes and the individual curls of their hair are carefully delineated, and the Titcombe man has traces of a five o'clock shadow. The eyes, though overly large, are carefully set into their faces. Particularly well handled is the scarf draped over the woman's head, highlighted in white to form an oval frame around her face that echoes the oval created by the colored spandrels (triangular areas) in the corners. Typical of Johnston's Irish work, the spandrels' color compliments the red-brown highlights of the woman's gray gown. Characteristic of portraiture at this time, the images reveal little of the sitters' personalities—they appear to be wealthy, self-satisfied individuals—their intent was instead to record the sitters' features and social status for posterity.

Although we do not know these particular subjects' names, Johnston habitually signed, dated, and noted where the works were created and the sitters' names in ink on the drawings' frames, a true boon for scholars. The frame of the portrait of the lady in gray is inscribed "Henrietta Dering / Dublin Anno 1705." Most of the works from 1704–1705 are signed "Henrietta Dering," but one of the Southwell portraits is signed "Henrietta Johnston" and therefore was created after her marriage to Gideon Johnston on April 11, 1705.

Henrietta de Beaulieu Dering Johnston's training has been the subject of much speculation. Scholars have named half a dozen English and Irish portrait artists as potential teachers. As a woman, she was not permitted to attend an art academy or join the painters' guild. In fact, any sort of artistic training was highly unusual for women at this time, so most likely she had private lessons with a sympathetic acquaintance. Regardless, her style was clearly influenced by the most fashionable English portraitists of her day, Peter Lely and Godfrey Kneller. Peter Lely (1618–80) was a Dutch artist who settled in England in the 1640s

during the reign of Charles I and emulated the Baroque style of Charles's favorite portraitist, Anthony Van Dyck. After Van Dyck's death in 1641, Lely emerged as England's leading portraitist, patronized by Charles I until the king was executed during the English Civil War. Loyalist aristocrats supported Lely during the Commonwealth of the 1640s and 1650s, and when the Restoration placed Charles II on the throne in 1660, Lely became the court's official portraitist.

Lely utilized the elegant poses, grandiose settings, and animated faces that characterize Van Dyck's Baroque portrait style. Lely also established in England a tradition of small-scale portrait drawings considered finished works of art in their own right (as opposed to studies for oil paintings), much like Henrietta Johnston's work. German-born Godfrey Kneller (1646–1723) was Lely's successor as court painter to Charles II and subsequently James II and William and Mary and carried the English Baroque portrait style into the eighteenth century. Johnston may have had direct access to Kneller's work, for he painted several members of the Dering family in the 1680s and Sir John Percival in 1703. Her work resembles that of Lely and Kneller in her sitters' poses, slight smiles, and heavily lidded eyes ("the sleepy Eye, that spoke the melting soul," according to a contemporary of Lely's[2]), although Johnston's sitters appear less haughty. They also share a degree of idealization and a somewhat formulaic approach, seemingly less concerned with capturing an accurate likeness than responding to contemporary fashion in portraiture.

It is possible that Johnston had training in London prior to her first marriage. Her work bears a resemblance to that of Edmund Ashfield (d. 1690) and his student, Edward Luttrell (d. 1724), both artists working in England in the late seventeenth century who continued the tradition of small-scale portraits introduced by Lely. Ashfield is considered the first English master in the art of pastel. Luttrell, who may have been Irish by birth, also worked in Dublin, painting portraits of members of the Irish aristocracy and clergy. Irish art at this time, much like that of the American colonies, can be regarded as provincial English art, sharing the same styles, subjects, and visual concerns. Another possibility is Thomas Forster (c. 1677–1712), a portrait miniaturist whose sitters' hairstyles, poses, and dress are very close to Johnston's. Others suggest that it was a colleague of Gideon Johnston, Simon Digby, Bishop of Elphin and the Diocesan of the Johnstons' Irish parish, who instructed Johnston. Digby was a watercolorist who executed miniature portraits on ivory, but it is unlikely that Johnston knew him until her second marriage in 1705, and by then she was already an established portraitist.

Pastel

That Henrietta Johnston chose to work in pastel rather than oil is surprising, for the use of pastel was not widespread at this time. Without a better understanding of her training, it is impossible to say who introduced her to the

medium. Pastel crayons are formed of the same ground pigments used in oil paints, but instead of using oil as a base, the pigments are combined with white fillers, often clay or chalk, and a weak glue binder, usually gum arabic, and pressed into sticks. Pastel is a delicate yet flexible medium that allows artists to work quickly in a wide range of colors to create both soft, blended shadows and luminous, dancing highlights. Pastels can yield hard lines, broad areas of color, and a variety of textures, evident in the gauzy garments of Johnston's female sitters and her male subjects' wooly wigs. Although the medium is easy to erase and thereby correct mistakes, one must proceed with a light touch and not overwork the pastel or it will be crushed, resulting in dull and muddy drawings.

Artists working in pastel must also choose their supports very carefully. Most work on paper (although Luttrell, oddly, also worked on copper). Very smooth paper is not appropriate for a pastel drawing. It must have a rough surface, so that the pigments can be "grabbed" by the "tooth" of the paper. In most eighteenth-century pastel portrait drawings, the chalky pigments cover the paper's entire surface, creating an opaque layer that reflects light, in contrast with the transparent layers of oil or watercolor through which light passes. Because pastel pigments rest so tenuously on top of the paper (a jolt to the surface can dislodge the particles of color), finished drawings must be coated with fixative. Considering pastel's fugitive nature, it is amazing that after nearly three hundred years so many works by Johnston survive.

As noted above, pastel was not widely used in early-eighteenth-century Europe. While works in pastel appear first in the late fifteenth century, many are preliminary sketches and not completed works of art, such as Leonardo da Vinci's portrait of Isabella d'Este of 1499 (Louvre, Paris). Artists' interest in the medium began to grow in the last quarter of the seventeenth century as technological advances improved the quality of pastel crayons and a wider range of colors was introduced. Pockets of pastel artists emerged in Italy, France, and Ireland, but broad use did not begin until the second quarter of the eighteenth century, encouraged in part by the work of Rosalba Carriera (1675–1757), an Italian artist who lived in France in the 1720s and transformed female portraiture with her light, lively images of the French aristocracy.

Art historian Whitney Chadwick connects the emergence of Carriera and several other prominent women portraitists to the growing role of women as art patrons and cultural powerbrokers and the emergence of the Rococo style in France. The Rococo was an outgrowth of the Baroque, maintaining the earlier style's complex compositions, yet Rococo artists preferred colors lighter in tone than the deep, rich hues of the Baroque. Instead of compositions organized primarily around vigorous diagonal lines and dramatic poses, Rococo compositions are based on softly curving lines and gentle, ballet-like poses. It is a relaxed and spontaneous style, appropriate for the casual, pleasure-loving court of Louis XV, where it first developed in the early eighteenth century. Intriguingly, Chadwick links the popularity of pastel among the French elite to the increasing use of cosmetics. The dry, chalky pigments of pastel are similar to those upper-class women used to make up their faces. Much like cosmetics, the Rococo style cre-

ated an "aesthetic artifice," abandoning psychological revelation for a more su-
perficial flattery. It is an art of surface elegance and sensation.[3]

The association between pastel, the Rococo, and the emergence of profes-
sional woman artists may not be relevant for Johnston because she worked so
early in the century. Yet one sees in her work the Rococo emphasis on pale col-
ors, flattering likenesses, surface effects, and diaphanous material combined with
the more Baroque directness of gaze favored by Lely and Kneller. And it is in-
teresting that she was a woman and chose to work in pastel, a medium that was
later viewed as appropriate for women's "feminine sensibilities." A more impor-
tant consideration for Johnston was probably the medium's portability and the
minimal number of supplies needed to create pastel drawings. As she traveled
from Dublin to London, from London to Charleston, and later from Charleston
back to London and to New York City, she could easily carry her materials with
her. There is no doubt that she brought pastel crayons and paper to Carolina,
for there were none available there and she had to stop working when her sup-
plies ran out. Gideon Johnston, writing to a member of the Society in July 1710,
commented, "my wife who greatly helped me, by drawing pictures, has long ago
made an end of her materials."[4] Shortly thereafter "a small packet of Crayons"
was sent to "Mrs. Johnston" by the Society.[5]

Immigrating to America

No portraits beyond the 1705 image signed "Henrietta Johnston" survive from
the earliest years of her second marriage, 1706–07. Apparently she was adjust-
ing to life as a clergyman's wife and the mother of four, as Gideon had two sons
from an earlier marriage, James, age ten in 1705, and Robert, age eight. Her sec-
ond husband, the son of an Anglican minister, was born in Tuam, County Mayo,
Ireland, in 1668. Gideon Johnston attended Trinity College, Dublin, one of the
finest schools in the British Isles, and assumed the pulpits of several Irish
churches after his 1692 graduation.

Why the Johnstons desired to move to America is unclear, although Gideon's
active involvement in the Society for the Propagation of the Gospel in Foreign
Parts certainly played a role. There is also evidence that he had accumulated a
significant amount of debt in Ireland, and may have had to leave or be jailed.
In 1706 or early 1707, Gideon Johnston applied to the Society for a position as
commissary, shortly after the Carolina Assembly had approved public taxation
to fund Anglican churches and their clergy and sent the Society a request for
more ministers. The Society was the Church of England's missionary division,
committed, as their name suggests, to spreading Anglicanism abroad. Johnston's
appointment was a significant one for the church, which feared the strength of
Catholic Spain in Florida and viewed Carolina as a bulwark against the spread
of Catholicism in the southeast. Johnston's primary task was to secure the place
of the Anglican Church in Carolina. A secondary objective was to convert African
American slaves and Native Americans. As commissary, Johnston was also ex-

pected to supervise fellow Anglican ministers and missionaries and report on the activities of the clergy of other faiths, assignments that caused him no end of trouble.

The Johnstons settled in London early in 1707, where Gideon pressed the Society for an answer to his application. Initially they hesitated because he was a family man and they considered the conditions in Carolina too arduous for women and children, but they finally relented and proceeded with his appointment. The Johnstons began their journey early in 1708 with great hope, having read and heard optimistic accounts of Carolina. As Gideon Johnston later wrote, he was seduced by descriptions of "the goodness of the Climate, the fertility of the Soil, the plenty of all things necessary for the life of Man. [T]he Peaches, the Nectarines, with the Super-abundance of which they feed their Swine; their Grapes, their Pears . . . the Variety of their animals, and the vast deal of fine wood they have, fit for all manner of work."[6] Their voyage went smoothly until they landed in the Madeira Islands off the coast of Portugal. There, Gideon Johnston went ashore to collect supplies and the ship proceeded before he returned. Henrietta Johnston landed at Charleston, unsure if her husband was alive or dead. One can only imagine her desperation, a woman in her mid-thirties arriving in an unknown country with four children.

Gideon finally arrived weeks later, much worse for the experience. On the approach to Charleston he was marooned on a small island in the bay with a merchant and a sailor. The sailor attempted to swim to shore and drowned. Johnston and the merchant were rescued after twelve days with no food and water beyond "Sea Weeds and his own urine, which he was obliged to preserve as the Choicest Cordial in Shells."[7] His health never completely recovered, and he was unable to write for nine months. Henrietta penned his first letters to England, which detailed their difficulty regaining the parsonage, the bickering of his parishioners, who resented an appointment made 3,000 miles away, and his ill treatment at their hands. In a letter that presents a dramatic contrast to his earlier optimism, Gideon wrote, "I have never repented so much of any thing, my Sins excepted, as my coming to this Place, nor has ever Man been treated with less humanity and Compassion considering how much I suffered in my Passage, than I have been since my Arrival in it." He begged to be reassigned, noting his willingness to accept an appointment in "the meanest thing in South Brittain, for I should be ashamed to return to Ireland."[8]

Early-Eighteenth-Century Charleston

Throughout his years in Charleston, Gideon Johnston maintained a steady correspondence with his sponsors in the Society and his friends back in England. His letters, published together in 1946, are an incredibly rich resource, revealing the circumstances that he and Henrietta faced and offering an insightful first-person account of early-eighteenth-century Charleston, between persistent complaints about his poor health and lack of money. Typical is a passage in a

letter of July 5, 1710: "As my Body is a Scene of diseases, so is my family of poverty and misery. And my necessity's are so far from lessening, that they dayly increase upon me; For what between poverty, disease, and debts, both I and my family . . . are in a most miserable and languishing Condicon."[9] Written primarily to his financial supporters, we can understand why he might exaggerate his desperation, yet the man who emerges from the letters strikes one as a complainer, a hypochondriac, and someone completely overwhelmed by difficulties that left him dumbfounded. His bias against the city and its residents is clear in this passage from a letter of September 20, 1708:

> The People here, generally speaking, are the Vilest race of Men upon the Earth they have neither honour, nor honesty nor Religion enough to entitle them to any tolerable Character, being a perfect Medley or Hotch Potch made up of Bank[r]upts, pirates, decayed Libertines, Sectaries and Enthusiasts of all sorts who have transported themselves hither from Bermudas, Jamaica, Barbadoes, Montserat, Antego, Nevio, New England, Pensylvania, & c; and are the most factious and Seditious people in the Whole World.[10]

Johnston's severe disappointment in his post appears to be in direct proportion to unreasonably high expectations prior to his journey. Another minister and close friend of the Johnstons, Reverend Doctor Francis Le Jau (c. 1665–1717), a Frenchman also appointed by the Society to serve in Carolina, paints a far more optimistic picture, noting Johnston's effectiveness as a pastor and describing the country as "mighty agreable."[11] In fact, Charleston was undergoing rapid change for the better by the time the Johnstons arrived. John Lawson, who visited Charleston in 1709, described the city as having

> very regular and fair streets, in which are good buildings of Brick or Wood, and since my coming thence [in 1701] has had a great addition of beautiful large Brick buildings. . . . this place is more plentiful in Money than most or indeed any of the [colonies] on the Continent. . . . the merchants are fair, frank traders. The Gentlemen seated in the country are very courteous, live very nobly in their houses, and give very genteel entertainment to Strangers and others that come to Visit them.[12]

The founding of Carolina was similar in some ways to that of Maryland, discussed in Chapter 5. Charles II, newly restored to the throne, in 1663 and 1665 granted eight noblemen proprietorships for the land from Virginia's south border to about fifteen miles south of current-day Daytona Beach, and from the Atlantic to the Pacific. As Lords Proprietor they owned the land and parceled it out to willing settlers very cheaply or for free. They named the land Carolina, from Carolus, the Latin translation of Charles, in honor of the king (not until 1712 was it officially divided into South Carolina and North Carolina). Charleston (or Charles Town, as it was then known), established in 1670, was also named in honor of the king. Placed at the mouths of the Cooper and Ashley Rivers, it was an ideal port with ready access to the hinterlands. From the beginning it was a very carefully planned city, one of only two in the colonies

to be laid out in a logical way (the other was Philadelphia). Charleston's roads were organized in an eight-block grid pattern, although like most colonial towns they remained unpaved, with street traffic that included free-roaming chickens and pigs. High walls, ditches, and bastions surrounded the city to protect it from the Spanish, Native Americans, and pirates.

In 1690, Charleston's population was about 1,100. It grew to 3,600 by 1706, with about 250 dwellings. By 1700 active trade in lumber, skins, and slaves created prosperous merchants, and before mid-century a plantation economy developed around the cash crops of rice, indigo, and sea island cotton. Luxury goods such as fine furniture, clothing, and jewelry began to appear in Carolina wills and inventories around 1700. As historian Forsyth Alexander explains, "Economic expansion and the rise of considerable personal fortunes produced an increased interest in the arts, education, science, and other intellectual pursuits."[13] Of course, it was the wealthy planters and merchants who composed the bulk of Henrietta Johnston's patrons. During "the season"—from May to November each year—the planters moved to town to escape malaria. This concentration of wealth and leisure time resulted in a cultural milieu unparalleled in any other southern colonial town, with musical entertainment, socials, balls, and lectures. Presumably it was during the season that Johnston was most active as an artist.

St. Philip's and its parsonage appear on a map of 1704, at the western edge of the city. The church was a small structure built in 1683 of black cypress wood on a brick foundation. On a later version of the map, St. Philip's new church, begun during Gideon Johnston's rectorship, looms over the town. It is the largest of six structures depicted, understandably so, as Anglicanism was established as the official religion of the colony in 1706. Non-Anglicans could, however, settle freely in Carolina and practice their religion without persecution. This degree of religious toleration attracted other Protestant sects, Quakers, and even Jews. Roman Catholics were not welcome because of the anti-Catholic hostility of the Anglicans and Charleston's powerful Huguenot community, who had suffered under the Catholic regime of France. St. Philip's parsonage was a two-story brick structure, one room deep, flanked by two large gardens. It was situated immediately outside the city walls, across a drawbridge, and was surrounded by a partial wall but open to the countryside beyond. It came with two slaves, a man and a woman, and cattle.

Charleston Portraits

Even if Gideon Johnston's complaints were exaggerated, the income his wife generated from her artwork was critical to the family's support. They were aided as well by charity and credit extended by local shopkeepers. Henrietta Johnston's earliest extant American pastel portrait, an image of Mary DuBose, dates from her first year in the colony, 1708. Johnston's class, her Huguenot heritage, and her ability to speak fluent French probably endeared her to Charleston's French population. In fact, it appears that the Johnstons preferred the city's

Henrietta Johnston, *Mary DuBose,* 1708. Pastel on paper (12 ½ × 7 ¼ inches). Gibbes Museum of Art/ Carolina Art Association.

French settlers to the English, for they maintained close friendships with many prominent Huguenots, some of whom joined St. Philip's. The Huguenots were among the city's oldest residents. A number had immigrated as early as 1679 and after the revocation of the Edict of Nantes in 1685. South Carolina had the largest percentage of French settlers of the thirteen colonies, and they played a major role in the colony's politics, economy, and culture. By 1700, 195 Huguenot families lived in and around Charleston. By 1710, Huguenot immigrants owned more than 104,000 acres of South Carolina land, developing vast plantations that resulted in astonishing economic success. Others, including Mary DuBose's husband Samuel Wragg, made a fortune selling slaves (he was also kidnapped in 1718 by Edward Teach, the notorious Blackbeard the Pirate, but released unharmed).

The portrait of Mary DuBose is a fine and quite typical example of Johnston's Charleston work. She is represented bust-length, slightly smaller than Johnston's Irish sitters at nine by twelve inches. Johnston also drew her sisters, Judith and Ann, in 1719 and 1722. The sisters were the stepdaughters of Dr. John Thomas, whom Gideon Johnston described as "a ffrenchman, the only P'son that deserves the name of Phisician in this place." The pastels may have been created as payment for debts incurred when Dr. Thomas treated the Johnstons during their many illnesses or as tokens of appreciation, for, as Gideon Johnston wrote, although Thomas "has constantly attended us on all occasions. . . . When I call'd for a Bill . . . he told me he wou'd not take one single farthing from me."[14]

As with the sitters in Johnston's earlier work, Mary DuBose's body is turned slightly to the right and her head slightly to the left. Johnston's female sitters all wear low-cut dresses with gauzy white chemise beneath light-colored gowns; Mary's gown is yellow with brown shadows. Johnston's male sitters wear street clothes and the exaggerated curled wigs then in vogue. The women's hairstyles reflect the current fashion at Queen Anne's court in England, with the crown brushed back from the forehead and long curls falling over the shoulders. Each of Johnston's American sitters has unusually large eyes, the result, most likely, of her reliance on a formula rather than careful observation of the sitter. The ears' placement and her sitters' small, stiff arms also suggest a lack of training in anatomy, although the taut diagonal line of the tendon accentuating DuBose's long, elegant neck indicates some awareness. Johnston probably rendered the background, hair, and dress first, drew the neck and face next so they would not be darkened by falling pastel dust, and then the highlights. Lines were blended with a paper or leather stump to keep the edges soft.

The Charleston portraits' colors are lighter than those of Johnston's Irish period, although they may have faded due to the stronger light of the American south, or she might have used her pastels more sparingly as her supplies dwindled. They also lack colored spandrels. Some of the portraits appear more quickly drawn and less carefully finished than her Irish work. Instead of the careful shading of the lady in gray, Johnston's portraits of Colonel and Mrs. Samuel Prioleau have hard, barely blended lines defining the crown and jaw line. This might be explained by the conditions under which she worked in 1715, a year of great hardship due to her husband's absence and the Yamasee Indian War.

A charming portrait that departs from the mellow colors of the majority of Johnston's Charleston work is the image of Henriette Charlotte de Chastaigner of 1711, which is distinguished by the sitter's luminous dark eyes, scarlet hair ribbon, and shaded background. Her dark, almost black hair contrasts effectively with her smooth white skin and rosy cheeks and lips. The nose is especially well modeled. An inscription on the portrait's support reads "Henrietta Johnston fecit Charlestown / South Carolina Ano 1711 / Mademoiselle Henriette Charlotte De Lisle agee de 11 et 4 mos" (Henrietta Johnston made this Charleston / South Carolina Year 1711 / Miss Henriette Charlotte De Lisle age 11 years and 4 months), which reflects the fact that Charleston's Huguenot community continued to write and speak in French. Henriette Chastaigner was the daughter of Alexander Thesée Chastaigner, Sieur de Lisle, who fled France after the Edict of Nantes was repealed. The title "sieur" is similar to the English "esquire," indicating that he was a gentleman and possibly a lawyer. He served in the General Assembly of South Carolina.

Like her Irish work, Johnston's Charleston pastels are not portraits of great psychological depth, although the sitters appear to relate more directly to us because they are placed closer to the picture plane. Instead, they emphasize the social status and mores of the class that led Charleston society. Her subjects include members of the Bacot family, prominent Huguenots; Colonel William Rhett, one

of the most powerful men in South Carolina; and Thomas Boughton, the colony's governor. What, one might ask, encouraged their desire for likenesses of themselves? Certainly their motivation was similar to other colonial patrons who wished to leave a record of their appearance for their heirs. Johnston executed a number of portraits of children, evidence that documenting lineage was a concern. Communicating refinement and cultural sophistication in a town where both were lacking was also a powerful incentive. And one cannot help but think that some of the portraits were commissioned out of kindness, to help the nearly destitute artist and her family.

Of course, her subjects' placid features give no indication of the difficulties the artist continued to face. In 1710 Gideon Johnston wrote of his wife, "God has pleased to visit her with a long and tedious Sickness; she is struggling with the fflux and the ffeaver, as so am I."[15] At another point he wrote, "this Distemper is one of those incident to this Climate and has been fatal to a great many this Year. It is not now so violent on me or my wife, having put some stop to it by the use of hypocochoana & Laudanum, but we cannot . . . intirely shake it off."[16] They were also beset by contentious church politics despite Gideon's attempts to please not only the Anglicans but also the Dissenters, non-Anglican Protestants such as Presbyterians, Methodists, Congregationalists, Anabaptists, and Quakers, who outnumbered members of the Church of England in Charleston. Despite these difficulties, the Johnstons oversaw the building of a new church several blocks from the old St. Philip's, which upon completion was considered one of the handsomest churches in the colonies. It burned in 1835 and was replaced by a similar structure that stands on Church Street in Charleston today. Gideon also persuaded influential Charlestonians to establish a school there. His letters speak of his commitment to preaching, saying prayers with his congregants, catechizing children, visiting the sick, taking care of the poor, and burying the dead.

In April 1711 Henrietta Johnston returned to England with the primary objective of soliciting more money from the Society. Her husband could not legally leave Charleston because of his accumulated debt. Pirates waylaid her ship off of the coast of Virginia, and Gideon Johnston presumed her dead until word arrived that the ship had escaped. Henrietta Johnston presented a petition to the Society requesting an additional eighty pounds a year and the appointment of a schoolteacher, at thirty pounds a year, to help her husband. Johnston stayed in England for eleven months, spending part of that time visiting her stepson James who was in boarding school near London. The Society granted her petition in March 1712 and she returned to Charleston.

In March 1713 Gideon Johnston, his son Robert, and a Yamasee Indian boy named Prince George traveled to England because of Gideon's poor health, which he believed would be relieved by the air of South Britain. Almost immediately, Henrietta Johnston wrote of her difficulties at home. Two hurricanes had flooded the city, one of which had blown the roof off of the new church. Further disagreements developed between the Huguenots and the Anglicans. The

Yamasee Indians became increasingly hostile due to rampant enslavement of their people and mistreatment at the hands of skin traders. Full-scale war broke out in April 1715, when the Yamasee attacked several isolated plantations and killed about one hundred settlers. Frightened farmers abandoned their plantations and flocked to Charleston for protection. Henrietta Johnston took in Dr. Le Jau's family and many others. Nevertheless, the commissary seemed reluctant to return and remained abroad for more than two years, finally arriving in Charleston in September 1715. Early on his wife had questioned his resolve to return. In a letter of August 2, 1713, describing the discord between the French and English clergy, she concludes, "I write you this that you may make use of it, as you see fit at home, if you ever design to return hither."[17]

Upon his return, the commissary found the parsonage crowded with refugees and his companion, the Yamasee Prince George, viewed with suspicion. The Yamasee War soon came to an end, however, when enemies of the Yamasee, the powerful Cherokee nation, "came down a month ago in a submissive manner, and made Peace with us with their wild Ceremonyes of Grave Danceing, wherin they Strip'd themselves and layd their cloaths . . . att the feet of some of our most considerable men, who in return must do like to them, this Exchangeing of Cloaths & smoaking out of the same Pipe is a solemn token of reconciliation of Friendship."[18] The coalition of settlers and Cherokee proved too much for the Yamasee. Henrietta Johnston continued to create portraits throughout the war, as is evident in the 1715 date of the Prioleau portraits.

Henrietta Johnston's Later Life and Reputation

Gideon Johnston died on April 23, 1716, just months after his return from England. He had accompanied a group of well-wishers to an island in the bay to bid farewell to Governor Craven, who was traveling to England to attend to personal affairs now that the Yamasee War was over. On the return to the mainland, the boat capsized and Johnston drowned. In a tragic irony, his body was washed up several weeks later on the island where he was marooned in 1708. It is unclear how Henrietta Johnston and her children supported themselves after Gideon Johnston's death, although Dr. Le Jau wrote to the Society requesting that the "pious and charitable Body" provide assistance for "Mr. Commrys Widow, two daughters and a niece all young women left here in sad Circumstances, besides two sons he had in England" (Robert had joined James at boarding school).[19] Henrietta Johnston's daughter Mary returned to England at some point and eventually served as a dresser to the daughters of King George II. Mary died in 1747, leaving a hefty will that mentions Johnston's sister Ann de Beaulieu and two friends of her mother's in the colonies, Mrs. Joseph Wragg (Judith DuBose), who Johnston drew in 1719, and a Mrs. Allen, of Cape Fear, North Carolina.

Johnston remained in Charleston. Little is known about how she spent her time, although she continued to produce portraits. A document from 1719 provides the only indication of the payment Johnston received for her work. An estate account for Mrs. Elizabeth Sindrey contains this notation: "To Cost of Mr. Clapp picture being two pistoles [pastels] paid Mrs. Johns[t]on . . . 10.00 [pounds]."[20] Also in 1719, Johnston would have experienced the transition of South Carolina from a proprietorship to a crown colony and a war with the Spanish colonists of Florida.

Charleston continued to grow economically and culturally in the 1720s, and literally as well—the western fortifications by the parsonage were torn down, and the grid of streets extended. St. Philip's prospered under the direction of another Society appointee, Reverend Alexander Gardner. The new church building was completed and the school Gideon Johnston initiated opened. In 1725 Henrietta Johnston traveled to New York City. The reason for the trip is unknown, but it may have been to earn money drawing portraits. At least five portraits exist from the trip; four depict members of the Moore family, Colonel and Mrs. John Moore and their children Thomas and Frances Lambert Moore. John Moore was the son of the secretary of the province of Carolina before the family moved north in 1696. The portrait of ten-year-old Frances is among the most Rococo of Johnston's works. She is shown waist length in a very adult gown with dainty white flowers in her hair, holding her skirt or a cloak to her chest. The Rococo style was well established in Europe by 1725, and Johnston may have seen other Rococo works in New York. The last securely dated portraits by Henrietta Johnston were created in 1726.

The final document related to Henrietta Johnston is the notice of her burial in the churchyard of the new St. Philip's on March 7, 1729. Her gravestone could be found there as late as 1826, but has since disappeared. In the decades that followed her death Johnston's work was certainly prized by her sitters and their heirs, even as other more skilled artists such as Jeremiah Theus and Henry Benbridge settled in Charleston. Beyond her sitters' relatives, however, her name was not widely known until 1899 when Reverend Robert Wilson published a list of fifteen portraits by Johnston in *The Year Book of the City of Charleston,* writing, "Whether Henrietta Johns[t]on was maid or wife we do not know, but we owe her a debt of gratitude for leaving us the counterfeit presentments of so many representatives of names famous in the early life of South Carolina."[21] Interest in Johnston grew in the 1920s when Eola Willis published articles identifying her as America's first professional woman artist. In the 1940s Anna Wells Rutledge made the connection between Henrietta and Gideon Johnston, and was the first to use his letters to illuminate her life and work. In 1966, Margaret Simons Middleton published a comprehensive account of what was known about Johnston to that date, again using her husband's letters extensively. Beginning in the 1970s, scholars inspired by feminism to redress the biases of the patriarchal canon of Western art history began to include Johnston in studies of women artists. In 1979 Feminist artist Judy Chicago included Johnston as one

of 999 "Women of Achievement" whose names are inscribed on the floor of her massive installation *The Dinner Party.*

In 1980, nine portraits by Johnston appeared in an estate auction in Ireland. The sale catalogue showed the portraits installed along a winding stairway at Belvedere House, an eighteenth-century country house in Westmouth County. This provided further insight into Johnston's career in Ireland. In 1991, Johnston's Irish and American works were exhibited together for the first time in exhibitions in Winston-Salem and Charleston, along with an exhibition catalogue that included new research on Johnston's life and work. Today, Johnston's portraits are recognized as an astonishing accomplishment for a woman who worked in exceedingly difficult circumstances. Despite a complaining husband and a large household to run, twice widowed, often ill, subject to pirate and Indian attacks, she remained committed to her artwork. Equally impressive, she was an intrepid traveler (the trip from Charleston to New York was an achievement in itself for a single woman in the early eighteenth century, not to mention four voyages across the Atlantic). Her work is also the result of a fascinating combination of French and English culture—French in Johnston's heritage, her Huguenot sitters, and her medium; English in her training, her reliance on English Baroque portrait devices, and her Anglican context—and in this way it typifies the cultural eclecticism of American colonial art.

Notes

1. Klingberg, *Gideon Johnston,* 31.
2. *Dictionary of Art,* s.v. "Lely, Sir Peter."
3. Chadwick, 141–43.
4. Klingberg, *Gideon Johnston,* 35.
5. Quoted in Alexander, 11.
6. Klingberg, *Gideon Johnston,* 60.
7. Quoted in Middleton, 7.
8. Klingberg, *Gideon Johnston,* 19–22.
9. Ibid., 35.
10. Ibid., 22.
11. Klingberg, *Dr. Francis Le Jau,* 24.
12. Quoted in Craven, 248.
13. Alexander, 19.
14. Klingberg, *Gideon Johnston,* 41–42.
15. Ibid., 35.
16. Ibid., 55.
17. Quoted in Middleton, 31.
18. Quoted in Ibid., 40.
19. Klingberg, *Dr. Francis Le Jau,* 177.
20. Quoted in Alexander, 16.
21. Quoted in Bolton, 41.

Bibliography

Alexander, Forsyth, ed. *Henrietta Johnston: "Who greatly helped . . . by drawing pictures."* Exhibition Catalogue. Winston-Salem, NC: Museum of Early Southern Decorative Arts, 1991.

Bolger, Doreen, et. al. *American Pastels in the Metropolitan Museum of Art.* Exhibition Catalogue. New York: Harry N. Abrams, 1989.

Bolton, Theodore. *Early American Portrait Draughtsmen in Crayon.* New York: Frederic Fairchild Sherman, 1923.

Butler, Jon. *The Huguenots in America: A Refugee People in a New World Society.* Cambridge, MA: Harvard University Press, 1983.

———. "The Revocation of the Edict of Nantes and Huguenot Migration to South Carolina." In *The Huguenot Connection: The Edict of Nantes, Its Revocation and Early French Migration to South Carolina,* edited by R. M. Golden. Dordrecht, The Netherlands: Kluwer Academic Publishers, 1988.

Chadwick, Whitney. *Women, Art, and Society.* Rev. ed. London: Thames and Hudson, 1996.

Craven, Wayne. *Colonial American Portraiture: The Economic, Religious, Social, Cultural, Philosophical, Scientific, and Aesthetic Foundations.* Cambridge: Cambridge University Press, 1986.

Edgar, Walter. *South Carolina: A History.* Columbia, SC: University of South Carolina Press, 1998.

Fraser, Walter J., Jr. *Charleston! Charleston! The History of a Southern City.* Columbia, SC: University of South Carolina Press, 1989.

Klingberg, Frank J. *The Carolina Chronicles of Dr. Francis Le Jau, 1706–1717.* Berkeley: University of California Press, 1956.

———. *The Carolina Chronicles: The Papers of Commissary Gideon Johnston, 1707–1716.* Berkeley: University of California Press, 1946.

Middleton, Margaret Simons. *Henrietta Johnston of Charles Town, South Carolina: America's First Pastellist.* Columbia, SC: University of South Carolina Press, 1966.

Nash, Gary B. *Red, White and Black: The Peoples of Early North America.* 4th ed. Upper Saddle River, NJ: Prentice Hall, 2000.

Rutledge, Anna Wells. *Artists in the Life of Charleston: Through Colony and State from Restoration to Reconstruction.* Philadelphia: American Philosophical Society, 1949.

———. "Who Was Henrietta Johnston?" *Antiques* 51 (March 1947): 183–85.

Saunders, Richard, and Ellen Miles. *American Colonial Portraits, 1700–1776.* Exhibition Catalogue. Washington, D.C.: National Portrait Gallery, 1987.

Severens, Martha R. "Who Was Henrietta Johnston?" *Antiques* 148 (November 1995): 704–09.

Willis, Eola. "The First Woman Painter in America." *International Studio* 87, no. 362 (July 1927): 13–20, 84.

———. "Henrietta Johnston, South Carolina Pastellist." *Antiquarian* 11, no. 2 (September 1928): 46–47.

Gustavus Hesselius (1682–1755), Colonial Realist

The work of Gustavus Hesselius, when compared with other colonial American portraits of the early eighteenth century, is noteworthy for its directness and uncompromising realism. This is particularly apparent in the two portraits for which he is best known, of the Lenni Lenape Indians Tishcohan and Lapowinsa, painted in 1735. The Native American chiefs, their chests bare, regard the viewer with penetrating gazes. Tishcohan has a slight smile but his brow is furrowed. Lapowinsa appears more careworn and a bit suspicious or skeptical, as the vertical lines between his eyes suggest. Hesselius captured the deep wrinkles around his mouth and carefully delineated each strand of gray hair on his head. While portraits by Hesselius's contemporaries, such painters as Justus Engelhardt Kühn and Henrietta Johnston, reveal a degree of idealization consistent with early-eighteenth-century European portraiture, Hesselius presents Tishcohan and Lapowinsa with a convincing naturalism that is quite distinctive. These are considered the first true Native American portraits produced in the English colonies—true, because they depict individuals rather than stereotypes. Was it Hesselius's Indian sitters that encouraged such scrutiny, in that they could not be depicted using standard formulas? Or was there something unique about the artist and his background?

Hesselius's straightforward approach to his Native American subjects may be due to his training, about which we know little, or the growing scientific interest in detailed images of races Europeans considered exotic. More importantly, it relates to circumstances surrounding the portraits' creation. They were painted when Tishcohan and Lapowinsa were in the midst of land negotiations with Thomas and John Penn, the stepsons of Pennsylvania founder William Penn. Commissioned by John Penn, the portraits are connected to the notorious Walking Purchase, a low point in white treatment of Native Americans. Thus, they are

not only the finest works by an important colonial painter, but also significant historical documents connected to a crucial episode in Pennsylvania history.

Gustavus Hesselius was a Swedish-born artist who settled in Philadelphia in 1712. While his story is consistent in many ways with the experiences of other immigrant artists in America, it also indicates the new directions that American painting would take as patrons grew wealthier and more sophisticated. In addition to the portraits of Tishcohan and Lapowinsa, Hesselius depicted community leaders and the cultured elite in Philadelphia and Annapolis, Maryland, where he lived in the 1720s. He left a forceful self-portrait, among the earliest extant by an American painter, suggesting his awareness of the growing status of colonial artists. Hesselius's work also demonstrates his patrons' interest in subjects beyond portraiture. He painted at least two church altarpieces, and two paintings of mythological subjects thought to be the first created in British America.

But it is the portraits of Tishcohan and Lapowinsa and their intriguing context that demand the most attention. Their striking visages contrast with earlier images of Native Americans, even those by John White addressed in Chapter 1. White's objective was to document the dress, markings, and surroundings of the Southeastern Woodland Algonquian; his subjects' faces, while ethnically correct, are generalized. They appear to be types—the warrior, the shaman, the chief's wife—rather than specific individuals. Hesselius's images seem to be genuine portraits that engage with the sitters' appearance and dress, but also with their personalities. Hesselius's intense analysis of the Indians' faces and characters may have been informed by the study of physiognomy, a popular eighteenth-century pseudo-science. Physiognomy, discussed below, analyzed facial features for what they reveal about the subject's state of mind, personality, and moral values, insights important to the works' patron, John Penn.

Hesselius's Background and Move to America

Gustavus Hesselius was born in Falun, central Sweden, in 1682, into a family committed to the Swedish Lutheran faith. His father, Andreas Olai Hesselius, moved the family to Folkärna when Gustavus was four to assume the pulpit of a Lutheran church. Four of Gustavus's brothers would become clergymen and five of his sisters would marry ministers. He was also related to Emanuel Swedenborg (1688–1772), the radical theologian, philosopher, and mystic who posited the demise of Christianity and proposed a new church, which his followers (known as Swedenborgians) would call the Church of the New Jerusalem, utilizing the term from the Book of Revelation for the dwelling place of the faithful after the Last Judgment (see Chapter 4). Swedenborg's ideas about religion attracted considerable attention in the eighteenth and nineteenth centuries, influencing the study of physiognomy and such important artists and thinkers as William Blake, George Inness, Ralph Waldo Emerson, and W. B. Yeats. Perhaps it was something common in their upbringing that made Hesselius a spiritual seeker as well. In America he was initially active in the Swedish Lutheran Church, then joined the Church of England in Annapolis, and after his return

to Philadelphia, associated with the Moravian Brotherhood before reverting to the Lutheran Church shortly before his death in 1755.

Swedish immigration to America began in 1638, inspired in part by the colonial aspirations of King Gustavus Adolphus. Settling primarily in what is today Delaware, southern New Jersey, and southeast Pennsylvania, they named the area New Sweden and built a fort at Christina (now Wilmington, Delaware). The Swedish colonists had both positive and negative interactions with the local Native Americans, although it appears that their relations were more amicable than most. In the 1640s, a Swedish clergyman produced a dictionary of the Algonquian language, into which he later translated Luther's catechism. The Dutch took New Sweden through military action in 1655, when about seventy-five Swedish families lived in the area. In 1664 the English conquered the Dutch. When William Penn took possession of the region in 1683 over one thousand Swedes lived there. He described them as "a plain, strong, industrious people. . . . I must needs commend their respect for authority and their kind behavior to the English. . . . As they are a people proper and strong of body, so have they fine children, and almost every home is full. . . . I see few young men more sober and industrious."[1]

Gustavus Hesselius attended the University of Uppsala in Sweden between 1690 and 1700; documents describe him as a *conterfejare,* or wood engraver and gilder. He immigrated to America in 1712 at age 30 with his brother Andreas, who was appointed pastor of a Lutheran church in Christina. Why Gustavus accompanied his brother is unknown, although Sweden was in the midst of an economic slump following a military defeat by the Russians in 1709. On their way they stopped in London, where Hesselius received a letter and passport from William Penn introducing him to Pennsylvania's colonial government. Perhaps they also visited Emanuel Swedenborg, who was studying in London at that time. Hesselius stayed in Christina only a few weeks before he moved to Philadelphia and gave his letter of introduction to the colony's deputy governor, securing his support. Philadelphia was an auspicious choice, for as a relatively new town it had no painters of skill. The Quaker settlers of Pennsylvania initially had little interest in the arts, which, in keeping with their plain ways, they considered a self-indulgent extravagance.

Hesselius reported that he first lived in Philadelphia with "a saddlemaker called Rabbinson he treated me very badly." In 1714 Hesselius married Lydia Gatchell, a native of Boston, at the Swedish Lutheran Church in Wicaco (south Philadelphia). He described her as having such a "pious, virtuous and God-fearing disposition, that I can never stop praising her." Shortly after his marriage, he wrote a letter to his mother. This rare document—one of only two surviving letters by Hesselius—reveals his fascination with his new home:

> this city is very beautiful and lovely and abundant with God's blessings on both land and sea, there grow so many lovely types of fruit and in such great amounts, that you can feed your pigs with it. . . . Apples there are plenty of, they make a kind of a drink of, which they call Scider is extremely good, and is used instead of beer. . . . There are many hundreds of types of trees here that I do not know

the name of. The forest is very lovely and beautiful, there is no garden in Sweden so wonderful to walk in, as the forest here in America and smells so good. . . . Watermelons are plentiful, very good to eat, they are sweet like sugar and filled with juice they chill so good and quench one's thirst, but if you eat too many of them soon you will start to shiver. . . . It is a very water-rich country, with plenty of fish. . . . I have many times gone out fishing and caught 6 to 8 dozen fish in just one hour.[2]

Hesselius's lengthy and enthusiastic descriptions of indigenous plants and fish suggest a well-educated man with the eye of a naturalist.

Lydia's father gave the couple a stone house with a garden; together Lydia and Gustavus had five children. Hesselius appears to have done well in Philadelphia, although his words are somewhat contradictory. He wrote his mother, "I now live among the English in Philadelphia have thank God my rich livelihood among them. there is no Portrait Painter here, work I have enough, money is scarce. For a Portrait I only have a meagre 4 pound. . . . Since I came to this country I have earned 600 pound; but here everything is too expensive."[3] Around 1719 or 1720 Hesselius and his family moved to Annapolis, perhaps encouraged by Lydia's sister's husband, Reverend Henry Nicols, who probably informed Hesselius of the renovations of St. Barnabas Church in Prince George's County and the need for a painter. Shortly after his move, Hesselius's name appeared in church records. Annapolis was experiencing rapid economic and cultural growth in the 1720s. Hesselius purchased a thirty-five acre tract of land he named "Swedenland" that his brother described as "a fine plantation" where "the ground is full of various colors, which serve the art of painting and which otherwise would have to be imported from England at great cost."[4]

There is additional evidence that Hesselius ground his own pigments, another indication that he had professional training.[5] Among his earliest extant American works is a portrait of James Logan probably painted between 1715 and 1720. Logan, a Quaker who held the most important position in Pennsylvania politics as the secretary to William Penn and acting governor, is plainly dressed, his face emerging from dark shadow. Unfortunately, the portrait has been extensively overpainted and therefore it is impossible to use it to assess Hesselius's technical skills. It suggests, however, that Hesselius utilized the same Baroque style as Justus Engelhardt Kühn (discussed in Chapter 5), which was established in seventeenth-century Europe by the Flemish painters Peter Paul Rubens and Anthony Van Dyck. The Baroque style was carried to Sweden by David Klöcker Ehrenstrahl (1629–98), the founding father of Swedish painting and court painter to Charles XI of Sweden. Ehrenstrahl created portraits of the royal family that Hesselius certainly knew. Hesselius's dark, warm palette, strong modeling in light and dark, his attempts (not always successful) to create three-dimensional environments for his sitters, and the use of "feigned" (painted) ovals in the portraits of Tishcohan, Lapowinsa, and James Logan indicate his familiarity with the Baroque style.

Hesselius returned to Philadelphia in the late 1720s. In 1735, the year he painted the portraits of Tishcohan and Lapowinsa, he purchased property on

High Street where he lived until his death. By 1735 Philadelphia was a thriving metropolis with a sophisticated intelligentsia that included the printer Benjamin Franklin, a professional acquaintance of Hesselius. It was also the government seat of a colony founded upon visionary ideals and unprecedented treatment of Native Americans. It is more than mere coincidence that Hesselius's sympathetic portraits of Lapowinsa and Tishcohan were painted in Pennsylvania.

William Penn's "Holy Experiment"

The colony in which Hesselius settled was distinct in many ways from the other British colonies. Like Carolina, though, Pennsylvania was a Restoration colony, established after Charles II regained the English throne in 1660. Initially the English expressed little interest in the region, concentrating instead on New England and the Chesapeake area. But as the crown's imperial ambitions grew, Charles II recognized the potential of the fertile, temperate region that would become known as the "middle colonies": New York (taken from the Dutch by the English military in 1664), New Jersey, and Pennsylvania. Unlike Carolina, which was shared by eight Lords Proprietor, the land that would become Pennsylvania was given by Charles II to William Penn alone. This 1680 grant consisted of 45,000 square miles, the largest amount of land ever awarded to a single individual. As with the Carolina proprietors, who had helped re-establish the monarchy, the king was in debt to Penn's father, Admiral Sir William Penn, for lending him over sixteen thousand pounds. When the Admiral died, the king owed William the debt payment.

In addition to the need to settle his debt, the king saw the land grant as a solution to the "Quaker Problem" in England. At age twenty-three Penn joined what would come to be known as the Society of Friends (Quaker was a derogatory term that alluded to the Friends' claim to tremble at the word of God). A committed member of the Society, Penn published over fifty pamphlets in its defense in the 1660s in response to the persecution the Friends faced after the Restoration, when special legislation was passed against them. He also spent time in jail because of his beliefs, and traveled to Holland and Germany to preach.

The Anglicans considered the Quakers a radical sect. Founded by George Fox in the 1650s, Quakers believed in pacifism and therefore refused military service. They also refused to swear oaths, to tithe to the Church of England or attend its services. They were welcoming to non-white races and those of other religions. Women held leadership positions in the Society and traveled independent of male escorts, which particularly irked the patriarchal Anglicans. They rejected ritual and the ordination of ministers, believing instead that one was responsible for developing a relationship with God by concentrating on the Inward Light, God's presence and will for each individual, a concept that the Anglicans viewed as overly mystical. Quakers also cultivated plain speech and dress to eliminate signifiers of social hierarchy.

Although they were both strict Protestant movements, the Puritans also distrusted the Friends. Cotton Mather, the prominent Puritan minister, described

them as "the chokeweed on Christianity."[6] In Boston four Friends were put to death between 1659 and 1661 for preaching publicly. Others fled to Rhode Island, where there was a higher degree of religious tolerance. Penn believed that the Quakers, and others oppressed for their religious beliefs, needed a secure sanctuary in the New World.

William Penn arrived in Philadelphia on October 29, 1682. His plan was to enhance his fortune and to create a utopian civilization based on the Quaker principles of pacifism, fair treatment of all, and religious tolerance. Unlike Puritan Massachusetts, his colony would have no official religion, but like John Winthrop, the founder of the Massachusetts Bay Colony discussed in Chapter 2, Penn's aspirations had a decidedly millennialist bent. George Fox preached of a "new found World" that would be established by "God's English Israel" (i.e., the Quakers, heirs to the promises God made to Israel's patriarchs). Penn could realize such ideas because of his wealth. Like Winthrop's Bay Colony, Penn claimed his settlement would be "an example . . . set up to the nations." Penn compared it to Israel's Mount Zion and the New Jerusalem, believing his mission was blessed by God. Pennsylvania would be "reserved to the last dayes" and Philadelphia, named after a holy city in the Book of Revelation, would "stand in the day of trial" and be "preserved to the end."[7] It is important to keep this in mind, for it explains in part Penn's radically different treatment of the Native Americans. It would be impossible, he believed, for Pennsylvania to play such a crucial role in the Second Coming of Christ if the Indians were mistreated.

What Penn called his "holy experiment" attracted many, and Pennsylvania became the fasted growing colony in British America. The population of Philadelphia grew from about two thousand in 1690 to over twenty thousand by 1770, second only to London in population among British-ruled cities. From the beginning Penn wished to avoid the overcrowding and social chaos of London, which he saw as responsible for the devastating plague and fire of 1665–66. Philadelphia's design was based on a simple grid plan, one of the few colonial cities to be so logically arranged, with a balance of domestic and public structures and green spaces. Like other successful colonial cities Philadelphia was situated on a river—the Delaware—and had a good port.

Penn's millennialism and pacifism (Pennsylvania was the only American colony with no armed forces) and the Quaker belief in the equality of races resulted in a relationship with the resident Native Americans that was markedly different than in the other colonies. Penn treated them with respect, insisting "I desire to enjoy [this land] with your Love and Consent, that we may always live together as neighbors and friends."[8] Penn believed that the Indians were the rightful owners of the property the king granted him and should be compensated for it. Through a series of meetings that began in 1682, he negotiated with the Lenni Lenape/Delaware Indians for their land. (*Lenni Lenape* is what the Native Americans of eastern Pennsylvania, New Jersey and Delaware called themselves. It means "common people" or "original people." *Delaware* was the name given to them by the English after the river along which they lived, which was in turn named after a British nobleman, Lord de la Warr.) Penn would not allow

other Europeans to settle on it until he purchased it from the Lenape, principally with trade goods such as kettles, tools, clothing, cloth, and shell beads. Lenape chiefs, or sachem, accepted the goods on their community's behalf and then distributed them. However, the Europeans and the Native Americans had entirely different views of the gifts' meaning and function, and the concept of land ownership. The Lenape believed that land was a gift from the benevolent Kishelëmukòna—the Creator—for all to share, like sunshine, water, or air, and Penn's goods payment for the use of the land, not for its permanent possession.

The Lenni Lenape had maintained their traditions longer than other coastal tribes primarily because there was little organized interest in their land prior to Penn's arrival. Part of the Algonquian language group, they were a nomadic people who moved with the seasons and depended on hunting and foraging for sustenance, but also raised corn, beans, and squash in the summer. Penn described them as "tall, straight, well built, and of a singular proportion; they are strong and cleaver, and mostly walk with a lofty chin," and noted, "they do speak little, but fervently, and with eloquence" (Penn learned the Algonquian language so he could deal with them directly instead of through translators).[9] By 1682, when Penn met with them, European diseases and alcohol had ravaged the Lenape, who were moving west in response to the influx of white settlers. Perhaps they decided they had little to lose in dealing with Penn. They may also have desired Penn's support in their disputes with the more militant Iroquois of New York.

Almost from the beginning there were challenges to Penn's proprietorship, with the colonists demanding a more direct say in their welfare. When Penn returned to England in 1684 to settle a dispute over the Maryland/Pennsylvania border, tensions escalated. The Quakers left in charge were inexperienced at governance, due in part to a strong anti-authoritarian bias developed under government-sponsored persecution in England. They quarreled with the non-Quakers—primarily Swiss, German, and Scotch-Irish—who were growing in number and had little interest in pacifism, racial equality, or Penn's authority, often refusing to submit the annual taxes he required of them. Penn did not return until 1699 and stayed only two years, moving back to London in 1701 for good. The issue of proprietary control would be a primary factor behind Penn's sons' negotiations with the Indians and the Walking Purchase. Another concern was William Penn's huge debts. Although the proprietor's altruism is clear, he was also a spendthrift who ran through much of his inheritance, made little money with the colony, and eventually spent time in debtor's prison.

The Walking Purchase and Hesselius's Indian Portraits

When William Penn died in 1718, control of Pennsylvania and his debts went to his wife Hannah, and at her death in 1725, to her sons Thomas, John, and Richard Penn. Evidently quite different from their stepfather—they converted to Anglicanism and had little concern for the Native Americans—the Penn

brothers usually remained in England, ruling the colony through James Logan. William Penn's vision of Pennsylvania as an example for all nations that would survive the last days died with him, as his sons faced a mountain of debt. Factions in the colony continually challenged their authority as proprietors. To secure control and pay their debts the Penn brothers decided they needed more land and encouraged illegal encroachment on the area north of Neshaminy Creek in and around the Forks of the Delaware near present-day Easton, Pennsylvania, ancestral hunting grounds that William Penn had reserved for the Lenni Lenape.

In 1734 or 1735 James Logan conveniently "discovered" a copy of a bogus 1686 deed supposedly signed by the Lenni Lenape ceding the contested land to William Penn. Although negotiations did take place in 1686 there is no proof that the purchase was ever concluded or the Lenape paid for the land. Despite this, the fake deed convinced the Indians to meet with the Penn brothers at Pennsbury, their family manor near Philadelphia in May 1735. This is when Hesselius painted the portraits of Tishcohan and Lapowinsa, two of the Indian sachem with whom the Penns negotiated (some speculate that Hesselius painted now lost portraits of the other chiefs as well). The sachems acted as community representatives; they could not sell the land without the clan elders' approval, so nothing was finalized. John Penn may have considered it politic to commemorate the meeting with respectful portraits of two men he wished to please. Yet their unusual degree of realism suggests other factors at work as well.

Hesselius's interest in painting Indian portraits and his fascination with Native Americans date to his earliest years in the colonies. In the 1714 letter to his mother he expressed his initial impressions. While his words reflect racist biases typical of eighteenth-century Europeans, the letter is worth quoting at length because it provides insight into the portraits of Tishcohan and Lapowinsa:

> Concerning the Indians it is a savage and terrifying folk. They are naked both menfolk and womenfolk, and have only a little loincloth on, they mark their faces and bodies with many kinds of colors as red, blue and black. . . . They grease their bodies and head with bearfat and hang broken tobacco pipes in their ears, some hang rabbit tails and other devilments, and they think they are totally beautiful. I have always thought of painting an Indian and sending to Sweden but have not seen any for a while. Last year one of their kings visited me and saw my portraits they astonished him very much. I painted also his face with red color he gave me an otterskin for my trouble and promised I could paint his portrait to send to Sweden; but I did not see him later. The king is no better then the others, all go naked and live worse than swine. I have also been in their village . . . some miles from here. They build their houses of bark and wish to please us; give us food and drink but God save us from their food. Some time they eat man meat when they kill each other. Last year I saw with my own eyes that an Indian killed his Wife in bright daylight in the street here in Philadelphia, and that bothered him nothing. . . . Otherwise they are very friendly with the Christians and do us no harm and would rather defend us if it should be needed.[10]

Clearly Hesselius's impressions of the Lenape were built upon both personal ob-servation and preconceptions about appropriate dress, body adornment, and behavior resulting from his European upbringing (e.g., there is no evidence that the Lenape were cannibals). One can only imagine what an Indian painted red by a European artist might look like. Hesselius's preoccupation with Indian dress and markings is consistent with what we see in the portraits of Lapowinsa and Tishcohan. One also wonders if Hesselius's later, more direct contact with Lapowinsa and Tishcohan and with William Penn's ideas tempered his racist perspective. His later association with the Moravian Brotherhood, a sect that welcomed people of color and especially embraced the Lenape certainly sug-gests so, as do the portraits themselves; their expressiveness indicates Hesselius's strong personal response to his sitters.

Hesselius was the first American artist to realistically depict the facial char-acteristics of the North American Indian. Although Lapowinsa and Tishcohan share large, rather bulbous noses, high cheekbones, and piercing eyes, they are clearly individuals with distinctive features and expressions. Hesselius took care to represent their accoutrements and the ways in which "they mark their bod-ies." On Lapowinsa's forehead either tattoos or paint form curved lines that re-semble two birds in flight and a snake. Dark parallel lines extend across his lower cheek from the corner of his mouth, and there are markings on his throat similar to a necklace. On his chest is a pouch probably used for carrying to-bacco made of chipmunk skin (the chipmunk's forelegs are tied on either side to a cord around his neck and its light-colored head forms a flap). Over Lapowinsa's left shoulder and around his waist is a blue cloak, perhaps a wool blanket given to him by the colonists. The blue color contrasts effectively with the warm red-brown tones of his skin. A lock of long black hair falls over his right shoulder. Tishcohan also wears a blue cloak and a chipmunk skin pouch— here, the chipmunk's back legs and tail are visible because he wears the cloak lower on his waist than Lapowinsa. Inserted in the pouch is a white clay pipe of colonial manufacture. He has no tattoos or face paint, in fact Tishcohan means "he who never blackens his face" (Lapowinsa means "he who goes away to gather fruit"). Tishcohan has a small goatee, an unusual feature for a Lenape, as they generally plucked their sparse facial hair. The differences in the Indians' ex-pressions are striking. Tishcohan appears pleased to have his portrait painted, Lapowinsa, much less so.

The realistic detail of the sitter's faces does not carry over to their bodies. In both portraits the Indians' torsos are handled much more summarily, with just a suggestion of musculature. Curiously, the shoulders underneath the blue cloaks appear to have disappeared, or at least do not correspond in size with the opposite shoulders, evidence that Hesselius had limited training in anatomy. Perhaps the faces were painted from life but the bodies were not.

The soft, blurred treatment of the sitters' torsos places further emphasis on their faces. Hesselius's detailed approach to the Indians' features and expressions may have been influenced by widespread interest in physiognomy. Physiognomy was a psuedoscience by which human character could supposedly be discerned

by analyzing facial features. Today it is universally discredited, although we still attempt to "read" faces. External forms—the forehead's height, the shape of the nose, the placement of wrinkles and even moles—were believed to reveal one's inner spirit. Physiognomy has a long history in the West. Aristotle wrote one of the earliest Western treatises on physiognomy. Physiognomic analysis was practiced in Ancient Rome and during the Middle Ages and Renaissance, when facial characteristics, and therefore personality, were often linked to celestial bodies, much like John Foster's Man of Signs, discussed in Chapter 2. In the seventeenth century, Shakespeare, Jonson, and Milton employed physiognomic analysis in literature. The new art academies established at this time relied on physiognomy to codify the meaning of facial forms and expressions in painting and sculpture. David Klöcker Ehrenstrahl, the leading painter in Sweden during Hesselius's youth, was academically trained in Paris and well acquainted with the work of Charles Le Brun, the head of the French academy, who wrote and lectured extensively on physiognomy.

The eighteenth-century Enlightenment abandoned astronomical physiognomy for a more scientific approach, culminating in the writings of Johann Casper Lavater (1741–1801). Lavater was strongly influenced by Hesselius's cousin Emanuel Swedenborg, who advanced the study of physiognomy by writing about the spiritual "correspondences" between internal emotions and external facial features. Lavater's first publication on physiognomy in the 1760s, which further popularized the practice, relied heavily on the ideas of Swedenborg, who he sought out in 1768.

Hesselius's attention to Tishcohan's and Lapowinsa's wrinkles may have been informed by an offshoot of physiognomy called metoposcopy that focused on the lines of the forehead. A popular mid-seventeenth-century physiognomic treatise that employed metoposcopy is Richard Sanders' *Physiognomie, and Chiromancie, Metoposcopie, The Symmetrical Properties and Signal Moles of the Body, Fully and accurately handled; with their Natural-Predictive-Significance*. According to Sanders, a forehead with both horizontal lines above and vertical lines between the eyebrows like Lapowinsa's indicated a melancholy disposition and a suspicious mind—"the forehead wrinkled or rough; the eyebrow inflexing and knitting toward the temple; the eyes little, roundish, or shining." Tishcohan's "right and straight lines have the significance of good conditions" although the broken line in the middle of his forehead could denote "crafty, dissembling persons." Tishcohan seems to have the most in common with Sanders's "strong man, or a man of fortitude," with "the head some what big; the hairs . . . between straight and curling; the forehead square, of a proportionable magnitude; the chin four square and hairy; the lips thin, the mouth being big." Sanders also discussed what distinguished the noble and heroic from the savage. Noble men have white complexions, yellow hair, and big eyes; while savage men have hard and rough foreheads and thick rugged hair.[11]

As this suggests, interest in physiognomic analysis increased as Europeans came into contact with other races. Because white men wrote the treatises, the Caucasian face was considered the ideal and the value of another race depended

on how much its facial forms deviated from the white countenance. Such ideas appear to have influenced William Penn, who wrote of the Lenape,

> Their eye is little and black, not unlike a straight-look Jew. The thick lip and flat nose, so frequent with east Indians [natives of Asian India] and blacks, are not common to them; for I have seen as comely European-like faces among them, of both, as on your side [of] the sea; and truly an Italian complexion has not much more of the white, and the noses of several of them have as much of the Roman.[12]

It seems likely that Hesselius would have relied on physiognomy when challenged to depict an unfamiliar race, as did many other eighteenth-century artists. Physiognomy's exacting analysis lent itself to Hesselius's innately realistic approach. Because we know so little about his training, there is no direct evidence that he studied physiognomy, although an understanding of its precepts was almost universal among professional European artists and others who used it to gauge a person's character and moral condition. Considering the circumstances of the portraits' creation, it would not be surprising if John Penn wanted meticulously detailed renderings of Tishcohan's and Lapowinsa's faces to provide insight into their temperaments. Hesselius's concentration on the Indians' faces distinguish his work from the portraits of Johnston, Kühn, and the Freake Painter, who relied instead on their sitters' clothing, surroundings, and portrait conventions to construct their identities.

According to an account of the May 1735 meeting, Lapowinsa "distinguished himself as the principal orator" of the sachem. Tishcohan believed that Logan was speaking to them honestly; his more benign expression might suggest his willingness to work with the colonists. The clay pipe in his pouch indicates a greater degree of contact with them and its placement over his heart could symbolize his sincerity.[13] John Penn took the portraits back to England. He did not return to Pennsylvania until 1737, determined to complete the negotiations. His resolve was inspired in part by recent meetings between Lapowinsa and some Huguenot settlers, which the Penns feared would encourage others to deal directly with the Indians rather than applying for land through the proprietors. Persuaded by gifts and a misleading map that minimized the amount of land the Penns wanted, the Indians agreed to the treaty in Philadelphia on August 24 and 25. Five sachem, including Tishcohan and Lapowinsa, signed the treaty; it was then witnessed by fourteen whites and twelve Native Americans, and sealed with the smoking of tobacco.

The Lenape agreed to give the Penns the land northwest of Neshaminy Creek that could be walked in one and a half days, hence the name *Walking Purchase*. What the Indians did not realize was that the Penns had arranged for a secret roadway to be cleared and had hired a team of trained runners who were able to cover thirty square miles a day, double the amount the Indians had anticipated. Horses carrying provisions and other interested white men accompanied them, as did two Lenape appointed to assure the honesty of the walk. The Indians repeatedly called after the whites, forbidding them to run, but to no avail. Tunda Tetamie, a Lenape, described what happened:

They accordingly had the Land walked over by what ye Indians call ye hurry walk & instead of following the Course of the River as they ought, they had a Line laid out by the Compass by wch: they were able to travel over a Vast Extent of Country, & by this time People came fast to settle the Land in the Forks, so that a short time it was full of Settlement & the Indians were oblig'd to remove further back.[14]

After the first day, Lapowinsa refused to send his representatives with the walkers. A contemporary reported that Lapowinsa stated that the whites "should have walkt along by the River Delaware or the next Indian Path to it, the Walkers should have walkt for a few miles and then have sat down and smoakt a Pipe and now and then have shot a Squirrel, and not have kept upon the Run, Run all Day," concluding that they "had got all the best of the land, and they might go to the Devil for the bad."[15] Ultimately Thomas and John Penn gained nearly twelve hundred square miles of the Lenape's ancestral homeland that they then sold for about ninety thousand pounds. So much, then, for William Penn's pledge that Pennsylvania's white settlers and Indians would "always live together as neighbors and friends."

John Penn's financial records indicate that Hesselius received 16 pounds for the portraits in June 1735, two years before the final negotiations took place. It is unclear if the swindle was planned from the beginning, but it is difficult to reconcile the sensitivity of the portraits, their evocation of human dignity, with the fraud that followed. As a further debasement, James Logan conspired with the more numerous and better-armed Iroquois to remove any remaining Lenni Lenape from the land. At a meeting in 1742, the Iroquois challenged "the misbehavior of our Cousins the Delawares with respect to their continuing to Claim and refusing to remove from some land on the River Delaware" and humiliated the Lenape thus,

> Let this belt of Wampum serve to Chastise You; You ought to be taken by the Hair of the Head and shak'd severely till you recover your Senses and become Sober. . . . We conquer'd You. We made Women of You. You know you are Women, and can no more sell land than Women. . . . We charge you to remove instantly. We don't give you the liberty to think about it. You are Women, take the Advice of a Wise Man and remove immediately.[16]

"We made Women of You" indicates that the Lenape were of inferior status. A Lenape sachem was then grabbed by the hair and forced out of the room.

Most Lenape traveled west, some settling as far away as the Ohio River. The few who remained in the area complained bitterly about the deception. Their revenge would come, however, 12 years later when they were the first Native Americans to ally with the French and attack the English during the French and Indian War. They decimated General Braddock's troops near Pittsburgh in 1755 and attacked outlying settlements in the Walking Purchase lands, led by the nephew of the sachem who was dragged by the hair.

To return to the questions posed at the beginning of this chapter, is the portraits' unusual realism due to the sitters' uniqueness, or was there something dis-

tinctive about the artist and his background? Probably a bit of both. The latter part of the question is difficult to answer without a better understanding of Hesselius's training, although his letters suggest a man with exemplary observational skills and a mind trained in Enlightenment empiricism. Hesselius's other portraits indicate that he applied his keen eye to all of his sitters, even the women. Certainly, the challenge to depict men unlike any he had painted before encouraged Hesselius to scrutinize their faces assiduously, inspired by his fascination with an unfamiliar race and perhaps the study of physiognomy. In addition, the demands of his patron for truthful likenesses he could study for insights into his adversaries might have augmented Hesselius's innately objective approach, resulting in the finest portraits the artist ever painted. The portraits of Tishcohan and Lapowinsa remained in England until 1834, when Granville Penn, Thomas Penn's son, gave them to the Historical Society of Pennsylvania.

Hesselius's Other Works

Hesselius's reputation as a realist was apparently well known in Philadelphia. James Logan wrote in 1733, "We have a Swedish painter here, no bad hand, who generally does Justice to the men, especially to their blemishes, which he never fails shewing in the fullest light, but is remarked for never having done any to ye fair sex, and therefore few care to sitt to him." Logan could not convince his wife and daughters to sit for Hesselius, writing that they believed, with Quaker modesty, that "the Originals have but little from nature to recommend them, would scarce be willing to have that little (if any) ill treated by a Pencil the Graces never favour'd."[17]

Like most colonial artists, to make a satisfactory living Hesselius was required to augment the fine art of painting with the utilitarian and decorative arts. He placed an advertisement in the December 11, 1740 edition of the *Pennsylvania Gazette* that reads,

> PAINTING done in the best MANNER by Gustavus Hesselius from Stockholm, and John Winter, from London, viz. Coats of Arms drawn on Coaches, Chaises, & c. or any other kind of Ornaments, Landskips, Signs, Shew-boards, Ship & House painting, Gilding of all Sorts, Writing in Gold or Colour, old Pictures clean'd and mended, & c.[18]

While the advertisement mentions painting and landscapes (very rare in the colonies at this time), surprisingly, there is no mention of portraits. Perhaps "painting" meant "portraiture"—the dominant theme in American painting throughout the colonial period. The other tasks listed are typical of the "painter-in-general," as such a jack-of-all-trades was known in the eighteenth century. Although none appears to have survived, there is documentation of the decorative work he did at St. Barnabas in Annapolis; at Thomas Penn's estate at Springettsbury, where he painted the interior, the tree and flower boxes, chairs,

Gustavus Hesselius, *Bacchus and Ariadne*, c. 1725. Oil on canvas (23¹/₂ × 31¹/₂ inches). Photograph. Gift of Dexter H. Ferry, Jr. © 1986 The Detroit Institute of Arts.

gates, and window lights; and at the Pennsylvania State House (Independence Hall), for which he was paid thirty-one pounds.

Despite such practical work, we can see further evidence of Hesselius's intellectual sophistication in his attempt to paint two themes from classical mythology. The earliest known paintings of mythological themes created in North America, today they are known as *Bacchus and Ariadne* and *Bacchanalian Revel*. Both depict Bacchus, the Ancient Roman god of wine. In their sensuality and abandon, these themes seem an odd choice for a devout Christian like Hesselius. Yet, since the earliest Christian period, Jesus was identified with Bacchus. Both were the divine sons of mortal women, both descended into the underworld but returned, and both promised their followers rebirth after death. Wine is a crucial element in Christian ritual, as it was in the Bacchic rituals of the ancient world. The attributes of Bacchus—wine, grapevines, and grape clusters—were assimilated by the early Christians to symbolize the wine of the Eucharist and therefore the blood of Christ. In *Bacchanalian Revel,* a maenad (female follower of Bacchus) stares reverentially at a large cluster of grapes, while another maenad points at grapes held by a child. *Bacchus and Ariadne* shows the god with his mortal bride Ariadne, the daughter of King Minos. Accompanied by an amor, or cupid, a maenad, and a satyr with a lion-drawn carriage, they are situated in a grove reminiscent of the mythological paintings of Titian or any number of seventeenth-century Baroque painters. Art historian Roland E. Fleischer, a Hesselius specialist, dates the paintings to early in his American career because of the awkward spatial relationships, perspective, poses (is the amor reclining or falling?), and anatomy (note the oddly shaped necks and boneless arms of Ariadne

and the maenad). Fleischer speculates that Hesselius may have painted them to advertise his skills at a time when he was optimistic about the tastes of his American patrons.[19] The paintings remained in the Hesselius family until the 1940s.

Hesselius's self-portrait of about 1740, painted when he was in his late fifties, suggests his awareness of visual artists' improving social status in the colonies. Borrowing the pose from a portrait by Godfrey Kneller (an English artist discussed in Chapter 6), Hesselius presented himself dressed as a gentleman in a deep blue coat, ruffled cravat, and white wig. His face is rugged and firm of jaw, defined by heavily applied layers of pigment. As in his Indian portraits, Hesselius accentuated his facial features to reveal his personality; he appears a frank and somewhat blunt individual, with a direct gaze that reminds viewers that he painted himself while looking in a mirror. His hands are small and elegant, distancing Hesselius from the manual realities of his trade. Hesselius painted the self-portrait around the same time that he placed the advertisement in the *Gazette*. Here, however, he is not the jack-of-all-trades but the respected professional. He was well known and well regarded in Philadelphia; Benjamin Franklin's account books refer to him as Mr. Hesselius, a title Franklin reserved for a select few of his most important business associates. It is difficult to imagine the Freake Painter producing a similar self-portrait, but by 1740, perceptions of the artist's place in society were changing, and self-imagery is among the best evidence of this transformation. Paul Revere, examined in Chapter 8, commissioned several portraits of himself, and John Singleton Copley and Benjamin West painted numerous self-portraits.

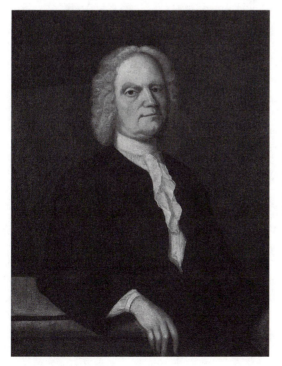

Gustavus Hesselius, *Self-Portrait*, c. 1740. Oil on canvas (36 × 28 inches). Courtesy of The Historical Society of Pennsylvania Collection, Atwater Kent Museum of Philadelphia.

Hesselius also created what are regarded as the first religious paintings executed in British America, two altarpieces that are also considered the first commissions for public buildings in the colonies. His first commission came in 1715 from the Swedish Lutheran church Gloria Dei at Wicaco, where Hesselius was a member. Peter Kalm, a friend of the artist, wrote that "Mr. Giosta [sic] Hesselius . . . gave to the church all his labor, but the church paid for the materials."[20] Although the subject of the now lost altarpiece is unknown, it was undoubtedly religious, considering its function. More certain is the Last Supper he painted for St. Barnabas in 1721. The church records indicate that Hesselius was commissioned to paint "ye History of our Blessed Savior, and ye Twelve Apostles at ye last supper. Ye Institution of ye Blessed Sacrament of his body and blood, Proportionable to ye space over the Altar."[21] The painting was replaced by another altarpiece in 1773, and was probably lost or destroyed at that time.

In 1744 Hesselius was called to the Moravian community in Bethlehem, Pennsylvania, in connection with the purchase of a church organ. Some scholars believe Hesselius built the organ himself, but Fleischer suggests that John Klemm, an organ maker mentioned in a letter from the Brotherhood to Hesselius, built it, and Hesselius handled only the purchase, installation, and decoration of the organ. In letters from the Moravians to Hesselius, he is referred to as "Brother Hesselius." By 1747 he had joined a Moravian congregation in Philadelphia. The 1741–43 visit of Count Nikolaus Zinzendorf, the German leader of the movement, had spurred the community's growth and influence.

Speculation about Hesselius's shifting religious affiliations ranges from one scholar's suggestion that he was "a soul searching religious rebel" to Roland Fleischer's insistence that Hesselius's association with the Lutherans, Anglicans, and Moravians did not reflect wavering religious convictions. Fleischer notes that the Swedish Lutheran and Anglican faiths were quite close, sharing ministers and doctrine, while the Moravians were thought to complement Lutheran belief; there were, after all, many Swedish Moravians in the 1740s. Yet Fleischer also documents the Philadelphia Lutherans' concerted efforts to bring Hesselius back into the fold. A Moravian acquaintance reported that "The Swedish Lutherans have lately made their abode much at Hezelius's & have labour'd diligely by lending him Books and Artfull Suggestions to draw him from the Bn. [Moravian Brotherhood]. . . . We hear & by these means he begins now to Stray from us & to speak against us."[22] Such efforts suggest Hesselius's prominent place in the Swedish community. Evidently it worked, for Hesselius returned to the Lutheran church at Wicaco in 1751 and was buried there four years later. That Gustavus remained closely connected to the Swedish Lutheran Church despite his wandering seems unquestionable. In addition to his brother Andreas, minister of the Swedish church in Christina, another brother, Samuel, arrived in 1719 to pastor churches in Pennsylvania and Delaware. In 1720 their cousin Jesper Swedenborg, also a Lutheran minister and Emmanuel's brother, arrived to work in the area as well. Upon his return to Sweden, Andreas published *A Short Account of the Present Condition of the Swedish Churches in America,* 1725, and later translated into English Jesper's *God's Holy Law of Destiny.* Further evidence of the fam-

ily's intellectual interests is the literary work of Andreas's son, Andreas Hesselius Americanus, born in Christina in 1714, who became "one of the best known and most prolific writers in Sweden about 1740, and composed what is probably the first drama in literature on an American Indian subject."[23]

Hesselius's influence on American art would be felt long after his death. One of his apprentices, John Claypoole, Sr., would instruct Matthew Pratt, who worked with Benjamin West in London. Hesselius's son John (1728–78) would replace his father as the leading portraitist in Philadelphia and Maryland in the mid-eighteenth century. Gustavus Hesselius's will instructed that his "chamber Organ, Books, Paints, Oils, Colours, and all [his] other painting materials and tools, and [his] unfinished Pictures" should go to John.[24] Building upon what Hesselius established, Philadelphia would develop a rich cultural life. E. P. Richardson, one of the deans of American art history, concluded his 1949 study of Hesselius with these words, which hold true today:

> Hesselius' art, with its classical and religious themes, at first glance so surprising in our colonial painting, represents this urbane and learned Philadelphia atmosphere. In fact, he seems the founder of a tradition. His ideal narrative subjects foreshadow the later art of Benjamin West. His mechanical gifts, his varied interests (if we may take his sympathetic Indian portraits as a hint of the scientific interests of Philadelphia) foreshadow the combination of artistic, scientific, and technical interests in the Peale family which dominated Philadelphia at the close of the century. To a striking degree, Hesselius embodies, if he did not create, the culture of the middle colonies, which was very different from that of either Calvinist New England or the Hudson River Dutch painters [portraitists of the New York area], and whose contribution to the formation of the new nation has not yet been given its proper weight.[25]

Notes

1. Quoted in Johnson, 23.
2. Arnborg, 5–8.
3. Ibid., 7.
4. Quoted in Fleischer, *Face Painter,* 21.
5. Swedish naturalist Peter Kalm wrote of the pyrites in the Lancaster region: "Mr. Hesselius had several of this kind of stone which he used in his painting. He first burnt them, then pounded or ground them into a powder and at last rubbed them still finer in the usual way and this gave him a fine reddish brown color." Quoted in Fleischer, "Study of His Style," 132.
6. Nash, *First City,* 23.
7. Hanson, 44–51.
8. Quoted in Taylor, 296.
9. Quoted in Showalter, 3, and Hanson, 64.
10. Arnborg, 7–9.
11. Sanders, 199, 246, 250, 254–55.

12. Quoted in Showalter, 3.
13. Bjelajac, 36.
14. Quoted in Hanson, 82.
15. Quoted in Kraft, 228.
16. Quoted in Hanson, 147–50.
17. Quoted in Tolles, 271–73.
18. Quoted in Fleischer, *Face Painter,* 23.
19. Ibid., 44.
20. Quoted in Fleischer, *Face Painter,* 45–46.
21. Quoted in Richardson, 224.
22. Fleischer, *Face Painter,* 25–27, 31.
23. Johnson, 47.
24. Quoted in Fleischer, *Face Painter,* 25.
25. Richardson, 226.

Bibliography

Arnborg, Carin K., trans. "'With God's blessings on both land and sea': Gustavus Hesselius Describes the New World to the Old in a Letter from Philadelphia in 1714." *American Art Journal* 21, no. 3 (1989): 4–11.

Becker, Marshall J. "The Swedes and the Dutch in the Land of the Lenape." *Pennsylvania Heritage* 10, no. 1 (Winter 1984): 20–23.

Bjelajac, David. *American Art: A Cultural History.* Upper Saddle River, NJ: Prentice Hall, 2001.

Carlsson, Sten. *The Swedes in North America, 1638–1988: Technical, Cultural, and Political Achievements.* Stockholm: Streiffert, 1988.

Colbert, Charles. *A Measure of Perfection: Phrenology and the Fine Arts in America.* Chapel Hill, NC: University of North Carolina Press, 1997.

Cowling, Mary. *The Artist as Anthropologist: The Representation of Type and Character in Victorian Art.* Cambridge: Cambridge University Press, 1989.

Fleischer, Roland E. "Gustavus Hesselius and Penn Family Portraits: A Conflict Between Visual and Documentary Evidence." *American Art Journal* 19, no. 3 (1987): 5–18.

———. "Gustavus Hesselius: A Study of His Style." Ian M. G. Quimby, ed. *American Painting to 1776: A Reappraisal.* Winterthur, DE: Winterthur Museum, 1971.

———. *Gustavus Hesselius: Face Painter to the Middle Colonies.* Exhibition Catalogue. Trenton: New Jersey State Museum, 1988.

———. "Gustavus Hesselius's Letter of 1714 and Its Contribution to Current Scholarship." *American Art Journal* 21, no. 3 (1989): 14–17.

Hanson, Stephen Craig. "Promised Land: The Holy Experiment and the Walking Purchase." Ph.D. diss., Lehigh University, 2001.

Johnson, Amandus. "History of the Swedes in the Eastern States from the Earliest Times Until 1782." In vol. 2 of *The Swedish Element in America: A Comprehensive History of Swedish-American Achievements from 1638 to the Present Day,* edited by Erik G. Westerman. Chicago: Swedish-American Biographical Society, 1931.

Kraft, Herbert C. *The Lenape: Archaeology, History, and Ethnography.* Newark: New Jersey Historical Society, 1986.

Nash, Gary B. *First City: Philadelphia and the Forging of Historic Memory.* Philadelphia: University of Pennsylvania Press, 2002.

———. *Red, White and Black: The Peoples of Early North America.* 4th ed. Upper Saddle River, NJ: Prentice Hall, 2000.

Reich, Jerome. *Colonial America.* 5th ed. Upper Saddle River, NJ: Prentice Hall, 2001.

Richardson, E. P. "Gustavus Hesselius." *Art Quarterly* 12, no. 3 (Summer 1949): 220–26.

Sanders, Richard. *Physiognomie, and Chiromancie, Metoposcopie, The Symmetrical Properties and Signal Moles of the Body, Fully and accurately handled; with their Natural-Predictive-Significance.* London: R. White for Nathaniel Brooks, 1653.

Showalter, Michael S. "Images of the Lenape Indians in Pennsylvania." *An Image of Peace: The Penn Treaty Collection of Mr. and Mrs. Meyer Potemkin.* Exhibition Catalogue. Harrisburg: Pennsylvania Historical and Museum Commission, 1996.

State Museum of Pennsylvania. "An Image of Peace: The William Penn Treaty." http://www.statemuseumpa.org/Potamkin.

Stemmler, Joan K. "The Physiognomical Portraits of Johann Casper Lavater." *Art Bulletin* 75, no. 1 (March 1993): 151–68.

Taylor, Alan. *American Colonies: The Settling of North America.* New York: Penguin Putnam, 2001.

Tolles, Frederick B. "A Contemporary Comment on Gustavus Hesselius." *Art Quarterly* 17, no. 3 (Autumn 1954): 271–73.

Wechsler, Judith. "Lavater, Stereotype, and Prejudice." In *The Faces of Physiognomy: Interdisciplinary Approaches to Johann Casper Lavater,* edited by Ellis Shookman. Columbia, SC: Camden House, 1993.

CHAPTER 8

Paul Revere (1734–1818), Artist and Revolutionary

Paul Revere's reputation as a key figure in the American Revolution rests not only on his brave ride but also on Henry Wadsworth Longfellow's famous poem, published in 1861, which begins,

Listen, my children, and you shall hear
Of the midnight ride of Paul Revere.
On the eighteenth of April in Seventy-five;
Hardly a man is now alive
Who remembers that famous day and year . . . [1]

Longfellow's poem recounts Revere's pivotal ride, including the signal from the North Church bell tower, "One, if by land, or two, if by sea," and his arduous passage through enemy lines to warn the patriots at Lexington and Concord of the approach of the British. The poem's importance in securing Revere's fame should not be overlooked. There was a second rider that night whom Longfellow did not immortalize, and his name—William Dawes—is almost lost to history. At Revere's death in 1818, his obituary does not mention the midnight ride, instead celebrating Revere for his business acumen, his many friends, and his benevolence. Surprisingly it also does not address Revere's career as the most important and prolific silversmith of eighteenth-century Boston. Today, those who know Revere's legendary stature as a patriot often do not know that he was also a skilled artist, producing elegant and functional works of silver, other metalwork, and prints that are among revolutionary Boston's most important visual documents.

During his lifetime Revere would have considered himself not an artist but an artisan, a skilled worker called a mechanic in the eighteenth century. As noted in the previous chapter, by the mid-eighteenth century a social distinction was

emerging in colonial society between fine artists—painters primarily—and artisans. Fine artists encouraged this distinction by emphasizing the refinement and education needed to paint, despite the fact that both artists and artisans worked with their hands. In addition, the gap between what are now called the decorative arts—aesthetically pleasing objects that serve a function—and the fine arts of painting and sculpture widened during the late eighteenth, nineteenth, and twentieth centuries. By 1970, however, with the postmodern breakdown of the prioritization of painting and sculpture and the recognition of the aesthetic validity of decorative arts forms, the line between the fine and decorative arts began to blur. Today decorative arts are exhibited alongside painting and sculpture in many museums. For this reason Paul Revere is now regarded as an artist, with creative and technical skills equal to those of painters and sculptors.

Recent scholarship suggests that despite American painters' efforts to distinguish themselves from artisans in the eighteenth century, the boundaries between the fine and decorative arts were even more indiscernible to the public than they are today. As American colonists grew wealthier, particularly in thriving urban centers like Boston, it is unlikely they made much of a distinction between a fine silver teapot and a portrait. Paintings were referred to as "wall furniture," and like all art forms were emblems of high social prestige, displayed to augment claims of status. Revere worked in an age when the demand for fashionable goods created what historians call a "consumer revolution," as Boston's elite built large homes with spacious rooms where they could host dances and tea parties in emulation of the English gentry. Revere's elegant silver vessels were popular items of conspicuous display.

As this suggests, what is so fascinating about Revere's life and work as an artist is how intimately they are connected to the crucial social and political issues of his day. First, his life exemplifies the breakdown of the traditional English social hierarchy into the more fluid social system that emerged in America. Second, the popularity of his silver reflects the growing wealth and cultural sophistication of the colonies and later the federal United States. Third, his prints helped encourage revolutionary sentiment, in addition to providing a visual record of the Revolution for posterity. He lived through a period of dramatic political, economic, and artistic change: the transformation from English colony to independent republic, from handcrafted goods to industrial production, and from the lavish Baroque style to the austere Neoclassical. This chapter will explore Revere's integrated identities as silversmith, printmaker, revolutionary, and entrepreneur.

Revere's Early Life and Career

Unlike most of the artists addressed in previous chapters, Revere's life was long and is very well documented. His father, Apollos Rivoire (1702–54), was a Huguenot from the Bordeaux region of France who immigrated to escape religious persecution, first to England in 1713 and then to America in 1716. Like Justus

Engelhardt Kühn, he was one of many European artisans attracted by the opportunities for skilled craftsmen. Rivoire had the great fortune to apprentice with the leading goldsmith in Boston, John Coney. (The term *goldsmith* is used interchangeably with *silversmith* for workers in fine metals. For Revere, *silversmith* is more appropriate because his work in gold was confined to small items like buttons, beads, and rings, few of which survive.) In 1729 Rivoire married Deborah Hitchborn, a member of an old New England family who served as her young husband's patrons and introduced him to prominent members of their church.

Apollos Rivoire anglicized his name to Paul Revere "merely on account that the bumpkins pronounce it easier," his son later revealed.[2] Paul Revere, Jr. (often referred to in the literature as Paul Revere II) was born on December 21, 1734, his parents' second child and first son. He attended North Writing School until 1741, and by 1748 began an apprenticeship with his father. In 1750 he was part of a guild of bell ringers who petitioned Christ Church to ring the bells for two hours each week, although his family belonged to New Brick Church, a strict Calvinist congregation. When his father died in 1754, Paul's apprenticeship was almost complete; however, he was not yet of age, so his mother ran the smithy and shop with Paul's help. Inheriting his father's clients and his tools, the younger Revere had a considerable advantage in the business. Silversmiths' tools were prohibitively expensive for most young men starting out in the trade, particularly the anvils, which were valued by weight. As a "largeworker"—a silversmith with full knowledge of all aspects of the trade who created large hollowware vessels such as tankards, teapots, and bowls—Revere needed several large anvils to succeed.

In 1756, at the age of 21, Paul Revere entered the infantry as a second lieutenant during the French and Indian War, when several sizable Native American tribes joined the French to challenge British hegemony in North America. He saw action at Crowne Point, on Lake Champlain, New York, in a battle described as short but quite intense. Revere was back in Boston by November 1756, working as a master silversmith with his younger brother Thomas as his apprentice. In 1757 he married Sarah Orne. Together they had eight children (six survived infancy) and purchased a house on North Square in Boston. Built around 1680 on the site of Increase Mather's parsonage, the Tudor style frame house is the only seventeenth-century row house that stands in Boston today and is currently a museum.[3] Sarah Revere died a few months after the birth of her eighth child on May 3, 1773. Revere married Rachel Walker in September 1773. Their courtship reveals Revere's tender side, for a love poem he wrote for her survives:

> Take Three fourths of a Paine that makes Traitors confess (Rac)
> With three parts of a place which the Wicked don't Bless (Hel)
> Joyne four sevenths of an Exercise which shop-keepers use (Walk)
> And what Bad men do, When they good actions refuse (Er)
> These four added together with great care and Art
> Will point out the Fair One nearest my heart.[4]

They also had eight children, although three died young. Once cannot help but speculate that Revere's business acumen related in some way to his need to support eleven children!

Craftsmen in colonial America experienced both significant challenges and unlimited opportunities. One difficulty was competition from England; most silver goods could be shipped from abroad and English wares were considered higher in quality and prestige. Yet the scarcity of skilled workers in British America could mean great success if one was willing to be flexible. Revere was typical of colonial craftsmen in the range of work he did. He manipulated metals of all sorts and produced a variety of prints, from book plates and business cards to broadsides and large-scale engravings. He even worked as a dentist, studying with a Dr. John Baker so that he could clean teeth and reset artificial teeth. Revere placed an advertisement in the *Boston Gazette* for his false teeth, claiming that he "fixes them in such a Manner that they are not only an Ornament but of real use in Speaking and Eating."[5]

Revere's shop was organized like any successful silversmith's workshop in Europe or America in the mid-eighteenth century. He would have had a room with a large forge where the silver was melted and refined. Here the more strenuous task of raising the forms through heating and hammering disks of silver on large anvils would take place. A smaller furnace, probably in the same space, would be used for annealing, the successive heating and cooling of the metal to make it less brittle. A separate room for engraving designs on the silver would have had large windows; bright light was needed for such fine finishing work. Engravers labored at tables with deeply scalloped edges; each concavity had a leather apron attached to the underside of the table that was tied around the worker's waist to catch gold and silver filings for re-melting. Every workroom would have had an array of tools hung on the walls to save space. The retail shop would be a third room at street level, where goods could be displayed and sold and orders taken. Generally, patrons provided some or all of the silver to be worked, often coinage that could be melted and refined. As a printmaker, Revere would have also had a printing press and the tools, plates, letter blocks, and paper needed to practice that trade. Revere trained a number of journeymen and apprentices, including his son, Paul Revere III, who ran his shop from 1775 to 1781 while his father fought in the Revolution. Revere was one of approximately seventy-five silversmiths in late colonial Boston, as the city maintained its status as the trade's center in British America. Valued for its flexibility, whiteness, and attractive reflectivity, silver was ideal for eating and drinking vessels because, unlike most metals, it is tasteless. About half the silver objects Revere produced were for dining and drinking.

Revere was recognized as a superior craftsman early in his career. Like all colonial silversmiths, he based his designs on European styles, which he knew through imported goods and stylebooks. His clientele—primarily prosperous merchants, lawyers, physicians, rural gentry, and churches—demanded wares that closely replicated those available in England. The dominant styles when Revere began his career were the Baroque and the Rococo, European styles estab-

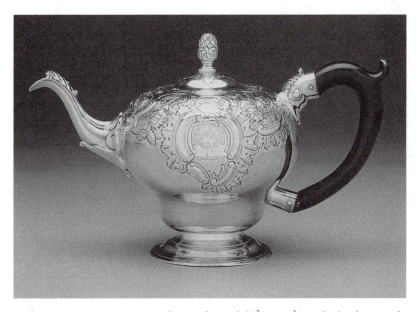

Paul Revere, Teapot, c. 1770. Silver and wood (6³⁄₄ × 3¹⁄₈ inches). Photograph. © 2003 Museum of Fine Arts, Boston.

lished in the seventeenth and early eighteenth centuries. In the decorative arts, the Baroque and Rococo were closely related in their visual vocabulary, with an emphasis on curving forms, asymmetry, and lively engraved and embossed decoration. In contrast, seventeenth-century American silver was restrained in form and decoration. This is apparent in a teapot Revere created around 1770, now in the Museum of Fine Arts, Boston. Its swelling pear shape typifies the exuberance of Baroque and Rococo silver, as does the play of light off of various surfaces. The concave and convex rhythms of the spout, handle, and body create a sense of movement that is characteristic of the Rococo style. Also consistent with the Rococo is the teapot's stylized organic decoration. The cartouche is engraved with an asymmetrical crest surrounded by wave-like acanthus leaves, flowers, and C-scrolls. Probably based on an English prototype, the crest indicates both pride and proof of ownership. The engraving around the pot's rim echoes the undulating forms below. The pineapple finial on the teapot's lid is evidence of Revere's awareness of current European fashion, for this was a new detail in Rococo silver. Such intricate ornamental effects create contrasts in light and shadow reminiscent of Baroque painting and sculpture.

Revere was also admired for his silver's fine proportions, where the body, its handle, base, spout, and lid all work together visually. It is important to remember that the style and decoration of a silver vessel is always subservient to the purpose it serves. In the case of a teapot, it must securely hold a hot liquid, be stable when set down, and have a workable spout and handle. Here, the handle is not silver but wood because silver conducts heat.

In the well-known portrait of Revere by the painter John Singleton Copley,

the artisan is shown at about age thirty-three, holding a bulbous teapot that resembles the one in the Museum of Fine Arts, Boston. The portrait is different from any examined thus far. Revere is in his shirtsleeves, without a wig, his tools placed before him on a polished mahogany table. The decision to depict Revere as a working artisan was highly unusual at a time when portraitists painted all sitters, even artisans, in fine dress, and it may be unprecedented in American colonial portraiture. In the portrait Revere appears to have been interrupted at his work, hand on his chin as if contemplating the design he is about to carve on the teapot. He looks up, confronting the viewer. The impression is one of an honest and thoughtful craftsman, a straightforward and self-assured individual.

There has been much scholarly speculation about Copley's unusual depiction of Revere. Wayne Craven, noted historian of colonial portraiture, presents the portrait as evidence of the American reverence for honorable work. With his tools and the result of his labor "thrust subtly towards the viewer," Revere's portrait is consistent with the Puritan emphasis on the sacredness of work (discussed in Chapter 3) and the contemporaneous celebration of work in Benjamin Franklin's writings.[6] Art historian Susan Rather argues that the portrait's statement about manual work was as much about Copley as about Revere. She posits that Copley emphasized Revere's labor to clarify the distance between Copley's social identity as a fine artist and that of Revere, a manual worker, although both were born and raised in similar circumstances (more on this in Chapter 9).[7] David Bjelajac links the portrait to Masonic imagery, noting that Revere's intense, centrally placed eye resembles the all-seeing eye of God that decorated Masonic materials, including engravings made by Revere. Bjelajac suggests that the Masonic eye of God symbolized His creative power and alludes here to Revere's abilities as a creative artist, which he will soon demonstrate by engraving the teapot.[8]

Revere's portrait was probably Copley's payment for the gold and silver frames and cases Revere made for him to hold miniature portraits Copley painted. Perhaps it functioned as an advertisement of sorts for Revere, who was experiencing a lull in production in the late 1760s. His pre-war income, which had reached a height of 294 pounds in 1762, was only 11 pounds in 1770 (although Revere's bookkeeping was erratic). The choice to be depicted in this way also separates Revere from the aristocratic airs of most portrait subjects, and therefore might reflect his revolutionary point of view. Craven describes the directness of his gaze as an "egalitarian feature."[9] Yet by showing Revere about to engrave a teapot, resting his hand against the sand-filled leather pillow he will use to support the teapot when he begins to carve, Copley asserted Revere's status among artisans, for engraving demanded the most skill and imagination, as Revere's thoughtful countenance suggests. Many Boston silversmiths subcontracted their hollowware to Revere to engrave because of his exceptional abilities. The prominence of the tools in the portrait is also significant. As noted, silverworking tools were expensive, passed down from father to son or purchased, they were part of the craftsman's sense of self, symbols of his identity.

The portrait's teapot may also be more than a reference to Revere's skill as a silversmith, for tea was a loaded commodity at the time. By the 1760s, tea-drink-

ing was one of the most widespread pastimes in the American colonies. Most drank tea at least two times a day, and a ritual-like atmosphere had developed around the act. Both the ceremony of serving tea and the implements involved— the tea table, the teapot, cups and utensils—were venerated. Tea was imported to the colonies in huge volumes, hence the seriousness of the tax on tea that was part of the Townshend Acts of 1767. The Townshend Acts were but one instance of many between 1765 and 1775 when the British raised taxes and trade tariffs to pay costs that remained from the French and Indian War. The new taxes also supported the growing British military presence in the colonies; forcing the colonists to pay for soldiers clearly placed there to police them was particularly problematic. The Townshend Acts infuriated Boston's merchants and artisans, who had grown wealthy with the lax enforcement of taxes and tariffs prior to 1765. They feared that Great Britain's greed would decimate their economy. Revere's firm grip on the teapot, so shiny and well painted that it competes for attention with his face, may allude to his loyalty to those who chose to boycott tea rather than pay British taxes.

Revere's Political Activities

Boston's mechanics were among the first to organize against the British, and Revere was a respected leader in the artisan community. He was actively involved in several revolutionary groups, including the North End Caucus, the Long Room Club, and the Sons of Liberty. What distinguished the Sons of Liberty was the combined membership of lower- and middle-class artisans with upper-class revolutionary leaders such as John Hancock and Samuel Adams. These are the men who grounded their revolutionary beliefs in Enlightenment philosophies of a universe based on order, reason, and the friendship of virtuous individuals, and who formulated an ideology of protest through meetings, speeches, and political tracts. Although a thorough analysis of the philosophies behind the Revolution and the actions that resulted are beyond this chapter's scope, it should be noted that Revere, among the upper echelons of Boston's mechanics, played an important role as a liaison between the revolutionary leaders and the city's artisans. Hancock, Adams, and Dr. Joseph Warren, all Harvard-educated men, relied on Revere to articulate their ideas to the lower classes, and respected him for this ability. Dr. Thomas Young, another patriot leader, described Revere as "my worthy friend. . . . No man of his Rank and Opportunities in life, deserves better of the Community. Steady, vigorous, sensible, and persevering."[10]

Revere was also a prominent Freemason, joining the secret society in 1760 at age twenty-five. As revolutionary agitation increased, many historians believe that the Masons were in the midst of it, possibly orchestrating the Boston Tea Party. Other scholars dispute this, arguing that there is no solid evidence linking Masonic organizations to political action.[11] Regardless, it was as a Mason that Revere honed his leadership skills, taking on increasingly important roles

in several lodges, where he learned the Masonic creed of fraternity, harmony, reason, and community service. Also, about half of his clientele were Masons.

It was for the Sons of Liberty that Revere created his most famous work of silver, the Sons of Liberty Punch Bowl, better known as the Liberty Bowl (Museum of Fine Arts, Boston). The bowl commemorated the result of John Hancock's attempt to provoke the British by bringing an illegal shipment of wine into Boston Harbor. This action encouraged 92 members of the Massachusetts House of Representatives to support Samuel Adams's Circular Letter of February 11, 1768, which summoned all colonial legislatures to resist the Townshend Acts and any further taxes without direct representation in Parliament. In refusing to rescind the letter, Massachusetts defied the direct order of King George III, a courageous act in the face of England's growing imperial ambitions.

Based on the shape of Chinese import porcelain punchbowls, the broad, low Liberty Bowl is simple in form but complex in iconography. It is inscribed below the rim with the fifteen names of the men who commissioned it and a statement celebrating the House's vote against repressive British policies, "To the Memory of the glorious NINETY-TWO . . . who, undaunted by the insolent Menaces of Villains in Power . . . voted NOT TO RESCIND." "The Glorious Ninety-Two" became a rallying cry at future political demonstrations. Above a circular crest is a Liberty Cap, a soft peaked hat that became a symbol of freedom, along with other references to human rights. Today it is considered the most famous example of American presentation silver, second only to the silver inkwell used in the signing of the Declaration of Independence as an important artifact of the Revolution.

One of Paul Revere's roles was that of courier for the Boston Committee of Correspondence, carrying dispatches between Boston and revolutionary groups in New York, Philadelphia, and outlying Massachusetts towns. A trusted messenger for Samuel Adams, Joseph Warren, and John Hancock, Revere delivered the news of the Boston Tea Party to New York in December 1773. In May 1774 he traveled to New York and Philadelphia to report on the Boston Port Bill, which closed the harbor. These are but a few of the many rides and riders he coordinated.[12] As a link between Boston and the Continental Congress in Philadelphia, Revere's political connections and influence grew—as did his fame. His cousin John Rivoire wrote from England that he had seen Revere's name in a London newspaper, which described him as an "Express from Congress of Boston to Philadelphia" (*express* is another word for courier on horseback).[13]

What fostered Revere's revolutionary ideals? Jayne Triber, author of a recent biography of the patriot, identifies as a factor his attendance, at age 15, at the sermons of West Church pastor Jonathan Mayhew, who preached against subservience to the British (and was the subject of one of Revere's earliest prints). Triber also believes that Revere wished to rise above his social station, thus the ideals of liberty and equality of opportunity based on individual merit attracted him, ideals nurtured by the Masons and the artisanal culture of Boston's North End. Revere, she writes, "was the product of a society that had very different

ideas about social structure and social mobility. In the colonies, individuals ex-pected personal independence and upward mobility." She concludes that it was "a combination of idealism, altruism, and self-interest" that spurred Revere's commitment to American independence.[14]

Revere's Printmaking

Paul Revere's actions as a revolutionary were not limited to his participation in revolutionary groups. He also utilized his skills as a visual artist to encour-age anti-British sentiment and further proclaim his dedication to the cause. His work as a printmaker was not inspired by the Revolution, however. As early as 1761 he purchased "half a Roiling Prefs" for 5.15 pounds and in 1769 he sold "a large rolling-press, for printing off a copper plate."[15] A 1765 newspaper ad-vertisement described a new book of Psalm tunes as "Engraved by Paul Revere." Soon he was creating certificates, periodical illustrations, advertisements, prints for mass distribution and political prints. Printmaking is a particularly appro-priate medium for political imagery. With the technique of copperplate engrav-ing, Revere could run dozens of prints from the same plate quickly and cheaply to spread revolutionary ideas to the broader public.

The tools and techniques needed to create copperplate engravings are very similar to those used to engrave silver. Revere's skill at working with silver would have easily translated to the carving of flat pieces of copper. Copperplate en-graving, an intaglio technique, is the opposite of the relief method of wood en-graving described in Chapter 2. The image is cut, or incised, in the metal with a sharp tool, so it lies below the plate's surface. Metal is harder to carve than wood, but it lends itself to fine lines, allowing greater detail, and the cuts do not wear as rapidly. The technique of copperplate engraving replaced woodcut as the primary method for the production of prints in America in the eighteenth century. As with woodcut, all forms carved into the plate will print in reverse, therefore any text must be incised backward. Once the design is complete, ink is rubbed on the plate's surface. It sinks into the incised lines and any excess ink is wiped away. A dampened piece of paper is placed on top of the plate and it is run through a printing press. The press forces the paper into the incised lines, where it takes up the black ink. The plate is re-inked and re-wiped for each impression.

While most of Revere's prints are based on designs by others, one of his ear-liest political images is believed to be his creation alone. *View of the Obelisk,* pub-lished in 1766, is a large print produced to commemorate the obelisk erected to celebrate the Stamp Act's repeal on May 16, 1766. The fight for the repeal of the Stamp Act—which required costly stamps on all paper products including newspapers, almanacs, playing cards, and commercial and legal documents—galvanized anti-British sentiment, particularly among those who depended on paper, such as merchants, printers, ministers, and tavern keepers. In his diary John Adams wrote, "The Year 1765 has been the most remarkable Year of my

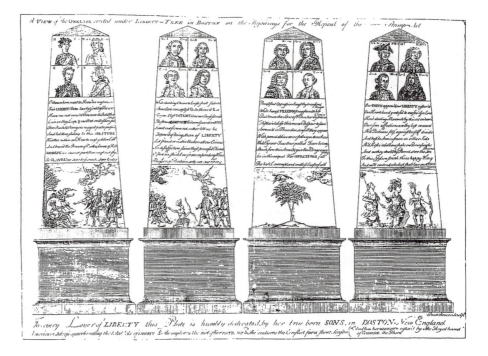

Paul Revere, *View of the Obelisk*, 1766. Engraving (9 3/8 × 13 1/4 inches). © Library of Congress.

Life. That enormous Engine, fabricated by the british Parliament, for battering down all the Rights and Liberties of America, I mean the Stamp Act, has raised and spread, thro the whole Continent, a Spirit that will be recorded to our Honour, with all future Generations."[16] Revere also welcomed the repeal for more practical reasons. Patrons did not order luxury goods like silver in a depressed economy.

The obelisk, formed of oiled paper and lit from within by 280 lamps, was raised on May 19 on Boston Common. Revere was probably involved with the obelisk's design and erection, for the print was ready that day as well. Unfortunately, the planned celebration, which included bell ringing, speeches, fireworks, parades, and other illuminated objects, was marred when the obelisk, "which was designed to be placed under the Tree of Liberty, as a standing Monument of this glorious Aera, by accident took Fire about One o'clock, and was consumed," according to a newspaper account.[17]

Revere's print, inscribed "To every Lover of LIBERTY" and dedicated to "the true born SONS, in BOSTON" shows a flat view of each side of the obelisk, with 16 portraits (4 per side) of Englishmen (and one woman) considered friends of the colonies. These include John Wilkes and William Pitt, who spoke out in Parliament against colonial taxes, and, somewhat surprisingly, Queen Charlotte and King George III, perhaps because George signed the repeal. The portraits, based on prints by other artists, reveal Revere's lack of anatomical train-

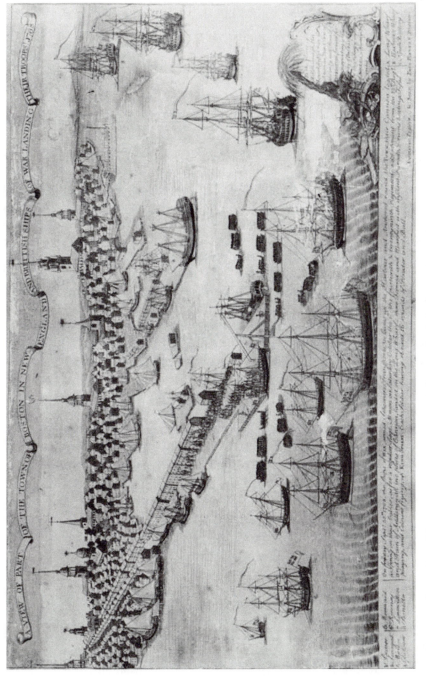

Paul Revere, *The Landing of the Troops*, 1770. Engraving (9¾ × 15½ inches). © Library of Congress.

ing in the distorted shapes of the heads and often awkward placement of the features. The story of the Stamp Act and the repeal are told below in text and images that represent America allegorically as a Native American woman. It is a straightforward and didactic presentation, with the obelisk's strict geometry relieved by the allegorical scenes' liveliness.

As tensions rose in Boston between the loyalist Tories and the patriot Whigs, King George III sent British troops to occupy Boston in 1768. Revere depicted the landing of the troops in a 9-by-15-inch print published in 1770. The print's inscription describes how the soldiers "Marched with insolent Parade, Drums beating, Fifes playing and Colours flying, up KING STREET." Revere appears to modify the print's outright bias by dedicating it to Lord Hillsborough, noting his "Well plan'd Expedition formed for supporting ye dignity of Britain and chastising ye insolence of America." Some regard this as sarcastic, for below the inscription an Indian woman symbolizing America places her foot firmly on the neck of a fallen British soldier.

Eight large man-of-war ships surround Boston, canons trained on the town, as longboats transport soldiers to Long Wharf. Only members of the British military are evident, no Bostonians, making the landing appear more like an invasion. Behind the port, Boston is depicted in great detail, probably based on a view of the city first published in 1723. Boston's seven main churches, particularly Christ Church to the right (better known as Old North Church, where the lanterns were hung), are rendered out of proportion to the other structures. Boston appears a peaceful, prosperous, pious city beset by hostile forces.

Revere's best known print is the dramatic rendering of the tragic Boston Massacre, the first open encounter between the British and the American colonists, on March 5, 1770. Printed 23 days after the event, the 8-by-9-inch print's intent was to serve as anti-British propaganda and fan the flames of rebellion. For this reason, Revere represented the massacre in an incendiary fashion that does not correspond with the facts. The image's inaccuracy is not its only controversial aspect. Some historians who have studied Revere's print believe that he stole the composition from a drawing that Henry Pelham, John Singleton Copley's half-brother, also published as a print. Copyright laws did not exist at this time, hence the widespread and legal copying of both images and text without credit or acknowledgment. A March 29, 1770, letter from Pelham to Revere clarifies his ire:

> When I heard that you was cutting a plate of the late Murder I thought it impossible as I knew you were not capable of doing it unless you coppied it from mine. . . . But I find I was mistaken and after being at the great Trouble and Expense of making a design paying for paper, printing & c. find myself in the most ungenerous manner deprived . . . of any proposed Advantage . . . as truly as if you had plundered me on the highway. If you are insensible of the Dishonour you have brought upon yourself by this Act, the World will not be so. However, I leave you to reflect upon and consider one of the most dishonorable Actions you could well be guilty of.18

There are several differences between the two prints, including the direction of the moon, the number of columns on the church steeple, and Revere's inclusion of a sign that reads "Butcher's Hall" above the heads of the soldiers. Pelham, the son of printmaker Peter Pelham, had more artistic training and his print is more freely drawn and more accurate in perspective. The inscriptions beneath the images also differ. Pelham's has a passage from Psalm 94 that suggests his print was intended as a call for peace. Revere's inflammatory poem describes Boston's "hallow'd Walks besmear'd with guiltless Gore" by "fierce Barbarians grinning o'er their Prey." Whose design came first may never be securely determined, but this does not detract from the power and immediacy of Revere's image.

Revere depicted the event as a confrontation between an organized, apparently impenetrable line of uniformed British soldiers with advanced weaponry against a motley, vulnerable, unarmed crowd of Bostonians. The quartering of British soldiers in Boston caused not only political indignation but also economic discord, as off-duty soldiers competed with Bostonians for odd jobs on the docks around the harbor. At 10:20 P.M. on March 5, a snowy evening that saw several mob actions in the city, resentment about the occupation boiled over as a mob taunted a sentry stationed near the Old Statehouse and First Church, the two large buildings in the background of the print. British soldiers came to the sentry's aid and someone (it was never determined who) yelled, "fire!" Two of the soldiers began to shoot. They could not have, in the midst of a near-riot situation, lined up, nor did the number depicted in the print open fire. The first to die was a free black, Crispus Attucks, described by witnesses as the rebellion's leader (although no African Americans appear in the print). Five Bostonians were killed and six wounded. Revere accentuated the victims' dark fate with the deep shadows and black smoke above them, as they collapse, bleeding profusely. A small dog in the center foreground attracts our attention; perhaps Revere intended to contrast the animal's innocence with the humans' barbarity.

The popularity of the print—which was also published as a broadside and illustrated a *Boston Gazette* account of the shootings—and the thirty imprints that still exist reveal the impact it had on anti-British feelings and ultimately the Revolutionary War. Shortly thereafter Revere published *The Landing of the Troops* to further capitalize on post-massacre outrage. Orders for Revere's prints rose into the thousands after 1770. Although quickly and somewhat crudely carved (the soldiers have disproportionately large heads and small feet), the Boston Massacre was ingrained in public memory because of this print. Revere knew the facts, for he drew a diagram of the confrontation used in the British soldiers' subsequent trial. The judge who presided over the trial warned jurors not to be influenced by the print's dramatic license. The trial further divided the city along class and ethnic lines. Many elite Tories supported the soldiers' right to defend themselves against a rowdy mob. To them the mob embodied the frightening growth of the city's poor, primarily Irish Catholic immigrants and African Americans who by 1770 composed almost one-third of Boston's adult male population. John Adams,

who defended the soldiers at trial, described the crowd as "a motley rabble of saucy boys, negroes and mulattos, Irish teagues and outlandish jack tarrs."[19]

From this point on, Revere's days and nights were consumed by revolutionary actions, often accompanied by the publication of a political print or cartoon. Using his skills as an artist to keep patriotic spirit alive, on the first anniversary of the massacre Revere created an illuminated tableau in the windows of his North Square home. In the first window he depicted the bleeding ghost of 11-year-old Christopher Sieder—murdered by Tory customs officer Ebenezer Richardson during a mob action on February 22, 1770—accompanied by the words "Sieder's pale Ghost fresh-bleeding stands / And vengeance for his Death demands." The second window depicted the British soldiers firing during the massacre, and the third a female allegory of America holding a staff affixed with a Liberty Cap, her foot on the head of a British soldier. The tableau was illuminated between nine and ten on the evening of the anniversary, viewed by "many Thousands" of spectators who "were struck with solemn Silence, and their Countenances covered with melancholy Gloom," according to the *Boston Gazette*.[20]

After the massacre Boston experienced a tense but comparatively quiet time until the passage of the Tea Act in 1773, which again inflamed its citizens. To relieve the financial problems of the British East India Company, Parliament and King George III decided to eliminate taxes for East Indian tea, thereby enabling it to be sold much more cheaply. However, American merchants had stocks of Dutch tea, which they now could not sell because it was more expensive than English tea. The colonists responded to the British monopoly on tea sales with another boycott and the Boston Tea Party of December 12, 1773, in which Paul Revere participated. A British ship loaded with tea was anchored in the harbor for days because Boston merchants would not allow the tea, a symbol of British control of colonial trade, to be unloaded. Revere was one of five men appointed to watch the ship. When Lieutenant Governor Thomas Hutchinson demanded that the tea be unloaded, under cover of night Revere and other patriots, dressed as Mohawk Indians, boarded the ship and dumped more than ten thousand pounds worth of tea in the harbor while hundreds of Bostonians watched from the wharves. This action, the last outbreak of large-scale mob violence in Boston before the war began, incited other colonies to do the same. Revere responded to the Tea Act with another political cartoon, *The Able Doctor, or America Swallowing the Bitter Draught*, 1774, in which the colonies are presented as a supine Native American woman forced to swallow a pot of tea by sinister bewigged and frock-coated men as an allegorical figure of Britannia buries her head in her hand. The Native American woman forcefully spits the tea back in the face of the man who holds her by the neck. The British responded to the Boston Tea Party by closing the harbor to all but food and fuel and appointing a council to rule the colony instead of elected officials. In support of Massachusetts, the First Continental Congress convened in Philadelphia in 1774 to address how to challenge British colonial domination, evidence of the increasing organization of resistance efforts.

The Midnight Ride

In 1798, thirty-three years after his famous midnight ride, Paul Revere sent a letter to the Massachusetts Historical Society recounting his experiences. In the fall of 1774 and the winter of 1775, he wrote, "I was one of upwards of thirty, chiefly mechanics, who formed ourselves into a Committee for the purpose of watching the Movements of the British Soldiers, and gaining every intelegence of the movements of the Tories." The group met secretly at the Green Dragon Tavern in Boston's North End (owned by Revere's Masonic Lodge), the location of much revolutionary planning. On Tuesday evening, April 18, 1775, after several days of suspicious activities, Revere wrote, "it was observed, that a number of Soldiers were marching towards the bottom of the Common. About 10 o'Clock Dr. Warren Sent in great haste for me, and beged that I would immediately Set off for Lexington" to warn Samuel Adams and John Hancock and the surrounding countryside of the troops' attempt to secretly leave Boston. Revere rode from Boston about eleven o'clock on "a very Good horse . . . upon a full Gallop" and "alarmed almost every house till I got to Lexington."[21] He shouted, "The Regulars are coming out!" not "The British are coming!" which would have made no sense because Americans still regarded themselves as British citizens. William Dawes rode off with the same message. Revere reached Hancock and Adams in Lexington and set off for Concord. Between Lexington and Concord he was briefly taken prisoner by British soldiers and "often insulted by officers calling [me] damned Rebel & c. & c.," who said "'We are now going towards your friends and if you attempt to run, or we are insulted, we will blow your Brains out.' I told him he might do as he pleased."[22] Longfellow described the ride more evocatively:

> A hurry of hoofs in a village street,
> A shape in the moonlight, a bulk in the dark,
> And beneath, from the pebbles, in passing, a spark
> Struck out by a steed flying fearless and fleet,
> That was all! And yet, through the gloom and the light,
> The fate of a nation was riding that night,
> And the spark struck out by that steed, in his flight,
> Kindled the land into flame with its heat.23

Warned by Revere, the patriots at Lexington prepared for the British and on April 19 engaged them in the first military confrontation of the American Revolution. The British, angered by the Continental Congress's decisions to support colonial rights, to institute a boycott of trade with England, and to form a militia of minutemen, had intended by marching on Lexington only to arrest Hancock and Adams and destroy patriot stores of weapons and ammunition at Concord. What actually happened at Lexington is still debated, particularly who fired "the shot heard 'round the world." A skirmish, which the British did not anticipate, took place on farm fields outside the town. The colonists reported rampant British atrocities, including the murder of women and children and the

burning of churches. British casualties were light, but on the return march to Boston seventy soldiers fell victim to snipers, alerted by Revere, and another 170 were injured.

The patriots established a provincial government in Watertown, outside Boston, as the city was under siege from April 1775 to March 1776. In May 1775 the Second Continental Congress met in Philadelphia to raise funds to support George Washington's army. The heroic Battle of Bunker Hill took place in Boston in June 1775. The British won the battle but at a great cost, losing about half of their forces, over one thousand men, against the poorly trained and armed provincial militia, who lost about four hundred men. At the end of 1775 George III proclaimed America to be in a state of open rebellion. George Washington marshaled his forces across the Charles River in Cambridge and laid siege to Boston. Many Loyalists left, particularly after the March 1776 evacuation of British troops, who were short on ammunition and ravaged by a small-pox epidemic. Washington took the city without firing a shot, the first American victory in the Revolution. On July 4, 1776, delegates of the Continental Congress in Philadelphia signed the Declaration of Independence. Boston quieted for the remainder of the war.

Revere was commissioned as a major in the Massachusetts militia and later transferred to the artillery in November of 1776, where he was promoted to lieutenant colonel. He ceased smithing between 1775 and 1781, turning over his shop to his son Paul Revere III, only fifteen at the beginning of the war, although he did print money for the provincial government during the siege. He sent Rachel and the younger children to Watertown. For much of the war Revere served as commander of Castle William, a fort on an island in Boston Harbor. In 1779 he was involved in an unfortunate event near Penobscot, Maine (then part of Massachusetts). Revere had negotiated with privateers to help the patriots attack a British fort on Penobscot Bay. On the appointed day, the privateers failed to attack and the American troops were delayed. The patriots argued about whether or not to continue the siege, and Revere was among the minority who voted not to proceed. When British reinforcements arrived, the Americans scattered. Enemies of Revere in the military brought charges of dereliction of duty, cowardice, and insubordination against him. A trial was held with no definite result, yet Revere was court-martialed. He fought against the verdict and was fully exonerated in February 1782.

Post-Revolutionary Revere

After his trial Revere returned to the smithy and his shop, now called Paul Revere & Son. His business continued to grow; the daybook for the period 1784 to 1797 records over four thousand silver objects of an incredible range of types. He also began to diversify. Advertisements placed in Boston newspapers in 1784 and 1785 list a tremendous variety of goods and services. In addition to silver "Tea-Pots, plain and chased, Butter Boats, 3 Pint Vase Coffee Pots, Cream Jugs,"

he sold household goods such as "Nails . . . Door Locks . . . Wood Screws . . . Warming and Frying Pans, Flat Irons, A very elegant Assortment of Princes Metal Candlesticks highly finished in the newest Taste . . . Irish Linnen . . . Green, ivory, tortoise shell and buffalo Penknives, Cutlas, Rasers, Scissars, Snuffers, Back and Knee Buckles."[24]

In 1787 he opened a foundry in Boston's North End that produced bells, cannons, and hardware for ships. About this time he stopped listing himself as "silversmith" in official documents and assumed the sobriquet "esquire," or gentleman, in the American sense of the word: one of social rank, certainly, but also a moral man, regardless of occupation. The silver shop became but one part of a larger business network as Revere also opened a copper rolling mill in Canton, Massachusetts, in 1800. The first of its kind in the United States, it produced sheets of copper for many purposes, most famously 6,000 feet of copper sheathing to cover the dome of the new Massachusetts State House in Boston, designed by Charles Bulfinch. Revere's copper and brass items were advertised as far away as Savannah.

The shift in Revere's post-revolutionary career reflects momentous changes in production in the late eighteenth century. The number of craftsmen who supervised small shops declined as artisanal culture was replaced by industrial production, where workers often performed a single specialized task on an assembly line. As silver historian Barbara McLean Ward notes, silversmiths in Massachusetts before the Revolution "were the last generation of fully trained artisans. These individuals were the last, we might say, of a dying breed."[25] Soon, silver would be stamped out by machine.

A portrait of Revere created by the French artist Charles de Saint-Memin around 1800 shows him not in shirtsleeves, like the earlier portrait by Copley, but dressed in a suitcoat, a rotund gentleman of wealth. Personal circumstances reveal his improved social status. While the daughters of Revere's first marriage married craftsmen, the daughters of his second marriage married merchants. The sons of his second marriage were not apprentices but students at Boston Latin School. John, his youngest son, graduated from Harvard and the University of Edinburgh, and became a physician and one of the most respected professors of medicine in the United States. In 1794 Revere was elected the first president of what would become the Massachusetts Charitable Mechanics Association, a benevolent organization intended "to assist the necessitous; to encourage the ingenious; and to reward the faithful."[26] The next year he was one of the dignitaries who laid the cornerstone of the new state house. Between 1795 and 1797 he was a Master, then Grand Master of the Mason's Grand Lodge of Massachusetts. From 1795 to 1800 he was appointed Suffolk County coroner by Governor Samuel Adams, presiding over 49 inquests for deaths ranging from accidental drownings to drug overdoses. After 1800 he purchased an estate along the river near Canton where he and Rachel spent many tranquil summers while his sons ran his businesses. Revere's last dated silver work is a pitcher made in 1806.

Revere's post-revolutionary silver underwent a stylistic transformation reflective of the young country's new ideals. In the late eighteenth century the Neo-

Paul Revere, Teapot, c. 1796. Silver and wood (6¼ × 5⅞ inches). Photograph. © 2003 Museum of Fine Arts, Boston.

classical style replaced the Baroque and the Rococo as the dominant style in Europe and the United States. Neoclassicism—which means *new classicism*—revived the visual vocabulary of Ancient Greece and Rome. Rejecting the asymmetrical forms of Baroque and Rococo art for simpler vertical and horizontal lines and basic geometric shapes in imitation of Greek and Roman architecture, Revere created refined vessels like the c. 1796 teapot in the collection of the Museum of Fine Arts, Boston.

The Neoclassical style—also called the Federal style in the United States—permeated not only silver but also architecture, sculpture, painting, dress, and other decorative arts forms such as furniture. This was more than a revolution in taste, it was also an attempt to perfect society, for Neoclassicism was associated with the virtues of rationality, honesty, and democracy encouraged in the new Republic. The Baroque and Rococo styles were now believed to embody aristocratic vices such as licentiousness, luxury, and immorality. As this suggests, the change in style was not simply a matter of fashion but also reflected contemporary ideologies, as the founding fathers viewed the United States, the first modern democracy and republic, as the descendent of Ancient Greece and Rome.

The Neoclassical teapot of 1796 reveals Revere's command of the new forms and techniques. In November 1785 Revere purchased a plating mill, one of only a few in the country at that time, which allowed him to roll thin sheets of silver. The body of the teapot was formed not by raising it from a disk of silver with a hammer and anvil, but by folding a sheet of silver into an oval, then soldering or riveting a seam where the sheet overlapped. This was simpler, faster, and more cost-effective than hand raising, manageable by young apprentices. Termed *fuse-plated hollowware*, here, the new technique resulted in a scalloped

profile that resembles the fluting of a classical column. Revere then finished the teapot with classical details, such as tasseled festoons and delicate ribbons of stylized leaves, depicted with a regularity that is a marked contrast to the more fluid engraving of the 1770 teapot. Revere's daybook also records the many copperplate engravings he produced after the Revolution, including portraits of revolutionary heroes like Samuel Adams and George Washington, religious images, bookplates, and Masonic certificates and invitations.

At Revere's death on May 10, 1818, at age 83, he was recognized as a highly successful entrepreneur, landowner, and community leader. He died wealthy, leaving 4,000 to each surviving child and 500 dollars to each of his 18 grandchildren (except one, Frank Lincoln, who angered his grandfather by changing his name to Francis and received only 1 dollar). The appraisal of his estate, which included expensive mahogany furniture, much personal silver, and extensive landholdings, was over 37,000 dollars, a considerable amount in the early nineteenth century. He was interred with honors in the Granary Burying Ground in the center of Boston. Curator Jonathan Fairbanks observes, "In every way Revere had echoed the emergence and growth of the new federal nation, as he had adapted his talents and faced challenges and great risk. His flexibility, energy, and ingenuity reflected the expansion not only of his own individual talents but also those of a vibrant new country."[27] As noted, Longfellow's poem later catapulted him to fame, and his life has been the subject of numerous biographies since 1861.

Today, silver with the "PR" or "Revere" mark is among the most valued American silver on the market, collected by museums and astute connoisseurs. Revere silver has been carefully studied by curators at Yale University; the Museum of Fine Arts, Boston; Winterthur Museum; and Worcester Art Museum. These institutions have large holdings of his work, which is featured prominently in studies of American decorative arts and texts on American art history. Revere's work has attracted renewed attention in recent years with the development of the study of material culture, where such objects are considered a reflection of the culture that produced them and an aid in understanding social history. Revere's prints have been less a focus of scholarship, although they deserve equal attention as works of art and, even if Revere manipulated reality, revealing remnants of their time. The most comprehensive study remains *Paul Revere's Engravings* by Clarence S. Brigham, originally published in 1954 and reissued in 1969. The dramatic intensity of the midnight ride has often obscured an equally fascinating narrative: the story of Revere's work as an artist, his rise from artisan to entrepreneur, and the extraordinary vitality, industriousness, and commitment that informed all facets of his life.

Notes

1. Longfellow, 275. The poem was first published in the January 1861 issue of *Atlantic Monthly* and later appeared in Longfellow's *Tales of a Wayside Inn,* 1863.

2. Fisher, 6.

3. *Massachusetts Historical Society,* "The Paul Revere House," http://www.paulrevere-house.org.

4. Quoted in Triber, 92.

5. Quoted in Quimby, 153.

6. Craven, 259, 334–36.

7. Rather, 281–90.

8. Bjelajac, 112.

9. Craven, 336.

10. Quoted in Triber, 81.

11. See Bullock; Ridley; York, 315–30.

12. See Fischer for a complete account of Revere's rides prior to and after the famous midnight ride.

13. Quoted in Triber, 101.

14. Ibid., 2–4, 13, 20, 61.

15. *Paul Revere—Artisan, Businessman, and Patriot: The Man Behind the Myth,* 72.

16. Quoted in Fairbanks, 115.

17. Quoted in C. Brigham, 22.

18. Quoted in C. Brigham, 41–42.

19. Bjelejac, 134.

20. Quoted in Triber, 85.

21. Ibid., 103.

22. Quoted in Fairbanks, 124.

23. Longfellow, 277.

24. Kane, 789–99.

25. Ward, 38.

26. D. Brigham, 634.

27. Fairbanks, 211.

Bibliography

Bjelajac, David. *American Art: A Cultural History.* Upper Saddle River, NJ: Prentice Hall, 2001.

Breen, T. H. "The Meaning of 'Likeness': American Portrait Painting in Eighteenth-Century Consumer Society." *Word and Image* 6, no. 4 (October–December 1990): 325–50.

Brigham, Clarence S. *Paul Revere's Engravings.* Worcester, MA: American Antiquarian Society, 1954.

Brigham, David R. "Paul Revere Silver at the Worcester Art Museum." *Antiques* 157, no. 4 (April 2000): 626–35.

Buhler, Kathryn C. *American Silver, 1655–1825, in the Museum of Fine Arts, Boston.* 2 vols. Greenwich, CT: New York Graphic Society, 1972.

Bullock, Steven C. *Revolutionary Brotherhood: Freemasonry and the Transformation of the American Social Order, 1730–1840.* Chapel Hill, NC: University of North Carolina Press, 1996.

Craven, Wayne. *American Colonial Portraiture: The Economic, Religious, Social, Cultural, Philosophical, Scientific, and Aesthetic Foundations.* Cambridge: Cambridge University Press, 1986.

Fairbanks, Jonathan L. *Paul Revere's Boston: 1735–1818*. Exhibition Catalogue. Boston: New York Graphic Society, 1975.

Fischer, David Hackett. *Paul Revere's Ride*. New York: Oxford University Press, 1994.

Jenison, Paul B., and Bryn E. Evans. "The Paul Revere and Moses Pierce-Hichborn Houses in Boston." *Antiques* 125, no. 2 (February 1984): 454–61.

Kane, Patricia E. *Colonial Massachusetts Silversmiths and Jewelers*. New Haven: Yale University Art Gallery, 1998.

Korsmeyer, Carolyn. "Pictorial Assertion." *Journal of Aesthetics and Art Criticism* 43 (Spring 1985): 257–65.

Longfellow, Henry Wadsworth. "Paul Revere's Ride." In *The Poems of Henry Wadsworth Longfellow*. New York: Modern Library, n.d.

Massachusetts Historical Society. "Beginners Guide." http://www.masshist.org/massacre. html.

Paul Revere Memorial Association. "The Paul Revere House." http://www.paulrevere-house.org.

Paul Revere—Artisan, Businessman, and Patriot: The Man Behind the Myth. Exhibition Catalogue. Boston: Paul Revere Memorial Association, 1988.

Quimby, Ian M. G. *American Silver at Winterthur*. Winterthur, DE: Winterthur Museum, 1995.

Rather, Susan. "Carpenter, Tailor, Shoemaker, Artist: Copley and Portrait Painting around 1770." *Art Bulletin* 79, no. 2 (June 1997): 269–90.

Revere, Paul. *Paul Revere's Three Accounts of His Famous Ride*. With an Introduction by Edmund S. Morgan. Boston: Massachusetts Historical Society, 1968.

Ridley, Jasper. *The Freemasons: A History of the World's Most Powerful Secret Society*. New York: Arcade Publishing, 2001.

Triber, Jayne E. *A True Republican: The Life of Paul Revere*. Amherst, MA: University of Massachusetts, 1998.

Ward, Barbara McLean. "Forging the Artisan's Identity: Tools and the Goldsmithing Trade in Colonial Massachusetts." In *Colonial Massachusetts Silversmiths and Jewelers*, Patricia E. Kane. New Haven: Yale University Art Gallery, 1998.

York, Neil L. "Freemasons and the American Revolution." *Historian* 55, no. 2 (Winter 1993): 315–30.

CHAPTER 9

John Singleton Copley (1738–1815), Anglo-American Master

John Singleton Copley's paintings of the 1760s and 1770s are considered the culmination of the Colonial American portrait tradition. Copley eclipsed all predecessors on a number of levels, as is apparent if one compares his portrait of Epes Sargent, 1760, with the work of earlier eighteenth-century portraitists. The portrait of Sargent, shown casually leaning against the base of a broken column, reveals Copley's command not only of the internal and external body structure of the rotund merchant, but also his ability to create one of the most convincingly solid, three-dimensional heads in the history of American painting. Copley's rendering of Sargent's skin, with the red and blue undertones that characterize Caucasian flesh, encouraged Gilbert Stuart, an American painter of the late eighteenth century, to proclaim "Prick that hand, and blood will spurt out!"[1]

The fact that Copley developed such masterful painting skills without formal art schooling has captivated scholars and the general public, who flock to exhibitions of his work. The unprecedented verisimilitude of his sitters' faces, bodies, dress, and surroundings has provoked debate among art historians. Are Copley's skillful portraits, as some suggest, a straightforward response to innate American characteristics such as individualism, materialism, and egalitarianism? Or are they evidence of Copley's uncanny ability to assimilate other artists' work to create compelling *fictions* reflecting his patrons' desire to appear to be English aristocrats? As art historian Margaretta Lovell succinctly phrased it, was Copley "an all-American hero or a complicit Anglophilic shill"?[2]

Such contradictions abound in Copley's life and career. He was a poor tobacco merchant's son who came to own vast land holdings and a grand home in one of Boston's most exclusive neighborhoods. He complained bitterly about the limitations placed on American artists but hesitated to leave because he was making such a good living. He enjoyed being "a big fish in a small pond" yet yearned to

try his hand in London's art world. He painted portraits of revolutionary Whigs Paul Revere, Samuel Adams, and John Hancock but married the daughter of a prominent Tory. How Copley negotiated between both camps is one of the more intriguing aspects of his life and work in pre-revolutionary Boston.

While Copley worked in the same time and place as Paul Revere, discussed in the previous chapter, his experience was quite different. Both men, born in Boston in the 1730s, lived amid the tremendous political, social, and economic upheaval of the decades before the American Revolution, but Copley viewed these changes from a different perspective than the artisan and patriot Revere. Copley strove to be apolitical, and although he began life at the same social level as Revere, by his twenties he reached a status unprecedented for an American artist. Each chapter has addressed the visual artist's shifting standing in colonial society. Copley, with his expensive home and well-bred wife, reached the pinnacle of social regard, in part because his portraits aided the elite in asserting their own high social status. And unlike Revere, whose prints directly addressed pre-revolutionary Boston's trying circumstances, Copley's portraits suggest nothing amiss, although even his wealthiest sitters must have been affected by the boycotts, the blockades, and the street riots.

Portraiture in Pre-War Boston

Chapter 3 explores the growing power and influence of the mercantile elite in 1670s Boston as an explanation for the sumptuous clothes and jewelry John and Elizabeth Freake wear in their portraits. As the portraits suggest, the Freakes were wealthy and materialistic people, but their fine dress also reflected the Calvinist commitment to work. According to Calvin's doctrine of prosperity, worldly success was evidence of God's blessing through material reward for diligence at one's calling. Such beliefs were the foundation of Puritan society, and the self-discipline and industriousness they inspired made Boston's merchants very wealthy.

By the 1670s, Boston's mercantile elite had begun to assume social and economic control of the city, replacing the Puritan theocracy that established the Massachusetts Bay Colony. Much to the clergy's chagrin, the commitment to work and the growth of a capitalist economy resulted in a materialistic, consumerist society, with wealth concentrated in the hands of the few. By 1771, fifteen percent of Boston's citizens controlled sixty-six percent of the city's wealth. More than sixty percent of Copley's patrons were those who dominated Boston's economy, as well as its political, cultural, and social life, imposing their tastes through conspicuous consumption. Unlike England, it was not birth or inherited land that determined one's standing in colonial America but wealth, public service, or the purchase of land. This explains in part the growing demand for large-scale, impressive portraits that emulated those of aristocratic Englishmen and women in form and content. Such portraits asserted the patrons' visions of themselves and the way they wished society to see them.

Copley was not the first portraitist to meet the needs of Boston's elite. By the 1740s Boston boasted several proficient portrait painters who would influence the young artist. Among the most important was John Smibert (1688–1751), a Scottish portraitist who accompanied the philosopher, scientist, and theologian Dean George Berkeley to America in 1728 to establish a school in Bermuda. Smibert was trained in London in the Lely-Kneller style of Baroque portrait painting discussed in Chapter 6. He had little competition when he arrived in Boston in 1729, and his grand compositions, including a life-size group portrait of Berkeley and his entourage titled *The Bermuda Group,* c. 1729–31 (Yale University Art Gallery), astonished provincial patrons. The plan for the school failed, and Smibert built a successful business painting portraits of New England's wealthy merchants and landed gentry, rendered with a painterly brushstroke and the physical idealization characteristic of European Baroque and Rococo portraiture. As influential as his own work were Smibert's copies of Old Master paintings, his European prints, and the casts of classical sculptures that he installed in a gallery by his studio (believed to be the first in British America). This, and the art supplies Smibert sold, made his studio a Mecca for young artists like Copley.

Smibert soon spawned several imitators, including Robert Feke (c. 1707–52), considered the first truly talented native-born American painter. Feke replicated Smibert's elegant poses but developed a more direct approach to his sitters' features and a crisp linear technique instead of Smibert's painterly style. Another artist Copley knew was Joseph Blackburn (active c. 1730–after 1758), an English immigrant who arrived in Boston in 1755. Blackburn's style was more overtly Rococo, with a light, pastel-toned palette, graceful poses, and generalized facial features. A consistency in Copley's predecessors' work is the detailed attention to what art historians call the portraits' "stuffs"—inanimate components such clothing, furniture, and drapery. This, as much as pose and facial expression, communicated the sitter's material success and sophistication. Copley's superior technical ability enabled him to better satisfy Boston's wealthy patrons' demands for visual status symbols. Compared with his predecessors, Copley's sitters' poses are easier and less artificial, their faces more direct and animated. The furniture has a solid believability, and the fabrics are rendered with such care that one can almost feel their textures. Copley created more convincing replications of the physical reality of the people of pre-war Boston than any of his predecessors.

Copley's Education and Early Career

John Singleton Copley was born on July 3, 1738, in Boston. His father, Richard Copley, was an Irish immigrant who lived on Long Wharf, the longest pier in Boston Harbor, depicted in Paul Revere's engraving *The Landing of the Troops.* He sold and traded tobacco from the family home, aided by his wife, Mary Singleton. Copley's father died in the mid-1740s. His mother maintained

the tobacco shop and in 1748 married Peter Pelham II, an auspicious choice for the ten-year-old Copley's future.

Peter Pelham II was the son of an English merchant, Peter Pelham I, whom documents describe as a gentleman. Pelham immigrated to Boston in 1727, bringing with him four sons, one daughter, and talent in a range of genteel art forms, including dancing, etiquette, needlework, music, and the visual arts, particularly painting and printmaking. The family settled in the center of the city; Copley's mother continued to sell tobacco and Pelham advertised as a schoolmaster and produced mezzotint portraits of famous Bostonians. Mezzotint is a form of engraving that involves roughening the surface of the plate with a tool called a rocker to produce subtle, painterly areas of light and dark instead of the linear definition of forms in engravings like Paul Revere's. Pelham's remaining works indicate that he was the most sophisticated printmaker in Boston in the mid-eighteenth century, far surpassing Revere in skill. Three of Pelham's sons followed in their father's footsteps, Copley's stepbrothers Peter III, a musician and teacher, Charles, a teacher and writing master, and Henry, Copley's half-brother born in 1749, a painter and printmaker. But it appears that Copley was the most visually gifted, for he inherited his stepfather's tools and other art paraphernalia after Pelham's death in 1751, with his stepbrothers' approval. For one of Copley's earliest works, created when he was about 15, he simply scraped the face off of a Pelham portrait mezzotint, leaving the body, and re-carved it with the face of Reverend William Welsteed, a librarian and teacher at Harvard.

Pelham's influence on Copley cannot be overstated. In addition to the technical skills needed to succeed as a painter and printmaker, Pelham taught Copley how to act in polite society. He believed of the portraitist, as art theorist Jonathan Richardson wrote, that "as his business is chiefly with people of condition, he must think as a gentleman."[3] Pelham introduced Copley to the writings of Richardson and other European art theorists such as Horace Walpole, Charles du Fresnoy, and Roger de Piles, who revolutionized English aesthetics in the eighteenth century. Copley was an avid self-educator, and read texts and treatises addressing technique and art history as well as theory. Copley's studies shaped not only his art but also his self-image and his conception of the artist's role in society. Eighteenth-century aesthetics encouraged recognition of a more exalted social position for artists, emphasizing that the fine arts promoted civic humanism and that the artist was an "active agent shaping society and promoting public virtue."[4] Pelham also modeled for Copley how to market himself and his works, establishing in his stepson an entrepreneurial spirit and a skill at self-promotion.

The impact of British aesthetics is clear in one of Copley's earliest oil paintings, a mythological scene titled *The Forge of Vulcan,* 1754 (private collection), depicting the classical gods Venus, Mars, and Vulcan. It is an awkward image, copied directly from a print, which explains the uneasy color relationships and the lack of integration of forms. But it indicates the young artist's awareness of the priority of historical themes in the hierarchy of subject matter established

by the European art academies. Influenced by the academies' emphasis on human proportion and movement, at age 18 Copley created a notebook of anatomical drawings showing the body in a variety of poses. The drawings were copied from European treatises, with the skin removed to reveal the placement of the muscles, which Copley labeled in precise detail. He kept the notebook with him always. After arriving in New York City without it in 1771, he instructed his half-brother Henry to send the drawings to him at once, for "I shall not be able to do long without them."[5] After his early experiments copying mythological prints, Copley did not paint another historical theme until after he left Boston 20 years later; there was no demand for history painting in the colonies. Portraiture still held sway as the only acceptable and lucrative subject for colonial painters. Throughout the American phase of his career, Copley chafed under such limitations.

Beginning in 1753 Copley produced portraits that borrowed extensively from the European prints that surrounded him in his stepfather's studio. A portrait of Mrs. Joseph Mann, 1753 (Museum of Fine Arts, Boston), replicates the pose and dress of Princess Anne in an English engraving. Copley's work of the mid-1750s reveals an immature hand, with flat areas, awkward anatomy, and faces with little individuality. He was, after all, only 15 years old when he painted Mrs. Mann. While copying from prints was certainly the unschooled young artist's attempt to assimilate fashionable poses, dress, and compositions, it was also common among artists of all levels in the eighteenth century. Joshua Reynolds and other leading figures viewed "quoting" from earlier works of art as evidence of an artist's sophistication, and it was a practice Copley would continue his entire career.

Copley's first studio was on Hanover and Court Streets, near the Orange Tree Tavern, close to Smibert's famous studio and gallery, which remained open after Smibert died in 1751. There is little specific information about Copley's studio practice, although his letters and the writings of his patrons and friends provide some insights. Art supplies were now widely available in the colonies, enabling Copley to outfit a studio similar to those of artists abroad. It is clear from his paintings that he was meticulous in his technique. Letters from sitters who complained of the many hours that Copley required them to sit, often just for the head and hands, confirm this. The son of Mary Turner Sargent, whom Copley painted in 1763, later wrote that the artist "painted a very beautiful head of my mother who told me she sat to him fifteen or sixteen times! six hours at a time!!"[6] Copley was notorious for mixing his paints to exactly replicate the skin tones of his subject—mixing, holding the palette knife by the sitter's cheek, re-mixing, comparing the tones again and again until they matched perfectly. Once the head and hands were completed, Copley often worked from a mannequin clad in the sitter's clothing, enabling him to concentrate on the details without trying his sitter's patience. In some instances his half-brother Henry Pelham painted the backgrounds. Often the same tables and chairs appear in Copley's portraits, suggesting that these were studio props. More surprising, the same clothing occasionally ap-

pears on different sitters. In 1763 Copley painted portraits of three women in the same blue silk dress, including Mercy Otis Warren. Was the dress also a studio prop? Or was it owned by one of the women who shared it with the others?[7]

Copley's Portraits of the 1760s

By the early 1760s Copley had come into his own as a portraitist. While he continued to borrow poses, dress, and surroundings from British prints, his works assumed a confidence and originality lacking in the works of the 1750s. As his proficiency in manipulating his brushes and colors increased, so did the demand for his portraits, and Copley attracted patrons from Massachusetts's leading families. Epes Sargent, whom Copley painted in 1760, was one such individual. Sargent, a Harvard graduate, was a ship owner and merchant in Salem, Massachusetts. He was so wealthy that he owned nearly half the town of Gloucester, where he grew up. By age 70, when Copley painted his portrait, he was highly respected and well liked, the devoted father of 15 children. One of Sargent's grandsons, Henry Sargent, would become a well-known painter in the late eighteenth century, and a more distant heir, John Singer Sargent, would be one of the most famous American painters of the late nineteenth and early twentieth centuries.

What does the portrait reveal about Epes Sargent and Copley? If, as many scholars believe, Copley worked with the patron to construct how he wished to be viewed by society, what did Copley project about Sargent's identity? First, we are drawn to Sargent's magnificent head. It is a tour de force of illusionistic painting, created with successive layers of oil-rich and opaque paint to suggest color beneath the skin, augmented by impasto, or a build-up of paint on the surface, to make forms such as the nose appear to project. It seems the head of a distinguished and modest man. Sargent's expression, somewhat distant in that his clear blue eyes do not look directly at the viewer, is consistent with literature on proper facial etiquette, which instructed the well-bred to appear "moderately cheerful" with "a gentle and silent smile."[8]

Similar attention is paid to Sargent's puffy right hand, placed directly in the composition's center and also defined by layers of paint. The position of Sargent's hand draws attention to his well-rounded belly. Sargent's weight is a signifier of his wealth, for only the rich could afford to eat enough foods like meat and sweets to add fat. His casual pose, elbow resting on the column, suggests a worldly man of confidence. Poses became much more relaxed in mid-eighteenth-century portraiture, in contrast with the rigid postures of earlier portraiture. While Sargent's demeanor suggests a casual elegance, his rough hand is that of a laborer, perhaps to indicate that he often worked the docks beside his employees. His clothing is plain compared to that of most of Copley's male sitters. His coat is made of gray broadcloth, although the buttons are covered with silk thread and a bit of his waistcoat's gold embroidery peeks through the lower opening of his coat. Cop-

ley's eye for detail is evident throughout the image. Note that some of the powder from Sargent's wig has drifted off and rests on his right shoulder.

Even more astonishing, considering Copley was only 22 when he painted Sargent, is the portrait's sophisticated light and color. Copley placed the light gray of Sargent's coat and his fair skin tone and white hair against a dark background, throwing his strongly modeled head into sharp relief; the contrast was perhaps influenced by Copley's early reliance on black and white prints. Copley echoed Sargent's coat's gray tones by mixing them with brown, coral, and beige in the truncated column. It is a subdued and mature palette, worlds away from the harsh colors of *The Forge of Vulcan*. Sargent's portrait is simpler and more direct than Copley's other work of the 1760s, which typically includes more visual distractions such as elaborate clothing, settings, and props. This directness may also allude to Sargent's personality. Although clearly wealthy, he appears not the least bit pretentious. Copley's portrait of Sargent, then, presents an affluent, confident, and elegant man; yet one whose plain coat, rough hand, and clear gaze suggest that he was also straightforward, modest, and hard working—a mixed message, or one in keeping with colonial American values?

While the portrait of Epes Sargent is an amazing production for such a young artist, it is Copley's portraits of women from the early 1760s that truly break new ground. Most images of women by Copley's predecessors, particularly Smibert and Blackburn, are based on conventional notions of female beauty and are so formulaic that they look like generic sisters rather than distinct human beings. Colonial portrait specialist Deborah I. Prosser describes the gendered implication of this. "Men," she writes, "appeared as individuals while women were presented as beautiful accessories or stereotypical figures."[9] Copley, however, painted women's portraits with the same attention to facial structure and marks like moles and wrinkles as his male sitters, rendered in scrupulous, sometimes unflattering detail. Copley's sitters may have demanded this as evidence of their individualism. Or perhaps it was due to their limited understanding of art's function. Copley complained that viewers admired his portraits "only for the resemblance they bear to the originals" instead of their artistry.[10]

Copley had a banner year in 1763, when he received commissions for several portraits of notable women. One of his finest works is the portrait of Mercy Otis Warren, the wife of James Warren of Plymouth, Massachusetts. By all accounts a remarkable person, unlike most colonial women Mercy Warren was well educated; her parents encouraged her to attend lessons with her brother as he prepared for Harvard. Her husband supported her intellectual interests, describing her as having a "Masculine Genius," and by 1759, when she was in her early thirties, she began writing poetry. In 1772 she published her first play. She also wrote political essays and satire that expressed her revolutionary views, usually published, as was her poetry, under a pseudonym. As this suggests, Mercy Warren's intellectual ambitions troubled her, for this was not considered seemly for women of her class. She once wrote John Adams to ask if she would be perceived as deficient as a woman for writing political satire. She persevered, how-

John Singleton Copley, *Mercy Otis Warren*, c. 1763. Oil on canvas (51 ¼ × 41 inches). Photograph. © 2003 Museum of Fine Arts, Boston.

ever, and in the late 1770s, with the war raging, began her best-known work. Warren's *History of the Rise, Progress, and Termination of the American Revolution* was one of the first accounts of the war. As the title suggests, it was published after the war ended (and in her own name) in 1805. John Adams included her— along with her husband and her brother-in-law Dr. Joseph Warren, who in-structed Revere to ride to Lexington—in his catalogue of "illustrious men" of the Revolution.

What is so striking about Copley's portrait of Mercy Warren is how well it appears to communicate her personality. Her expression is not the demure smile of most mid-eighteenth-century female portrait subjects. Instead, she gazes directly at the viewer, her eyes radiating intelligence, the firm set of her jaw suggesting determination. There is evidence here of psychological nuance; one recalls Leonardo da Vinci's insistence that the best portraits capture not only the sitter's appearance but also "the motions of the mind." Her pose, however, is consistent with proper comportment for upper-class women. Control of the body and good grooming were as much signs of the social self as fine dress and surroundings.

Mercy Warren wears a fashionable blue satin-weave silk "saque" dress, with a fitted bodice, a full skirt, and loose fabric draping from her shoulders, trimmed with ruched silk and silver braid—the same dress that appears in two other portraits painted by Copley in 1763. The other portraits are of recently married women in their late teens and early twenties.[11] In the Warren portrait the dress is differentiated by a lace fichu covering her chest and a double row of lace at the cuff, to distinguish her as a matron (Warren was in her mid-thirties when she sat for Copley). The lace was imported, probably point d'Aleçon needle lace. Warren wears about ten pounds worth, more than the cost of the portrait, further evidence of the Warrens' wealth. Mercy Warren's lace cuffs are also a fine example of the care Copley took with materials that conveyed such a message. The lace is delicately painted, with sweeping strokes that define the smooth, transparent panels; short, thin brushstrokes to capture the geometric grid of the border; and small, flat strokes for the floral forms at the edges. Copley admired the same attention to detail in other artists' works. Of a painting by the Renaissance artist Correggio he wrote, "What delights us in this picture is that universal finishing and harmoneising of all parts of it. . . . In the Back and fore Ground every leaf and shrub is finish'd with the utmost exactness."[12]

Copley, an accomplished gardener, often painted women with flowers, a feminizing accoutrement that, depending on the context, could symbolize fertility or the fragility of life in the emblematic tradition discussed in Chapter 5. Warren gently holds a meandering nasturtium. The nasturtium was a rare species in Boston at this time; its inclusion suggests Warren's wealth and ability to cultivate the exceptional. It also alludes to her abilities as a mother; for children, like plants, must be cultivated. Mrs. Warren had three sons by 1763 and another was born the year after Copley painted her portrait.

The portraits of Epes Sargent and Mercy Otis Warren, both three-quarter-length images of about fifty by forty inches, probably hung in the public areas of their grand homes, most likely in the entry hall or living room. They were placed there for visitors to see; but, as noted above, scholars debate how their contemporaries would have interpreted the portraits. Wayne Craven suggests that in the veristic faces and fine trappings, one sees middle-class virtues such as industriousness, individualism, egalitarianism, and self-confidence, in addition to a residual Calvinism suggesting that material wealth was the result of God's grace. Citing straightforward portraits such as those of Paul Revere and

Epes Sargent, Craven contrasts Copley's "honest" American work that "captures the colonial character and personality" of a resolutely middle-class people with the more aloof, idealized, aristocratic portraits by European artists, and suggests that, on one level, the contrast could reflect the sitters' desire for independence from England.[13]

Paul Staiti, on the other hand, argues that Copley assimilated a vocabulary of English portrait conventions that were not reality but "the site of dreams" and "the individual's projected illusion of himself" to ameliorate feelings of cultural inferiority.[14] Copley, Staiti suggests, did not distinguish his work from British portraiture (Copley considered himself British, after all, as did his sitters), in fact, he emulated it. These two views of Copley are difficult to reconcile, although Margaretta M. Lovell encourages recognition of Copley's ability to seamlessly combine both: an empirical realism encouraged by the circumstances in colonial New England and a fictional world of English conventions of dress, body type, pose, and surroundings. Copley, then, ably assimilated a whole world of references, ranging from observed reality to the symbolic and imagined. His meticulous technique is evidence that he carefully studied what he could see, yet he also relied on the prescribed codes of European portraiture. As Lovell suggests, Copley's genius was his ability to synthesize observed phenomena and appropriate emblems and attributes to create believable statements of identity, as in the portraits of Sargent and Warren, where we feel we know not only what they looked like but also something about their personalities and their place in society. It is critical for the future of Copley scholarship, Lovell argues, that analysis be embedded in the objects—the paintings themselves—and avoid nationalistic or moralistic hyperbole.[15]

Around 1769 Copley created a pastel self-portrait, probably to celebrate his marriage to Susanna Farnham Clarke, for he drew a bust-length pastel portrait of his new wife that was the same size at about the same time. At 23 by 17 inches, the self-portrait is much smaller than the paintings examined thus far. It is also simpler; as a bust-length portrait it presents only Copley's head and shoulders. Despite its small size and limited content, it is an exceptionally revealing image. Copley depicted himself wearing a red embroidered vest under a brightly colored turquoise silk damask banyan, a Turkish-style robe worn by gentlemen of leisure at home. His face, turned to the right, is smooth and pleasant in expression, with a slight smile. His hair is carefully styled and powdered. As art historian Susan Rather argues, the self-portrait reveals Copley's imitation of his patrons' aristocratic trappings, and therefore asserts their values, a necessity for cultivating his clientele.[16] He appears wealthy—as the banyan suggests, wealthy enough to enjoy leisure time. There is no evidence of his lower-class background or his manual trade, unlike the portrait of Paul Revere, painted about the same time. As British aesthetics instructed, Copley worked diligently to distinguish himself from others who worked with their hands. In his self-portrait, Copley fashioned himself as a successful gentleman, which he was. By the late 1760s Copley was earning about three hundred pounds a year.

Copley's choice of pastel is also illuminating. As noted in Chapter 6, pastel

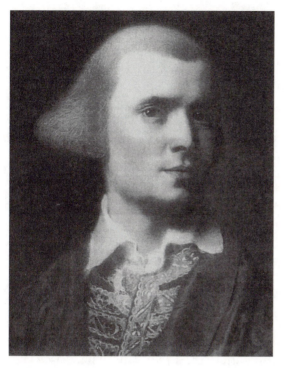

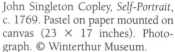

John Singleton Copley, *Self-Portrait*, c. 1769. Pastel on paper mounted on canvas (23 × 17 inches). Photograph. © Winterthur Museum.

was not a widely used medium in the colonies. Few other mid-eighteenth-century Boston artists, if any, worked in pastel; but Copley, with his awareness of current European fashion, knew the medium was attracting attention abroad. He also knew Henrietta Johnston's work, having copied one of her portraits. In 1762 he wrote to Jean-Etienne Liotard, a Swiss artist considered one of Europe's best pastelists, requesting that he send "one sett of Crayons of the very best kind such as You can recommend [for] liveliness and colour and Justness of tints. In a word let em be a sett of the very best that can be got."[17] Rather describes the association of pastel with women artists (also discussed in Chapter 6), and notes that Copley was aware that Benjamin West and Joshua Reynolds condemned the medium because of its feminine associations. By 1772 Copley had abandoned pastel, even though he claimed that some of his best works were in the medium.

By the time he created the self-portrait, Copley was corresponding with West, the first internationally known American-born artist, who lived in London. Copley's familiarity with British aesthetics encouraged him to seek out advice from his more famous peers. He sent paintings to London for West and Reynolds to critique. One, a fanciful portrait of his half-brother Henry Pelham (Museum of Fine Arts, Boston), exhibited in London in 1766, seems intended to demonstrate his proficiency in painting a range of materials, textures, and colors. Henry is represented half-length, leaning on a polished mahogany table; before him is a glass of water, always a challenge to paint. Shown in profile, he wears a midnight blue velvet frock coat with a pink satin collar and holds a shiny gold chain attached to a soft gray pet squirrel. West and Reynolds, while noting that it was

"a very wonderfull Performance" considering the conditions under which Copley worked, criticized the very things that captivate us today, describing the portrait as having a "Hardness in the drawing," being too "liney," with "an over minuteness."[18] In other words, the forms were defined too precisely and the brushwork was invisible, in contrast with the more painterly, generalized approach favored in London. Copley responded to West, "I think myself peculiarly unlucky in Liveing in a place into which there has not been one portrait brought that is worthy to be call'd a Picture within my memory, which leaves me at a great loss to gess the stile that You, Mr. Reynolds, and the other Artists practice."[19] His frustration is clear, although it is unlikely that the English style would have satisfied his American patrons, whose materialism demanded Copley's realistic replication of details.

Prelude to War: Copley's Portraits of the 1770s

Copley's personal situation improved even more with his marriage to Susanna Clarke. His father-in-law, Richard Clarke, an agent for the East India Company, was one of Boston's wealthiest men. With Clarke's help, Copley purchased land on Beacon Hill next to John Hancock's estate and across Boston Common from the governor's home. Eventually he would accumulate more than twenty acres, with several houses, a barn, and an orchard. Plans for the studio that he built there still exist. It was quite sumptuous, about twenty-four by seventeen feet, with a large window that allowed enough light to make it "very commodious for painting a whole length picture," according to Henry Pelham, who helped design and build it.[20]

In the late 1760s and 1770s Copley accommodated patrons with a wide range of political views. Around 1768 he painted Paul Revere, who, seven years before his famous midnight ride, was already a committed patriot. Copley either had no strong political opinions or chose not to voice them publicly because this would be bad for business. As partisan lines hardened in the early 1770s, he felt increasing pressure to commit, but as he wrote to West, "I am desirous of avoideing every imputation of party spirit," and later advised Henry, "be neuter [neutral] at all events."[21] Copley attended one meeting of the Sons of Liberty in 1769; many of his friends belonged to the revolutionary organization. Most of his clients, however, were Loyalist Tories, who generally had more money than the patriot Whigs. There were, of course, exceptions. Copley painted one of Boston's richest men, John Hancock, in 1765, the year of the Stamp Act Crisis. Despite Hancock's wealth, it is a restrained portrait, perhaps intended to promote Hancock, who was running for office, as a man of the people. In 1770–71, Copley painted Samuel Adams. Commissioned by Hancock, it is an unusual portrait for Copley in that it shows Adams in action, glaring and pointing forcefully at documents and the Massachusetts seal as he holds a peti-

tion to remove British troops from Boston. He is represented as he appeared when confronting Governor Hutchinson with the petition immediately after the Boston Massacre (see Chapter 8). Like Revere and Hancock, Adams is dressed plainly in comparison with Copley's Loyalist sitters. In speeches Adams attacked the Loyalists' vanity, flaunting of privilege, and mimicry of English aristocrats, in which Copley's portraits were clearly complicit. Despite this, Copley apparently had no difficulty painting a portrait of Adams so powerful that it became an instrument of political propaganda, later hung in Faneuil Hall along with Copley's portrait of Hancock and replicated as a print with the inscription "His Country's Saviour, Father, Shield & Guide."

John Singleton Copley, *General Thomas Gage*, 1768–1769. Oil on canvas (50 × 39¾ inches). © Yale Center for British Art. Paul Mellon Collection.

Copley's 1768 portrait of General Thomas Gage, a Tory described as the most powerful man in North America, provides further evidence of the artist's willingness to accept portrait commissions from sitters of either political persuasion.[22] Gage, from an aristocratic family in Sussex, England, served as a lieutenant colonel under General Edward Braddock in the French and Indian War. Though seriously wounded during Braddock's disastrous final battle near Pittsburgh in 1755, Gage protected a young George Washington and helped him escape. Unlike many British officers, he remained in the colonies after the war, first as the military governor of Montreal, then in 1763 as commander-in-chief of the British forces in North America, concurrent with rising political and economic tensions. He served in this position until 1774, when he was appointed governor of Massachusetts. Gage met Copley in 1768 when he was sent to Boston to quell the unrest that resulted from the quartering of British troops there.

The portrait displays none of the tension that must have accompanied the visit. Copley depicted Gage in the striking redcoat uniform of the British military, reviewing his troops. His pose, standing and pointing at his regiment, is a traditional one in portraits of military officers. As in his portrait of Mercy Warren, Copley placed Gage before a dark rock outcropping, drawing the viewer's eye to his firmly modeled head and direct gaze. In representing Gage in full military dress before his regiment, Copley created a political statement that reinforced Gage's authority in the colonies.

Gage took the portrait with him when he returned to New York City, and it helped establish Copley's reputation there. A patron of Copley's, British army officer Captain John Small, wrote, "Your picture of the General is universally acknowledg'd to be a very masterly performance, elegantly finish'd, and a most striking Likeness; in short it has every property that Genius, Judgement and attention can bestow on it."[23] Demand for quality portraits was high among New York's elite, and Copley wisely decided that a stay in the city would be financially lucrative. Small wrote to assure him that a visit "has been earnestly and eagerly wish'd by some of the finest women in the *World*. The fame of your performances had Long ago Reach'd them, and the Specimens which have recently made their appearance, have confirm'd in them the Idea of your Superior genius."[24] Friends of the artist coordinated his visit, contacting potential patrons and arranging sittings. Copley established his studio, and wrote home of the schedule he and Susanna kept in New York: "We commonly rise by Six oClock in the morng, breakfast at 8, go about our respective Labours till 3, when we dine."[25] Copley completed between fifteen and twenty-five portraits during his nearly seven-month stay.

One of his first patrons was Margaret Kemble Gage, General Gage's wife, who asked Copley to create a pendant of her to hang next to her husband's portrait. The result is one of Copley's finest and most original works, a painting he described as "beyand Compare the best Lady's portrait I ever Drew."[26] Several qualities distinguish the portrait. Mrs. Gage's relaxed pose is unprecedented in colonial portraiture. Copley depicted her lounging languidly on a deep blue camel back couch, her fluid form echoed by the couch's double row of decora-

tive nails, very different from the erect postures of most of his female sitters. Mrs. Gage's dreamy expression augments the pose's sensuality. Head on hand, she looks away from the viewer, a marked contrast with Mercy Warren's direct gaze. She seems lost in reverie, detached and pensive.

As distinct as her pose is Mrs. Gage's unusual dress. She is uncorsetted, shown in a style of dress called *turquerie* because it mimicked the garments of Turkish women. She wears a loosely structured salmon-colored robe with gold trim, secured by an ornate blue belt embroidered in gold, over a white chemise with its sleeves pulled up and wrapped with strands of pearls. Her hair is unbound and falls over her right shoulder, topped with a lavender-gray scarf loosely wrapped to look like a turban.

Margaret Gage's portrait challenged contemporary codes of conduct for women, causing considerable speculation among scholars regarding the portrait's intent. Some connect her dress to her background. Her father, Peter Kemble, had a Greek mother and was born in Smyrna, Turkey, where his father was a British merchant. But Gage was not the only woman Copley depicted in turquerie. Dress of this type was popular among English aristocrats, worn particularly for fashionable masquerades, reflecting a fascination with the Middle East encouraged by expanding trade. It is unlikely that the colonial elite held masquerades (too decadent), but turquerie was apparently acceptable for portraits intended to draw parallels between wealthy colonial women and their English counterparts, for Copley painted more than half a dozen women dressed this way. Yet more than the others, Margaret Gage's portrait captures the sensuality and exoticism westerners associated with "the Orient," as the Middle East was then known.

In a recent study art historian Isabel Breskin suggests that the choice to wear turquerie may have been a political one. Depending on the wearer, turquerie could indicate either support of British rule, as it was associated with English aristocrats, or commitment to the patriot cause. Wearing turquerie might be an attempt to draw parallels between the colonial relationships of England and Turkey and England and America, both cultures chafing under British control. Or, in its fancy and fantasy, it could represent the sitter's desire to remove herself from the difficult realities of the pre-war years, which were particularly pressing for Mrs. Gage as the American-born wife of the British commander.[27]

Others have linked Mrs. Gage's striking portrait to her personal situation. There is evidence that her loyalties were divided, and tension in her marriage resulted. She feared that her husband would be "the instrument of sacrificing the lives of her countrymen" and is known to have lectured him about liberty and justice.[28] Although she smiles slightly, the head-on-hand pose had symbolized melancholy since the Renaissance. Some have even suggested that, in turmoil, she passed British military secrets to the colonial militia. Historian David Hackett Fischer points to Margaret Gage as the confidential informant who told Dr. Joseph Warren of General Gage's plan to march on Lexington and Concord, prompting Warren to send Revere on his midnight ride.[29]

Beyond the Gages' specific situation, the pendants also reflect Copley's re-

liance on conventions of male and female representation. General Gage stands upright, with a commanding gesture and gaze. Margaret Gage is passive in pose and facial expression. His body is turned from the viewer while hers is frontal, inviting the viewer to look (as does her gaze, for it does not challenge the viewer). General Gage is represented in an active role reflecting his achievements. She is shown in a fantasy garment that would never have been worn outside the home. As Prosser notes, in the colonial portrait marketplace "men should appear as accomplished individuals while women must make pretty pictures." Colonial portraits, she observes, "were visual manifestations of the patriarchal society that produced them."[30] Yet again Copley departs from tradition. Despite her distant gaze, Margaret Gage is self-possessed and individualized, and therefore distinct from the vapid appearance of so many eighteenth-century female portrait sitters.

Margaret Kemble Gage was the most socially prominent woman in New York City, and Copley must have known that her portrait would make his name there. He wrote, "I have done some of my best portraits here," and "I am visited by vas[t] numbers of People of the first Rank, who have seen Europe and are admirers of the Art."[31] The portrait also enhanced his reputation abroad, for Copley sent it to an exhibition in London in 1772, where it garnered praise from West and Reynolds. According to Copley, Matthew Pratt, an American artist who worked closely with West, said of the portrait, "It will be flesh and Blood these 200 years to come, that every Part and line in it is Butifull, that I must get my Ideas from Heaven."[32] One can only imagine what such acclaim meant to Copley, who yearned to compete with artists abroad.

When Gage accepted the position of governor of Massachusetts in 1774 he initially hoped he could keep the peace. But there was no love lost between Gage and the citizens of Boston, whom he described as "the greatest bullies" in North America.[33] His image was burned in effigy as revolutionary agitation escalated. Gage was behind the notorious Coercive Acts (called the Intolerable Acts by the colonists) that closed Boston Harbor to trade and curtailed group meetings. He was blamed for orchestrating the failed attempt to take patriot arms at Lexington and Concord, which resulted in the first battles of the Revolution. He sent Margaret to England shortly after that, and was called back himself after the disastrous Battle of Bunker Hill, when the British lost over one thousand men. There is evidence that by then their marriage was beyond repair.

Copley Abroad

As political tensions rose in Boston, Copley's circumstances became increasingly difficult. In 1769 revolutionaries cut the "heart" out of Copley's portrait of Loyalist Governor Francis Bernard, which hung in a public area at Harvard. In November 1773 vandals attacked Richard Clarke's home and he fled with his sons to a Boston Harbor island well protected by British troops. Just prior to the Boston Tea Party Copley unsuccessfully attempted to act as a mediator between

the revolutionaries and East India Company agents, including his father-in-law, to whom was consigned much of the tea dumped in Boston Harbor. In 1774 Copley was threatened by a mob that accused him of harboring George Watson, a Tory. One wonders if Copley watched the increasingly raucous pro-revolutionary rallies on Boston Common from the piazza of his grand home above the Common. Copley's fears, coupled with his long-standing frustration with the situation of the arts in the colonies, finally compelled him to make the move he had contemplated for at least a decade. It was a good time to go. Boston's economy was collapsing, and many of his patrons were fleeing the city. Copley left Boston for England on June 10, 1774, and shortly thereafter traveled to Italy, where he studied ancient classical and Renaissance masterpieces. He traveled without his family; Susanna was pregnant with their fourth child.[34] He wrote home often, expressing his concern: "I am Ancious for you, my Dear, and our lovely Children, for I know not what state you are in, in Boston; but I pray God to preserve you and them. . . . give my blessing to my dear Babys and a thousand Kisses. tell my dear Betsey [his oldest child] not to forget he[r] Papa."[35]

Copley returned to England in October 1775; his family had arrived in May after the battles at Lexington and Concord. To celebrate their reunion he painted a life-size group portrait of himself, Susanna, their four children, and his father-in-law, who wisely joined his daughter's family at the end of the year (National Gallery of Art, Washington, D.C.). Placed in a splendid setting of impressive architecture and furniture before a breathtaking landscape, it is clear that Copley has abandoned his provincialism and is starting a new phase of his career. In a canny act of self-promotion, he exhibited the portrait at the Royal Academy in 1777. The family initially lived on Leicester Square, across the street from Joshua Reynolds, then moved to a large home on George Street, where Copley would spend the rest of his life. While not the first artist to "cross the pond" in the other direction, he was the only one who had established a successful career in America before making the move.

Now in his mid-thirties, Copley immediately assimilated the fashionable techniques of London's painters, which were quite different from his own painstaking approach. His brushstroke became looser and more fluid as he abandoned the "liney" appearance that West and Reynolds criticized. A painting that reveals the differences between his American and English work is the full-length portrait of Major Hugh Montgomerie, 1780 (Los Angeles County Museum of Art), who, like General Gage, is shown before his troops. Instead of Gage's static pose, Montgomerie is striding forward, his arm outstretched, against a vibrant stormy sky that swirls with painterly brushstrokes. While Gage's distant regiment is shown practicing maneuvers, Montgomerie's troops are closer to the picture plane, in hand-to-hand combat with Cherokee Indians. The portrait's drama, scope, and expressiveness resemble history painting.

In England Copley was finally able to satisfy his prolonged aspiration to paint grand historical themes, the subject matter esteemed by European theorists as the most challenging in its visual complexity, intellectual demands, and moral and didactic implications. His first attempt was the painting *Watson and the Shark*

(National Gallery of Art, Washington, D.C.). Here Copley took to heart Benjamin West's insistence that history painting could address recent events, not just the distant past, which revolutionized the theme (see Chapter 10). *Watson and the Shark* depicts Brook Watson when, as a young seaman in Cuba, he was attacked by a shark while swimming in Havana Harbor in 1749. In 1778, when Copley painted the image, Watson was a wealthy merchant who knew Copley's in-laws. It is a dramatic, even operatic painting. Watson has already lost his lower right leg as his rescuers struggle to reach him by boat, tossing him a lifeline while the shark rears, readying for another attack. It is a tour de force of accomplished technique, composition, and emotion, and attracted considerable attention when exhibited at the Royal Academy annual exhibition. The next year Copley was elected to full membership in the Academy, among the first Americans to be so honored.

Copley settled comfortably into the heady art world of late eighteenth-century London. He exhibited frequently and challenged himself with exacting "contemporary" historical themes, including *The Death of the Earl of Chatham,* 1779–81 (Tate Gallery, London), depicting the sudden collapse of William Pitt during a session of the House of Lords in April 1778. His most ambitious and adept history painting is *The Death of Major Peirson,* 1783 (Tate Gallery, London). Peirson was a British military commander who led a small contingent of British and Scottish soldiers in the defeat of 900 French troops attempting to take the island of Jersey in 1781. The huge canvas depicts the moment of British triumph but also the end of Peirson's life, as he was felled by a French bullet just as the tide turned. Like *Watson and the Shark,* the painting attracted acclaim. To promote it and make some money (for it was uncommissioned), Copley arranged a private exhibition in a rented gallery space to which he charged admission and sold subscriptions for an engraved reproduction.

By the mid 1790s, London's art world was in transition and Copley seemed unable to keep up with the changes. He continued to paint portraits, which, as in America, were his bread and butter. He also painted a series on Biblical subjects. His work, however, was not as well received as it was earlier in his career. Copley remained active in the Royal Academy, running for the presidency in 1792 (he lost to Benjamin West). He died on September 9, 1815, at age 77, after suffering a stroke on August 11. Susanna lived until 1830. Copley, who began life as the son of a poor tobacco merchant, would have been thrilled when his son, John Jr., was appointed to Parliament; knighted by Queen Victoria, for whom he served as Lord Chancellor; and received the title Lord Lyndhurst.

Copley and American Art History

As the most highly regarded colonial painter, Copley was among the first studied by art historians and is easily the colonial American artist who has received the most extensive scholarly and popular attention.[36] William Dunlap's *A History of the Rise and Progress of the Arts of Design in the United States,* 1834, dedi-

cated more pages to Copley than to any other colonial artist save Benjamin West. It was Dunlap who established the standard story line on Copley, writing that he was no longer an American painter after he went to England. Subsequently dozens of scholars would celebrate Copley's American portraits and denigrate his English work as pompous, conventional, and stilted—a betrayal of his American roots. This simplistic perception persisted for well over a century.

Copley's American portraits were featured in exhibitions throughout the nineteenth century. The first checklists of his work appeared in the 1870s, well before scholarship on any of the other artists examined here, and the first monograph (account of his life and work) appeared in the 1880s. Copley was included in the first surveys of American art history, such as Henry Tuckerman's *Book of the Artists,* 1867, an influential text that corresponded Copley's meticulous technique with the spirit of colonial America—hard work, directness, and simplicity. In 1914 *Letters and Papers of John Singleton Copley and Henry Pelham, 1739–1776,* an invaluable resource for scholars and students of colonial art and history, was published.

Writings accentuating Copley's Americanness proliferated in the nationalistic period after World War I. Lloyd Goodrich, one of the leading lights in early American art history, chastised Copley in 1937 for having "exchanged the integrity of his American style for the graces of a decadent tradition" by moving to England.[37] In the 1930s the first one-man exhibitions of Copley's paintings were held at the Metropolitan Museum of Art in New York City (1936) and the Museum of Fine Arts, Boston (1938). Jules Prown produced the first truly comprehensive and analytical study of Copley's life and work in two volumes in 1966, which encouraged scholars to be less chauvinistic and study Copley's English works as well. Since 1966, as American and English art of the eighteenth century has gained wider acceptance as a field of academic interest, the number of studies of Copley and his work have continued to grow and include analyses from a range of methodological perspectives. Two recent catalogues and exhibitions, *John Singleton Copley in America,* organized by the Metropolitan Museum of Art in 1995, and *John Singleton Copley in England,* organized by the Museum of Fine Arts, Houston the same year, present a balanced and thorough consideration of both phases of his career. Relying on visual, biographical, and contextual analysis and newer methodologies from social history and anthropology, the catalogues, while exploring the astonishing visual appeal of Copley's works, also recognize their function as compelling historical documents that shed light on crucial decades in American history.

Notes

1. Quoted in Rebora and Staiti, 186.
2. Lovell, 7.
3. Quoted in Lovell, 2.
4. Staiti, "Accounting for Copley," 29.

5. Copley and Pelham, 117.

6. Quoted in Lovell, 8.

7. The implications of the shared dress are discussed in Lovell.

8. Quoted in Staiti, "Character and Class," 57.

9. Prosser, 182.

10. Quoted in Craven, 323.

11. Copley's other portraits depicting women in the blue saque dress are *Mary Turner Sargent,* 1763 (Fine Arts Museum of San Francisco) and *Mary Topham Pickman,* 1763 (Yale University Art Gallery).

12. Quoted in Rebora, "Transforming Colonists," 20.

13. Craven, 257–68, 310–12, 320, 326–34.

14. Staiti, "Accounting for Copley," 35.

15. Lovell, 5–7, 37–39.

16. Rather, 76–79.

17. Copley and Pelham, 26. A comprehensive examination of Copley's work in pastel is Shelley, 127–41.

18. Copley and Pelham, 41–44, 51.

19. Ibid., 54.

20. Quoted in Rebora, "Transforming Colonists," 9.

21. Quoted in Breskin, 111.

22. Fischer, 30.

23. Copley and Pelham, 77.

24. Ibid., 94.

25. Quoted in Rebora, "Transforming Colonists," 9.

26. Copley and Pelham, 174.

27. Breskin, 106–23.

28. Rebora and Staiti, 291.

29. Fischer, 95–97.

30. Prosser, 188, 195.

31. Copley and Pelham, 128.

32. Ibid., 174.

33. Fischer, 31.

34. Susanna and John Singleton Copley had four children in Boston: Elizabeth, born 1770, John Jr., 1772, Mary, 1773, and Clarke, 1775. Clarke died in 1776, the same year that Susanna was born in London, and Jonathan, their last child, was born in 1782. Susanna and Jonathan died in 1785.

35. Copley and Pelham, 259–60.

36. The historiography of Copley studies is addressed in Rebora, "Copley and Art History," 3–23."

37. Quoted in Ibid.,13.

Bibliography

Breskin, Isabel. "'On the Periphery of a Greater World': John Singleton Copley's *Turquerie* Portraits." *Winterthur Portfolio* 36, no. 2/3 (Summer/Autumn 2001): 97–123.

Canton Museum of Art. "John Singleton Copley and Margaret Kemble Gage: Turkish Fashions in Eighteenth-Century America." http://tfaoi/com/newsm1/n1m303.htm.

The Collection: National Gallery of Art. "Tour: John Singleton Copley (American, 1738–1815)." http://nga.gov/collection/gallery/gg60b/gg60b-main2.html.

Copley, John Singleton, and Henry Pelham. *Letters and Papers of John Singleton Copley and Henry Pelham, 1739–1776.* Boston: Massachusetts Historical Society, 1914.

Craven, Wayne. *Colonial American Portraiture: The Economic, Religious, Social, Cultural, Philosophical, Scientific, and Aesthetic Foundation.* Cambridge: Cambridge University Press, 1986.

Dunlap, William. *A History of the Rise and Progress of the Arts of Design in the United States.* New Edition. Vol. 1. Boston: C. E. Goodspeed, 1918.

Fischer, David Hackett. *Paul Revere's Ride.* New York: Oxford University Press, 1994.

Lovell, Margaretta M. "Mrs. Sargent, Mr. Copley, and the Empirical Eye." *Winterthur Portfolio* 33, no. 1 (Spring 1998): 1–39.

Neff, Emily Ballew. *John Singleton Copley in England.* Exhibition Catalogue. Houston, TX: Museum of Fine Arts, Houston, 1995.

The 1911 Edition Encyclopedia. "Lyndhurst, John Singleton Copley, Baron." http://33.1911encyclopedia.org/L/LY/LYNDHURST_JOHN_SINGLETON_COPLEY_BARON.htm.

Prosser, Deborah I. "'The Rising Prospect of the Lovely Face': Conventions of Gender in Colonial American Portraiture." In *Painting and Portrait Making in the American Northeast,* edited by Peter Benes. Dublin Seminars for New England Folklife Annual Proceedings. Boston: Boston University, 1994.

Prown, Jules. *John Singleton Copley.* 2 vols. Cambridge, MA: Harvard University Press, 1966.

Rather, Susan. "Carpenter, Tailor, Shoemaker, Artist: Copley and Portrait Painting around 1770." *Art Bulletin* 74, no. 2 (June 1997): 269–90.

Rebora, Carrie. "Copley and Art History: The Study of America's First Old Master." In *John Singleton Copley in America,* Carrie Rebora and Paul Staiti. Exhibition Catalogue. New York: Metropolitan Museum of Art, 1995.

———. "Transforming Colonists into Goddesses and Sultans: John Singleton Copley, His Clients, and Their Studio Collaboration." *American Art Journal* 27, no. 1/2 (1995/96): 4–37.

Rebora, Carrie, and Paul Staiti. *John Singleton Copley in America.* Exhibition Catalogue. New York: Metropolitan Museum of Art, 1995.

Shelley, Marjorie. "Paintings in Crayon: The Pastels of John Singleton Copley." In *John Singleton Copley in America,* Carrie Rebora and Paul Staiti. Exhibition Catalogue. New York: Metropolitan Museum of Art, 1995.

Staiti, Paul. "Accounting for Copley." In *John Singleton Copley in America,* Carrie Rebora and Paul Staiti. Exhibition Catalogue. New York: Metropolitan Museum of Art, 1995.

———. "Character and Class." In *John Singleton Copley in America,* Carrie Rebora and Paul Staiti. Exhibition Catalogue. New York: Metropolitan Museum of Art, 1995.

Tuckerman, Henry T. *Book of the Artists: American Artist Life.* New York: G. P. Putnam, 1867.

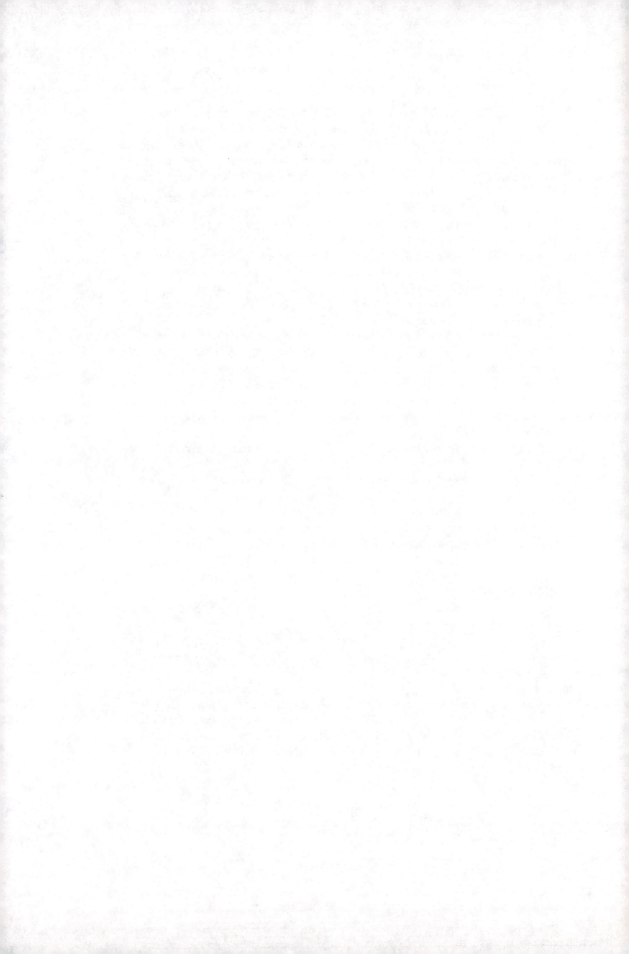

CHAPTER 10

Benjamin West (1738–1820), American Artist Abroad

Benjamin West's engaging self-portrait of c. 1776 depicts a fashionably dressed man, hand on chin, regarding us with a direct and intelligent gaze and a slight smile. It is the image of a sophisticated eighteenth-century gentleman, confident in his abilities as he holds a drawing of his masterpiece, *The Death of General Wolfe,* 1770. West wears a broad-brimmed hat reminiscent of the one that Baroque master Peter Paul Rubens wears in a 1623 self-portrait that West knew, thereby associating himself with the successful artist and courtier. Bright light falls on one side of West's face, casting the other side in shadow and accentuating his handsome aquiline nose. His broad forehead is also highlighted, as is the hand below his head from which his index finger projects, pointing arrow-like at his forehead, recalling the prioritization of the artist's intellect over his manual skills in eighteenth-century aesthetic theory. His dress, his pose, and the objects surrounding him are in every way consistent with British images of artistic genius.[1]

By 1776, West had reached the pinnacle of success in the English-speaking art world, an appointment as Historical Painter to His Majesty King George III. Yet he began life as the son of a Pennsylvania innkeeper and was raised among Quakers, a strict sect that regarded art as a trivial indulgence. How he emerged from such humble origins to become the king of England's favorite painter and confidant and a founding member and later president of England's Royal Academy of Arts is a fascinating tale and evidence that by the end of the colonial period, an American artist could compete at an international level.

Benjamin West left America for Europe in 1758 at the age of 21 and, after 3 years in Italy, lived in England for the rest of his life. This begs the question: how can we regard West as an American artist if the majority of his career was spent abroad? This is a point of debate among art historians. Specialists in English art

171

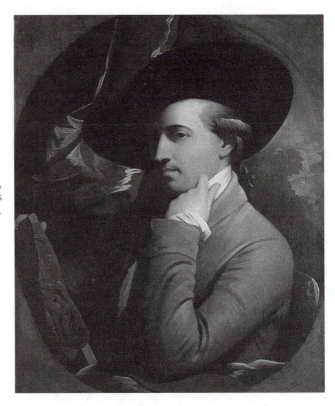

Benjamin West, *Self-Portrait*, c. 1776. Oil on canvas (30 1/4 × 25 1/8 inches). © Library of Congress.

claim West as their own, for he was an integral part of London's art world and had a profound effect on late-eighteenth- and early-nineteenth-century British painting. Historians of American art, however, consider West an American painter and a proper focus for scholarship for several reasons. First, he was born in America and maintained his American identity throughout his life. He remained in contact with his family, friends, and patrons in America, particularly during the American Revolution, which he supported. West addressed American themes in his work, including two paintings regarded as his most important and influential, *The Death of General Wolfe,* 1770, and *William Penn's Treaty with the Indians,* 1772. Both paintings were reproduced as prints that decorated thousands of American homes. Americans traveled to England to study with West in such numbers that his studio was known as the American School. West's instruction inspired an ambitious agenda among his American students, who attempted to replicate his success at home. And finally, since the earliest writings on American art, West has been identified as the father of American painting. For these reasons, he is an appropriate figure with whom to conclude a study of colonial American artists. West's life and work demonstrate the tremendous cultural shift that took place during the colonial period. Early colonial artists were isolated individuals working in challenging circumstances—struggling, as the colonies struggled, to establish themselves. With West, the colonial period ends with an American painter dominating the field in England.

West in America

The first biography of Benjamin West appeared during his lifetime, a two-volume text published in 1816 and 1820. Written by John Galt, a Scottish romantic novelist, the title of part II, *The Life, Studies, and Works of Benjamin West, Esq., President of the Royal Academy of London, Composed from Materials Furnished by Himself,* reflects how closely West worked with Galt. The biography's accuracy is often questioned, based as it is on recollections made decades after most events. Galt also exaggerated aspects of West's life to create a particular persona, relying on topoi as much as truth. (A topos is a story or theme that appears repeatedly in a genre of writing. For example, in their biographies artists almost always have to overcome obstacles, such as disapproving parents, to pursue their chosen career.) West's biography over-emphasizes his rustic origins, weaving into the narrative charming topoi accentuating his naiveté and love of nature and recalling West's carefree days among the Native Americans to make his later ascent seem all the more miraculous. West was complicit in mythologizing his past; throughout his life he used his unique upbringing to market himself, and he read and approved drafts of the biography. Therefore one must be cautious with Galt's assertions and seek confirmation in other sources.

Benjamin West was born in Springfield (now Swarthmore), Pennsylvania, about ten miles west of Philadelphia, on October 10, 1738, the same year as John Singleton Copley. He was his parents' tenth and last child. Springfield was located on one of the primary routes west from Philadelphia, and West's father, John West, ran an inn that catered to travelers. John West immigrated to America in 1714, although his parents had arrived in 1699 among the original Quaker settlers of Pennsylvania. Benjamin's parents were raised in the Society of Friends, but West and his siblings were not birthright Quakers because their parents had both experienced difficulties with the Society. John West was not in good standing with the meeting he left behind in England. The Springfield Friends disavowed Benjamin's mother, Sarah Pearson, at age twenty for the offence of fornication. Despite this, West was raised in a Quaker milieu; later in life West described his religious upbringing as Quaker. The Friends' religious beliefs and settlement of Pennsylvania are described in Chapter 7. It is important to remember that the Friends emphasized plainness in speech and dress and discouraged the arts.

West had little formal schooling and was an atrocious speller throughout his life (although his mistakes are corrected in some publications, hence the range in the quotes that follow). West claimed he began to paint around age 9; by age 12, Galt states, he announced he would be the companion of kings and emperors.[2] His earliest existing work is a childlike landscape painting created in the early 1750s, an amazing artifact in that it exists at all. The painting conflates several disparate scenes—a bridge with fishermen, buildings from different historical periods, a large cow—probably based on painted china, embroidery, or wallpaper. Galt insists that West was self-trained (another common artist topos), except for the Indians who taught him how to grind and mix pigments. While

possible, this strains credulity, for there were few Native Americans in Spring-field by the 1740s. West did note in other sources that he prepared his own pig-ments from bark, roots, and herbs and spent "many Innocent and Diverting hours" in Indian wigwams, although this may be more myth-making.[3]

Subsequent scholarship belies Galt's assertion that West was self-educated. Instead, the influence of several artists appears in West's early work, and evidence indicates that he studied with at least two painters. The first was William Williams (1727–91), who lived in Philadelphia in the 1740s and 1750s. West wrote in 1810, "had not Williams been settled in Philadelphia I shd not have embraced painting as a profession." West met Williams in 1747, when a cousin, noting West's interest in drawing, took the nine year old to Philadelphia and "bought me colours, & all the other materials for making pictures in oils."[4] He also introduced West to Williams, who was taken by the youngster's reaction to his work, initiating a relationship that lasted until West left Philadelphia in 1760 and resumed when West and Williams reconnected in the 1770s in London.

Williams painted elegant portraits in the Rococo style. His best known work, the portrait of Deborah Hall, 1766 (Brooklyn Museum of Art), is a full-length image of the fifteen-year-old girl in a pale pink, heavily boned open robe dress standing in a stage-like formal garden setting. Precisely detailed objects surround Hall—a squirrel on a chain, a clinging vine, a fountain, a rose tree on a pedestal—that probably allude to her virtue and unmarried state. The portrait may have functioned as an invitation to suitors, as 15 was considered marriageable age.

West learned the rudiments of portrait painting from Williams and from studying the works of two other artists, John Wollaston and Robert Feke. One of the most sophisticated works of West's American period is a portrait of Jane Galloway painted c. 1757, when he was nineteen years old. Although not represented full-length, Galloway is posed like Williams's Deborah Hall, with her body turned to the left and her head presented almost frontally. She wears a gray-blue dress with pink highlights, similar in coloring and style to that of Hall, though the dress's sheen and sculpted folds resemble the fabric in Wollaston's portraits. West's attention to detail, evident in Galloway's lace cuffs and collar, earrings, and the flowers she holds, is consistent with the work of Williams, Wollaston, and Feke. Jane Galloway was the daughter of wealthy Quakers and would later marry West's friend, Joseph Shippen, who accompanied him to Italy. In the late 1750s, word of West's talent spread, and he spent time traveling to Philadelphia, Lancaster, and New York to paint portraits.

While Williams was in Philadelphia he wrote and illustrated a manuscript titled *Lives of the Painters,* which consisted of biographies of the great European masters. To read of those who were, in fact, the peers of emperors and kings must have inspired West to consider how far his talent might take him. West wrote, "it was to his books and prints that I was indebted for all the knowledge I possessed of the progress which the fine Arts had made in the world, & which prompted me to view them in Italy."[5] Williams gave West other books to study: Jonathan Richardson's *Two Discourses* (1719) or *An Essay on the Theory of Painting* (1725)

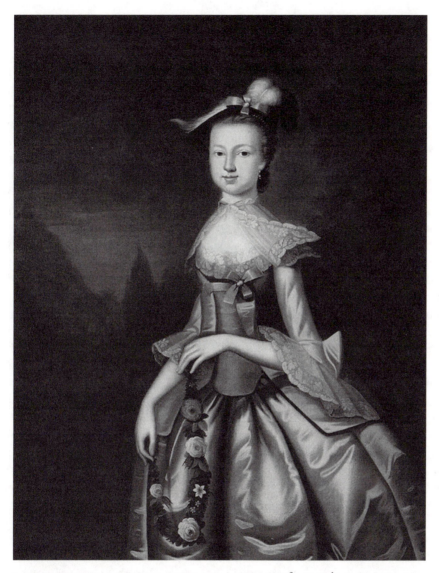

Benjamin West, *Jane Galloway*, c. 1757. Oil on canvas (49¾ × 39¼ inches). Courtesy of The Historical Society of Pennsylvania Collection, Atwater Kent Museum of Philadelphia.

and Charles-Alphonse du Fresnoy's *De Arte Graphica: The Art of Painting* (1695). Both authors' writings were seminal in defining eighteenth-century English art theory, encouraging the recognition of visual artists as intellectuals, establishing the art of Ancient Greece and Rome as the model to emulate, and promoting the pre-eminence of history painting in the hierarchy of subject matter.

If West was introduced to Richardson's and du Fresnoy's writings at such an early age—and indeed could understand such sophisticated theory—it would explain in part the small, awkward painting he produced in 1756, *The Death*

of Socrates (private collection). Both Richardson and du Fresnoy proclaimed historical themes the only subject matter worthy of the greatest artists. History paintings depict important past events, including actual historical occurrences and mythological, biblical, and literary subjects. The knowledge of history and the classics and the compositional and technical skills needed to paint such complex, morally uplifting themes required a painter of exceptional talent and intelligence. The death of Socrates was a popular theme among history painters, for it involved a number of figures expressing a range of emotions and conveyed a compelling moral message. Although West's painting is clumsy compositionally and technically, it is astonishing that an uneducated colonial portrait painter produced such a painting at all. This has encouraged scholars to seek other influences on his early years as an artist. Art historian Ann Uhry Abrams suggests that West studied with John Valentine Haidt (c. 1700–80) in the mid-1750s. Haidt was a Moravian lay preacher who painted biblical themes and complex, multi-figural allegorical compositions celebrating the accomplishments of the sect and its leader, Count Nikolaus Zinzendorf. West told a friend that "Mr. Hide [the phonetic spelling of Haidt], a German, gave him some instruction," and West's figures' poses, body forms and emotional expressiveness in *The Death of Socrates* resemble Haidt's figures, some of whom appear based on Greco-Roman statuary.[6] *The Death of Socrates* also reveals that while supporting himself as a portraitist, West had the inclination to attempt something more ambitious.

Another individual, who in modern terms can be regarded as West's mentor, encouraged his aspirations. Anglican minister William Smith was the provost of the College of Philadelphia (later the University of Pennsylvania). Although only 31 when he met West, Smith was one of the leading classicists in America, regarded as a brilliant, volatile, and charismatic man. He was passionate about the arts, believing that a well-rounded education must include music, painting, and poetry. *The Death of Socrates* caught his eye, and he began to nurture the young painter. Smith knew that a history painter must be well-versed in European literature and history, and he introduced West to the classics, including the writings of Livy, Plutarch, and Pliny.

After his mother died in August 1756 West moved to Philadelphia permanently as Smith's protégé. He lived there until he left for Italy, cultivating not only his mind but also a circle of friends, primarily wealthy merchants who had confidence in the young artist's abilities. Smith's instruction convinced West that while he could probably make a comfortable living painting portraits in Philadelphia, this was a dead end creatively. He saved his money, and with the emotional and financial support of Smith and his Philadelphia friends, West departed for Italy on April 12, 1760, at the age of 21. Although Galt wrote that there was nowhere "so unlikely to produce a painter as Pennsylvania," it is clear that West found there the training, education, and resources he needed to support such an unprecedented voyage.[7]

West in Italy

West sailed on the ship the *Betty Sally* to the port of Livorno on Italy's west coast. William Smith and William Allen, a wealthy merchant and chief justice of Pennsylvania, coordinated the trip; Allen was shipping a load of sugar to Italy, supervised by his son John, who with his friend Joseph Shippen planned to embark on the Grand Tour. They were among the first Americans to join the thousands of wealthy English men and women who flocked to Italy to see the masterpieces of the ancient classical world and the Renaissance and Baroque periods.

The importance of Italian study for an artist who wished to paint historical themes cannot be overestimated. In addition to the writings of art theorists, the interest among art patrons in the classical style—established in Ancient Greece in the fifth century B.C.E., perpetuated by the Ancient Romans until about the third century C.E., and revived during the Italian Renaissance—motivated artists to familiarize themselves with classical themes and forms. Another instigation was the excavations underway at Pompeii and Herculaneum, two Ancient Roman towns destroyed by the eruption of Mount Vesuvius in 79 C.E. Covered with volcanic rock and dust for centuries, the cities were unearthed over the course of the eighteenth century and yielded work after work of classical art that captivated European artists and collectors.

What distinguished the eighteenth-century interest in classicism was the writing of Johann Winckelmann, who codified the classical style as the height of Western art in *Thoughts on the Imitation of Greek Works in Painting and Sculpture* (1755), and *The History of Ancient Art* (1764). Winckelmann is regarded as the first to organize Western art stylistically, dividing it not by chronological periods alone but also by similar formal characteristics, or style. This is how art history continues to be organized to this day. Winckelmann judged styles qualitatively, by how well they replicated classical ideas, prioritizing the Renaissance over the Baroque, for example, because Renaissance art and architecture maintained more purely the classical emphasis on harmony, balance, and order. Winckelmann played a key role in defining the Neoclassical, or new classical, style, which would dominate late-eighteenth-century European art. In the 1760s Winckelmann was on the staff of Cardinal Alessandro Albani, an arbiter of taste in Rome, and it is likely West met Winckelmann at Albani's home.

It was in this atmosphere of reverence for the classical style that West arrived in Italy. He settled in Rome, a rural Yankee with a Quaker upbringing who spoke barely a word of Italian in the center of ancient art and Catholicism! But West was charming, handsome, and had excellent letters of introduction from such important Americans as Smith and Allen. Again, Galt relied on a topos—the innocent abroad—to characterize West's early experiences in Italy. He wrote of West's first meeting with Cardinal Albani, who was nearly blind at this late stage of his life. Albani touched West's face and asked if he was dark-skinned, like an Indian, assuming that all Americans must be. Accompanied by a crowd of con-

noisseurs, West and Albani then visited the Vatican collection to see the Ancient Greek sculpture the *Apollo Belvedere,* the viewing of which was considered the Grand Tour's high point. According to Galt, West responded to the sculpture by exclaiming "My God, how like it is to a young Mohawk warrior!"[8] The connoisseurs were offended by West's comparison of the Greek god to a "savage" and demanded an explanation. West then launched into a speech on the "strength, agility and grace" of the Native Americans, noting how the eyes of the Apollo looked like those of an Indian archer following the course of his arrow, thoroughly charming his listeners.

West's most fortuitous contact in Rome was another member of Albani's circle, the German artist Anton Raphael Mengs, one of the most admired painters in the city. Mengs was painting a ceiling based on Winckelmann's ideas in Albani's villa, and West spent time there assimilating his style and European painting techniques. Mengs also coordinated West's Italian experience, instructing him to first spend time in Rome drawing from "the Antique," and then travel to Florence, Bologna, Parma, and Venice to study the masterworks of the Renaissance and Baroque periods. In addition to drawing classical sculpture, West copied paintings by the Renaissance artists Titian and Correggio and the Baroque artists Domenichino, Guido Reni, and Anthony Van Dyck, although his studies were curtailed by illness that forced his return to Livorno for treatment and recovery. He also executed drawings after Michelangelo's Sistine Chapel ceiling and sculptures of Moses and the Pietà. When Copley traveled to Italy in 1774, West advised him similarly to study "Antient Statuarys, Raphael, Michal Angilo, Corragio, and Titian, as the Sorce from whence true tast in the arts have flow'd."[9] West sent copies to William Allen and James Hamilton, the Lieutenant Governor of Pennsylvania, to repay the money they lent him for the trip. West also produced original works in Italy, including a striking portrait of John Allen, and, on Mengs's advice, "a historical composition to be exhibited to the Roman public" for "the opinion which will then be formed of your talents should determine the line of our profession which you ought to follow."[10] The result was *Angelica and Medoro,* based on a sixteenth-century poem by Ludovico Ariosto.

West in England

Benjamin West sailed to England on August 20, 1763, intending to stay only a few months before returning to America to establish his career. Yet fortune intervened. Artists he met there encouraged him to submit three paintings, including *Angelica and Medoro,* to the 1764 exhibition of the Society of Artists. The paintings attracted very positive critical attention. The press described West as the "American Raphael." William Allen, also in England, wrote home that West "has so far outstripped all the painters of his time as to get into high esteem at once. . . . If he keeps his health he will make money very fast."[11] The enthusiastic reception of his work induced West to remain in London. No doubt he

also realized that history painting—which, he learned as a boy, all great artists aspired to do—had no secure place in the colonies.

West arrived in England at an opportune time in the history of British art. As noted in previous chapters, despite the improved status of artists in continental Europe since the fifteenth century, when Italian artists recognized the intellectual demands of the profession and promoted it as a liberal (instead of merely a mechanical) art, the status of artists in Great Britain lagged behind. England maintained a more medieval perception of native-born artists as craftspeople rather than creative geniuses (although foreign-born artists who worked in England, such as Hans Holbein, Peter Paul Rubens, and Anthony Van Dyck, were accorded greater status). By the late seventeenth century, Godfrey Kneller and Peter Lely began to reshape the public perception of artists as professionals rather than tradesmen. By the mid-eighteenth century, Thomas Gainsborough and Joshua Reynolds were regarded as almost the peers of their wealthy clientele. The founding of the Society of Arts (later the Society of Artists of Great Britain) in 1754 was an additional boost to the profession's prestige, as was the establishment of the Royal Academy of Arts in 1768. (The late date of the Academy's founding is another sign of the distinction between the artist's status in England and in continental Europe, where Italy and France had maintained government-sponsored academies since the sixteenth and seventeenth centuries.)

In 1768 West submitted a work to the Society's annual exhibition that is regarded as his first masterpiece, *Agrippina Landing at Brundisium with the Ashes of Germanicus* (Yale University Art Gallery), a painting that, as art critic Robert Hughes observes, "fairly creaks with antiquarian correctness."[12] Here West demonstrated the result of his Italian study by directly quoting from well-known classical works of art. The painting's central group of Agrippina and her children and attendants is based on the Ara Pacis Augustae, a Roman relief sculpture from 13–9 B.C.E. The columned structure in the background resembles the palace of Emperor Diocletian in Spalatro. With this work West became the leading proponent of the Neoclassical style in England. He also demonstrated his intense concern with the use of historically accurate detail to establish a scene's authenticity.

The painting's subject comes from the *Annals* of Tacitus, who wrote of the Roman general Germanicus, poisoned in Syria by agents of his uncle, the Emperor Tiberius, who feared Germanicus's popularity. Tiberius forbade Germanicus's burial in Rome, but his widow Agrippina defied the emperor by bringing his ashes to the city via the port at Brundisium, where a crowd of mourners met them. West depicted the moment when, according to an English translation of Tacitus, Agrippina disembarked "with her eyes riveted to the earth" and "there was a one universal groan" from the mourners.[13] It is an appropriate story for grand manner history painting, which aspired to teach moral lessons, in this case the values of loyalty, courage, and dignity. Scholars have suggested that West's historical themes may also comment on contemporary political concerns. Art historian Albert Boime regards Agrippina's loyalty to her husband as a sym-

bol of larger loyalties at a time when factionalism divided Parliament and England's Protestants. West's source for Agrippina—the Ara Pacis, or Altar of Peace—thereby becomes more than a formal stimulus. The Archbishop of York, Robert Hay Drummond, who commissioned the painting, was active in English politics and was a close friend of George III.[14]

Another work of 1768 also demonstrates West's adherence to Neoclassical subject matter, composition, technique, and expressive content. *Venus Lamenting the Death of Adonis,* a painting that West scholar Allen Staley notes "has fair claim to being considered one of West's most beautiful paintings," is based on Ovid's *Metamorphoses.* Pricked by Cupid's arrow, Venus fell in love with the beautiful mortal Adonis. She warned him against hunting wild beasts alone but he disobeyed and was gored in the side by a boar. Ovid wrote of Venus descending from the skies and, wailing and rending her garments, confronting the body of her dead lover on a parched plain. West transformed the scene into an image of emotional restraint consistent with the Neoclassical emphasis on dignity and calm grandeur; Venus gazes stoically at her beloved, her noble head bent in grief. Instead of the deep wound in Adonis's side that Ovid described, we see only a scratch and a small pool of blood. West placed the lovers not on a barren plain but in a protective copse of trees, flanked by the delicate red anemones that grew where Venus sprinkled Adonis's blood with nectar. To the left, in the distance, Adonis's dogs chase the deadly boar.

Characteristic of Neoclassical compositions, Venus, Adonis, and Cupid are in the front of and parallel to the picture plane, resembling theater, with the protagonists positioned like actors on a stage. Here, the pale body of Adonis and Venus's white robe and shoulder sharply contrast with, and therefore project from, the dark background. Consistent with classical aesthetic values, the composition is coherent and easy to grasp. The viewer's eye moves clockwise, following the curve of Venus's back to Cupid's head and arm, then down to the right across Adonis's convex form, and up again to Venus's thigh and back. Within this circle is a tight oval formed by the faces of Venus, Cupid, and Adonis, focusing our attention on the painting's emotional core.

West's technique in *Venus Lamenting the Death of Adonis* demonstrates what he learned from Mengs and the study of Renaissance painting. The brushstroke is smooth and unobtrusive in the figures' bodies and meticulous in details such as the pearls wound in Venus's hair, Cupid's tears, and Adonis's blue-tinged fingertips. The background is handled more summarily, with painterly brushstrokes defining the clouds and sky to Venus's left. Adonis's well-defined body, pale in death, resembles classical sculpture, which West believed could not be surpassed. He wrote, "the form of man has been fixed by eternal laws, and therefore must be immutable. It was to those points that the philosophical taste of the Greek artists was directed, and their figures produced on those principles leave no room for improvement."[15] The term Neoclassicism did not exist in the 1760s, instead it was called the "true style" or the "correct style," reflecting its adherents' belief that it was the epitome of visual expression.

The Death of General Wolfe, 1770

By 1770 West had completed his first commission for George III and helped found the Royal Academy of Arts. He was close to the top rank in London's competitive art world as he set out to secure his position with the most innovative and spectacular painting of his career, and also the work for which he is best known today. *The Death of General Wolfe,* 1770, was not only a phenomenon in eighteenth-century London, it is a painting that changed the direction of Western historical painting. With this work, West invented contemporary history painting—seemingly an oxymoron yet an accurate phrase—by applying to a recent event the compositional complexity and moral gravity heretofore limited to scenes of the distant past.

West found an appropriate vehicle with which to explore his ideas in the story of Major-General James Wolfe, the commander of British forces in Canada during the French and Indian War. By the 1750s English and French rivalry over American land and trade had reached a climax. While Great Britain controlled the eastern seaboard from Georgia to Massachusetts (of which the current state of Maine was part), the area beyond the Appalachian Mountain chain was in dispute. The French attracted the allegiance of many Native American cultures, including the Lenni Lenape, still angered by the fraudulent Walking Purchase of 1737 (see Chapter 7). Beginning in 1754 skirmishes between the allied French and Indians and the British erupted throughout the colonies as England worked to sever French-controlled Canada and Louisiana.

On September 13, 1759, General Wolfe's troops engaged the French in the Battle of Quebec, a turning point in the war. Surrounded by steep hills and the St. Lawrence River, Quebec was considered impregnable, yet Wolfe discovered an unguarded path from the river to the Plains of Abraham outside the city. Under cover of night he led 5,000 soldiers up the path, forcing the French to leave their fortress to defend the city. Tragically, Wolfe was shot in the stomach during the battle. As he lay dying in a ditch with a few men by his side, a ranger scout arrived to report the defeat of the French. Wolfe said "Now, God be praised, I will die in peace," quietly passed away, and promptly became a national hero. As his contemporary, London writer Horace Walpole noted, a "whole people . . . triumphed . . . and they wept . . . for Wolfe had fallen in the hour of victory!"[16] A drawing of Wolfe from c. 1765 indicates that within six years Benjamin West had decided to honor Wolfe with a painting that would break several of the genre's rules and thereby chart a new course for European history painting.

As noted, Wolfe died with little fanfare. West ignored the specific details for a more operatic conception, in which Wolfe is cast as a hero dying amid a crowd of onlookers, with the hectic battlefield behind them, the towers of Quebec to the left, the masts of the British fleet to the right, and a turbulent sky above. West was not concerned with documenting the event, but instead wished to create a dramatic staging emphasizing the sacrifice of a great man for duty,

honor, and patriotism. This message is certainly appropriate for a grand history painting, even if Wolfe's sacrifice took place only 11 years instead of centuries before. West later justified his choice, writing that he could not depict Wolfe dying "like a common soldier, under a Bush" because "all shd. be proportioned to the highest idea conceived of the Hero . . . a mere matter of fact will never produce this effect."[17]

Even more groundbreaking was West's decision to clothe Wolfe and his men in contemporary uniforms—the image, he no doubt reasoned, should be convincing if not completely accurate. This seems like common sense to modern viewers. But in the eighteenth century, artists who created large scale, grand manner history paintings, even of events more recent than the classical past, were encouraged to garb figures in ancient dress such as togas or armor to make them appear timeless and universal. Modern dress, it was believed, dated the image and detracted from the grandeur of the conception and the moral messages conveyed by ideal form. By dressing his figures in contemporary clothing, West rejected one of the basic premises of history painting.

It was West's use of contemporary dress that the painting's early viewers found most objectionable. Joshua Reynolds, president of the Royal Academy, reminded West that "the classic costume of antiquity" was preferable to the "modern garb of war," although he did predict (according to Galt) that the painting would "occasion a revolution in the art." King George III, who would soon become West's primary patron, commented that "it was thought very ridiculous to exhibit heroes in coats, breeches, and cock'd hats," although later he ordered a copy of the painting.[18] West did not waver in his conviction that figures in contemporary dress could convey moral lessons as powerfully as those dressed in togas. As West remarked to Reynolds, "the same truth that guides the pen of the historian should govern the pencil of the artists"—an interesting defense given his fictionalization of the circumstances around Wolfe's death, but consistent with West's insistence on the appearance of historical truth in earlier works.[19] As Allen Staley notes, "the mix of grand manner and contemporary factual reportage in *The Death of General Wolfe* had no precedent."[20]

The Death of General Wolfe looks very different from West's Neoclassical compositions of the 1760s. The painting demonstrates West's stylistic flexibility as he appropriated Baroque formal, compositional, and figural forms rather than classical ones. As noted in Chapters 3 and 5, the Baroque style is characterized by dramatic contrasts of light and dark; rich, deep color (here West used a vivid red to draw the viewer's eye across the picture plane); and compositions organized around dynamic diagonals, such as the flag poles, rather than the staid verticals and horizontals of Neoclassicism. West arranged the figures in three pyramids, with the body of Wolfe forming the base of the central pyramid. All eyes are on Wolfe, focusing our attention on him as well. His form recalls the lifeless body of Adonis, although West borrowed Wolfe's pose directly from a painting by Anthony Van Dyck of the dead Christ. Christ's pose was not only appropriate for the dying general, it also augmented the painting's presentation of Wolfe as a martyr and the savior of his people. In keeping with his Baroque

sources, West also abandoned the restrained emotion of his earlier work. Wolfe's eyes roll heavenward as his companions gasp, sob, and wring their hands.

A second focal point is the Native American who sits at the base of the pyramid of figures to the left. As the *Apollo Belvedere* anecdote suggests, early in his career West drew parallels between Native Americans and the Ancient Greeks. The conflation of the two races appears in West's first painting of Native Americans, *Savage Warrior Taking Leave of his Family,* c. 1760 (Royal College of Surgeons, London), where an Indian chief assumes the muscular form and striding and pointing pose of the *Apollo Belvedere.*West furthered the association in *The Death of General Wolfe* by emphasizing the sculpted muscles of the Native American, whose idealized body, face, and proportions mirror those of Greek sculpture. West's inclusion of a Native American (presumably a Mohawk, one of the few Indian cultures sympathetic to the British) situates the scene in North America and underscores Wolfe's death's significance in that even a "savage" was affected by it.

But the Indian's prominence has deeper implications as well. Art historian Vivien Green Fryd argues that the Indian may function as a metaphor for his vanishing race. He is an explicit visual contrast with Wolfe. While Wolfe is fully clothed, the Native American wears only a blanket; Wolfe's skin and hair are very light, but the Indian has tawny, painted skin and dark hair decorated with feathers and beads; Wolfe represents America's future while the Indian embodies its past. The Indian's pose, seated with head on hand and elbow on knee, is traditionally associated with melancholy; Fryd suggests that the figure radiates "inertia, sorrow, perplexity and contemplation," and that the Indian is pondering not only Wolfe's death but also the impending death of his race at the hands of the forces he observes. She notes that the seated Indian supporting his head with his hand became an emblem of the race's demise in the nineteenth century, further evidence of the painting's profound influence on later artists.[21]

Yet art historian Leslie Reinhardt cautions against viewing West's Native Americans as metaphors. Reinhardt suggests that the tendency of modern scholars to view West's Indians reductively, as either noble savages (classical types in Indian dress) or ignoble savages (lesser beings and therefore evidence of West's Eurocentric bias), "blinds us to variations between depictions and flattens the images individually," and is inconsistent with West's concern with authenticity.[22] Reinhardt and Fryd agree, however, that West's Native American images were intended to remind viewers that his unique upbringing made him the artist most fit to record North America's history. West also had his finger on the public's pulse, for despite his colleagues' reservations, *The Death of General Wolfe* was enormously popular when exhibited at the Royal Academy. West had the painting reproduced as a 19-by-24-inch engraving that was published in an unprecedented initial run of 1,200 impressions. Described as "the single most reproduced work of art in the eighteenth century," versions appeared throughout Europe and America, not only as prints but also on porcelain teacups, beer mugs, iron trays, and needlework.[23]

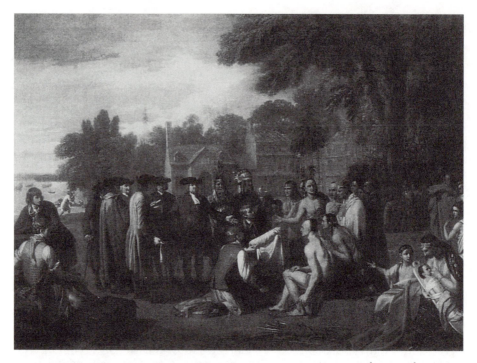

Benjamin West, *William Penn's Treaty with the Indians*, 1772. Oil on canvas (75½ × 107½ inches). © Pennsylvania Academy of Fine Arts.

William Penn's Treaty with the Indians, 1772

Shortly after his success with *The Death of General Wolfe,* West was commissioned by Thomas Penn, the stepson of William Penn and proprietor of the colony of Pennsylvania, to paint an image of his father to commemorate his peaceful negotiations with the Indians almost one hundred years earlier. The result, *William Penn's Treaty with the Indians when He Founded the Province of Pennsylvania in North America,* 1772, is one of the most famous images of an American historical event ever created. Reproductions appear in history textbooks and classrooms throughout the United States. West had doubtless been raised on tales of the devout Quaker Penn, who insisted that the Native Americans be paid for the land the colonists wished to settle, as discussed in Chapter 7. According to legend, in 1682 Penn traded goods for land under an elm tree at Shackamaxon (now Kensington, part of Philadelphia) on the Delaware River. What many modern viewers do not realize is that, as in *The Death of General Wolfe,* the event did not take place as West represented it.

Regardless of the scene's authenticity or lack thereof, many scholars believe the painting was created in response to contemporary political circumstances in London and Pennsylvania. Since the 1730s, various factions in the colony had challenged Thomas Penn's proprietary rights. One faction, composed primarily

of Quaker merchants led by Benjamin Franklin, wished to replace Penn with a government sponsored by the king. Franklin went to London to petition Parliament in 1757, but failed to prevail over the Penn family's supporters. Discord between Thomas Penn and Pennsylvania's merchants continued, escalating with the Townshend Acts of 1767 (see Chapter 8).

Thomas Penn, who had converted to Anglicanism, also upset Pennsylvania's pacifist Quakers by forming a militia during the French and Indian War. Another point of contention was the continuing disputes over territorial rights. Equitable treatment of the Indians eroded soon after William Penn's death in 1718. Most Native Americans were forced out of their homeland by encroaching settlement and the notorious Walking Purchase agreement of 1737 discussed in Chapter 7. Penn made additional attempts to gain land around the Susquehanna River and west to the northern Ohio River Valley in 1754 by purchasing it from the Iroquois, angering the Lenape, who were not consulted and forced Penn to relinquish the claim in 1756. In 1768 Penn reinitiated negotiations to extend his land past the new town of Pittsburgh. He succeeded, in part because white settlement in the region was much more extensive than in 1756. The treaty was ratified about a year before West began the painting, resulting in a considerable financial gain for Penn that was greatly resented by Pennsylvania's colonists, not to mention many Native Americans.

After more than thirty years of factional strife, a painting depicting peaceful relations between William Penn, Quakers, merchants, and Indians must have had an intent beyond honoring the patron's father. A secondary narrative is clear: that merchants, Quakers, and Native Americans could resolve their conflicts and live and work together in harmony, under the paternal figure of the proprietor. It is likely that Thomas Penn commissioned the painting to remind Pennsylvanians of his father's beneficence and reinforce his own claims to the colony's proprietorship. As Ann Uhry Abrams suggests, the painting therefore functioned as "an allegory of provincial politics and not as an artistic representation of an actual event."[24] As it happened, West's benefactor and mentor William Smith, as well as his patrons William Allen and James Hamilton, were staunch supporters of Penn's proprietary rights, which may have predisposed West to accept the commission.

West reinforced this message with the work's visual qualities. Formally and expressively it is the antithesis of *The Death of General Wolfe*. This is apparent in the dominance of horizontal and vertical directional lines, which augments the painting's sense of stability and peace, unlike the dramatic diagonal lines in the image of General Wolfe. It does share with the painting of Wolfe the arrangement of figures into three groups—Penn and his fellow Quakers with the merchants and Indians are in the center, flanked by groups of observers: two dockworkers on the left and the Indian mother and her children on the right. In this case, however, they watch a peaceful exchange rather than a bloody death. The painting's colors, predominantly earth tones, are far more muted than the rich hues of the earlier image. West wrote about the painting in 1805:

The great object I had in forming that composition was to express savages brought into harmony and peace by justice and benevolence, by not withholding from them what was their reight, and by giving to them what they were in want of, as well as a wish to give by that art a conquest made over native people without sward or Dadger.[25]

It appears that West also intended to distinguish British American and Native American culture. The Quakers observe quietly, reflecting the mood of a Quaker meeting, while the Indians express more emotion; some appear astonished by the gifts. The orderly line of Quakers parallels the neat facades of the houses behind them, several still under construction, in contrast with the more chaotic grouping of teepees to the right. West's concern with ethnographically accurate detail is evident here, although he combined Algonquian, Iroquois, and Lenape dress based on artifacts from the Penn family and other collections. Their bright feathers, jewelry, and body decoration contrast strongly with the Quakers' plain garb. To reinforce the painting's message of "savages brought into harmony and peace," at the center front of the painting West juxtaposes a quiver and arrows, emblems of war now placed aside, with the long peace pipe held by the seated Native American. West also included two, possibly three, portraits in the painting beyond that of Penn. West's father John is the stern looking white-haired Quaker, third from the left in the group of Quakers, and West's half-brother, Thomas, stands to the left of Penn. The dockworker leaning against the barrel is thought to be a self-portrait. If so, it is intriguing that West associated himself with mercantile interests rather than the Quakers.

As interesting to modern viewers as the painting's association with a specific political context and its visual and iconographic qualities are its many inaccuracies. It is unlikely that a single meeting with a ceremonial presentation of gifts beneath the Shackamaxon elm tree ever took place. Instead, numerous meetings were held between the proprietor and his agents and the Indians. Penn appears older than the 38 years he was in 1682, and too portly for a man known to run footraces with the Native Americans. West probably based the portrait on later images of Penn. Nor did Penn wear plain Quaker garb during negotiations, but instead dressed in formal English clothes, with, in one instance, a silk sash. The houses in the painting are much more advanced architecturally than any in Pennsylvania in 1682, and the harbor is far more active than it would have been. Both the boats and the houses suggest that the simpler times represented by the Indians and their settlement, significantly placed in shadow, will soon pass.

A single image exhibited in London and then hung at the Penn estate would not have the propagandistic impact that Thomas Penn wished, so he made sure that West coordinated the reproduction of the painting as a large-scale engraving. The print sold in the tens of thousands in Europe and America; it was a popular wedding gift among Quakers and often the only work of art they allowed in their homes. Its renown has given it the validity of historical fact. The first published account of Penn's meeting with the Indians under the elm did

not appear until 1813 and reads suspiciously like a description of West's painting. Unquestionably, the painting has influenced the way Penn's relationship with the Indians is viewed to this day.

West's Alliances

Agrippina Landing at Brundisium with the Ashes of Germanicus not only established West's name in London's competitive art world, but also attracted the attention of King George III, who in 1769 commissioned West to paint a historical theme, the departure of Regalus from Rome, for a paneled recess in a room at Buckingham House (now Palace). Pleased with the result, the king commissioned West to fill the six remaining panels, paying him over two thousand pounds. West became the Historical Painter to the king in 1772. In addition to the money he was paid for his paintings, after 1780 West received a 1,000-pound yearly stipend and no longer needed to paint portraits to support himself. George III and West were only four months apart in age, and they developed a close friendship as the king spent whole mornings in West's painting rooms at Buckingham House and Windsor Castle discussing art and his concerns as head of state. They even remained friends during the American Revolution, despite West's republican sympathies. When George III died in February 1820, West said, "I have lost the best friend I ever had in my life."[26] West himself died less than six weeks later.

Between 1772 and 1802 West created over sixty paintings for the king. The most ambitious project was the 1779 commission to produce about thirty-six large-scale paintings for a Windsor Castle chapel, a project attributed with loosening the Anglican proscription against religious imagery in place since the Protestant Reformation. West had long aspired to do a complex religious scheme like Michelangelo and Raphael, another indication of his distance from his Quaker upbringing. The chapel's theme was "the progress of Revealed Religion from its commencement to its completion," including biblical episodes from the fall of Adam to the New Jerusalem of the Book of Revelation.[27] West executed hundreds of preliminary sketches and more than half of the paintings in the 1780s and 1790s, but he did not complete what should have been the consummate achievement of his career, and the paintings were never installed at Windsor. Scholars speculate that West fell out of favor with Queen Charlotte, who had growing influence over the king after 1788 during his successive bouts of apparent mental illness (today his ailment is diagnosed as the hereditary metabolic disorder porphyria, whose symptoms resemble insanity). The king was also displeased with West's continued and vocal support of democratic principles, particularly in 1794, during England's war with France—now a republic that had recently beheaded its king. Their relationship did not improve when West expressed admiration for Napoleon Bonaparte and visited France in 1802, shortly after the Peace of Amiens briefly settled the countries' differences. Napoleon had

Benjamin West, *Death on a Pale Horse*, 1796. Oil on canvas (23 3/8 × 50 5/8 inches). © Library of Congress.

"collected" many of Europe's masterpieces from the nations he conquered and West was anxious to see them. While there he met Napoleon, who admired a framed oil sketch of a recent composition for the Chapel of Revealed Religion, *Death on a Pale Horse,* which West exhibited at the Louvre. George III learned of their meeting and viewed it as evidence of West's disloyalty.

Some have suggested that the queen viewed West's new work for the chapel as so frightening that she feared it might further disturb the king's fragile health. This is understandable when one views *Death on a Pale Horse,* 1796. The painting depicts the Four Horsemen of the Apocalypse riding out after the first four of the seven seals are broken. As John wrote in Revelation 6:8, "and I saw, and behold, a pale horse, and its rider's name was Death, and Hades followed him; and they were given power over a fourth of the earth, to kill with sword and famine, and with pestilence and by the wild beasts of the earth." Fittingly, West's conception is far from the cool Neoclassicism of his early career. Instead, the painting writhes with dark energy as the horses trample the dead and dying (whose forms still resemble the heroic nudes of antiquity), followed by horrific winged demons from Hell. By the 1790s, a new aesthetic sensibility was beginning to replace Neoclassicism. *Death on a Pale Horse* anticipates the Romantic style, with its emphasis on extreme emotion, characterized in the eighteenth century as "the sublime," then defined as the terrifying awe provoked by experiences perceived as threatening, such as lightning storms, erupting volcanoes —or stampeding horses with monstrous figures upon them. *Death on a Pale Horse* typifies the sublime in the chaotic and unnerving scene's intense drama. As Robert Hughes sardonically commented, "Is there another eighteenth-century painting with so many flaring nostrils and flashing eyeballs?"[28]

Formally, strong light-dark contrasts, painterly brushwork, deep colors, and a dominance of diagonal and curving lines characterize Romantic painting. Compositions lose the logic of Neoclassicism and become complex and difficult to grasp. In defining the style West turned to Baroque painter Peter Paul Rubens, particularly his animal themes. Again we see his ability to quote from past art, a skill much admired in his day. As with Neoclassicism, West was instrumental in establishing a style that would dominate European painting, particularly that of France. The work of the early-to-mid-nineteenth-century French painters Eugène Delacroix and Théodore Géricault exemplifies the Romantic style. Is it a coincidence that West's *Death on a Pale Horse,* a painting that demonstrates all of the formal and expressive qualities of Romanticism, was exhibited in France in 1802? Intriguingly, Allen Staley suggests that the painting may have been West's response to the atrocities of the French Revolution, and that West was one of many late-eighteenth-century painters who correlated revolution and Revelation.[29]

Almost as soon as West was established in London, he received visitors from the colonies. Among the first was the artist Matthew Pratt, who accompanied John West and West's betrothed, Pratt's cousin Elizabeth Shewell, to London in the summer of 1764. There is some debate about whether Pratt was West's student or an independent master who simply shared his studio space. In 1765 Pratt painted a view of West's painting room showing West instructing several students

in drawing while Pratt sits at an easel, indicating that he considered himself West's equal rather than his subordinate. Pratt exhibited the painting in the 1766 Society of Artists exhibition under the title *The American School*. This suggests that at this early date West was recognized as an instructor of American students or, as Pratt's painting was created so soon after West settled in London, that West intended to develop a school and hoped the painting might function as an advertisement of his (and perhaps Pratt's) willingness to take on students.

Subsequently, almost every major late-eighteenth- and early-nineteenth-century American painter studied with West, and his influence on the direction of American art was unparalleled. Early students included Charles Willson Peale, John Trumbull, Ralph Earl, Robert Fulton (inventor of the steamboat), William Dunlap, and Gilbert Stuart. Closer to the end of his career Samuel F. B. Morse (inventor of the telegraph and Morse Code), Washington Allston, Rembrandt Peale, and Thomas Sully studied with West. West was regarded as a generous teacher, unfailingly kind and encouraging. A visitor in 1774 commented, "Never did I hear him Speak evil, or judge uncharitably. You perceive in Him nothing proud, conceited, puffed up, or envious."[30]

Most of West's students returned to the United States and struggled to maintain the aesthetic values he taught them, including the prioritization of history painting. Some did paint important historical scenes; Trumbull, for instance, produced an ambitious series on battles of the American Revolution. None, however, were able to succeed painting historical themes alone. Portraiture remained the predominant subject preferred by most American patrons as late as the 1820s.

When Matthew Pratt visited West in 1764, he reported that West "had a very elegant house, completely fitted up, to accommodate a very large family, and where he followed his occupation, in great repute, as a Historical & Portrait painter."[31] Two years after his marriage to Elizabeth Shewell, the Wests had their first child, a boy named Raphael after the Renaissance master. West painted many portraits of his wife and children. Among the most interesting is a small group portrait West created to commemorate his father's and brother's visit after West's second child Benjamin's birth in 1772 (Yale Center for British Art). West depicted his father and brother in somber Quaker garb, seated stiffly in an attitude of Quaker meditation with their hands clasped on their laps. West leans casually on his father's chair, holding a palette and wearing an embroidered shirt, dressing gown, and an elegant powdered wig—a pointed contrast with his relatives. Elizabeth, as sumptuously dressed as her husband, is seated on the other side of her in-laws, holding the infant Benjamin as Raphael, age six, leans against her chair in a relaxed attitude much like his father's. The painting eloquently discloses the distance West had traveled from his humble beginnings.

By 1772 West had acquired a country house in Hammersmith, north of London, as he wrote to one of his patrons in Lancaster, Pennsylvania, "four miles distance from town where Betsy and her little boy stay eight months in the year, and another in London where I carry on my painting. By that I get exercise of coming into town and going out to them every day."[32] In the 1780s the West family moved to 14 Newman Street, London, where West established an art

gallery and large sky-lighted studio to accommodate his many students. By this time American painters' prominence in London was attracting attention. One Englishman wrote peevishly, "Mr. West paints for the Court and Mr. Copley for the City. Thus the artists of America are fostered in England, and to complete the wonder, a third American, Mr. Brown of the humblest pretenses, is chosen portrait painter to the Duke of York. So much for the Thirteen Stripes—so much for the Duke of York's taste."[33] Mr. Brown was Mather Brown, a student of West's and also a descendant of the famous Mather family of Puritan ministers discussed in Chapter 2. The "humblest pretenses" allude to the fact that Brown was an orphan raised by two maiden aunts.

West was also instrumental in the creation of the Royal Academy of the Arts. As noted above, a significant step in the professionalization of painting and sculpture was the development of academies, which stressed the visual arts' intellectual substance. In 1768 the king encouraged West and three other dissatisfied members of the Society of Artists to draw up a charter for a new organization. George III pledged financial support, hence its designation as a Royal Academy. The Academy accepted only 40 members initially; it was a sign of prestige to be able to follow one's signature with the initials "RA" for Royal Academician. The king asked West to invite Joshua Reynolds to be the first president of the Royal Academy (George III did not like Reynolds and rarely dealt with him). When Reynolds died in 1792 West was elected to succeed him and served as president of the Academy until 1805. Like the Society of Artists, the Royal Academy sponsored annual exhibitions. To the first, in 1769, West submitted the king's painting of Regalus and *Venus Lamenting the Death of Adonis*. However, the Royal Academy was a more ambitious organization, establishing a school for young artists based on the curricula of the French and Italian academies.

After 1802, West experienced a downturn in his career. He had survived years of infighting and factionalism as president of the Royal Academy, including numerous challenges to his presidency, some led by his former protégé John Singleton Copley. He resigned after a particularly difficult year in 1805. He was out of favor with the king and sorely disappointed by the cancellation of the Chapel series. Elizabeth was very ill and West was suffering from episodes of severe gout. Also, his sons had grown into irresponsible spendthrifts. Yet in 1806, West triumphed once again. He was invited to return as the Academy's president, serving until his death, and attracted even greater acclaim with the painting *The Death of Lord Nelson,* 1806 (Walker Art Gallery, Liverpool). He regained his health and worked energetically, completing huge canvases such as *Christ Healing the Sick,* 1811 (Tate Gallery, London), which was painted as a gift for the Pennsylvania Hospital in Philadelphia. When exhibited in London the painting was so well received that subscriptions were raised to pay West the unheard-of price of 3,000 pounds to keep it in England (he painted a duplicate for the hospital). *Christ Rejected,* 1814 (Pennsylvania Academy of the Fine Arts), at 200 by 260 inches was the largest work West ever painted. It attracted almost 250,000 viewers at 1 shilling each in an independent showing West arranged in London. In 1816 the first volume of Galt's biography was pub-

lished. Readers were fascinated by Galt's fanciful stories of the youth of "the venerable West," as he was then known.

While Galt was preparing the second volume, West's health began to decline, and he suffered several episodes of paralysis before dying on March 11, 1820. West painted his last self-portrait in 1819, about a year before his death (National Portrait Gallery, Washington, D.C.). Compared with his earlier self-portrait it is a somewhat chilling image. His flesh is slack and forms deep wrinkles around his sunken mouth. His nose is more hooked than aquiline, again accented by a contrast of light and dark. His shoulders are slumped and the visible hand appears weak. Yet his eyes are as forceful as in his earlier self-portrait. After his death West's body lay in state at the Royal Academy in a room hung with black curtains and lit by candles, in a coffin covered by a pall and black feathers. The funeral procession included more than sixty mourning coaches, holding the lord mayor of London and many of noble rank. Benjamin West was buried in St. Paul's Cathedral, in a section known as Painter's Corner, next to Joshua Reynolds.

West's Reputation

It is surprising, considering the height of his fame, that West's reputation fell so sharply after his death. Although he was recognized as the father of American painting in William Dunlap's 1834 text, *A History of the Rise and Progress of the Arts of Design in the United States,* West's grandiose imagery was out of step with mid-nineteenth-century taste. In 1826 his sons petitioned the United States government to purchase a group of the artist's canvases as the basis of a national gallery. They claimed that the paintings were "the production of an American-born genius . . . the honor of having them belongs to the United States of America."[34] The government, always reticent in its support of the visual arts, declined and 3 years later his sons auctioned 19 of the paintings for the Chapel of Revealed Religion. Although George III had paid West 23,000 pounds for the paintings, his son George IV, who disliked West's work, returned them to Benjamin and Raphael at no cost. At auction, only 16 paintings sold for the dismal sum of 2,262 pounds.

During the rest of the nineteenth century and well into the twentieth, West's work was for the most part ignored or ridiculed. He was accused of banality and vanity, and even blamed for luring John Singleton Copley from Boston to London and thereby ruining him. A reassessment of West's career did not begin until 1938, with an exhibition acknowledging the bicentennial of his birth at the Philadelphia Museum of Art and an essay by William Sawitzky addressing his American period. In the late 1930s and 1940s, less biased and more accurate scholarship began to appear; scholars were particularly attracted to the revolutionary nature of *The Death of General Wolfe.* Interest in West accelerated around the bicentennial year 1976, when American art in general gained greater recognition. The large number of studies since 1976 reflects the interest in academic

painting among postmodern scholars, who are less inclined to favor the visu-ally avant-garde and more concerned with what works of art reveal about the taste of the times—which few paintings do better than West's. In 1986 a 606-page catalogue raisonné, or collection of all of West's known works, compiled by Helmut von Erffa and Allen Staley, was published. In 1985 a groundbreak-ing contextualization of West's paintings of the late 1760s and early 1770s, *The Valiant Hero: Benjamin West and Grand-Style History Painting* by Ann Uhry Abrams, addressed how seemingly elitist works of art were in fact embedded in contemporary political and cultural concerns. Since the late 1980s, about half a dozen articles on *William Penn's Treaty with the Indians* alone have appeared, approaching the painting from a range of methodological perspectives (see Bib-liography).

That such attention is deserved is unquestionable when one reviews West's accomplishments. Although uneducated, he was shrewd enough to recognize the steps he needed to take to succeed as a history painter and pursued this goal assiduously, cobbling together what was available in the colonies to prepare for his Italian sojourn. He was the first American painter to transcend the bound-aries of colonial art by working consistently in a genre other than portraiture. He produced images that pushed the field of history painting in new directions and appealed to a broad audience in addition to art connoisseurs. West advanced the status of the artist in the English-speaking world through his personal and professional relationship with George III and his active work for the Society of Artists and the Royal Academy. He was the progenitor of an American school of painting, raising the standard of the arts in this country far higher than they had ever been before. He helped initiate two styles, Neoclassicism and Romanticism, that invigorated European art. West also revived religious subject matter in Protestant England. Clearly, his life was a remarkable success story, along the lines of the famous tales written by Horatio Alger a century later.

Notes

1. The hand on chin pose is also found in portraits of West's contemporaries: Joshua Reynolds, painted by Angelica Kauffman in 1767; a self-portrait by John Runciman, 1767; and self-portrait drawings by Henry Fuseli, 1780 and James Barry, 1800–05. See Shawe-Taylor.

2. Galt, *Life and Studies,* 30.

3. Quoted in Abrams, "Colonial History," 62.

4. Quoted in Dickason, 130–32.

5. Quoted in Ibid., 131.

6. Quoted in Abrams, "A New Light," 245.

7. Quoted in Ibid., 243.

8. Galt, *Life and Studies,* 103–6.

9. Quoted in Prown, 29.

10. Galt, *Life and Studies,* 122.

11. Quoted in Alberts, 61.

12. Hughes, 73.
13. Quoted in Alberts, 89.
14. Boime, 123–25.
15. Quoted in Prown, 29.
16. Quoted in Taylor, 431.
17. Quoted in Staley, 325.
18. Galt, *Life, Studies, and Works,* 46–50.
19. Quoted in Alberts, 107.
20. Staley, 54.
21. Fryd, 78–83.
22. Reinhardt, 283.
23. McNairn, 679.
24. Abrams, *The Valiant Hero,* 195.
25. Quoted in Staley, 59.
26. Quoted in Postle, 122.
27. Staley, 72.
28. Hughes, 79.
29. Staley, 89–90.
30. Quoted in Abrams, *The Valiant Hero,* 109.
31. Saunders and Miles, 268.
32. Quoted in Alberts, 102.
33. Quoted in Ibid., 167.
34. Erffa and Staley, 150.

Bibliography

Abrams, Ann Uhry. "Benjamin West's Documentation of Colonial History: *William Penn's Treaty with the Indians.*" *Art Bulletin* 64, no. 1 (March 1982): 59–75.

———. "A New Light on Benjamin West's Pennsylvania Instruction." *Winterthur Portfolio* 17, no. 4 (Winter 1982): 243–57.

———. *The Valiant Hero: Benjamin West and Grand-Style History Painting.* Washington, D.C.: Smithsonian Institution Press, 1985.

Alberts, Robert C. *Benjamin West: A Biography.* Boston: Houghton Mifflin Company, 1978.

Boime, Albert. *Art in the Age of Revolution, 1750–1800: A Social History of Modern Art.* Vol. 1. Chicago: University of Chicago Press, 1987.

Brigham Young University Museum of Art. "Benjamin West, *The Baptism of Our Savior,* 1794." http://www.byu.edu/moa/exhibits/Current%20Exhibits/150years/840002400.html.

Dickason, David H. "Benjamin West on William Williams: A Previously Unpublished Letter." *Winterthur Portfolio* 6 (1970): 128–33.

Dillenberger, John. *Benjamin West: The Context of His Life's Work with Particular Attention to Paintings with Religious Subject Matter.* San Antonio, TX: Trinity University Press, 1977.

Dunlap, William. *A History of the Rise and Progress of the Arts of Design in the United States.* New Edition. Vol. 1. Boston: C. E. Goodspeed, 1918.

Erffa, Helmut von, and Allen Staley. *The Paintings of Benjamin West.* New Haven: Yale University Press, 1985.

Evans, Dorinda. *Benjamin West and His American Students.* Exhibition Catalogue. Washington, D.C.: National Portrait Gallery, 1980.

Fryd, Vivien Green. "Re-reading the Indian in Benjamin West's *Death of General Wolfe.*" *American Art* 9, no. 1 (Spring 1995): 73–85.

Galt, John. *The Life and Studies of Benjamin West, Esq., President of the Royal Academy of London, Prior to His Arrival in England; Compiled from Materials Furnished by Himself.* London: T. Cadell and W. Davies, Strand, 1816. Gainesville, FL: Scholars' Facsimiles and Reprints, 1960.

———. *The Life, Studies, and Works of Benjamin West, Esq., President of the Royal Academy of London, Composed from Materials Furnished by Himself.* Part II. London: T. Cadell and W. Davies, Strand, 1820. Gainesville, FL: Scholars' Facsimiles and Reprints, 1960.

Historical Society of Pennsylvania. "Finding Aid For: Staley/von Erffa Benjamin West Archive, 1940–2000." http://www.hsp.org/text/guides/staley.html.

Hughes, Robert. *American Visions: The Epic History of Art in America.* New York: Alfred A. Knopf, 1997.

Jaffe, Irma, ed. *The Italian Presence in American Art, 1760–1860.* New York: Fordham University Press, 1989.

McNairn, Alan D. *Behold the Hero: General Wolfe and the Arts in the Eighteenth Century.* Montreal and Kingston: McGill-Queens University, 1997.

———. "Benjamin West and the death of General Wolfe." *Antiques* 150 (November 1996): 678–85.

Neff, Emily Ballew. *John Singleton Copley in England.* Exhibition Catalogue. Houston, TX: Museum of Fine Arts, Houston, 1995.

Palumbo, Anne Cannon. "Averting 'Present Commotions': History as Politics in Penn's Treaty." *American Art* 9, no. 3 (Fall 1995): 28–55.

Postle, Martin. "A Taste for History: Reynolds, West, George III, and George IV." *Apollo,* n.s., 138 (September 1993): 186–91.

Prown, Jules David. "Benjamin West and the Use of Antiquity." *American Art* 10, no. 2 (Summer 1996): 28–49.

Rather, Susan. "Benjamin West's Professional Endgame and the Historical Conundrum of William Williams." *William and Mary Quarterly* 59, no. 4 (October 2002), http://www.historycooperative.org/journals/wm/59.4/rather/html.

———. "A Painter's Progress: Matthew Pratt and *The American School.*" *Metropolitan Museum of Art Journal* 28 (1993): 169–83.

Reinhardt, Leslie. "British and Indian Identities in a Picture by Benjamin West." *Eighteenth Century Studies* 31, no. 3 (Spring 1998): 283–305.

Rigal, Laura. "Framing the Fabric: A Luddite Reading of *Penn's Treaty with the Indians.*" *American Literary History* 12, no. 3 (2000): 557–584.

Saunders, Richard H., and Ellen Miles. *American Colonial Portraits, 1700–1760.* Exhibition Catalogue. Washington, D.C.: National Portrait Gallery, 1987.

Sawitzky, William. "The American Work of Benjamin West." *Pennsylvania Magazine of History and Biography* 62 (1938): 433–62.

Shawe-Taylor, Desmond. *Genial Company: The Theme of Genius in Eighteenth-Century British Portraiture.* Exhibition Catalogue. Nottingham: Nottingham University Gallery, 1987.

Staley, Allen. *Benjamin West: American Painter at the English Court.* Exhibition Catalogue. Baltimore: Baltimore Museum of Art, 1989.

State Museum of Pennsylvania. "An Image of Peace: The William Penn Treaty." http://www.statemuseumpa.org/Potamkin/index.htm.

Stebbins, Theodore, Jr. *The Lure of Italy: American Artists and the Italian Experience, 1760–1914.* Exhibition Catalogue. Boston: Museum of Fine Arts, Boston, 1992.

Strazdes, Diana. *American Painting and Sculpture to 1945 in the Carnegie Museum of Art.* New York: Hudson Hills Press in association with the Carnegie Museum of Art, 1992.

Taylor, Alan. *American Colonies: The Settling of North America.* New York: Penguin Putnam, 2001.

Towbin, Beth Fowkes. "Native Land and Foreign Desire: *William Penn's Treaty with the Indians.*" *American Indian Culture and Research Journal* 19, no. 3 (1995): 87–119.

Tuckerman, Henry T. *Book of the Artists: American Artist Life.* New York: G. P. Putnam, 1867.

Index

About the Author

ELISABETH L. ROARK is a Phi Beta Kappa graduate of Allegheny College in Meadville, Pennsylvania, and earned a M.A. and Ph.D. in art history at the University of Pittsburgh, supported in part by a Smithsonian Pre-Doctoral Fellowship. Dr. Roark has worked as an assistant curator at the Carnegie Museum of Art and taught at the University of Tennessee, Knoxville, and Randolph-Macon Woman's College. She is currently an Associate Professor of Art History and Chair of the Arts and Design Division at Chatham College, Pittsburgh. In addition to colonial American art, her research interests include mid-nineteenth-century American painting and sculpture, self-portraiture, and cemetery sculpture. Dr. Roark has published journal articles in *Prospects, American Art,* and *La Gazette des Beaux-Arts.*